S0-AXZ-219

AHMANSON · MURPHY
FINE ARTS IMPRINT

THE AHMANSON FOUNDATION

has endowed this imprint

to honor the memory of

FRANKLIN D. MURPHY

who for half a century

served arts and letters,

beauty and learning, in

equal measure by shaping

with a brilliant devotion

those institutions upon

which they rely.

701.030905 Z

The publisher gratefully acknowledges the generous support of the Art Endowment Fund of the University of California Press Foundation, which was established by a major gift from the Ahmanson Foundation.

Art and the Global Economy

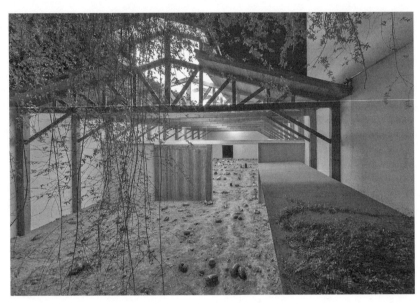

Adrián Villar Rojas, *Los teatros de Saturno* (The theaters of Saturn). Kurimanzutto Gallery, Mexico City, 2014. Courtesy the artist and Kurimanzutto. © Michel Zabé.

Art and the Global Economy

John Zarobell

UNIVERSITY OF CALIFORNIA PRESS

University of California Press, one of the most distinguished university presses in the United States, enriches lives around the world by advancing scholarship in the humanities, social sciences, and natural sciences. Its activities are supported by the UC Press Foundation and by philanthropic contributions from individuals and institutions. For more information, visit www.ucpress.edu.

University of California Press
Oakland, California

Library of Congress Cataloging-in-Publication Data

Names: Zarobell, John, author.
Title: Art and the global economy / John Zarobell.
Description: Oakland, California : University of California Press, [2017] | Includes bibliographical references and index.
Identifiers: LCCN 2016046419 (print) | LCCN 2016047981 (ebook) | ISBN 9780520291522 (cloth : alk. paper) | ISBN 9780520291539 (pbk. : alk. paper) | ISBN 9780520965270 (eBook)
Subjects: LCSH: Art and globalization. | Art—Economic aspects—21st century. Globalization in art. | Consumption (Economics) in art.
Classification: LCC N72.G55 Z37 2017 (print) | LCC N72.G55 (ebook) | DDC 701/.030905—dc23
LC record available at https://lccn.loc.gov/2016046419

Manufactured in the United States of America

26 25 24 23 22 21 20 19 18 17
10 9 8 7 6 5 4 3 2 1

For the artists, who dare to dream

CONTENTS

ILLUSTRATIONS

ACKNOWLEDGMENTS

I have been working on this book for over four years, but many years of experience have, in one way or another, gone into it. There are so many people to thank for their engagement with me and participation in my professional and personal development. I could not possibly list them all, but I count myself fortunate. Friends and colleagues at the Philadelphia Museum of Art and the San Francisco Museum of Modern Art seriously enriched this book, and working at these institutions provided me with a range of perspectives on art and society that I could not have otherwise imagined. Thanks also to University of San Francisco Dean Marcelo Camperi, Associate Dean Pamela Balls-Organista, and chair of the International Studies Department Dana Zartner.

For the research and travel that made this book possible, I thank the Faculty Development Fund of the University of San Francisco and the Lahore Literary Festival. At the University of San Francisco, I have had the chance to teach two classes on the topic of this book that helped me to shape my ideas and to sharpen my thinking. The students directed my attention to countless issues and texts that propelled this project forward, so I would like to thank all of those who took those classes, and also Paula Birnbaum for asking me to teach the course in the first place. Thanks are also due to Todd Hosfelt, Erica Gangsei, and Xiaoyu Weng, who came to participate in the class as experts. From this class I cultivated my wonderful research assistants Emma Rogers and Marian Berthoud, and Jenna Herbert rounded out my research team—thanks to all! Eva Krchova also worked as a research assistant and during her time she developed the graphics that are so crucial to this book.

My travels have also been facilitated by many friends and colleagues who provided introductions for me, and all of those professionals I met during

these trips have provided me with insight into the global dimension of their art worlds. Thanks to Enrique Chagoya for introducing me to wonderful folks in Mexico City, including Lorena Woffler, Lourdes Grobet, and the profile author for Mexico City, Mariana David. Thanks also to Armando Colina, who took the time to enlighten me about many aspects of the art world there. Thanks to Xiaoze Xie for introducing me to Ferdie Ju in Shanghai, who then introduced me to Xiang Yuping, and thanks to Yan Chen for showing me Hangzhou and the China Art Academy. Thanks to Deepak Talwar for being my guide to Delhi, and to Dipti Mathur who provided me with introductions. Thanks to Andrew Gilbert for guiding me through his art world in Berlin, and to Shahzia Sikander for getting me to and around Lahore, as well as to Waqas Khan for his driving, advice and companionship. Thanks to Diana Campbell Bettancourt, who invited me to Dhaka and helped me to understand the implications of the Dhaka Art Summit.

The authors of the emerging city profiles have all been amazing, and I am honored to publish their writing in this book. I thank you all and also those who helped me to find you, including Deena Chalabi, Karin Oen, Kim Anno, and Anna Parkina.

Of course, there have been countless conversations that have stimulated and informed me and it is impossible to list even a fraction of all I have learned from. I have had a few structured interviews with Lorena Woffler, Celenk Bafra, Vishaka Desai, and Abdellah Karroum. Thank you all for your time and your willingness to review what I have written. Beyond those already listed here, I must thank other interlocutors, including Joe Rishel, Shelley Langdale, Carlos Basualdo, Kerry James Marshall, Betti-Sue Hertz, Carrie Pilto, Andrea Buddensieg, Hans Belting, Andrew Schoultz, Christo Oropeza, Qamar Adamjee, Pamela Echeverría, Fernando Mesta, Christopher Fraga, Olav Velthuis, Cheryl Haines, Matt Gonzalez, Andres Guerrero, Ranjani Shettar, Bob Herbert, Erin Gleeson, Marjorie Schwarzer, and Sofia Carillo.

I would also like to thank my readers who contributed much to my thinking on the manuscript, including Cheryl Finley, Jennifer A. Gonzalez, and two anonymous reviewers. Some of the writing in Part III has previously appeared in *San Francisco Arts Quarterly* and *Arts Quarterly*, and I thank Andrew McClintock for allowing me to republish it here, and the editor of those pieces, Peter Cochrane. Thanks to all of those institutions and photographers who have given me permission to publish images here, and those who facilitated sending images and permissions. Thanks to artists and architects

whose works are featured in the photographs, including Herzog and de Meuron, Adrián Villar Rojoas, Thukral and Tagra, Marcos Kurtycz, Subodh Gupta, Ackroyd and Harvey, Pete Pin, Amy Lee Sanford, and Seoun Som.

Finally, thanks to Keally, Celeste, and Theo for all of the love and support; I could not have done this without you.

Introduction

MEASURING THE ECONOMY OF THE ARTS

As an artist with a day job thinking about grad school, I was surprised to learn from a newspaper article one morning in 1993 that the arts had generated $9.8 billion and supported 107,000 jobs in New York City in 1992, making a major contribution to the local economy, according to the Port Authority of New York and New Jersey (Redburn 1993; Port Authority 1993).

I suppose this should have occurred to me earlier. When I was an art student in western Massachusetts, my girlfriend and I had made many trips to the city, spending what little money we had on museums and meals; mercifully, we got to look at art in galleries for free. If we had spent all our extra money in New York, what about the busloads of suburbanites who flocked to Broadway? And those galleries, well, they must have been able to pay their rent somehow, so I guess they were selling art. But I was young and idealistic, imagining that art was my means to escape the world of business and make a more substantive contribution. My studies had filled my head with theories of art transcending a hopelessly materialistic bourgeois society. If the arts were important, they were bound to be rejected by large segments of the population, only to be later enshrined at museums and celebrated as revolutionary. But the discovery that the arts actually bolstered New York's economy undermined those assumptions. The glass wall that separated art from capitalism cracked in my mind, and the webs of lines that resulted radiated in every direction. I was not shocked by this revelation; as an artist, I felt vindicated.

More than twenty years later, I am no longer an artist, and I no longer have such a rosy view of the economic impact of the arts. I took a PhD in Art

History and became a curator, first of modern and then of contemporary art. In these roles, I have watched the world of visual arts expand more than I ever could have imagined. Working at the Philadelphia Museum of Art and the San Francisco Museum of Modern Art, I attended art fairs, biennials, and auctions. I also visited galleries, nonprofit art organizations, artists' collectives, and countless studios. As a result, I bring an array of experiences to bear in analyzing and interpreting the expansion of the art world. There are many different views of the developments in the arts, but all agree on a few points: the terrain has shifted, new fairs, biennials, and museums have proliferated, and commerce and art have become closer than any moment in recent memory.

The earnings of art commerce and the various industries that comprise what John Howkins (2002) has called the "creative economy" have increased exponentially. Since the New York Port Authority's 1993 study, many other locations across the United States, and indeed the globe, have sought to measure the economic impact of the arts, resulting in countless reports. A number of these are discussed below. Significantly, in them the arts have been and are being measured in economic terms. This amounts to circumvention of prevailing theories of the avant-garde (Berger 1970; Bürger 1984; Krauss 1985). Rather than refuting the ideas put forward by artists and social critics, authors of these economic studies have simply applied formulas to quantify artistic production and the value-added impact of the arts in their own quantitative domain. Economists evaluate economic impact as a means to understand how events or processes add real value to the economy (Guetzkow 2002). Thus, they have succeeded in framing the arts—a group of contingent, sometimes oppositional, and occasionally revolutionary practices and transactions—as a single economy, albeit as a subset of a larger structure. The subject of economic impact studies is not just the art market, though this is the most common way of grasping the arts economy. Rather, these studies outline a distinct economic process in which the arts, and the creative spirit essential to them, acquire a putative fiscal value that can have a tremendous impact on local, national, and international economies.

But this empirical maneuver is only the beginning of the story, for the process of globalization has transformed what we used to know as the art world. Globalization has accelerated the world's integration in the past generation, and the result is that these economic aspects of the arts have been generalized across the planet. A wide range of authors have contributed to the prolific literature on globalization. David Harvey (1990) and Zygmunt Bauman (1993) have examined the transformation of traditional perceptions of space and

time. Manuel Castells (1996) has discussed the erosion of social processes in what he calls the "network society." Others have discussed the globalization of culture (see, e.g., King [1990] 1997). The term "world city," dating as far back as 1915, and still used by many academics in Britain, has been superseded by Saskia Sassen's (1991, 2000) introduction of the notion of the global city, which has generated an impressive array of research attempting to locate the effects of globalization on various populations (Brenner and Keil 2006).

At bottom, globalization is the result of a growth in international organizations (from the United Nations to the International Monetary Fund and the World Trade Organization) that promote cross-border exchange and finance, resulting in a fundamentally different economic order than had previously existed. This economic dimension of globalization is central, but knowledge and information are also exchanged internationally, and the process of migration has become much more prominent. Such transnational trajectories lead to more global integration. One central question that has been taken up by authors addressing globalization has been the question of cross-border flows, whether they be economic, social, or cultural, and whether they flow primarily one direction (from the center to the periphery) or whether these flows are reciprocal. This is a central question that will be explored through the domain of the visual arts in this book. It was once assumed that culture flowed from Europe to the rest of the world, via institutions such as museums, or via representational innovations, such as modernism in art. Some still argue that the flow of influence is primarily unidirectional, but this study undertakes to demonstrate a variety of multidirectional flows that demand a reconsideration of the center/periphery dynamic.

When applied to the art market, globalization means that the national and regional economic interactions around art have been subsumed into a larger pool of global art and capital, and so the economy of the art world has changed considerably as a result. Of course, much research has also been introduced linking globalization to contemporary art (Stallabrass 2004; Bydler 2004; Elkins et al. 2011; Lee 2012) and to the evolving domain of the museum. The work of the Global Art Museum project emerging from the Zentrum für Kunst und Medien in Karlsruhe is exemplary here (Weibel and Buddensieg 2007; Belting and Buddensieg 2009; Weibel et al. 2011, 2013). Both consumers and producers can be found around the world. American domination of the art market has mostly persisted so far, but it is easy to imagine that this will not always be the case. At this point, locations such as Dubai and Hong Kong now count among the commercial hubs of the art

world and each will, in a few years' time, have a selection of art museums to compete with most art capitals. In 2012, Shanghai, China's largest city, opened the China Art Museum, measuring 690,000 square feet, in a bid to compete with institutions such as the Louvre and the Metropolitan Museum of Art. China has gone from having 25 museums when the People's Republic of China was founded in 1949 to having 3,866 as of 2012 ("Mad about Museums" 2013). The internationalization of contemporary art has received the most press, and indeed the market for this material has exploded in the past decade, but it is hardly the exception. I now consider the impulse to quantify the creative forces in the contemporary world, and particularly in the visual arts, as a pernicious historical formation, and demystifying the numerous intersections of the visual arts and market structures is therefore one of the primary aims of this book.

What could be pernicious about economic growth in the arts? After all, does it not mean that more people are enjoying art and buying it, that more artists are able to make a living from their work enabling them to let go of those day jobs? What is troubling is the impulse to measure art's value in strictly economic terms and thereby to quantify its contribution to society. Cultural production may be thoroughly implicated in the market system, and indeed the global economy, but it has long been perceived to represent an alternative to that system, and the most subversive aspects of it cannot be quantified. Since Charles Baudelaire wrote art criticism in mid-nineteenth century Paris, art critics have railed against market-oriented artists, and it is received wisdom that artists are not in it for the money—despite evidence to the contrary in certain cases. Earlier theories of the avant-garde have, however, been reevaluated by recent contemporary art historians who have taken the ideas of the Frankfurt School and given them new life (Foster 1996; Lee 2000, 2012; Bourriaud 2002). It is not simply that artists today aim to transcend commerce; the essential tools that they employ reconsider the problematic of consumerism and reintegrate it into their alternative ways of making and displaying art.

Furthermore, the experience of an art exhibition or performance regularly transcends the money that people pay to have the experience (i.e., its use value). The fact that some exhibitions are attended by half a million visitors certainly testifies to the star power of certain artists and the willingness of museums to innovate new ways of engaging publics. Viewers perceive such events as rare cultural opportunities, or else they would spend their money on some other form of entertainment or consumer gratification. But block-

buster exhibitions are not generating huge surpluses for institutions, given the years of planning and development at multiple organizations, the enormous effort involved in prying important art works from institutions and private collectors, and the considerable expense of the catalogue. However, the success and visibility of such events draws the attention of those who do not have to confront the ticklish tasks of bringing them to fruition. When the financial outlook and management system that undergirds cultural organizations begins to attract the attention of MBA programs and commissioners of the European Union, a new sensibility has emerged. If the Chair of the National Endowment for the Arts has to defend the very limited funds that the federal government in the United States delivers to artists each year on economic grounds alone, the important distinction between the values of art and the value of the arts is being eclipsed. Whether you believe that any government has a responsibility to fund the arts, it is clear that a bottom line has been drawn beneath artistic creation, which on some level argues for the significance of culture but on another level reduces it to a subset of the global economy, another measure of our collective productive capacity.

We need to consider the concept of economic impact and the creative economy, taking stock of calculations that glorify culture as an economic force in the global economy. This book situates the economics of the arts in relation to the process of globalization, which involves both increased diversification of content and the dissemination of norms, a homogenizing system that allows that content to be transferred anywhere (Appadurai 1998). The expansion of the art world into an integrated global market has transformed every aspect of exhibition, sale, and production in the process. Given the ubiquity of the metaphor of globalization, and the fact that most everything we own or consume comes from abroad, it begins to seem impossible to conceive of our immediate experience and production apart from global processes. It thus seems essential to consider how the art world has blossomed into a global economy in the past generation, and what that means to artists, dealers, curators, cultural administrators, educators, and the public. How can these changes even be comprehended, let alone measured?

Many dimensions of this fundamental inquiry are explored in following chapters of this book, and the complexities will be teased out through specific inquiries into various domains of the art world, including institutions, exhibitions, and the market. It would be unwise to make broad prognostications about the globalization of the art world, or even the art market, because the dynamics are generally uneven (Velthuis and Baia Curioni 2015). Yet the

tendency to measure and to produce data-driven analysis is paramount in the twenty-first century so taking stock of measurements of the purported value of the arts is a productive means to initiate this inquiry. Of course, developing metrics is the prerogative of economists and management consultants, who sensibly assert that we need to evaluate the economic successes that the arts accrue. So I begin this analysis by turning to studies of the economic impact of the arts, and their limitations.

The gold standard of economic impact statements is the series of reports titled *Arts & Economic Prosperity* (4th ed., 2012; 5th ed. in production), published by Americans for the Arts. Based on a survey done in 2010, in the wake of the "Great Recession," when the unemployment rate in the United States was 9.7 percent, *Arts & Economic Prosperity IV* was able to report that of "the $135.2 billion of economic activity generated by America's arts industry, $61.1 billion [came] from . . . nonprofit arts and culture organizations and $74.1 billion from event-related expenditures by their audiences. This economic activity [supported] 4.1 million full-time jobs and [produced] $22.3 billion in revenue to local, state, and federal governments every year—a yield well beyond their collective $4 billion in arts allocations" (Lynch 2012).

The first economic impact report on the arts in the United States was published in 1977 (Cwi and Lyall 1977). Such studies measure economic activity that results from both the production and the consumption of the arts. On the production side, an example would be that walls have to be built and art has to be shipped to create a blockbuster exhibition. Thus construction and shipping are affected industries that increase as a result of artistic events. On the consumption side, these studies take the number of visitors and attribute value to each one, assuming that a certain percentage of visitors go out to dinner, for example, when going to the theater. Greater values are attributed to those visitors who come from out of town, estimating that they spend a certain amount on food, lodging, and other services when they attend a performance or exhibition, and the combination of these estimates is the figure for the value of the economic activity. It accounts for jobs, not just by considering how many employees are engaged at the arts institutions themselves, but taking into account the various industries that service these institutions, from security to catering. These are considered indirect jobs, but these industries realize profits as a result, employ workers, and, of course, pay taxes. Though these numbers seem clear, they are derived from complex algorithmic formulas for measuring the economic impact of events like the World's Fair, or long-standing attractions, such as sports teams.

No art gets made without some form of patronage, and since the nineteenth century, the market has provided a major portion of such support. But marketing is not the artist's role, despite the fact that that many supporters of the arts are swayed by marketing in their appreciation of particular artists. Furthermore, successful artists in all fields take up a significant portion of the market share in their respective domains, eclipsing other producers. When the focus is on patronage, and the arts are seen in terms of industry, artists can end up as little more than businessmen. This is a moral crisis for the arts, and one could easily list some of the most celebrated contemporary visual artists whose range of activities have clearly been eclipsed by marketing. Such a situation creates cynicism and leads to a loss of faith in the arts' offering an alternative to the dominant culture that binds the world together through economic integration. When the arts are portrayed as a device for economic integration, they cannot represent a critique, but only a reflection of our current phase of service-dominated capitalism. Without a doubt, the world we inhabit today is one driven by economic norms, and adapting to these norms is the latent condition of a globalized world. However, if one can only account for art's impact in economic terms, the dominant narrative of accounting has engulfed the alternative vision that what is most valuable in the arts is precisely what cannot be measured. An excellent example of this phenomenon is that the creative potential that is the core of the artistic enterprise has recently been appropriated as central to the machinations of the business world, particularly through the figure of the entrepreneur who succeeds through creative disruption. This notion will be further elaborated below through the discussion of the creative economy.

The *2014 Otis Report on the Creative Economy of the Los Angeles Region* (Los Angeles County Economic Development Corporation 2015) expands beyond the notion of economic impact to embrace creativity as an essential aspect of the economy. It is fitting to employ the term "creative economy" in sizing up the overall economic productivity of the culture industry in Southern California, the home of the film, television, and music industries in the United States, which could all be genuinely described as generating economic growth based on creative activity. This term is also used to describe a host of nonprofit organizations for the arts also located in the region.

Based on economic census data, the 2014 *Otis Report* notes that the creative economy is the second largest sector in the local economy, comprising some 406,900 direct jobs (more than 800,000 when direct and indirect are combined) and generating $140 billion in revenue in 2014, producing $5.7

billion for the local tax base. The entertainment sector makes up 45 percent of it, while art galleries account for so small a portion that their listing is simply "N/A." But these results are given a different treatment in a paper by Ann Markusen, "Los Angeles: America's Artist Super City," appended to the 2010 *Otis Report*, which notes that Los Angeles is home to more artists than any other metropolitan area in the United States, including New York, and that it is "the premier place to pursue an artistic career." Though the aggregate data used for artists includes musicians, performing artists, writers, and visual artists, a chart makes clear that Los Angeles is actually home to more visual artists than any other urban center in the United States. Yet, the author notes, "compared with other cities, Los Angeles has no coherent strategy for celebrating and nourishing the artistic capital that comprises the region's innovative and creative genius" (7). Though the visual art market has expanded considerably in Los Angeles since then, it does not appear that Los Angeles has provided any significant incentives for artists, with the exception of a 2014 proposal for an Arts District Live/Work Zone (Los Angeles Department of City Planning 2014).

Markusen, an economist herself, calls attention to the fact that the above-mentioned economic impact studies leave the artist out of the equation, and that, in terms of policy, there is little initiative on the part of local government to treat its artists as assets that need to be preserved in a world where economies are diversifying and form a global, as opposed to a national, network. The problem is not that artists are going to move from Los Angeles to New York; it is that they may move to Beijing or Bangalore or Mexico City. Ditto for the industries themselves. If American manufacturing has lost out in the globalizing world, why not the creative industries too?

This question introduces one of the central arguments of this book: the arts are not insulated from larger economic processes. Many have narrated the history of the intersection of arts with contemporary social developments (the social history of art) but economic paradigms have not been addressed as much by art historians and critics, save in their analyses of the market (Bydler 2004; Stallabrass 2004; Horowitz 2010). This is why economic impact and creative economy studies are worth considering in detail; they introduce the idea that the current art world is embedded in an economic system, and they begin to explore the complexities of our current situation. Nevertheless, they are written from the point of view of economics, not from that of the arts. What is needed is a macro-level reevaluation of the global arts economy that highlights, not simply the development of the business of

the arts, but the way the visual arts have shifted as a result, becoming embedded in the process of economic globalization in the past generation. Economic impact reports and creative economy studies provide a window on specific local economies, and the *Arts & Economic Prosperity* report even cobbles together a national picture, but that is not nearly broad enough to provide an understanding of worldwide economic integration, the expansion of the art market in that context, and the implications for the visual arts that result.

Nevertheless, there is another reason to look more closely at the way such reports have proliferated around the world. Given recent global integration under the terms of neoliberalism (also known as the Washington Consensus), it is perhaps not surprising that studies of the creative economy have spread from the United States, Australia, and Europe to the United Nations, and then on to locations as diverse as Istanbul and China. Each case is distinct, yet what one can glean from this upsurge is a shared interest in the economic developments in the arts, as well as a globalization of the economic metaphors related to them. While it is important to grasp the broader picture, these examples need to be assessed in turn. From this analysis, one can derive a comprehension of some shared terms, despite differences in context. Such terms, though they may be quantitative or fundamentally abstract, are one site where the global economy of the arts starts to become visible.

A recent creative economy report sets a new standard for considering the economics of the arts as a global process. "Cultural Times: The First Global Map of Cultural and Creative Industries," commissioned by CISAC, the International Confederation of Societies of Authors and Composers, and executed by the consulting firm EY (Ernst & Young), appeared in December 2015. Its results present some amazing numbers and a regional and sectoral analysis of the economic impact of art and culture worldwide. The biggest takeaway is that cultural and creative industries generate $2.25 trillion dollars annually and provide some 29.5 million jobs, of which the visual arts sector accounts for $391 billion and 7,320,000 jobs globally, making it the second largest sector overall, behind television, but well above books, performing arts, and even film (EY 2015). This report is a big advance on previous reports focused on European and American creative industries, but it does not clarify many details on how the creative industries relate to economic development more broadly.

Inasmuch as support for culture by governments around the world differs tremendously, and the importance of state support for the arts is left untouched by this EY study, it is useful to look at a 2006 European Union

study, outdated though it is. "The Economy of Culture in Europe," a pioneering study of the state of the arts in the twenty-five countries then in the EU, plus Romania and Bulgaria, which were not officially admitted to the EU until 2007, was prepared for the European Commission's Directorate-General for Education and Culture by the Brussels-based research and advisory company KEA. It summarizes the results of economic arts studies and provides a broad synthetic tool for making comparisons between countries like Britain and Germany that have strong support for the arts and more recent additions to the EU, which were only beginning to measure the economic effects of the arts at the time the study was published. Since the data on which the study is based were collected only as late as 2003, it cannot be said to reflect the current state of affairs. Nevertheless, it contains a wealth of useful information. Considering the overall numbers, the creative economy was a considerable force in the EU economy at the time, representing 2.6 percent of total EU GDP, a total of 654 billion euros in 2003. Furthermore, the cultural sector growth in the twenty-five EU countries from 1999 to 2003 was 12.3 percent higher than overall growth. While Germany and Britain were the leaders in GDP performance, the largest growth was in eastern Europe (KEA 2006).

Some of the most compelling points in this report are not in the tables, but in the narrative sections. For example, in order to provide clear delineation of information, the authors map several approaches to the question of measuring the cultural economy. The British creative industries model (shared by Austria, the Baltic republics, and Sweden) is juxtaposed to other forms of measurement, such as the French method of measuring specific "cultural industries" and the Nordic approach, described as "the experience economy" (Pine and Gilmore 1999). All of the trends are historically traced and methodological questions about what is getting measured, and why, are clearly outlined (KEA 2006, 44–48). In another chapter, the dynamic between culture and creativity is succinctly elaborated and brought into line with the broader goals of European integration and economic development, as articulated in the Lisbon Strategy of 2000. Concerning the creative economy, the authors explain: "In this context, culture is not analysed as a source of final consumption (as in the case of films, books, music, cultural tourism, etc.) but as a source of intermediate consumption in the production process, most of the time the final products being functional (to the contrary of works of arts or to the output of cultural industries)" (36).

This is a far cry from actually putting a value on artists' contribution to society, or even the economy. Rather, the disembodied notion of creativity

itself is prized, and this idea is explicitly paired with economic development. The other side of the coin would be to see the creative economy as a manifestation of "cognitive capitalism," defined by Bernard Paulré as "including knowledge, information, and communication: in a nutshell everything that constitutes intellectual activity" (Paulré 2010, 171). In his view a "cognitariat" has come to dominate through "cognitive accumulation," which is distinct from industrial capitalism, because it is not based on labor.

A United Nations Conference on Trade and Development report states:

> Thus it can be seen that the concept of the "creative economy" has evolved along several paths over the last ten years. It has emerged as a means of focusing attention on the role of creativity as a force in contemporary economic life, embodying the proposition that economic and cultural development are not separate or unrelated phenomena but part of a larger process of sustainable development in which both economic and cultural growth can occur hand in hand. (UNCTAD 2010, 10)

The Creative Economy Programme, the organization that authored the report, received its mandate in 2004 from the São Paolo consensus to support developing countries in efforts to increase the potential of the creative industries. At the São Paolo UNCTAD conference, it was perceived that many such countries possess cultural assets that could aid their economic advancement. That mandate was enforced and expanded at a more recent convention in Accra in 2008. As the name suggests, the United Nations Conference on Trade and Development is an arm of the UN that promotes international business development, and in this sense it is a mechanism that promotes globalization. Though it was originally conceived as a check on global economic powers, such as multinational corporations, it is now widely perceived as serving their interests (Prashad 2007).

Whether one discusses the creative economy in terms of growth, assets, or development, the terms of the debate are fundamentally economic, and the goal is to implement technological and industrial development through "creativity." Creativity was once considered the mainstay of the arts and was not previously perceived to be either quantifiable or valuable outside of the domain of artistic production. In this new context, creativity is an essential element of an entrepreneurial culture, and the "creative class" employs its innovative potential to accelerate the "creative industries," yielding broader economic growth. Such a model becomes a mantra in the hands of UNCTAD that can be recited to the developing world. Given the centrality of this

narrative in international policy circles, it will be valuable to explore one instance where the creative economy has been successfully integrated into economic development.

In their 2005 paper "What Are the Dynamics of the Creative Economy in Istanbul?" Erhan Kurtarir and Hüseyin Cengiz outline two central ideas around the creative economy advanced by Richard Florida (2002) and John Montgomery (2004) and apply them to the urban fabric and demographics of Istanbul. They find a concentration of essential features in the area around Beyoğlu, but point out that no data existed in order to evaluate the scale of the creative economy in Istanbul at that point and recommend that cities should develop their own creative economy reports in order to determine which sectors are active and how to spur growth. They conclude:

> As mentioned above, cultural industries and cultural strategies have become important elements in urban policies and the creation of consumption patterns and varieties of these patterns have become the main aims of local authorities. With the increasing importance of symbolic economy, the policies of image creation for place promotion has become inevitable for governments. The main purpose of this approach is to establish an attractive city for investors and visitors. (Kurtarir and Cengiz 2005, n.p.)

These authors seem to have preempted the UNCTAD suggestion that developing nations study potential ways to employ culture to increase economic development, and they are also interested in the ways that cities can develop locations that serve to create an "image" that translates into a recognizable international brand. If they did not yet have the data to analyze the creative economy, they nevertheless underline that the goal for local governments in developing the creative economy is not to support the arts, or artists per se, but to create a location that draws investment and tourism.

What can be said about the aggregate data here presented on the creative economy and the economic impact of the arts? The first point to be made is that methodologies are numerous, and they therefore find a variety of results. All of these studies employ data collected by government organizations for other purposes, including census data, economic data, and occupational data, and they develop their own paradigms in which to make sense of the data. This means that if you are looking through the lens of economic impact, the focus is to rationalize funding for the arts, but if you are concerned with the creative economy, the goal is to highlight the development of new industries and images through entrepreneurship. Studies of the creative economy are

more likely to overestimate the percentage of GDP related to innovation and to define it as fundamentally creative. The idea of a creative class suggests that a society, state, or region ought to work to sustain those who generate their own destinies and define the future of their respective fields.

Another general point to be made is that the models being employed are all conceived to be universal, if distinct. Since all of these studies are based on existing data being reconfigured to suggest new outcomes, it is possible that any set of data normally collected by governments around the world could be plugged into one of these models and reinterpreted to allow for comparisons. This is precisely what one finds in the EY global study "Cultural Times" as a model for the entire world. This study aims to measure the economic dynamic of the arts on a global scale, and the results suggest that, as the authors state "the cultural and creative world is multipolar":

> Asia-Pacific accounts for US$743b in revenue (33% of global CCI sales) and 12.7m jobs (43% of CCI jobs worldwide). . . . Europe and North America are the second and third largest CCI markets. Today Latin America, and Africa including the Middle East rank fourth and fifth, respectively—but CCI players see great development opportunities in these two regions. Though symbiotic, each world region is developing a momentum of its own. (EY 2015, 8)

This is an important formulation lacking in previous reports, namely, that there is a decentralization, in economic terms, driven by the cultural and creative economy, and neither Europe nor North America can be seen to dominate it. This perspective is new, and it dovetails with the central argument of this book that a geography based on center and periphery is no longer an accurate means of addressing the art world.

Nevertheless, all of these reports represent a transformation of thinking on the arts that needs to be evaluated in order to get beyond some of the reductive assumptions that such studies embody. Here is the fundamental turn: creativity now means economic growth, not artistic decision making. Instead of an author struggling against the proverbial empty page, a member of the creative class may instead be trying to determine what data to plug into a spreadsheet. If the success of a postindustrial economy is tied to a cognitariat and their innovative capacity, creativity is a value that needs to be cultivated in order to achieve financial success, and even sustainability. This is good economic sense, and it ought to influence policy, but what does it mean for the arts, and indeed for artists themselves?

While some artists, like my younger self, may feel vindicated by these studies, the question is whether all of this has anything to do with them. I would argue that it does not. As economists, arts agencies, municipal governments, and foundations all over the world are seeking to promote the creative economy or the creative class, to build institutions, and promote the arts, they are neglecting the essential creative forces generated by artists and makers of all kinds, because there is simply no way that such capacity can be measured and plugged into a table. The fact that the strength and value of the arts are primarily evaluated through data means that all those ineffable aspects of artistic creativity are simply not considered, and, as a result of current and future policies, they will not be supported. In truth, the only reason for supporting the arts that makes sense is that what artists achieve is not measurable by any metric, and yet it is essential to modern life. If this were not the case, why would anyone want to evaluate the economic impact of the arts in the first place? These reports provide data on something that *can* be quantified, but it just isn't what matters for the arts.

So why write a book on the topic of art and the global economy? Doesn't that just situate the arts back into that economic model in which they do not fit? The answer is multilayered and yet very simple in the end. We live in an era of globalization, and it is economic integration that connects us across oceans, mountains, and language barriers. Artists and those that support them ignore these issues at their peril, because the world that gave birth to the ideas of the arts that we have inherited is in a process of metamorphosis. As many commentators on globalization have noted, now going back more than thirty years, there is a notable acceleration of flows of humans and capital that marks our era as distinct from any previous one. If one looks at the domain of visual arts in the past generation, it is clear not only that it has expanded exponentially but that it has become both more diversified and more homogeneous. This is the paradox of globalization: the more interdependent we become, the more we need to come to terms that are simple and immediate enough that anyone, no matter what their background or where they are currently located, can share them. This book is an attempt to grapple with the question of what this means for the visual arts and how the entire ecosystem that exhibits, promotes, and supports the visual arts has been remade in the twenty-first century. As Charlotte Bydler has observed, "Globalization and historicism are thus intertwined subjects. The narrative efforts to describe relations in history become reality in the process of description of the whole art-world system. The available narrative structures

for the international also form the areas for its realization" (Bydler 2004, 267). In other words, the story that one can tell about the globalization of the art world allows such a process to come to be seen as a reality we endow, as opposed to a hollow economic mantra to which all must submit.

In order to explore this terrain anew, I slice across a wide array of social and economic spheres in order to capture an image of a world in flux, rather than become immersed in a single key aspect. Eight subsequent chapters each seek to articulate a structure for comprehending the changes that have occurred in the past generation. The first two consider art museums, because they are the institutional bedrock of the arts, and they are now expanding to become a global phenomenon, with some unexpected results. I focus on museum financing and museum exhibitions respectively. The first chapter explores how museum financing in the United States and Europe has changed in the past generation; it is being challenged by new financial and management models, and the way institutions build their collections has to respond to new pressures in the market. These shifts will shed light on the growth of museums in other parts of the world and, with recent developments in contemporary art, how museums have to stretch to accommodate new media within their limited physical plants. Of particular interest is the growth of the private or vanity museum model in developing economies where contemporary art has not been supported by state institutions. This reflects both the growth of the international bourgeoisie and the turn to individual, non-state actors, who are more potent in the current neoliberal economic climate. The next chapter on traveling exhibitions will treat recent developments of the blockbuster phenomenon and the rise of an array of institutions around the world that are not collecting museums but exist in order to present artistic events for a temporary run to attract tourists and engage new approaches to the presentation of works of art. Many of the most popular exhibitions in past years have been staged outside of Europe and the United States, and emerging economies are successfully employing major exhibitions to bring art, particularly modern and contemporary art, to new audiences.

The next two chapters, constituting Part II, advance beyond the research on museum exhibitions to consider two exhibition formats that have exploded in recent years, biennials and art fairs, and how they impact comprehension and consumption of contemporary and other forms of visual art. Chapter 3 focuses on the assessment of biennials, which are nonprofit cultural festivals. Though the Venice Biennale is the oldest (dating to 1895), there

are now approximately 150 biennials worldwide seeking to attract art world audiences and a broader population of the art viewing public. The biennial was developed in Europe, but its spread throughout the world allows for an examination of how this structure has been redefined when manifested in formerly colonized countries, and these new developments have had broad implications on the organization of biennials both in Europe and in the Global South. The main thrust of Chapter 4 is to examine art fairs, which have a shorter history but have expanded even more since 2000, reaching a current total of approximately 250 worldwide. These fairs are equally spectacular, but they provide another means to encounter works of art, and they have created new economies for dealers, as well as helped to drive up the prices of contemporary art. In both of these exhibition formats, one can find a significant increase in presentations occurring outside of Europe and the United States, so these chapters specifically consider the implications of globalization of two fundamental exhibition paradigms from the West and not only demonstrate a degree of homogenization but illustrate how the traditional center/periphery model of artistic production and consumption is challenged through these festivals.

The next chapters, on the market, consider recent changes from the perspective of the gallery (the traditional retail unit of art consumption in the modern world) as well as the bigger picture of multinational auction houses and increased scale in the market overall. Chapter 5 focuses on galleries and look at the specifics of how a business can make money by selling art, but approach this question from a global perspective, considering galleries around the world in order to find shared common practices and unique traits. The growth of the multinational gallery is investigated here, since the paradigm has shifted from creating a particular niche market around a single individual to developing a recognizable brand that is exportable to new markets. Auction houses are the subject of Chapter 6. The rise of auction house business in contemporary art has been much remarked upon, but the economies of scale involved—€24.6 billion worldwide and growing—have wide reaching effects (McAndrew 2015, 26). A series of record-breaking sales continues, giving collectors a sense that the appropriate artistic assets are both desirable and fungible. Simply put, auction houses have existed since the eighteenth century for the quick disposal of cultural goods. However, they also provide an outlet for market valuation and make speculation possible, two essential components in an arena of economic growth. One fundamental difference to consider here is between the primary market (dealers) and the

secondary market (i.e., resale of art), and how that difference is perceived within the art world, whether as the mark of sheer speculation or as two aspects of an economic system that thrives on visibility.

Chapter 7 discusses recent developments in financial instruments related to the art world and how those are producing new effects in the market. The goal here is to step outside familiar paradigms and reframe the art market based on activities happening at the margins, including offshore areas that allow for tax-free storage and consignment of art works. Freeports have long existed for goods in storage or transit, but their expansion and development to meet the demands of the growing art world in Switzerland and now Beijing and other locations around the world will be considered in light of recently developed investment strategies that allow wealth to be tucked away, and to expand, through a system of unregulated and mostly invisible financial machinations. This hidden aspect of the art market refocuses art works as assets that can be secreted away from governments and their regulatory structures while providing enhanced financial leverage to their owners. The informal dimension of the art market is also considered here, including everything from the gift economy in the art world to the unique status that art commodities have in the shadowy world of money laundering.

The conclusion looks beyond the traditional boundaries of the market to investigate the expanding domain of artist run spaces and artist collectives. This chapter explores the other side of the coin, considering the art world that thrives despite the fact that few if any employees are getting paid. In effect, the social dynamic of the arts thrives in small-scale institutions that present themselves as an alternative to the market forces in the art world. These organizations serve as crucial hubs for bringing together artists with new publics, and their coordination in a networked era leads to the sharing of strategies across the world. A consideration of artist collectives will demonstrate how alternative economic and social arrangements for making and exhibiting art can allow for a group of artists to survive and to impact a local population. The idea of artists' collectives has spread throughout the world, and the goals are universally similar, though specific to regional contexts. These explorations lead to a consideration of how the contemporary art world has become a field for global cultural production and dissemination, but also how these dynamics have changed who participates and how they participate in it. The migration of cultural forms, artistic language, and domains of authority has become the norm, and the interpretation of institutions, galleries, and exhibitions around the world allowed by this study facilitates a

deeper consideration of how globalization affects the domain of the visual arts.

By considering a variety of locations, both long-standing art capitals and up-and-coming art centers of the future, this study aims to open up new perspectives on the economic, political, and social dynamics of the global art world of the twenty-first century. The scope of the book is perhaps too large, but it provides a broad perspective and a selective accounting of recent changes in the visual arts. For this reason I have invited a group of international contributors to provide art-world profiles of emerging art cities that they have lived and worked in. The purpose is twofold. On one hand, it is imperative that perspectives on globalization include multiple voices, because the process is not perceived, and cannot be adequately described, from a single perspective. On the other hand, looking at globalization requires looking at specific contexts, so these brief city profiles are designed to cut against the grain of the book and to provide a panorama of a world in transformation as a result of the processes that have emerged. The book aims to provide an overall view not possible through a series of essays written by individual authors, yet these particular perspectives demonstrate most effectively how the new geography of the art world is shaping up.

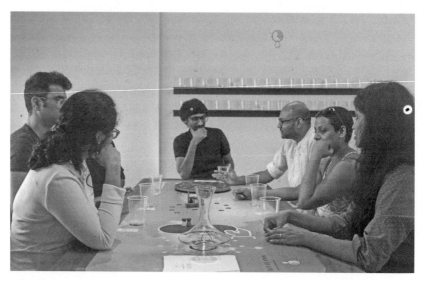

FIGURE 1. Thukral and Tagra, *Walk of Life II*. Artists and players. KHŌJ, New Delhi, 2016. © Thukral and Tagra.

Emerging Art Center

DELHI

Chhoti Rao

> It is said of Indian cities that Calcutta, the former British capital, owned the nineteenth century, Bombay, the center of films and corporations, possessed the twentieth century, while Delhi, seat of politics, has the twenty-first.
>
> **RANA DASGUPTA**
> *(2014, 27)*

With a population of approximately twenty-five million reported by the United Nations in 2014, Delhi is the second most populous city in the world after Tokyo. A truly renaissance city, built and rebuilt over centuries, Delhi is a massive metropolis, with its three historical precincts Nizamuddin, Mehrauli, and Shahjahanabad making up Old Delhi to the north, Sir Edwin Lutyens's New Delhi to the south, and a host of "colonies" and "villages" erupting and spanning even further south. Navigating this vast urban sprawl is not without its challenges, but the new Metro system has done an excellent job of connecting these neighborhoods and integrating their residents. Its three million plus daily commuters range from tourists to CEO's to students and housewives. The clean, orderly, smooth and efficient Delhi Metro, while attempting to solve the megacity's congestion and traffic issues, also provides optimism for an ideal vision of Delhi as a modern world-class city, rapidly transporting it into the twenty-first century.

My first ride on this hope on rails took me to the studio space of Thukral & Tagra (figure 1), the dynamic duo of Indian contemporary art, which turned

out to be a sweet treat for me on many levels. Firstly, as a fan, it is always fun to hang out with Jiten Thukral and Sumir Tagra, and what was initially supposed to be an hour meeting turned into a three-hour-long conversation with these ambitious, savvy, talented young men; secondly, the space is filled with their projects, both completed and in progress, often in candy-coated colors in a plethora of media; and lastly, they very kindly served me some delicious gulab jamuns, a popular, syrupy milk-based Indian dessert. T&T in many ways embody Delhi, its past, its present and especially its future. Their practice delves into the hopes and dreams of Delhi-ites, themselves included, as well as the socioeconomics realities and transmuting urban landscape of Delhi. Embracing change, technology, and experiment, but still rooted in their Indian identity, they are products of their time, unconventional, enterprising, and energetic. And it is artists like them that will ensure Delhi a place on the art world stage. A little over one hundred years ago, the American poet Ezra Pound (1885–1941) wrote, "All great art is born of the metropolis" (Pound 1951). There can be no question about the quality and the diversity of artistic practice in Delhi. The capital city is home to some of India's contemporary art super stars such as Subodh Gupta and Bharti Kher, while also providing a base for well-established artists, emerging talent, and young hopefuls alike.

There are many things that make Delhi unique. In 2014, it was ranked fifth as an emerging city in the global management consulting firm A. T. Kearny's "Global Cities Index" and "Emerging Cities Outlook" report, which examined a comprehensive list of eighty-four cities, measuring how globally engaged they are across numerous metrics in five dimensions: business activity, human capital, information exchange, cultural experience and political engagement (A. T. Kearny 2014). Delhi, home to numerous world heritage sites, such as the thirteenth-century Qutb Minar and its monuments, was also being considered for the World Heritage City title by UNESCO until its nomination was pulled in late 2015 due to the infrastructure restrictions the prestigious tag would undoubtedly bring to the nation's capital (PTI 2016). This special combination of old and new, ancient and modern, coexisting in an optimistic harmony, is what distinguishes Delhi from other cities around the globe. Coupled with the fact that it is the historical seat of both governance and culture means that the city of Delhi exudes a great deal of power and influence over India's overall position both domestically and internationally.

Globalization became a tangible phenomena in the 1990s. The end of communism, the birth of the worldwide web, the rise in human migration,

and the exponential growth of international trade and commerce linked countries all over the world like never before. India underwent major economic reforms during this period. New neoliberal policies included opening up to international trade and investment, deregulation, initiation of privatization, tax reforms, and inflation-controlling measures. India's booming global services industry and openness to the global economy paved the way for a new wave of economic prosperity and a burgeoning middle class with steadily increasing disposable income. The fruits, both sweet and sour, of this liberalization were manifold and especially felt in the cultural sector.

In less than two decades the Indian art world has gone from boom to bust to rebirth. Despite the measured recovery from a devastating global recession, Delhi's art scene today is full of hope and enthusiasm, albeit a cautious enthusiasm, but enthusiasm nonetheless. Today, Delhi's urban landscape is littered with swish art galleries catering to a world-savvy international crowd of artists, curators, critics and collectors, who jet in from Hong Kong to Basel and Miami. Several factors have aided this development from a motley crew of art enthusiasts to a bustling contemporary cultural enterprise.

The India Art Fair founded by Neha Kirpal in 2008, one of the most important annual events on the Indian art calendar, is one of these factors. In seven years it has become a leading destination for members of the international art circuit and an opportunity for the Indian and international art fraternity to address both a local and global audience. In 2015 the seventh edition of this fair took place with a new face at its helm. Girish Shahane, a well-known critic and curator, is the Fair's first-ever artistic director. In an effort to give this largely commercial enterprise a curated feel, the 2015 Fair included (in addition to its ninety booths and eighty-five exhibiting galleries) a feature called Art Projects, with performance art, live acts, and installations by artists such as Daniel Buren, Chitra Ganesh, and Atul Bhalla, as well as a Speakers' Forum that injected a dose of weighty dialogue, with a host of international participants such as Julian Stallabrass, Jeremy Deller, and Adam Szymczyk. Post Fair reviews noted a twenty percent drop in attendance but also reported an increase in overall sales and in the percentage of Indian buyers, signaling the upswing in confidence in the Indian art market described in ArtTactic's Indian Art Market Confidence Survey in December 2014 (ArtTactic 2014). The India Art Fair has also spurred on many spin-off events such as museum shows, gallery openings, seminars and art talks, book launches, and glamorous parties. "What really interests me is the collateral effect the Fair has across Delhi. The effect of the Fair far exceeds what

happens on the Fair grounds, the way Delhi lights up and programs itself around the Fair, really makes it a convergence point," the artist Jitish Kallat, curator of the 2014 biennale, commented (*The Wall Art TV* 2015). In September 2016, the Swiss based MCH Group, which owns the Art Basel franchise, announced that it had now become the majority stakeholder of the India Art Fair. This is their first initiative in establishing a new portfolio of leading regional art fairs around the world. The full impact of this new partnership on the India Art Fair remains to be seen and will only become evident over the next few years.

Galleries in Delhi have long been at the epicenter of its art scene, and rightly so, given that the primary responsibility of gallerists is to position artists and their work both within and beyond the market. Vadehra Art Gallery is the leader of the pack, with an impressive roster of art exhibitions since it opened more than two decades ago in 1988. In 2006, Vadehra Art Gallery launched the Foundation for Indian Contemporary Art (FICA) to support artists and visual arts education. Its annual programs include a Public Art Grant, a Research Fellowship, and an Emerging Artist Award. Nature Morte Gallery in Neeti Bagh, a mainly residential area of South Delhi, represents some of India's leading contemporary artists, such as Dayanita Singh and Pushpamala N. With collaborations and branches over the years in New York, Berlin, and Calcutta, a second Delhi space in Gurgaon, and, more recently, one in Greater Kailash, the gallery champions artists who incorporate conceptual, installation, and lens-based work into their practice. Also in Neeti Bagh is Talwar Gallery, which opened in 2007, six years after its launch in New York, showcasing artists such as Alwar Balasubramaniam and Ranjani Shettar. In South Delhi's Lado Sarai, a blossoming art district that hosts a regular Art Nite program in an effort to attract new art patrons, boasts numerous newer art galleries. The standouts here are Exhibit 320, set up in 2010, which exhibits young talent such as Princess Pea, and Latitude 28, which supports experimental art and has published *TAKE (on Art) Magazine*, a quarterly theme-based publication, since 2011, providing an important platform for critics, writers, and other art world commentators to share opinions and expertise with a wider audience. Gallery Espace, which celebrated its twenty-fifth anniversary in 2014, has served as a launching pad for many eminent artists, including M. F. Husain, a founding member of the path-breaking Progressives Artists' Group. In North Delhi, Photoink, founded in 2001, is dedicated to photography in India and showcases artists such as Dhruv Malhotra and Vivan Sundaram.

Delhi has always been a center for higher learning and is home to India's foremost universities, such as Delhi University, Jawaharlal Nehru University (JNU), and the Lalit Kala Academy, also known as the National Academy of Art, among others. Delhi is also home to the National Gallery of Modern Art (NGMA) and the National Museum of Art, both founded within a decade of independence in 1947. This rich tradition of critical discourse, combined with generations of classically trained progressive thinkers who helped win India's political freedom, catapulted Delhi into the modern era. After a strong start, the country's cultural agenda unfortunately took a back seat to its many economic and social issues and the government soon developed a reputation for apathy toward the arts. However, recent initiatives by the NGMA, subsequent to its 2009 expansion, have included exhibitions of numerous contemporary artists, such as the world-renowned sculptor Anish Kapoor, the leading Indian contemporary artists Atul Dodiya and Subodh Gupta, a retrospective of Raqs Media Collective (a Delhi-based group of three artist collaborators founded in 1992), a solo show dedicated to Mrinalini Mukherji, and an exhibition by Sudarshan Shetty, offer a glimmer of hope that the state is finally catching up to contemporaneity and will begin to build the arts infrastructure India requires to compete on a world stage. The acclaimed Indian art historian Geeta Kapur asserts that Delhi is unquestionably India's center for advanced discourse on art, with newly minted academic programs, such as the School of Art and Aesthetics at JNU, founded in 2001, and the Mass Communication Research Centre at Jamia Millia University, established in 1982. Young art world professionals in Delhi have also rallied together and organized an independent platform called PRAC Forum (Professionals in Art and Curation), where they share ideas, experiences, and knowledge both conceptual and practical in the new but budding curatorial field and seek to generate dialogue and collaborations around art. They will be participating in the 2016 Kochi-Muziris Biennale as part of its Collateral Projects.

The private sector has also stepped up and provided an expanded platform for the arts to flourish. The Alkazi Foundation for the Arts (1995), a private charitable trust dedicated to the exploration and study of India's cultural history, houses an unprecedented collection of Indian photography. The Devi Foundation (2008) and the Kiran Nadar Museum of Art (2010), a not-for-profit art space and a private museum respectively, which are both free and open to the public, develop and create exhibitions and programs to engage the public with contemporary Indian art practice and to help foster a

museum-going culture in India. The Devi Art Foundation, located in a corporate office complex in Gurgaon, a rapidly growing financial and industrial sector, houses one of India's most important private art collections. Assembled by mother and son team, Lekha and Anupam Poddar, it reflects their unique cross-disciplinary interests. Comprised of more than seven thousand contemporary, modern and tribal artworks from across the Indian subcontinent, the collection is one of the most comprehensive compilations of the art from this region. Its diverse exhibition roster includes shows such as *Vernacular in the Contemporary Part 1 & 2* (2010–11) and the more recent *Fracture: Indian Textiles, New Conversations* (2015). "I think people or civilizations get remembered for their art. Devi Art Foundation is such a small part of what India is and hopefully is just a way of capturing this moment in time" Anupam Poddar said in a 2013 interview (Christie's 2013). Established by the avid art collector Kiran Nadar, the KNMA, has a growing permanent collection dedicated to twentieth- and twenty-first-century Indian art. It is currently located in a shopping mall in the upmarket residential neighborhood of Saket, in an effort to bring art to where the people are the KNMA is "focused on bridging the disconnect between art and the public and enhancing museum-going culture in India," its web site states. From March 18 to June 5, 2016, the KNMA presented *Nasreen Mohamedi: Waiting Is a Part of Intense Living* as part of a traveling exhibition organized in partnership with the Museo Nacional Centro de Arte Reina Sofía, Madrid, and the Metropolitan Museum of Art, New York, successfully forging an alliance with the international museum community.

Besides enlightened collectors, artists too have taken up the cause. KHŌJ International Artists' Association, located in Khirkee village in South Delhi, began as a space for artists, operated by artists (the Hindi word *khōj* means "to search" or "to seek"). Today KHŌJ is a registered, independent, artist-led, not-for-profit organization. From its humble beginnings as an annual workshop in 1997, through its robust variety of programs, including workshops, residencies, exhibitions, talks, and community art projects, KHŌJ has become an incubator of creativity and grown into a unique space that is deeply committed to expanding the development and understanding of avant-garde contemporary art practice in India, of whose art ecosystem it is an essential part. The Sarai Program at the Center for the Study of Developing Societies was set up in 2000 by members of the CSDS faculty and Raqs Media Collective. Sarai's mission is to act as a platform for discursive and creative collaboration between theorists, researchers, practitioners, and

artists actively engaged in reflecting on contemporary urban spaces and cultures in South Asia. Another initiative involving Raqs was INSERT2014, which, through its programs held in January 2014, examined Delhi's role as a cultural city, its infrastructural pitfalls, and the role artists play in confronting these existing realities and facilitating change. It is through these profoundly forward-thinking and energetic spaces, working in tandem with artists, dealers, museums (both public and private, national and international), art patrons, scholars, and art fairs that Delhi's art world is being shaped, will continue to grow, and, hopefully, to thrive.

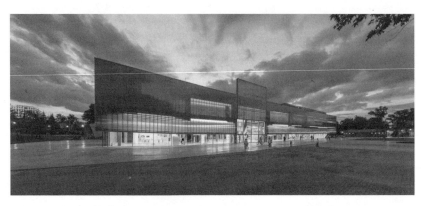

FIGURE 2. Garage Museum of Contemporary Art, Moscow. In June 2015, Garage moved to its first permanent home, a groundbreaking preservation project by Rem Koolhaas that transformed the famous 1968 Vremena Goda (Seasons of the Year) Soviet modernist restaurant in Gorky Park into a contemporary museum. Courtesy Garage Museum of Contemporary Art. © Yakov Khrutsky.

Museums in Flux

Historically, there have been two central models for art museums: those funded by the state and those nonprofits funded primarily by private donors. Of course, this division is entirely too pat, but it will be useful to explicate the models before attending to the exceptions in detail in future chapters. I leave out another category entirely, the university museum, because analyzing developments in that sphere is beyond the scope of this Part I of this book.

In the state-run museum—the European model—the government determines that providing access to art is part of public well-being and so sets up and funds institutions where visitors can go to see national treasures, be they the product of national heritage or a broader collection that has been assembled by the government through historical royal collections, purchase by the state, or donations from private individuals. The idea that art is a public good that must be shared is the governing ideology here, and these institutions preserve the glory of human creation, while acknowledging the magnificence of the state that has assembled such treasures and taken on the responsibility of preserving them. The first public museum founded was the British Museum in the 1750s. Napoleon expanded the nascent public museum idea by plundering other countries and bringing the booty back to the Louvre, but this model has been redeemed through the development of countless national galleries and museums around the world, which see a direct connection between the nation, its collected treasures, and the public who enjoy the benefits (McClellan 1994; Duncan 1995; Bergvelt 2009). Having a national art museum or gallery is more or less as common among nations as having a parliament, and such an institution is a showplace that serves many publics.

The nonprofit art museum—the American model—enshrines art works collected by private individuals that are given to the institution in order to

serve the public in much the same way that national treasures do. The goals of serving the public and works of art are quite similar in well-run state-run and private nonprofit institutions, so the fundamental difference really lies in the funding. Nonprofits of all sorts are supported by many levels of government in the United States, since they do not pay taxes and are thus indirectly subsidized by the state. Private individuals who donate their works to museums also get tax advantages, so the taxpayers are subsidizing the acquisitions to nonprofit art collections made through private donations. Overall, the nonprofit museum works via collective public support (subscription). Anyone can buy a membership and thus support their local art museum. The idea that such institutions serve the public good rationalizes the tax breaks, and nonprofit art museums cannot make money from their activities. But that does not keep them from amassing large capital reserves, called endowments, to ensure the stability of their finances over the long term and to guarantee that they do not have to break even every year from their direct sources of income such as ticket sales. This goes a long way to keeping them independent of the logic of the market, which is the whole point of a nonprofit, and the most effective nonprofit museums are often those that are the best endowed. Since the funding source is not secure, as in state-run institutions, this means that a lot of energy is devoted to fund-raising. The need for fund-raising and other factors, such as the development of an audience and the rising costs of collecting, storing, and maintaining art, make it difficult for nonprofits to maintain a real separation from the market system (Alexander 1996; Schwarzer 2006).

Financing is one of the central issues here, but it is important to comprehend that both models elaborated above are currently challenged. In order to understand the fundamentals of museum funding, it is crucial to come to terms with the fact that it is constantly evolving and indeed, in the past generation, art museum funding and exhibitions policy have taken some pretty dramatic leaps forward. The very definition of the museum is in flux. While there has been a general upsurge in museums worldwide, and therefore significant growth in the area of museum funding, it is impossible to say with any confidence where museum funding is headed next. The landscape has changed, with the Louvre opening branches at Lens in the Pas-de-Calais department in northern France and in Abu Dhabi in the United Arab Emirates; privately funded museums opening in capital cities like Beijing, Mexico City, and New Delhi, where they compete with state-supported institutions; and New York's nonprofit Solomon R. Guggenheim Museum expanding into a global brand.

These transformations are a result of prerogatives emerging from both within institutions and from outside them. While the divisions between the two models elaborated above have never been as simple as presented here, the new hybrids emerging today trace an epoch of dynamism within the museum field whose effects have only begun to emerge. The growth of countless institutions worldwide that do not fit into this model challenge not only its centrality but its coherence in the contemporary world. State funding for the arts is profoundly challenged in both Europe and the United States, while at the same time new sources of wealth have been accumulated in emerging markets, where public arts traditions can seem both outmoded and underfunded (Robertson 2011). In the People's Republic of China, which has led the way in state funding of art museums, there are now almost four thousand of them—in contrast to only twenty-five in 1949, when the PRC was founded ("Mad about Museums" 2013), but five hundred of these are privately funded (Baumgartner 2015). Global trends like these lead to innovation; new forms of art museum are intimately connected to new ways to fund them. Perhaps the ultimate example of this is the West Kowloon Cultural District in Hong Kong, scheduled to open in 2019 (Ho Hing-kay 2009). Though the city and the national government are supporting the creation of the cultural complex including a public museum (M+), the idea is for the entire complex to be self-funding with monies generated by the real estate and other commercial components of the cultural complex. Though most art museums engage in commercial ventures such as restaurants and museum stores, this is a new approach. Shops, restaurants, and condos in West Kowloon will pay for the museum. The tail wags the dog.

With all the funding developments elaborated above, it is also evident that museum exhibition programming has also changed substantially and become more implicated with museum funding in general. This chapter also aims to investigate some of the complexities of the blockbuster phenomenon in an age of globalization. Seven of the twenty most visited exhibitions worldwide in 2014 took place in Brazil (Pes and Sharpe 2015), a sign that the art world "centers" are being displaced by the former periphery (see figure 5). One of the results of the current global economy is that there are now wealthy art patrons with cultural ambitions in many countries who are willing to invest in bringing blockbuster exhibitions to their cities. Collecting museums everywhere have taken the bait and are packaging their collections for touring exhibitions, a trend especially prominent among museums closed for renovations. Packaged shows are not only being developed by noteworthy

museums but also by private collections, and the Saatchi collection and the Mexican Modernist collection of Jacques and Natasha Gelman, among others, have toured as blockbuster shows. Perhaps the largest trend emerging worldwide is the opening of museums designed to promote and capitalize on the excitement that builds around novel visual art exhibitions. In countries that do not have long traditions of collecting institutions, the best solution can be to open a museum that exhibits great art but does not own any. These are commonly referred to using the German term *Kunsthalle,* here defined as an exhibition center without a collection, a concept whose origins date back to northern Europe in the nineteenth century. In countries all over the world, institutions that do not own a single work of art have adopted this model and call themselves art museums, perhaps pointing to one future for art exhibitions.

Another trend that will be considered here is exhibition development outside the traditional art world centers. If global institutions are changing the way contemporary art is seen around the world, the arrival of contemporary artists from the margins is one of the most visible effects of globalization in art museums. The presence of an international roster of contemporary artists has undoubtedly transformed the landscape of cultural production, and one of the questions discussed here is how these artists have been introduced to museums in Europe and North America. While the blockbuster art show is a Western cultural phenomenon that has been introduced globally and the kunsthalle idea has spread from Europe to exhibition centers around the world, the decentered production of global and transnational artists expands previous notions of contemporary art. Since some of the essential dimensions of contemporary art are social and cultural, global integration hastens the development of alternative networks of art making and consumption and challenges the fundamentals of artistic reception, leading to new questions about the relationship between producer (artist) and consumer (viewer).

The following two chapters are divided equally between considerations of museum financing and museum exhibitions, although the two are intimately connected. Chapter 1 covers the basic principles of museum financing, looking at sources of revenue and financial governance as well as examining the recent museum building boom and the various ways that museums acquire works of art and develop collections. The last section of this chapter extends this discussion to explore recent trends in art museums as a result of economic changes that have been felt around the globe. The neoliberal trend of

increasing privatization has led to the development of both the private museum and the franchise model for established museums, but new developments raise questions about how museums might be funded in the future.

Chapter 2 begins by laying out the fundamental dynamics of blockbuster exhibitions, how they are organized, and how the blockbuster phenomenon has led to structural changes museums and their budgeting process. Another section examines how this model has been transformed to produce blockbuster exhibitions in emerging economic centers, and how cultural difference visible as a result of globalization has been featured at museums in Europe and the United States. In the final section of this chapter, museums and art centers in the former periphery are presented. These institutions, founded for the most part in the twenty-first century, offer emergent alternatives for presenting contemporary art to new publics around the globe.

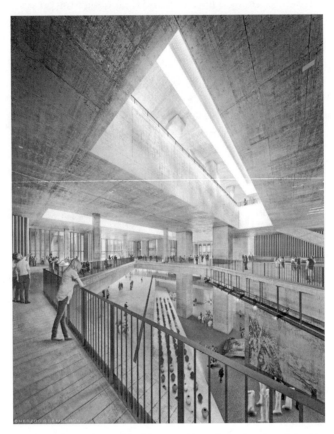

FIGURE 3. *Found Space,* M+ Museum, Hong Kong. Interior of the M+ building, showing the lobby and the "found space." Courtesy Herzog & de Meuron and West Kowloon Cultural District Authority. © Herzog & de Meuron.

———————

Museum Funding

WHO SHAPES INSTITUTIONS?

1 THE SHIFTING SOURCES OF MUSEUM REVENUE

If you have ever wondered how museums are financed, you are not alone. Every museum director has asked herself that question, and the answers are never the same. Nor should they be. Each institution has its own advantages and its own community, and in order for a public institution to exist, an equilibrium must be struck between a museum and its audience. So the question of financing is finally a question of audience. Who values what your museum does? Who is able to enjoy the benefits of it? Whose interest is served by the museum's activities (both collecting and exhibiting)? Since this book is concerned with art, these questions ought to be addressed to an art museum, and if one examines the history of art museums, it is clear that they have some divided loyalties. Before diving in, let's turn back the clock to 1989.

In order to lay out some basic concepts in museum funding and to flesh out a baseline measure of where American museums stood a generation ago, it will be helpful to turn to a key text on the topic, a National Bureau of Economic Research conference report, *The Economics of Art Museums* (Feldstein [1989] 1991). A chapter titled "Museum Financing" resulted from a conversation between eminences such as Harry Parker (of the Fine Arts Museums of San Francisco), Thomas Krens (of the Guggenheim), and Neil Rudenstine (who would later become president of Harvard University) to discuss museum financing and changes in that area. Discussing the Fine Arts Museums of San Francisco, which, as the name would suggest, were formerly funded principally by the city, Parker discussed the merging of the public and private administrative segments of the museum for more stable financing and "a related change in the government structure... to tie the Fine Arts

Museums Foundation more firmly to the trustees" (63). For a publicly funded museum to have had two separate administrative units might seem odd, but it is not at all exceptional. However, merging them seemed the best way to promote further evolution of the institution, uniting private and public funding and giving the trustees a more prominent role in funding and governance. In this way, the public aspect of the institution yielded to the wealthy patrons who served on the board.

Though he represented an ostensibly private institution originally funded by and devoted to the collections of a single family, Krens addressed public funding for art museums. He pointed out that aggregate public arts funding was declining in the United States and correctly predicted a continuation of this trend, even though museum expenses had increased, meaning that institutional endowments were not able to cover so much of operating expenses as they had before. In the case of the Guggenheim, he noted that the change over twenty-five years was from 75 percent to "about 20" (Feldstein [1989] 1991, 64). Krens was a brilliant strategist, and he had already begun to develop one of the most effective and lasting solutions to this problem, museum branding or franchising. This strategy will be investigated in detail in a later section of this chapter.

William Luers, the chief financial officer of the Metropolitan Museum in New York, reinforced Krens's assertions, noting that between 1967 and 1989, the Met's budget had increased tenfold, from $6.98 million to $68 million, due to the growth of buildings, staff, and programs (in Fiscal Year 2015, it was $361 million). In 1989, 20 percent came from the city and only 14 percent from endowments (Feldstein [1989] 1991, 67). Currently, the city pays less, just under 8 percent (Metropolitan Museum of Art 2015). Rudenstine sized up the trends nicely by demonstrating the shrinking share of municipal and endowment support at the same time that exhibitions, staffs, and physical plant had increased to meet growing demand. He proposed two solutions to this evolving problem. The first suggestion was for museums to solicit more gifts and grants, and this seems to have been followed by all art museums. But his other recommendation—that museums should not take on more fixed costs and tone down special exhibitions—was clearly not embraced at the Met, or anywhere else. All of these institutions, and indeed almost every other art museum in the United States, has expanded considerably since 1989, with the result that museums are larger, fuller, and more in debt than ever before. Further, the number of art museums has increased in the ensuing years. In his 1989 talk, Rudenstine referred to 550 art museums; in 2014,

according to the Institute of Museum and Library Sciences, there were 1,581 (Feldstein [1989] 1991, 79; IMLS 2014). Today, moreover, there are a lot more museums overall competing with art museums for visitors and revenues.

These directors and others were addressing major changes in art museum culture that had taken place in a very short span of time (from the 1960s to 1989). Museums and their financing have changed even more in the ensuing years. Dwindling public financial support is only part of the story. Museums everywhere have expanded their buildings to accommodate increased visitor demand, more popular exhibitions, and exceptional growth in collections.

The presentations cited above, outdated though they now may be, all touch on the essentials of managing collections of art. Sources of revenue were the topic of preeminent concern during these conversations, and these needs ought to be explicated at greater length. Another central issue is the physical plant of the institution, the museum's building, and the management of its facilities. While most thinking on museum buildings centers around the appeal of the architecture, another set of issues is at the core of museum planning and sustainability: how large are the galleries and storage facilities to be, and how do these numbers relate to the size of the current collection, as well as to how it will expand in the future (Merriman 2008)? Collection expansion raises questions about acquisitions. Where do new objects come from, how are they paid for, and who determines whether gifts will be accepted and what works of art will be purchased? Presumably, there is some plan in place, or at least a strategy for collections management (Fahy 1994; Evans and Saponardo 2012; AAM 2012). Collections management, which includes storage, conservation, and display of the collection, is one of the most expensive line items in any art museum's budget, and museums have continued to build apace without considering the concerns raised by Rudenstine in 1989, especially how to find funding in a rapidly shifting economic climate.

In 2016, the funding climate remains volatile, but we need to look at the big picture. Every national gallery exists to serve the state, and much the same could be said of cities and their museums. The goal is to serve the entire public, so entry to such institutions is often free to all or some the population (e.g., children and students). Although they derive some revenue from their restaurants, cafeterias, and shops, public museums get the bulk of their incomes from line items in the annual budget of a national, state or municipal government (or some combination of these). This is an implicit guarantee the museum will be supported from year to year. Fiscal accountability is more or less required, but government has made a commitment to supporting the

institution as part of its responsibility to its citizens. Of course, this depends on government solvency, and public museums, particularly in some European countries, have consequently faced new funding challenges. Significant individuals, whether trustees, collectors, or representatives of the government, do have unique relationships with public arts institutions, whether in terms of collection building or governance and planning, but the role of private citizens is much greater in nonprofit institutions.

Fundamentally, there are two groups that are served by an institutional art collection. On the one hand, it is the public who benefits from a public institution that collects and exhibits visual art. Through museums, countless individuals have the opportunity to see treasures that were paid for and hoarded by the upper classes for centuries before public art museums came into existence. Yet the museum serves another group that could be called an "internal public" far more graciously.

This group of trustees, patrons, artists, and scholars has unique access to both the building and the works in the collection beyond what the general public enjoys. It could well be argued that every institution has its insiders, but museums thrive by virtue of the generosity of key figures who literally create the meaning and mode of public address within an institution. Unless the institution is entirely funded by the government or a private entity, someone has to pay the bills. So donors must be cultivated and, once they become active, they are coddled. The reason is not merely to ensure their consistent commitment to the institution, but also to encourage them to represent the museum to their friends and acquaintances as worthy of support, because donations are the result of social networks (Becker [1982] 2008). The social network of any single institution may overlap with many others, but art museums are unique because they are focused upon collecting and most serious donors to them are themselves major collectors of art.

In simple terms, museums are built upon hierarchies: hierarchies of art and hierarchies of public. Just as museums do not put up just any art in their galleries, they cannot rely on just any public to keep the doors open. So those that can afford to pay more than the price of admission have greater access to the opportunities that an art museum can offer. Donors have come to serve not just a symbolic role but a structural one within the emergent business model of art museums. They are not merely the prominent individuals who know how best to appreciate the cultural treasures on view, their contributions fill out the spreadsheet that determines the institution's budget. And this introduces the most essential aspect to note about art museum financing

in the nonprofit model: it is paid for and supervised by the same individuals, namely, the trustees.

Museum trustees, boards of directors, and the like are not, and perhaps never were, disinterested third parties. As donors, whether of art or money, they have the role of overseeing the governance of the institution. It is possible to reverse this equation and to argue that because they are responsible for governance, they see the need to contribute support, but either way this is a clear conflict of interest. The result is that those who possess the greatest resources have the most power to direct the activities of the institution, though this influence is usually wielded as "soft power." Strong-minded board members have been known to handpick directors and other key staff members of art museums, but it is by no means the norm for board members to involve themselves directly in day-to-day governance. To be fair, there are a variety of nonprofit cultures and differences among boards, and their responsibilities are legion. But given their key role as funders, board members have a major negotiating tool at their disposal, and the defection of a major donor can be disastrous for an art museum. As a result, donors are kept happy, and the bigger the donor, the happier they are kept. This is the role of development departments that cultivate donors and raise funds for the museum, and it should come as no surprise that these departments have expanded considerably in recent years. In effect, art museum governance revolves around patrons who provide a structural and even a moral role for the institution. While it would be incorrect to assert that art museums exist for the benefit of their donors, it is nevertheless true that their concerns are the central preoccupation of a large portion of the staff of each art museum. Furthermore, while knowing and maintaining boundaries is part of the trustee's role, they nevertheless dominate the institution's energy and their preeminent concern is not only the museum's greatness, but its solvency.

Since few if any art museums exist solely as a result of their trustees' contributions, the central questions are increasing the revenue stream and limiting expenses. Nonprofit museums are thus not only responsible for eliciting charitable contributions, they are also yoked to the logic of the market, despite the appearance of offering an alternative. Yet art museums do not actually operate like corporations, since most of the employees come up with ways to spend revenue rather than to generate it. This explains a lot about why so may college graduates are interested in working in art museums, and indeed why so many young hopefuls labor without pay as interns there. Anecdotes aside, it is crucial to figure out how such an institution has been

transformed into a workable business model and, more important, how fundraising has changed in the past generation to accommodate the demands for transparency and balanced budgets increasingly voiced by those who run nonprofit art museums.

Revenue comes primarily either from public or private sources, but museums also derive income from shops and restaurants, as well as from reproduction services and private rentals for special events. These are the most obvious forms of museum financing, but some sources of income are not so evident at first glance. For example, any institution that has an endowment is generating income from its investments, and to maximize returns on these without jeopardizing core funds, nonprofit museums have investment committees made up of members of the governing board members whose specialty is finance. However, such investments are as volatile as the financial world is today, and the size of an endowment is highly flexible. Since 2000, there have been two major shocks to endowments at American nonprofit museums, the first after the Enron crash in early 2002 and the more considerable one with the stock market decline in 2008. Both of these changed the financial dynamic for art institutions. The Getty Center in Los Angeles, for example, is reported to have lost around $1.5 billion from its endowment in 2008 (Kaufman 2009). Though the value of the endowment has since increased, the loss of around 25 percent meant that the amount that could be drawn from the endowment in the next few years was considerably lower, resulting in a tremendous loss to the annual budget and layoffs at the foundation and the museum. The lesson here is that income can go up or down, and that nonprofits, like businesses, are vulnerable to broader economic trends, even if they are prudent in their economic planning (Ojama 2013).

2 MUSEUM EXPANSION AND ACQUISITIONS

All art museums occupy buildings that provide not only the frame but the best visual advertisement for the museum's collection. The commissioning of a showpiece building to house the collection is one of the major developments of the past generation in the art museum domain (Newhouse 1998; Davidts 2006; Smith 2009). So many articles and even books have been written on Frank Gehry's Guggenheim building at Bilbao that it seems hardly necessary to repeat the refrain but art institutions everywhere have sought out major architects to make statements with their buildings, in a rhetorical

strategy to put art museums at the core of an emergent urban fabric, whether the city is Paris or Cincinnati. When Robert Lynch employed the term "placemaking" in his summary of the Americans for the Arts economic impact report (see Introduction), he was making reference to the role that art institutions of all kinds can make in creating an active and visible civic culture, and art museums, for better and for worse, are at the forefront of this trend in urban planning.

While the immediate result is greater visibility for art museums worldwide, it also means that institutions are investing heavily in buildings designed as showpieces by the most famous "starchitects" available. Many questions have been raised about whether unique art museum spaces in such landmark structures are suitable for the art they are ostensibly designed to highlight. Yoshio Taniguchi's redesign of the Museum of Modern Art in New York that opened in 2004 at a price of $858 million was considered a success in providing a suitable environment for the variety of art works in its collection (Baker 2004; Goldberger 2004; Ouroussoff 2004). Conversely, Daniel Liebeskind's expansion of the Denver Art Museum was flogged for designing an architectural gem that did not stoop to providing vertical walls useful for hanging pictures (Ourossoff 2006).

Whether a building design suits a collection well or generates continual marketing for the institution, there are two other fundamental issues to consider in this context. First, the money that pays for the expansion is distinct from the budget of the institution and is raised through a capital campaign. That means that art museums struggling to raise enough income to stay afloat have to redouble their efforts and raise enough income—in many cases ten times their annual budgets—to finance a new building. Of course, once completed, the institution must then service this new space, so its fixed costs will increase substantially. These costs range from higher utility bills and increased security staff to more visitor services staff to handle the rise in visitor numbers that results from an expansion. The highest costs may well be keeping the galleries full, which requires increased programming and all of the other staff, from curators to educators to art handlers, necessary to manage and interpret the collection in this new space.

The second point to make about buildings is that the showpiece architecture is, at bottom, only a container for the collection and its staff. As physical plant, it has natural limitations and it is a liability in logistical terms as much as it is an asset in terms of marketing. While any museum would want the newest and best building technology, there is an inherent conflict between

the transitory nature of such innovative systems and the ideal permanence of the art museum as such. Simply put, museums are supposed to last forever, and most buildings do not. This was highlighted in 2013 when the Museum of Modern Art proposed demolishing the landmark building designed by Tod Williams and Billie Tsien for the Folk Art Museum that opened in 2001. The Folk Art Museum decided to sell the building in 2011 because of financial troubles, and two years later, MoMA decided to remove the building to make way for the expansion of its campus. The Folk Art Museum building proved too expensive for the institution that commissioned it. Furthermore, it interfered with MoMA's plans for an 82-story tower designed by Jean Nouvel, 53W53, which will be partially occupied by MoMA (Pogrebin 2013; Kimmelman 2013). Avant-garde designs can go out of fashion quickly, and, more important, it can be quite impossible to determine how a brand-new building will age and how that will relate to the collection's growth and its institutional stability. This may not be the first thing on the director's mind when she needs to raise half a billion dollars.

Space issues related to art museum buildings are intimately connected to the continuous acquisition of new works by the museums. There are a handful of ways that art museums extend their collections, but pretty much every art museum, no matter how well or poorly endowed, is seeking to expand its collection. Art museums have differing views on collecting, and there can be little generalization in this regard, since some museums collect only to display (this is the model of the National Gallery in London), while others, particularly modern and contemporary institutions, are constantly building their collections as new works become available (Altshuler 2005). Drawing, photography, print, and new media departments pursue specific agendas, operating more like libraries, because it is assumed that only a handful of works will be put on view at any given time. Given the limited supply of historical works of art, it is no surprise that the largest area of growth has been in contemporary art, as well as adding non-Western art to public collections that did not previously house it. There are three basic ways in which collections expand.

Major gifts are the first and most desirable way. These come from significant private collections that, rather than being dispersed following the death of the collector, are transferred to a single institution. Needless to say, such collections are rare, and those who possess them are courted by multiple suitors. Such collections—for example, Steve Cohen's has been in news often—possess art that could not easily be acquired today because of the cost

and the rarity of the works, and they can potentially transform an institution's ability to generate interest and draw an audience. Such was the case with the Arensberg and Gallatin collections, which around 1950 endowed the Philadelphia Museum of Art with a tremendous trove of modern art that lures visitors to this day. In other cases, as with the Annenberg collection of Impressionist art given to the Metropolitan Museum in 1992, the gift shores up an already strong presentation and helps to cement its prominence. Such largesse is becoming rare these days, as many donors prefer to offload their collections in segments, sometimes to multiple institutions over a number of years. In some recent cases, such as those of the Donald and Doris Fisher Collection and that of Eli Broad, strategies are emerging in which the donors do not give their collections to any institution but instead set up a trust to loan them out. Whereas the Fishers have loaned their collection to a single institution, the San Francisco Museum of Modern Art, Broad originally thought about loaning his to multiple collections, but finally opted to build his own museum in downtown Los Angeles (Kino 2010; Ng 2013; Stromberg 2015; Knight 2015; Whiting 2015). Of course, an alternative to providing a major gift to an existing institution is to start one of your own. The tradition of doing so goes back to the American Robber Barons, consider the Frick Museum, and extends, through the Barnes Collection, right up to the present day. But it has become considerably more visible internationally, a trend explored below.

The other ways for museums to increase their collections are more incremental, through gift or purchase, and in both of these cases it is donors, often trustees, that provide opportunities for both public and nonprofit institutions, while directors and curators direct traffic. Art museum trustees are often collectors themselves, and they amass private collections that they can make available to the public by giving them to an institution on whose board they serve. In this case, the identity of the collector will be permanently preserved in the annals of the museum and displayed in perpetuity to all who read the labels next to works of art. Donors to art museums receive tax credits in the United States, and other countries are attempting to replicate this system on some level (at the very least, one can pay estate taxes by donating works of art), so there are both altruistic and financial incentives to give art works to an institution. Any individual can offer a work of art to an institution, but, since artists can write off only the costs of materials, not the actual value of the work of art, U.S. tax laws since 1969 have discouraged artists from donating their own works to museums. Legislation has been introduced

to change this law but at time of publication, nothing has changed (Americans for the Arts 2012).

The main question is whether the museum is interested in acquiring the work of art, and there is generally a multi-step process for determining its acceptability as a gift. The first step usually involves a curator responsible for that type of art work (painting, print, video, etc.) examining the potential gift and determining if this it will enhance the institutional collection. In many cases the answer is no, even if the collector is a donor to the institution, because it is plain that there is far more art in the world than needs to be preserved forever, as museums intend to do. If the work is desirable, the curator refers the matter to the administration, which, considering her advice, determines whether to promote the work for accession to the museum through an accessions or acquisitions committee (Storr 2005). Such a collections committee serves a key governance function in the institution, because it determines what objects an institution ought to have, and to preserve as part of its collection. It considers many questions, from the condition of the work to the reputation of the artist to whether the museum has any related work and how often this piece might be shown. In brief, this committee is charged with determining whether a potential donation is in keeping with the institution's mission, and whether the museum ought to take responsibility for this object. Such committees, as will be shown below, can also fund acquisitions.

When it comes to buying works of art, differences emerge. The European model generally assumes that funds will be provided by the government, usually as a fixed amount in the annual budget for new works, so curators and administration can make regular decisions about how to expand the collection. But in recent years, the price of all manner of art works has skyrocketed, so that museum accession funds can no longer be counted on to secure important works that come to market. Therefore all art museums, public or private, have begun to seek out donors to fund acquisitions that the institution feels it cannot live without. Whether these works are sold privately or at auction, an institution will line up some generous soul to pay the bill and give the work to the museum. Sometimes multiple donors are lined up to finance such acquisitions, and this generates a new dynamic between the curators, directors, and donors, while making it possible for more and more significant works to enter public collections (and thus concomitantly raising the demand for, and the price of, key art works that remain in private hands).

The other way that museums buy art works is with funds earmarked by the donor for a specific purpose. This is termed a restricted gift. Sometimes

these are provided as a one-time opportunity (a donor gives the museum a fixed sum of money to be spent on acquisitions), but more often a donor will set up a fund (a mini-endowment) that will generate a regular income for acquisitions through investment, leaving the initial fund intact. In either case, the donor is acknowledged in the credit line (e.g., "purchased through the John Zarobell fund") on the label mounted next to the work, as well as published along with any reproduction of the work either in print or online. As to budget-line-item acquisitions, these are generally limited to smaller sums, fixed by the annual budget and usually are discretionary, determined by the director. In such a case, a curator who wants to purchase a print by Whistler, for example, would go to the director and make the case for why this work is essential to the collection, presents a unique acquisition opportunity, and so forth. While the director holds the reins in such cases, all museum accessions are subject to approval by the museum's board of trustees and, in medium-to-large institutions, there is often a collections committee involved too, as explained above. Alternatively, accessions can be approved by a curatorial department committee, such as the European decorative arts committee or the photography committee.

In the case of modern and contemporary museums, a trend has emerged to have collections/accessions committees themselves fund acquisitions. The funds are raised through subscription: anyone who sits on the accessions committee contributes a certain amount annually, and that money is pooled for museum acquisitions. This system can also be based on curatorial department committees. Depending on the amount of money contributed and the size of the committee, this can raise a substantial amount of capital for annual accessions without burdening the annual budget of the institution with these costs, as well as distributing the decision-making process into a wider group. (Of course, the director must approve anything that goes before the committee in advance, but the situation is different when funds are not coming from the annual budget but from donors.) In this context, each member of the committee casts a vote on each work of art that is offered to the museum, whether through gift or purchase, but the information on the works is supplied by the curatorial departments and conservators as well. In this democratic system, the curator can be overruled by the committee but it is also true that the curator is the expert in these matters, even if every member of the board is a collector, so what the curators propose by and large will succeed.

It may seem totally obvious, but it is important to underline that the accessions or collections committee system has a number of characteristics

that could lead to problems. First and foremost, those who determine democratically what to acquire for the nonprofit institution are paying for the privilege,* and they control not only what the museum buys with their funds but what the museum accepts as gifts. Perhaps the most difficult issue here is one that touches on the relationship between museum collections and the market and the role played by curators as tastemakers in the domain of contemporary art. William Cole notes: "With strategic donations, rich collectors and dealers gain influence in major art museums. Whose works do you suppose they encourage those museums to purchase and exhibit? Whose works do they donate, sometimes retaining a life interest, for huge tax deductions calculated according to market prices, however ridiculous those prices might be?" (Cole 2013).

The complications introduced by accessions committees in this context are clear. Curators explain to a group of collectors what they want to acquire for the institution and why it is so important to the institution's collection. Then the private collectors at the table are aware of how in demand the works of certain artists are, as well as the fact that the museum is considering a purchase, which of course drives up prices of this artist's work since being collected by museums is the highest aspiration for a contemporary artist. Dealers and artists themselves donate works to museums for exactly this reason. Getting backroom tips on assets on the market that will increase in value after an upcoming acquisition is roughly equivalent to insider trading, but in the context of nonprofit governance, this committee system does not break any rules. Nevertheless, one of the indirect results of a collections committee is to produce a very tight-knit web between museums, dealers, and collectors. That such a series of connections might have implications for the market of an artist's work is obvious, but that lies beyond the scope of this chapter.

In nonprofit museums, a collections management plan is a must but the question of sustainability, raised by Nick Merriman (2008), is one that now concerns all museums' collections planning considerably. The question of how large a collection can grow is a real issue for a range of institutions and, if one looks carefully at the rationale for the art museum expansion boom worldwide, one finds that one of the central reasons for expanding or replacing the building is that the institution's collection has outgrown it. Of course,

* Usually, such committees have a few members, with voting rights or ex-officio, who are not required to pay because they are experts or representatives of the board or another museum committee.

with the prospect of a new building, it is quite common for a museum to go on a collecting spree to acquire impressive new works to fill the landmark addition. Needless to say, this means that expansion does not always satisfy the demand to increase the amount of work on view significantly. And few, if any, art museums have determined that their collection is large enough and they must stop acquiring works.

With more works come greater collections management needs, but there are also residual needs for collections management brought about by expansion, because such enlargements often include expansive special exhibition galleries that require the involvement of the collections management staff, such as registrars, conservators, and so on. Works of art need sometimes need to be cleaned for exhibition, but they always need to be accounted for and installed, so the collections management staff are diverted from the care of the collection proper to focus upon the work needed to satisfy the demand for special exhibitions in-house and loans to other institutions—quite often the same partners who have themselves loaned to the museum in the past. As the number of special exhibitions increases, art collections are more in demand and the amount of care required to maintain them increases. There is simply no end in sight to this trend, so the implication is that the costs of maintaining a collection are going to continue to increase. Of course, new expansions will age, and maintenance will be required, so the costs of servicing the physical plant will increase too. Furthermore, increases in collection size will force museums to secure offsite storage.

The sustainability of collections management thus quickly becomes a question of sustainability of funding sources. This puts the nonprofit model in a better position than the state-funded model in many respects, since budget line items are not often elastic but more private funders can always be cultivated, and museum costs have continued to spiral upward. Yet these logistical challenges, introduced by the two main museum trends, expansion and the special exhibition boom, have forced museums to reconsider their business plans and to get more creative with their funding sources. Coupled with a new focus on management at nonprofit institutions and the hiring of administrators with MBAs, it begins to seem as if museums have entered a new era, more focused on the prerogatives of meeting the bottom line. Museum funding sources are changing, and many of the values of the business world, and even an entrepreneurial spirit, have been inculcated into both state-run and nonprofit arts institutions. The next section addresses some of these new developments.

Changes in the nature of funding streams, debated by Parker, Krens and Rudenstine among others in 1989 (see above), have continued unabated. Yes, governments in general have less money to provide, especially in national economies weakened by increasing global disruptions. While the shrinking of the state and state funding under neoliberal policies has, in a broad sense, been the major trend to consider with regard to new funding sources for art museums, the other side of the coin is rising costs. The larger question is how these museum-funding models, established in Europe and the United States, are spreading alongside the expansion of art museums throughout the rest of the world. As state support contracts worldwide, even institutions whose finances were once assured have to go in search of new sources of revenue. Corporate funding of art museums peaked in the United States in the 1980s and 1990s, but it is gaining new prominence in Europe. For example, anyone who took a boat tour down the Seine in spring of 2011 was treated to colossal advertisements on the outside of scaffolding on the Louvre and the Musée d'Orsay.

If government assets everywhere are being privatized under the neoliberal doctrine, it should come as no surprise that these pressures should exert some impact on state-funded arts institutions. "The Louvre's state subsidy shrank from 75 percent of its budget in 2001 to just over half of its $340 million budget last year. A new 5 percent cut is looming for almost 500 French cultural institutions," Doreen Carvajal noted in the New York Times (Carvajal 2011). With the exception of China's prolific growth in the museum sector (Perlez 2012; Cotter 2013), the era of governments bankrolling art museums appears to be coming to an end. However, the same neoliberal policies have strengthened the economic position of the most wealthy (Harvey 2005; Piketty 2014), and so it is to them that art museums increasingly turn. Whether museums look to particular individuals, their private foundations, or foundations that pool funds from a variety of donors, the fact is that private funds are increasingly taking the place of other funding sources. It must also be said that these donations are a form of tax haven for their donors, reaping benefits for the institutions at the expense of governments everywhere. As more private wealth is accumulated globally, grant making (foundations providing funds to nonprofits) increases apace.

What emerges globally are a handful of developments that are now remaking the funding dynamic for art museums. These trends are not necessarily going to determine the future of museum funding for all institutions, and

many art museums have figured out how to balance their audience and their funding streams carefully to succeed in their own niches. Nevertheless, the trends seen here change the overall picture and the models they introduce, if successful, will seem like viable new paths for art museums to pursue. The most prevalent trend is perhaps the proliferation of private museums, or private-public partnerships that make possible new venues for the presentation of the visual arts to new publics. This is not a new idea, but its growth in the era of expanding personal fortunes globally is destined to impact, and in many countries to take the place of, state-funded institutions. The broader trend here can be found most prominently in the most rapidly expanding sector of modern and contemporary art.

Museum "branding," a concept bequeathed to the nonprofit sector by marketing consultants, is now relatively common in the United States, but the franchise phenomenon is far more ambitious in its aim to change the nature of museum governance. Thomas Krens must be credited, for better or worse, with the idea of developing a chain of museums worldwide whose particular character and collections are as recognizable and sought after as Starbucks or McDonald's (Cuno 2004; Lowry 2004; Werner 2005). Not to be outdone, the Louvre and the Centre Pompidou and have copied this corporate model in state-run institutions (to say nothing of the Tate and the Hermitage), thereby demonstrating that the ostensible gap between the American and European museum models is easily breached. It also should be pointed out that the Guggenheim is perhaps the most successful manifestation of the private museum model that has undergone some changes over the years. The twin developments of the private museum and museum franchises are entwined with the expansion of neoliberal economic doctrine. Moreover, cities in emerging economies are experiencing significant growth as a result of changes wrought by economic globalization, and they seek cultural institutions to burnish their status as global metropolises. Two important innovations in museums that have emerged from these historical developments are the income-funded museum, best represented by the West Kowloon Cultural District, and the role of place making to encourage not only art museum expansion but public-private partnerships that are explicitly connected to economic growth and consumer development.

A good example of a public-private partnership can be seen in the Istanbul Museum of Modern Art, which grew out of the Istanbul Biennial and is supported by a single family foundation (the Dr. Nejat F. Eczacıbaşı Foundation) and the Eczacibasi Group, yet receives a modicum of support

from the Turkish government, as well as project-based support from the European Union and other international funds and local sponsors. "The public authorities, especially the Ministry of Foreign Affairs and the Ministry of Culture, have understood for quite some time the importance and interest of Turkey's artistic production and the international authorities in the Turkish art scene. So they started using art exhibitions as a tool of communication and for diplomacy, in order to demonstrate, especially to the Europeans especially that Turkey is a modernized, Westernized, Europeanized country ... given the fact that we have this kind of art, i.e. contemporary art," Çelenk Bafra, curator and head of exhibitions at Istanbul Modern and former director of the Istanbul Biennial, explained in an interview (personal communication, September 15, 2012).

Istanbul Modern is a hub for contemporary art, both Turkish and international, and the government provides support to this private museum initiative because it serves its interests and projects the image of the country that it hopes will be received by others. In fact, the announcement that the government would provide the museum with a lease for its current building, a former warehouse in a prime location on the Bosporus, came in 2003 when the European Union was first considering Turkey as a potential member of the European Union. While private museums can serve the interest of governments for the purposes of cultural diplomacy, they are usually left to their own devices in terms of fund-raising and programming.

The Global Private Museum Network (originally the Hong Kong Private Museum Forum) is a demonstration, if any were needed, that the private museum has come of age in a globalized world. The Forum was originally concurrent with the Hong Kong International Art Fair, which was bought by Art Basel in 2013. At that point, the organizers updated the concept and moved the conference to London to coincide with another art fair, Art 13 (Global Private Museum Network n.d.). In 2016, it was moved back to China, taking up residence in Shanghai (Baumgartner 2015). The fact that this forum is attached to art fairs underlines the significance of the market in helping to shape the next generation of museum development through the collectors who frequent such fairs. The list of participants from 2012 sheds light upon which individuals open their own museums. Of course, it includes such well-known figures as Don and Mera Rubbell, whose Miami showcase for their collection has long been a necessary stop during Art Basel Miami Beach each December. Also attending were Europeans such as Ginevra Elkann, of the Pinacoteca Giovanni e Marella Agnelli in Turin and Anita

Zabludowicz, co-founder of the Zabludowicz Collection in London. But there were many Asian collectors who had opened their own museums as well, many in the heart of the People's Republic of China, one of the few countries where the national government is still quite active in funding and building museums. Figures such as Thomas Ou of the Rockbund Museum in Shanghai and Li Bing, were joined by the owner of the Beijing He Jing Yuan Art Museum and Dai Zhi Kang, founder of the Himalayas Art Museum in Shanghai, Wang Wei, owner of the Dragon Museum, also in Shanghai, and Budi Tek, owner of the Yuz Museum in Jakarta (Sinclair 2012; Olson 2013). The list of participants stretched to forty, and this is just the tip of the iceberg. Many of the world's most prominent private museums, such as those opened by Alice Walton in Bentonville, Arkansas (Crystal Bridges Museum), Charles Saatchi in London (Saatchi Gallery), Carlos Slim in Mexico City (Museo Soumaya), and the ruling family of Qatar, the Al Thanis (the Museum of Islamic Art and the Mathaf: Arab Museum of Modern Art in Doha), were not represented, but their larger and more prominent institutions are driving the conversation about which artists are important and how private collections might be used for the public good. They are also setting an example for other new collectors to follow. "Private Collectors are setting the agenda for which artists are the most significant by stimulating other collectors to emulate them and compete for works, which drives up prices." (Adam 2014, 85).

A report emerged in 2016 that aggregated data for the first time on private museums internationally (Larry's List and Artron 2016). There are many interesting findings. It lists 317 privately funded contemporary art museums internationally and reports that South Korea is the global leader in private museums with a total of 45, followed by the United States, Germany, China, and Italy. The report also notes that only one-third of private museums have over 20,000 visitors per year; this makes it seem that the benefits for the public are slim indeed, since 20,000 visitors a year is fewer than 55 a day.

A section of this report also addresses the foundation and legal status of private museums. Many of these museums have sought nonprofit status by setting up foundations. They explain that half of the museums surveyed are foundations, but this is more the case in the United States and Europe; in China, only 10 percent of private museums are foundations (Larry's List and Artron 2016, 32). Many of these "museums" are thus content to be for-profit institutions run like companies, and it is clear that the term "museum" is being refined in locations like China. One wonders whether the income

revenues pay the costs of such institutions, whether they make a profit or take a loss, but in some sense this is to miss the point. Such museums provide a public service by making private works available to the public, and they are, to be sure, vanity projects that show a collector's work to the best effect and keep more of it on view than would be possible if these collectors gave their art to public institutions.

Another point is that art shown in museums generally increases in value, and the museum building itself (as well as the land it sits upon) both appreciate, so a private museum is a real estate investment—one often is secured with the aid of local governments, since it will provide ostensible benefits for the community it serves. Private museums that do not seek nonprofit status do not have to play by the same rules, so they can deaccession (sell off) works whose values have increased while in the collection, and they can also easily go bankrupt if the funding stream from a single individual dries up or if there is not a well-developed business plan. Businessmen everywhere see the logic of investments, as well as the value-added dimension that museums confer. An article in the *Art Newspaper* made this motivation clear: "'Private museums are proliferating because China has a lot of property developers,' says Shen Qibin, the former director of the Zendai Museum of Modern Art and the director of the planned Himalayas Art Centre, both funded by property magnate Dai Zhikang. Developers often build a museum 'as an advertisement for nouveau riche developments'" (Movius, 2011).

Of course, if you are already building a single private museum and your collection keeps growing, why stop at one? Budi Tek, owner of the Yuz Museum in Jakarta, is following Dai Zhikang's lead by building a second private museum in Shanghai (Kinsella 2015).

Such expansionism might be expected from businessmen who own private museums, but it originally emerged from a New York-based nonprofit, the Guggenheim. The Guggenheim had long maintained two branches; aside from its landmark Frank Lloyd Wright building on Madison Avenue, the institution maintained the former residence of Peggy Guggenheim in Venice as a house museum that featured temporary exhibitions as well, showing the collection that she lived with there. With the boom in Manhattan's SoHo neighborhood in the 1980s, to get a piece of the action, the Guggenheim opened a SoHo branch in 1992 (it would close permanently ten years later). Not long afterwards, Krens, then director, began to look further afield at Berlin and, most famously, at Bilbao, Spain. In this unique case, the architect Frank Gehry's collaboration with the Guggenheim created another land-

mark building that literally put this aging industrial center on the map for many potential tourists both inside the art world and beyond (van Bruggen 1997; Plaza 2007, 2008). The Guggenheim's expansionism may have peaked—although a new Guggenheim on Saadiyat Island in Abu Dhabi is planned, Guggenheims in Las Vegas and Berlin have closed and Guggenheim's bid to put museums in Rio and the West Kowloon Cultural District did not come to fruition— it nevertheless created a viable new model for large institutions whose expansive and excellent collections in storage were underutilized. It is a revolution in the collections management paradigm to ship portions of the collection around the world to compete with native cultural attractions for a share of tourist revenue. Such a move would only be possible with global networks of transportation and infrastructure like the ones that make it possible for an American company to manufacture a computer in China and sell it in Europe. In essence, such a move represents how even nonprofit museums have become adept at the strategies of economic globalization.

It also demonstrates significant innovations in the means of paying to maintain a bricks-and-mortar institution with large, valuable holdings. Those modernist paintings that the Guggenheim had sitting in storage were assets whose potential was not being maximized. As shown above, constructing new buildings through capital projects stands apart from a museum's annual budget, and it takes a lot of energy for an institution to raise money for a new building. But the Guggenheim Bilbao was built on credit from the Basque regional government and bonds floated by the Guggenheim Foundation (a separate nonprofit entity and legally distinct from the museum proper). Guggenheim thus also changed the paradigm of fund-raising for the arts in order to create this new landmark, which became an instant popular success when it opened in 1997 (Plaza 2007, 2008; Smith 2009). The incredible amount of press this expansion elicited and the resulting tourist traffic went a long way toward paying back the debt and showed municipalities everywhere that a well-planned cultural institution could change the economic climate, something now known as "the Bilbao effect." The place-making idea came together here with the self-funding museum model to create a combination that urban planners worldwide long to replicate.

Juan Ignacio Vidarte, director of the Guggenheim Bilbao and Solomon R. Guggenheim Foundation's deputy director and chief officer for global strategies, noted, however, that this kind of development cannot operate effectively without a coordinated plan and a deep understanding of the local community. "A cultural institution can be a tool to develop a community, but it is not

just about a cultural institution or a spectacular building," he said in 2012. "Bilbao was just one part of a broader effort—building the metro, cleaning up the river." The Guggenheim had turned down many cities that had approached it "because there wasn't a real understanding" (Pes 2012, n.p.).

Saadiyat Island in Abu Dhabi has developed a plan (now delayed) that includes both a Guggenheim museum and a branch of the Louvre, and other places have developed more local partnerships with wealthy individuals and investment groups to develop their city's desirability and increase tourism revenues. The government of Singapore is noteworthy in this context. Other cities, such as Istanbul and Moscow, are featured in profiles of rising art capitals in this volume, but Hong Kong is a unique case. This city is the third largest market in the world for art (after New York and London), and its effort to develop the West Kowloon Cultural District has been open and visible, driven by both developers and public conversations about the nature of the cultural district. The resulting museum concept, M+, will be the result of an almost twenty-year process, since the district was first incorporated in 1998 and it is not due to open until 2019. This museum will feature twentieth- and twenty-first-century art, design, architecture, and the moving image. The report on cultural institutions developed by the museum advisory group's recommendations states: "M+ is more than a museum or building space. It would be a new type of cultural institution with its mission to focus on 20th–21st century visual culture, broadly defined, from a Hong Kong perspective, the perspective of now, and with a global vision. With an open flexible and forward-looking attitude, M+ aims to inspire, delight, educate and engage the public, encourage dialogue, interaction and partnership, explore diversity and foster creativity and cross-fertilization" (WKCD 2006, n.p.).

This ambitious museum program is meant to be a leader in the development of the region but it also clearly aims to overcome previous museum models in a variety of ways. In terms of funding, the government of Hong Kong provided a bond of 21.6 billion Hong Kong dollars (about U.S.$2.8 billion) in 2008 for the cultural district at large, which includes financing for the construction of the district and establishing the museum's collection. To this end, Uli Sigg's collection of contemporary Chinese art has been acquired by the museum through a combination of gift and purchase (the WKCD paid the equivalent U.S.$22.7 million for forty-four works, and more than a thousand more, worth $167.5 million, were donated). The architectural competition for the building was won by Herzog and de Meuron (figure 3), who built the Tate Modern among many other museum buildings worldwide.

Programming has already been going on for years. Nils Littve, the founding director of the Tate Modern, was appointed director of M+ in 2011, though he stepped down in 2015 and in 2016 was replaced by Suhanya Raffel. Nittve expounded on various dimensions of the museum, particularly the importance of building public trust, and explained the financing of the museum, saying: "The government has given the authority, the land, and HK$22 billion to build the buildings. Then we also have the right to develop and build restaurants and shops, entertainment spaces, and cinemas, and to use the revenue from the rents to subsidize the museum and the theaters" (Li 2013).

Nittve describes this as a Hong Kong model—comparing it to the Hong Kong subway, which is cheap and not subsidized by taxpayers—and notes that such a model has never been used to fund a museum, but that it may prove influential in other contexts. Nittve did not rule out corporate or other sponsorships in the future, because exhibitions can be expensive and, even with HK$1.7 billion (around U.S.$219 million) to fund the collection, "the collection is a black hole and you can spend endlessly on it" (Li 2013).

The model of funding an art center based on the rents of surrounding commercial and residential development is related to the market orientation that has succeeded in propelling countries around East and Southeast Asia into prosperity in the generations since the end of World War II and decolonization in the region. The West Kowloon Cultural District Authority, while originally funded by the government, will derive its income from its very desirability as a developer of cultural content for the public. Other dimensions of the museum's innovation, that it is more than just a building, that it features visual culture and will focus on the ways different art forms overlap and integrate in the contemporary world, are linked to this public-private partnership funding idea. In both cases, the model is not top-down but structured along the desire and interests of the audience. Whether one addresses the potential visitors or the funding stream, the market is the solution, since the interdisciplinary programs, featuring art and film and performance, are being designed to appeal to the broadest audience and the economic advantage derived from the desirability of the cultural district will support the institution. Though the government plays a financial role to set these developments on track, it is up to the rotating members of the board of the West Kowloon Cultural District Authority to develop its plans in association with the public and to determine how to realize the ambitious plans put forward by the museum's advisory board and articulated by the administration. The result is not just a new museum, but a new district. M+ is being designed as

a cultural attraction to have global appeal, as well as a new way to fund art museums by and for the public.

In order to demonstrate the way such developments have broader effects, one needs only to look, by contrast to the Museum of Modern Art that is planning a "campus" on the block they currently occupy between 53rd and 54th Streets in Manhattan. While the overall architects of the campus are Diller, Scofidio, and Renfro, Jean Nouvel has designed an 82-story tower for the Hines corporation (53W53) that will house 40,000 square feet of galleries for the Modern on its lower floors. Though the Modern sold the property to Hines in 2007 for $125 million, the museum is clearly cultivating a cozy relationship with the property developer and has leveraged the value the museum adds to the neighborhood by securing gallery space in the building for its campus. Jerry Speyer, the real estate developer who was the Chair of MoMA's board of trustees, explained in a *New York Times* article that this new expansion, following on the heels of another in 2004, was planned because "we have a lot of art that we own that we would like to show," (Pogrebin 2013, C2). Expansion for the purposes of the collection in this case is a justification for developing a cultural complex with significant real estate values that will be added to the local economy. While MoMA has clearly benefited from this arrangement, the museum will not be the primary beneficiary of this value added to the local economy. They will have their campus but, unlike M+, it will not pay for itself. Of course, if it did, the museum would not need those trustees to keep it afloat and the entire funding model they have developed would be unnecessary. The most pressing question is: which of these models is the way of the future? If one perceives the museum and the cultures it represents as autonomous or independent, the Hong Kong model is no doubt the more effective on a financial level. However, if the museum exists to serve the interests of its board members, MoMA wins hands down. Examining museum funding can indicate a lot about the goals and the nature of an institution and, political and economic contingencies aside, its funding model illuminates where the power to shape the institution resides.

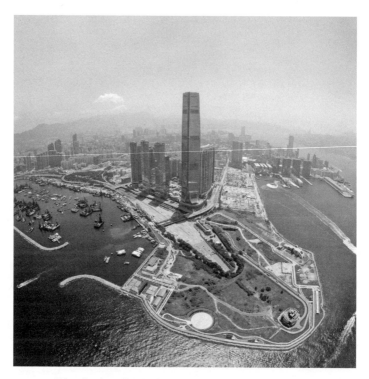

FIGURE 4. West Kowloon Cultural District, aerial view. Courtesy of West Kowloon Cultural District Authority. 西九文化區, 鳥瞰圖, 圖片由西九文化區管理局提供 (This photograph's copyright is provided by the West Kowloon District). © West Kowloon District.

Emerging Art Center

HONG KONG

Michelle Wong

> History is that certainty produced at the point where the imper-
> fections of memory meet the inadequacies of documentation.
>
> **JULIAN BARNES**
> *The Sense of an Ending*

This profile of Hong Kong's art ecology departs from three conceptual anchors. The first of these is that hyper-capitalist Hong Kong can be a forgetful place, and although it has a well-argued history as an economy, its formation as a civil society is just beginning. Art, its infrastructures and surrounding ecology, are not only one of the entry points to understanding the current situation, but also a way proactively to help form such a civil society. Second, many of the "success stories" of Hong Kong's current art ecology that circulate and are remembered today—if we can call them that—are not first attempts in the territory. It is important, and necessary in trying to locate previous attempts that may have become invisible for one reason or another as context shifted. These immediate pasts are necessary conditions for us to understand the present, and to imagine and act upon what lies ahead. Lastly, this profile proposes the reexamination the recent history of art in Hong Kong as form of participation in the making of a civil society; that it is a necessary step toward developing a more nuanced vocabulary and framework for productive discourse. This profile will examine the terrains of government and nongovernment exhibition-making institutions, artist-run and

project spaces, and, last but not least, the writing of art history in Hong Kong.

The first museum in Hong Kong was established in 1962 as the Hong Kong City Hall Museum and Art Gallery, the equivalent of a city-level museum in Great Britain. Later regrouped into the Hong Kong Museum of Art and Hong Kong Museum of History in 1975, the Museum of Art has been one of the primary and most important official exhibition site in the city, its curatorial team arguably responsible for shaping and bringing forth key "movements" such as Modern Chinese Ink, or what some would call Hong Kong Ink. The Museum of Art is currently closed for renovation and construction until 2018.

The construction site for the other government-funded museum, M+, in the West Kowloon Cultural District, is also in the Tsim Sha Tsui area in southern Kowloon. M+'s Herzog de Meuron building and its collection are still under construction, and it is now scheduled to receive its first visitors in 2019. Meanwhile, M+'s most vigorous and exciting program is arguably "M+ Matters," a series of public discussions of its collection, key issues for art in Hong Kong, the larger region of Asia, and the global art world. Each session of M+ Matters is held at a different venue, usually at a university, and the participants, formerly predominantly art professionals, now include students, who often raise critical and important questions. In February 2016, M+ exhibited the Uli Sigg collection, which forms a cornerstone of its collection of visual art, for the first time. Other areas in which M+ is collecting include moving images, design, and architecture.

Much of the discussion about M+ and the Hong Kong Museum of Art has focused on the "overlap" of their collection on Hong Kong and China. Indeed, the momentum M+ has been gathering may well be a much needed prod for the Hong Kong Museum of Art to articulate its art historical narrative and position that stem from fifty years' worth of collection building as well as exhibition programs. With the city's name as part of its institutional title, it is only necessary that the museum, which is staffed by Hong Kong civil servants, become more vocal in its role of writing the city's art history. If museum collections are an integral part of a place's art history, then the exhibitions museums put on deserve not only media attention but also critical analytical debate.

Apart from collecting government institutions, various noncollecting non-government art institutions that function more or less like kunsthalles in Hong Kong are also closed from 2016 to 2018 for different reasons. The oldest of such spaces in Hong Kong is the Hong Kong Arts Centre, which first opened its doors to the public as an exhibition space, as well as offices for art and cultural organizations. Considered the prime exhibition space in 1980s–90s Hong Kong, it was the site of key exhibitions such as *Hong Kong Reincarnated: New Lo Ting Archeological Find,* illustrating the purported "rediscovery" of a fictional mythological creature called "Lo Ting," in 1998. This exhibition could well be read as a commentary on Hong Kong's precarious quest for both its pasts and future as a Special Administrative Region of China.

On the other hand, an air of imminent arrival and limitless potential is embodied in institutional projects such as the Tai Kwun Centre for Heritage and Art, funded by the Hong Kong Jockey Club, the largest charity in Hong Kong, which will open in 2017 as part of the revitalized former Central Police Station compound in the Central district. Many see this area as the heart of Hong Kong, but few may know that it was formerly part of the old walled city of Victoria. Tai Kwun means "Big Station," the name used by local people in colonial times. The Tai Kwun Centre will be the home of Old Bailey Galleries, and the site for contemporary art exhibitions developed both by Tai Kwun's in-house team and in collaboration with other institutions. The opening date of Tai Kwun has been postponed till 2017, however, because of the recent collapse of the façade of one of the buildings.

Another upcoming nonprofit cultural institution that is linked to revitalization is the Mills Gallery, part of the Mills, a project by the local textile factory Nan Fung Textile Mill to turn its former factories into a cultural space that houses design studios and a nonprofit art gallery. The Mills Gallery opened its inaugural exhibition at the Nan Fung building in its prime location building in Sheung Wan in November 2015 with a solo exhibition of work by the Hong Kong–based artist Leung Chi Wo, one of the co-founders of Para Site. Meanwhile the Mills in Tsuen Wan, Kowloon is under construction and will open in 2018. What roles revitalization projects will and can productively play in Hong Kong is nevertheless a hopeful space to watch.

Para Site, founded in 1996 by a group of six artists, is one of the spaces that most people passing through Hong Kong would know and visit. Since 2005

Para Site has become curator-run, where its team curates the space's exhibitions and programs, also in collaboration with other practitioners from outside the institution. In 2015, Para Site moved to its current premises in Quarry Bay on the east side of Hong Kong Island, away from the gallery clusters on the central and south sides of the island. The new space, next to a funeral home, is the biggest Para Site has ever occupied—this may indeed account for the expanding ambition of the space's exhibitions, although they are often known for the large number of participating artists and art works, put together with the art space's identifiable curatorial flare. Para Site's recent shows, such as *Great Crescent, Art and Agitation in the 1960s—Japan, South Korea, Taiwan in Tokyo* (2015) and *The World Is Our Home: A Poem on Abstraction* (2016) can be considered as exhibitions that attempt to shift art historical narratives that could well have been staged in museum settings. This raises a series of questions: what drives a nonprofit art space to do exhibitions with museum-scale ambitions? What gaps are asking to be filled in this case? Who should, who can, and, in practice, who are filling these gaps?

Since 2014, Hong Kong has seen a mushrooming of small-to-medium-scale nonprofit art spaces, some of them quickly gaining visibility within a matter of months. One such space is Spring Workshop, a private, nonprofit residency and exhibition space of over 10,000 square feet in the industrial area of Wong Chuk Hang on the south side of Hong Kong Island. Another project-cum-residency space is Things That Can Happen, which invites resident artists to intervene in its space inside an empty residential building that is due to be redeveloped in two years' time. 100ft Park, an artist-run space founded in 2012 that moved into its current space in 2014 is on the same street as Things. Its first site in Sheung Wan was literally 100 square feet—a room that the founders sublet from a second-hand bookstore. It has since relocated twice—first to a storefront on a major thoroughfare in Kowloon, then to Ap Liu Street, most famous for its markets and stores selling cheap electronic appliances and parts. Other recently established spaces include the private-foundation-funded Starr Projects, the curator-run Shop A3 in Causeway Bay, Floating Projects in Wong Chuk Hang, and Neptune in Chai Wan. C&G Artpartment in Kowloon's Prince Edward district, an artist-run space and alternative art school founded in 2007, relates to this cluster of art spaces as an older sibling.

It is intriguing to observe the circulation of artists and practices in these spaces. The challenge is in maintaining diversity in what is shown—other-

wise there is the risk of such spaces becoming siloed circuits of display showing more or less the same practices. Another aspect of Hong Kong's art scene to consider is how this current generation of artist-run spaces interact with those that sprang up, starting in the 1990s, in high-ceilinged warehouse spaces in the former Government Supplies Department on Oil Street. These were evicted from Oil Street in early 2000, but many of them have continued to operate independently in the government-run Cattle Depot Artist Village, occupying a former slaughterhouse in Kowloon.

In mapping of Hong Kong's current art scene, this profile looks at a city that is very familiar with the discourse of lack—not only of art history but also of historical knowledge infrastructure in general. This leads me to a consideration of the Asia Art Archive—a nonprofit organization for which I have been working for the past four years. There is necessarily bias here, or, rather, a belief that what AAA does in Hong Kong, like other art organizations in the city, is of a certain value. Its projects range from assembling material for research, such as oral histories and digitized archives, to creating infrastructure such as an undergraduate art history workshop developed in collaboration with University of Hong Kong, as well building communities involving cultural practitioners, teachers, and student groups through regular public programs and workshops.

At their best, the art organizations described in this profile can intervene in the smooth running of a market-dominated art infrastructure. One of the major challenges is that such intervention demands attentiveness and drive that goes beyond taste-making circulation of the market. These practices have to be deep-rooted and, at the same time, unafraid of taking risks and asking questions. Such a mind-set will undoubtedly play a key role for an entire generation, if not more, of cultural practitioners politicized by Hong Kong's Umbrella Movement in 2014. Art is not only a form of knowledge but also a means by which we make sense of the world. Through art, we ask questions about what the world can be, and what we, as individuals who inhabit it, can do. And as Gilles Deleuze and Félix Guattari write in the introduction to their book *A Thousand Plateaus,* "Since each of us was several, there was already quite a crowd."

Museum Exhibitions in the Era of Globalization

1 THE ALLURE AND MECHANICS OF THE BLOCKBUSTER

We've all been there. Standing in line to get into an exhibition so crowded that you have to wait to see the paintings in detail. You are likely to get jostled by other zombie-like visitors hypnotized by the knowledgeable mutterings of an audio guide, and if you try to back up to take a painting in, you probably trip over a baby stroller and get a nasty look from the attendant parent. Though not quite as overpromoted as a pop music concert or a World Cup game, blockbuster exhibitions focus the star power of the visual arts, sending art lovers clamoring for their fix of a must-see group of art works. For the museums that house such attractions, the wave of popularity that comes with hosting a blockbuster is a gratifying nod from the world at large. That a museum exhibition organized by a scholarly curator could attract half a million, or even a million, visitors would seem to be a sign that there is broader significance of visual art in society. The thrill that comes with seeing the host city festooned with banners and bus sides advertising a museum show allows museum professionals to believe, for a few months at least, that their invisible work in archives and conservation labs could one day come to be hailed as a public triumph. Though most blockbusters feature a handful of modernist masters (Picasso, Matisse, Monet, etc.), there is no hard and fast rule for success. King Tut was one of the first to wear the crown, and the Renaissance tapestry exhibitions organized by Thomas Campbell in 2002 and 2007 at the Metropolitan Museum proved to be unlikely blockbusters and must have contributed a little to his chances of winning the job as director there.

For collecting institutions, the blockbuster is a way of winning recognition of the significance of the collection. You may have walked by that paint-

ing the last time you were in the museum, but now that you see it in its proper context, you understand its significance and world-class standing. It is also, quite frankly, a cash cow, and though it may be quite expensive to organize, it will drive so much traffic to the museum that proceeds from new memberships, ticket sales, and auxiliary services, such as shops and restaurants, can more than offset any deficits from the fiscal year. This popularity that yields so much income has resulted in a number of transformations that have significant implications for museums (Alexander 1996). Even institutions whose collections are major tourist attractions have been transformed by the development of an exhibition program that is reliant upon blockbuster-like success to sustain the growth that has resulted from previous blockbusters.

The number of blockbuster exhibitions has increased significantly as a result of globalization. Both the spread of information across previously differentiated cultures and the increased network that allows art works to be transported safely to a much broader area than previously conceivable have increased the scope of the blockbuster phenomenon considerably. This has implications for every art museum, and it has produced something of a backlash. As Blake Gopnik wrote in the *Art Newspaper,* "The quaint old notion of the museum as a haven for the contemplation of the art it owns has given way to the museum as a cog in the exhibition industrial complex" (Gopnik 2013, n.p.). Since the number of works available for blockbuster exhibitions has not increased, the number of loan requests for works of art has skyrocketed (Barker 1999; McClellan 2008). This dynamic forces collecting museums to determine what the best interest of the art work is and to square that against their own exhibition ambitions. While conservators and collections managers sometimes cry foul, reciprocity is the name of the game: every loan request accepted yields a favorable approach to one's next loan request, while every loan request refused opens the door for the next loan request to be rejected on similar grounds.

One doesn't have to be an economist to figure out that the more exhibitions succeed, the more they will be proposed, and further, the more in demand works of art that might be put to such uses are, the more difficult and expensive blockbuster shows will be to mount as time goes on (Moss 2011; Waterfield 2011). It seems almost an impossible conundrum until one remembers that collecting museums are always seeking new funding streams, and that funding a blockbuster exhibition, whether as an institution or a private organization, is very likely to yield a profit no matter how much it costs. Blockbusters have thus become a global business model, changing museums from within and without.

The idea of the blockbuster exhibition may be a relatively new develop-
ment (the term began to be used in the United States in the 1970s), the roots
of the blockbuster go further back, at least to the nineteenth century. The
Crystal Palace Exhibition, held in London in 1851, began a tradition of
World's Fairs, originally designed to highlight advances in manufacturing
and trades, but that also featured the works of artists and designers (Csaszar
1996–97; McClellan 2008). The first section under the rubric of Fine Arts
appeared at the 1855 Exposition universelle in Paris and drew throngs of visi-
tors to both monographic galleries of prominent French artists (Eugène
Delacroix and Jean-Auguste-Dominique Ingres, among others) and to an
international competition for contemporary paintings and sculpture from
around the world (Mainardi 1987). As time went on, photography and archi-
tecture were added to such exhibitions, and the popular event called the
international blockbuster thus has a long and storied history (Barker 1999).

The 1990s seem to be the decade when blockbuster exhibitions came into
their own as a universal phenomenon in art museums. During these years,
the number of major shows spiked, drawing countless new visitors to exhibi-
tions worldwide. Some examples would be the Cézanne retrospective held at
the Grand Palais in Paris, the National Gallery in London, and the
Philadelphia Museum of Art. In Philadelphia, the number of visitors over the
summer reportedly topped 777,000, at an institution that usually welcomed
that many visitors in an entire year (Csaszar 1996–97). Not to be outdone,
the Art Institute of Chicago organized a Monet exhibition the same year that
drew 965,000. In São Paolo, the Museu Nacional de Belas Artes, normally
attracting 70,000 visitors a year, hosted a Monet exhibition that brought in
435,000 in 1999 (Sepulveda dos Santos 2001).

If we think of the blockbuster exhibition as a crowd-pleasing show pro-
moted to attract a broad range of visitors, its rise tells us something about the
maturity of art museums with universal collections. Museums had previously
focused on serving as regional cultural bastions for the limited number of
those interested in art, but then Thomas Hoving of the Metropolitan
Museum, among others, had the pioneering idea of putting on exhibitions
that would increase the museum's prominence and bring in new attendees
(Hoving 1993).

A little known fact is that many major museums around the United
States, and indeed the world, were the permanent result of a temporary exhi-
bition. The Philadelphia Museum of Art began in 1876, as a result of the
Centennial Exhibition hosted in the city that year. When the time came to

close up the show, many exhibitors donated their wares to the city and the art works were housed in a building built for the fair, Memorial Hall (Brownlee 1993). Similarly, the De Young Museum in San Francisco was originally built as part of the Panama Pacific Exhibition held there in 1915. The trend continues to this day. The China Art Museum that opened in 2012 in Shanghai was built for the 2010 World Expo, where the building—then called the China Pavilion—was a gargantuan modern pastiche of Chinese temple architecture. In two years, the state transformed it into a museum housing modern and contemporary Chinese art. Since many museums began as the permanent residue of blockbuster exhibitions, it is a sign that they have come of age as a cultural force when museums begin to stage their own blockbusters.

In terms of blockbusters, there are two distinct models currently in operation at art museums: collaborative collections-based exhibitions and package shows. Basically, the difference is between exhibitions co-organized by the host institutions themselves and those organized from the outside and offered to various institutions, landing at whichever institutions accept the terms first. There are countless variations, but these categories will help to explain how exhibitions are organized and carried out at art museums today.

The co-organization model operates as follows: a small group of art museums with strong holdings in a single area, whether it be an artist, a style, or an art movement, will work together to pull together an exhibition project that each of them will host in turn. Usually drawn together by curators, a project is designed that will highlight the works already in the collection of these institutions, but that need to be supplemented by works in private and public collections around the world to fully realize the project. Such projects are therefore sometimes referred to as "loan exhibitions," but they have a unique internal logic. Monographic exhibitions, featuring the work of a single artist, most frequently presented as a "co-org," are the easiest to explain.

If a curator sets out to organize a Picasso portrait exhibition, for example, there ought to be a Picasso portrait, or a group of them, in her collection, and it is fair to say that the organizers are in the best position if the key works for the show are in their hands. So one would look to other institutions of similar size and scope that also have Picasso portraits and begin to discuss the possibility of a coordinated project with them. When a group of institutions are mutually interested in a project, the curators work with exhibitions coordinators and others in their institutions and begin to knock out the details, such as scheduling (which venue comes first), object list (what exactly will they request for the show, and what are the chances of receiving these loans),

and catalogue (which institution will produce the catalogue, and who will write for it). Then the curators get to work on research and loans, while the development department starts raising money for the project, and various other organs of the museum, such as registration, public relations, and exhibition design, go into operation based on their own schedules.

Many of these exhibitions are motivated by, or at least actively engage with, outside scholars who are experts in the field. So while curators play a scholarly role, it is altogether common to import a specialist who knows the material intimately. Whether engaged as an advisor or as a catalogue author, the specialist contractor is a key element even in collection-based exhibitions. These specialists play a rather larger role in package shows, since they are the prime intellectual force behind them, and they work with collectors and curators they know to assemble the necessary works and sometimes to locate venues. Package shows are of an incredible variety, so it is difficult to generalize about their origins, but they can be distinguished by their being offered to museums regardless of the nature of their institutional collections. In fact, package shows are perhaps most successful when nothing of the kind can be found nearby, and this is why they are particularly appealing to museums without collections (kunsthalles) and in locations where an eager viewing public might not otherwise have the opportunity to see the likes of the works on view, whether it be Rodin in Puerto Rico or King Tut in Los Angeles.

In the 1970s and 1980s, blockbusters were often distinguished by title words such as "treasure," "gold," and "royal." While one still finds such atavisms, new trends involve the loan of works from a single museum or famous collection. The Barnes Collection unwittingly established a trend in 1993 by sending the highlights of its collection around the world as a means of funding renovations to the building that housed it, including upgrading the climate system to guarantee the stability of the art works. Though this was not the first instance of a collection going on tour—how else could one describe the group of objects from King Tut's tomb?—the idea that art should not sit idly by when institutions are renovating has become a major trend in international package shows. When the Musée d'Orsay had to close its Impressionist and Postimpressionist galleries in 2009–11, it sent two package exhibitions on world tours, earning a considerable, if undisclosed, amount (Bailey 2012). Some of the venues were collecting institutions; others were kunsthalles. This also has the advantage of building a museum "brand" that comes to be recognized around the world as the result of such exhibitions,

and such brand recognition has long-term implications for the sustainability of the institution.

Of course, a museum does not have to be closed to send part of its collection on tour and reap the financial rewards. The Museum of Fine Arts in Boston has long sent package shows to Japan and, more recently, the Bellagio Art Gallery at the Bellagio Casino in Las Vegas (Kaufman 2004). The Louvre made big news when the Atlanta Museum of Art agreed to pay $7 million for a series of loan exhibitions of European paintings in 2006 (Loos 2006). The Rodin Museum in Paris has a surfeit of bronzes by the master at its disposal, as well as plasters and marbles, and it has produced blockbusters that have traveled to Mexico, Korea, Argentina, Puerto Rico, and Quebec City (where one exhibition attracted over 525,000 visitors in a city with a population of 516,000).

The world of contemporary art may not produce as many blockbusters, but this segment of the market has been increasing in recent years (Nairne 1999). Shows by four living artists—Milton Machado, Tino Sehgal, Isaac Julien, and Yayoi Kusama—have recently ranked in the top twenty ("Exhibition and Museum Attendance Survey and Visitor Figures, 2014"). These are not exactly household names, but they demonstrate that postwar and contemporary art can exert popular appeal. Of course, the important parallel here is to the steep increase in the contemporary segment of the art market. A small percentage of those exhibitions achieve blockbuster status, but the rising popularity of contemporary art among the viewing public is perceptible, particularly among visitors in cities such as New York and London. The Tate Modern in London, the Centre Pompidou in Paris, and the Museum of Modern Art in New York are all among the top fifteen most-visited museums in the world. All of these institutions have made renewed commitments to mounting exhibitions of contemporary art in the past twenty years, and viewers have flocked to these shows, some of which featured unconventional viewing experiences, such as Olafur Eliasson's interactive installations at the Tate in 2003 and at MoMA in 2008 and Marina Abramović's performances at MoMA in 2010. While these exhibitions are not necessarily the revenue accelerators the treasure shows are, they have the advantage of introducing a much broader public to the domain of contemporary cultural production, as well as signaling the significance of these artists in the hierarchy of the art world, and this translates into higher prices for their works at auction and in the galleries.

There are other commercial complexities lurking behind museum exhibitions beyond the well-worn formulas of whether they debase an institution's

mission or are a waste of a museum's valuable resources (Barker 1999). In presenting exhibitions by contemporary artists, museums are conveying their imprimatur to the market, effectively sorting out the amazing range of contemporary art and ruling on what is worth remembering and collecting. A blockbuster contemporary art exhibition is designed to engage a broad public and heavily marketed, with all of the apparatus, such as timed tickets and gift shops, that accompanies any blockbuster show. But that does not guarantee that it will be successful. In fact, mounting a large-scale exhibition of a living artist becomes a test of sorts. Will this artist appeal to the public at large, beyond the audience already committed to contemporary art? The real question lurking here is one of relevance, whether an artistic project is significant at a moment in time, or whether the oeuvre of an artist sustains careful reflection made possible by large-scale exhibitions. This also has implications for the market.

Like capital projects, the funding of exhibitions often lies outside of the museum's annual budget expenditures and must be funded independently, sometimes after initial start-up funds are supplied by a museum. Exhibition budgeting is managed differently at each institution, but a central tenet that most subscribe to is that funds must be raised independently to pay for large-scale shows designed to attract crowds (Alexander 1996). This is true partially because the outsized costs of such projects could not be easily fitted into an annual budget—a single blockbuster can cost as much as 5 or 10 percent of a museum's annual expenditures—but also because these shows are designed to attract enough visitors for the costs to be easily offset by proceeds. Such an exhibition is a highly visible, well-advertised public event, of the kind that corporate marketing departments seek in order to promote their products, whether they are energy drinks or financial services. While it may not make sense for a company to provide annual donations to a museum budget, a corporation gets a flashy advertisement from a blockbuster show, and its name is on every advertisement that circulates for the exhibition, from broadcast media to posters in subway stations.

Chin-tao Wu has pursued a useful investigation into corporate funding of art museums, particularly in its heyday during the 1980s and 1990s. His research points out the rise of an "enterprise culture" in Britain during the Thatcher years and its impact on arts funding for public institutions. "The transformation of art museums in the 1980s from purveyors of a particular élite culture to fun palaces for an increasing number of middle-class arts consumers has thus to be seen within the dual perspective of government policies and business initiatives," he observes (Wu 1998, 30). What Wu puts his finger

on here is the way that government has encouraged corporate investment in the arts, not simply to cover the costs that the state can no longer afford, but as an ideologically motivated attack directed against the perceived elitism of art museums whose goal is to open these institutions to the mechanics of the market. Considering that most art museums in Britain are currently funded by the Heritage Lottery Fund, Wu does not seem to be far off the mark.

Of course, a separate funding stream for blockbuster exhibitions, a trend pioneered in the United States, has the effect of enhancing the market logic at work in a museum. This is precisely why Philippe de Montebello changed exhibition funding policy at the Metropolitan Museum in New York during his tenure (Perl 2008). The Met includes all exhibition funding in a single annual budget expenditure, allowing all of the museum's programming to be funded, regardless of particular project costs and whether the marketing department thinks it will generate significant revenue. The Met also stopped the practice of issuing timed tickets to its exhibitions in 1988, which provides a populist feel when one sees the lines snaking around the museum on weekends. First come, first served is not the normal approach to selling tickets to blockbusters, but it is a high moral ground that the Met shares with MoMA and a handful of other institutions. Of course, they can afford to be high-minded on such matters because they are in Manhattan and their visitor numbers are astronomical, to say nothing of their endowments. Most institutions are using the blockbuster to increase their visitor numbers and, at kunsthalles, a blockbuster is no more than a more successful version of what it does all the time. So outside funding and visitor services for exhibition management are the norm.

The Met and MoMA policies are fighting a kind of rearguard action against a broad transformation of collecting museums as a result of their successes. If your museum welcomes the equivalent of a year's worth of visitors in a summer, you need to beef up your staff capacity on a number of levels. First of all, there need to be more front-line staff (who sell tickets and answer questions in the lobby), plus more bodies to staff shops and restaurants, take tickets, and secure loaned works of art. Since building up the infrastructure for such projects is something that takes expertise, visitor services staffs are cultivated who concern themselves with ensuring that the visitor's experience is positive. Such staff are brought into exhibition planning meetings and even design consulting sessions so that they can express their concerns about visitor flow and interrogate the curators. They need, for example, to determine how much time an average visitor will spend in the exhibition, and one question might be: "How many hundred people per hour can go through this exhibition

comfortably?" They often advocate a unidirectional flow of visitors so that people will not lose those they came with or come back to the beginning of the show and unwittingly start again. These concerns are very real when one is shepherding five thousand viewers a day through an exhibition, and they are an essential element in exhibition planning. Ideally, from the logistical perspective, an exhibition is a one-way street that exits through the gift shop. Audio guide headsets provide essential information for visitors to extend their experience, but they also push the visitors from one key work to another and provide a script for the show that lasts approximately forty-five minutes.

It is not only for the duration of a blockbuster that such concerns come to dominate a museum's energies. Since the payoff is so big, finance, marketing and development departments all start looking eagerly for the next big thing. Many departments spend a considerable amount of energy on large loan exhibitions. Cultivation of visitors and donors is much easier when one's institution is the talk of the town. When the show is over, and things to get "back to normal," museums usually skip a season and then start cranking up the machine all over again. If one has hired staff to manage crowds and whisk potential donors past the line, what are these staff members to do when there are no lines? One can hire and release temporary staff, but every large collecting institution now has a permanent staff that handles special exhibitions. The expectation is that the spike in visitor numbers and revenue that accompanies a blockbuster will become a consistent feature of the institution. After museums have expanded, it is very hard for them to shrink again. The sociologist Howard Becker has analyzed how networks are necessary to support individual artistic accomplishments ([1982] 2008). Nothing could demonstrate this idea better than a blockbuster exhibition. The museum network of institutional professionals that supports major exhibitions is beholden, not just to the exhibition and the artist, but to the system of exhibition making itself. The decision to shift a museum toward blockbusters does not come from on high, but out of a series of interactions between the museum and its evolving publics. The dynamics of the museum are transformed nonetheless.

2 THE BLOCKBUSTER, NEOLIBERALISM, AND CULTURAL DIFFERENCE

It is not surprising that the idea of the spectacular loan show is a formula that applies just as well in cities outside of Europe and the United States. Major

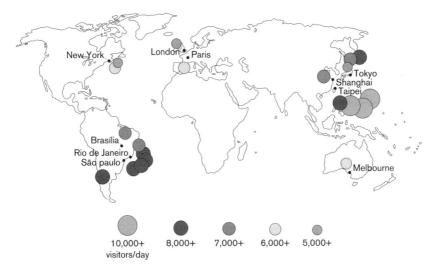

FIGURE 5. The "20 Most Popular Exhibitions in the World 2014." *Art Newspaper* no. 267 (April): 2–15. © Eva Krchova.

exhibitions of both Asian and Western art targeting newly affluent strata of the population have been held in Japan, Taiwan, and South Korea, and such initiatives have expanded further afield with the rise of the global middle class in more and more nations (see figure 5). Cities such as Istanbul, Mexico City, and Rio de Janeiro have recently become regular stops on the blockbuster circuit. Indeed, the best-attended blockbuster exhibitions in 2014 were much more likely to occur in Taipei or Rio de Janeiro than in Paris or London (Pes and Sharpe, 2015). However, there are differences.

One of the main divergences in cities outside of Europe and the United States is that the institutions that host such exhibitions do not often organize such shows, resulting in the decline there of the "co-org" model. Shows can be organized by companies, sometimes even media companies whose newspapers can drum up support for the projects being offered and ensure a return on its investment (Moon 2012). The other point is that many of the institutions that house them are built for the express purpose of presenting exhibitions. In fact, they might not even be held at museums at all, but in exhibition halls and cultural centers. This practice is not new to the blockbuster phenomenon, but in the developing world, where well-endowed public institutions are not the norm, the pursuit of interest in blockbuster exhibitions goes beyond the simple goal of making money. Popular international exhibitions increasingly work to shore up support for multinational corporations,

particularly in the banking industry (Wu 1998; Coffey 2010). Thus the advantages of cultural globalization are secured with the help of companies that are themselves benefitting from the increasing internationalization of the financial sector. A blockbuster exhibition with popular appeal can parallel the development of a network of less visible and unregulated international monetary practices. A few examples will serve to illustrate how this works..

The Banco do Brasil operates Centros Culturais Banco do Brasil in Rio de Janeiro, São Paulo, and Brasilia. All three are on the list of the one hundred most-visited art museums ("Exhibition and Museum Attendance Survey and Visitor Figures, 2014"). The Rio branch alone scored five exhibitions among the top twenty most visited worldwide, and Brasilia had another, making the CCBBs among the most prominent exhibition presenters on the planet. The Centro Cultural in Rio was opened in 1989 in the bank's old headquarters building, occupied since 1906, after the bank moved its headquarters to Brasilia. It offers free admission, is open for twelve hours a day, and presents several art exhibitions simultaneously, as well as theater, film and periodic conferences. The CCBB is, in brief, a vast, well-financed cultural center operated by a bank for the good of the public. As a cultural center, it houses no permanent collection (save for material on the history of the bank) and there is no curatorial staff. Instead, it imports exhibitions organized by visiting curators or package shows, and its location attracts a lot of interest from the public and from tourists. Exhibitions regularly last only two months, but they attract so many visitors per day (6,909 for an Anthony Gormley show, for example) that the Rio CCBB must be counted as one of the most visible cultural centers in the world. Its manager Marcelo Mendonça was quoted as saying of a 2012 exhibition of works from the Musée d'Orsay: "The credibility this country has gained in the last few years in several areas has contributed to the finalization of this exhibition making its way here. Today, Rio de Janeiro is the stage for big international events and is now developing especially in the visual arts" (Froio 2012, n.p.).

This represents corporate patronage on a grand scale, but it is also funded indirectly by the government through Brazil's 1991 Rouanet Law (Brandellero 2015), which permits companies to donate to cultural activities in lieu of tax payments, netting around $630 million to support the arts in Brazil in 2012. This is far more generous than the policy in the United States, where companies are only allowed to deduct such donations from their earnings, but it comes with the catch that such activities must be free to the public. So the largesse that Banco do Brasil demonstrates in its three well-attended art cent-

ers is actually publicly funded. The *Art Newspaper* quotes Marco Mantoan, the director of the CCBB, as saying: "We spent $5.6m on the Impressionist show [the Musée d'Orsay collection] in Rio and São Paulo, made possible largely by tax incentives" (Martí 2013). This exhibition, which attracted about 886,000 visitors in Rio and São Paulo, can be compared to the most ambitious exhibition organized by the Museu de Arte de São Paulo that year, *Caravaggio e seus seguidores* (Caravaggio and His Followers), which brought in about 185,000 visitors. Thus, the exhibitions that take place in the CCBB far outpace in attendance figures those organized by the national museums of Brazil. This amounts to the liberalization of the arts sector in Brazil; private companies, using money that would otherwise have been paid to the state, can outcompete state-funded institutions by presenting exhibitions that cater to the interest of the broadest possible public. Brazil's economy and political climate have been hugely impacted by the Petrobas scandal (see pp. 248–49), but there is no sign that the Rouanet Law will be altered. Such programs sponsored by corporations may presumably be impacted by the economic downturn, but they are likely to continue nonetheless.

The second example of how neoliberalism has impacted the world of the blockbuster exhibition concerns an art exhibition developed in Mexico to tour in the United States and Europe. Mary Coffey (2010) has investigated the exhibition *The Great Masters of Mexican Folk Art,* which traveled from Mexico to New York, as well as Madrid, London, Berlin, and Paris. Coffey asserts that this exhibition follows a model developed earlier at the Metropolitan Museum, *Mexico: Splendors of Thirty Centuries,* which she describes as "the template for the neoliberal blockbuster" (296). The author proceeds with a dual analysis of the show based on political economics, on the one hand, and material culture, on the other. *Great Masters* was organized by the Fomento Cultural Banamex, AC a civic organization owned by Banamex, Mexico's largest bank. The exhibition was timed to coincide with the Citigroup acquisition of Banamex in 2001, and it certainly marked a watershed for Mexican banking: prior to 1994, the percentage of foreign ownership of Mexican banks stood at 3 percent, but with Citigroup's buyout, it increased to 80 percent in 2001 (298). Given that it increased Citibank's access to transborder financial transfers (from the United States to Mexico), the merger actually facilitated an acceleration of such transfers from $9 billion annually to $14.5 billion within three years of the buyout (299). So Banamex's interest in organizing this exhibition coincided well with its parent company's growth strategy.

Nonetheless, there were other initiatives developed as part of the exhibition that seem less than self-interested. The exhibition featured small-scale crafts artists from Mexico whose support the Fomento undertook as a means to preserve Mexican lifeways. The organization also sought not only to purchase their work, but also to help these producers train others and develop workshops into micro-enterprises (301). Such a pro-active effort to support disappearing craft traditions may seem reminiscent of William Morris's efforts to reinvest in the arts and crafts in nineteenth-century England. But Citibank is not run by socialists, and it is highly ironic that a global financial company whose actions promote economic globalization that puts such producers out of work would make an effort to safeguard their traditions. *Great Masters* was not a blockbuster in terms of visitors compared to *Splendors of Thirty Centuries*. However, this presentation of folk art had the effect of promoting cultural tourism to Mexico, and by so doing, it linked cosmopolitanism museum visitors in the United States and Spain to an emerging tourist economy, as well as to the largest bank facilitating foreign trade between these countries and Mexico.

Coffey's research is unique and rich, but this phenomenon is far more prominent among contemporary global artists whose work has graced more exhibitions in American and European museums in the past generation (Belting 2009). One major turning point was unquestionably the presentation of *Magiciens de la terre* at the Pompidou Center and the Parc de la Villette in Paris in 1989. Organized by Jean-Hubert Martin, director of the Pompidou at the time, this exhibition has been celebrated and pilloried, both for good reason, but it represents a transformation of thinking about and curating the art of non-Western cultures and the significance of contemporary cultural production (Martin 1989; Araeen 1989; Altshuler 2013; Steeds et al. 2013). Martin set out to make a selection of fifty artists from the center and an equal number from the periphery (so-called non-Western cultures). A project that allotted equal space to Western and non-Western artists was a radical proposal. Among most museum professionals, curators, and academics at the time, artists from the periphery who employed modernist visual or sculptural language were generally seen to be aping Western traditions that they had not mastered or fully digested. Centuries of racism and colonialism still weighed upon aesthetic judgment, and its residues have not yet fully evaporated, so Martin's exhibition, necessarily flawed, was nevertheless a bold move.

This idea of parity was new, but so was Martin's reconceptualization of the contemporary artist, demonstrating how narrow the definition previously

had been. After generations of Europeans and Americans looking at African and Asian modern artists as essentially derivative of Western modernism, Martin turned the tables by taking up not only non-Western artists but a new generation of producers in both central and peripheral cultures whose works could not be understood in traditional terms of mastery. The notion of turning artists into magicians may undermine their very real social and political critiques, but it sought to refute the discourse around "primitivism," and it served as a means to reframe the debate about center and periphery in the arts. As Lucy Steeds puts it: "'Magiciens de la Terre' may be seen to have developed a transnational and project-based approach that offered a useful model for the subsequent curation and production of large-scale exhibitions that would flourish in the emerging climate fostered by the neoliberal globalization of capital" (Steeds 2013, 25).

Western artists in the era of "the dematerialization of the art object" (Lippard 1973) came of age around 1970 with free-form exhibitions such as Harald Szeeman's *Live in Your Head: When Attitudes Become Form,* organized at the Kunsthalle Berne in 1969, and *Information,* assembled by Kynaston McShine at the Museum of Modern Art in 1970. Historians and curators labored to organize the various artistic activities presented there into clear identifiable movements with labels such as conceptual art, postminimalist art, and the pluralist era. While productive on one level, these efforts served to demonstrate the limitations of the art historical typology of artistic movements as a means to frame contemporary cultural production. Vague though it was, Martin's notion of artists as magicians was a loose category that could be applied to a wide array of original practices emerging both from center and periphery. It sought to unite an array of creators whose activities were *mutually* visible for the first time due to advanced transportation and information networks developed at that historical juncture. In this sense, it introduced the globalization of contemporary art into the most prominent museum of modern and contemporary art in Europe at the time.

Magiciens introduced Europeans to a whole generation of artists, but it left many questions unresolved (Araeen 1989; Deliss 1989; Belting 2007). One of the most important issues was how to come to terms with the difference that non-Western contemporary art represents. What traditions must be considered? How was modernism experienced differently in other parts of the world, and how might that lead to new forms of artistic practice? From what traditions were these non-Western artists developing their practices? In other words, it pointed out all the questions that neither art historians nor

anthropologists had ever asked about non-Western art, and it left viewers uncertain about how to evaluate and come to terms with these new and surprising art works.

Although *Magiciens* approached its topic with a critical perspective, it ironically opened itself up to charges of not being critical, or rigorous, enough in determining how to conceptualize artistic production in a global context. What forms of aesthetic experience were these artists aiming for and why? If one does not know the history of the country, the political and social context that gave birth to the work, how is one to evaluate the artist's success in addressing these issues? In other words, *Magiciens* asked more questions than it could possibly answer, and, while it provided an image of what global contemporary art might look like, it did not satisfy the demands of scholars and critics, nor did it sort out what art from the periphery ought to be collected and how it might come to be valued. Later museum exhibitions, such as Okwui Enwezor's *A Short Century: Independence and Liberation Movements in Africa* (2001–2), among others, attempted to focus on such issues, but these questions were left largely for the market and other exhibition venues, such as biennials, to determine.

Museums did come to present more non-Western artists as a result, however, and new institutions came along to fill gaps that more established museums had left open. Beyond this singular exhibition organized by the state-run Pompidou, a group of kunsthalles in Europe rushed into the fray. Exhibition centers such as the Whitechapel Gallery in London, the Kunsthalle Düsseldorf, and the Museu d'Art Contemporani de Barcelona (MACBA), among many others, began presenting non-Western artists as part of their regular exhibition programs, and the presentation of contemporary cultural production has accelerated at such institutions ever since. On the other side of the Atlantic, museums designed to serve and promote minority populations became the main presenters of global contemporary art in New York in a climate in which identity politics proliferated (Ramírez 1996).

El Museo del Barrio began by serving local populations, particularly Latin Americans, but ended up as a cultural center for Latino arts. Beginning in 1970, it introduced a series of Latin American artists to museum visitors and, for a generation, it maintained the spirit of being an ad hoc community organization (a kind of cultural center). Now it is well ensconced on the museum mile on upper Fifth Avenue in New York, with a permanent exhibition space and even a biennial for artists from the New York area of Latin American heritage. The Studio Museum of Harlem played a similar role for

African American and African art beginning in 1968. Its first survey of contemporary African art was in 1990. While these two museums are cultural projects developing out of the civil rights movement in the United States, with the goal of fostering myriad voices in the community, they both developed an international scope to a certain degree.

Other institutions were focused on the international project from the start. The Museum for African Art was inaugurated in 1984 and, by 1992, the curator Susanne Vogel presented a kind of rejoinder to *Magiciens* entitled *Africa Explores: 20th Century African Art*. This project opened up new conversations relating to cultural points of reference and artistic agency that Martin was either unwilling to have or did not seek out, but it did much to put the work of contemporary African artists in historical context (Vogel 1994). The museum of the Asia Society, under the directorship of Vishakha Desai, introduced a series of contemporary Asian art exhibitions as well. Beginning with *Traditions/Tensions: Contemporary Art in Asia* in 1996, a survey of contemporary Asian art held at the Asia Society galleries, the Queens Museum, and the Grey Art Gallery of New York University, she began to bring together a broad group of artists whose work was not being shown in institutions in the United States. Desai progressed to the next level by focusing on specific cultural traditions *in Inside Out: New Chinese Art* in 1998, *Paradise Now? Contemporary Art from the Pacific* in 2004, and *Edge of Desire Recent Art in India* in 2005. Though the last two exhibitions were realized by Melissa Chiu after Desai had been appointed president of the Asia Society, the organization of these survey exhibitions took place as a result of curatorial collaborations that Desai opened up through a committee of American and Asian specialists she assembled in 1991. In an interview, Desai, who left the Asia Society in 2012, explained:

> We really took our time in the early 1990's when nobody was really focused on this to develop a thorough plan for the next five, six, seven years. . . . We really intended to provide a thorough scholarly sense of the vibrancy of cultural expression in these countries that were both locally driven but part of a global conversation and so the selection of the curator, the section of the themes, what we were looking at was really a very intense part of the discussion. (Desai, personal communication, April 17, 2013)

All of these examples point to the importance of new smaller institutions that would initiate dialogues about global contemporary art that larger institutions were not yet willing to take on.

While non-Western artists would regularly be included in broad survey shows hosted by large institutions, it was largely up to the smaller museums to introduce alternative cultural traditions and to bring to light the way that globalization was affecting artistic production worldwide. Indeed, these New York museums are all nonprofits with specific educational missions. The Asia Society was founded, not as a museum, but as an organization to teach the world about Asia, and it had a collection of art bequeathed by its founder, John D. Rockefeller, and a museum to show these objects. Contemporary art fulfilled the ambition to explore current issues in Asian society and politics perfectly. "They [contemporary artists from Asia] give voice to that idea of connectedness and relationship, along with the unique creativity coming from that part of the world," Desai observes. Though such organizations also came into existence in other cities around the United States, institutions such as the Asia Society, the Museum for African Art, and El Museo del Barrio organized both survey and monographic exhibitions that brought a new generation of peripheral artists to the center and celebrated their accomplishments. In this way, they introduced new dynamics of cross-cultural discovery and contact into the art world, as opposed to the traditional art historical terms of mastery and influence. Globalization did not just arrive as a means of introducing new aspects into a familiar formula, what John Picton has described as "the new way to wear black" (Picton 1998), it actually challenged the norms of the art world, and the entire center/periphery model.

3 EXHIBITIONS AND TRANSNATIONAL DIALOGUE IN THE AGE OF GLOBALIZATION

It would be an error of perspective to imagine that cultural difference in contemporary art was the result of exhibitions in New York and Paris without the ground shifting in other parts of the world. Needless to say, this is because art museums that feature contemporary art are most abundant in such locations, and their funding allows them to realize ambitious projects that institutions in other countries can only dream about. But an analysis of the contemporary global art production goes amiss if one does not consider the view from the periphery and the recent rise of exhibition spaces in countries around the world.

The focus here is the rise of the kunsthalle model for the purpose of presenting special exhibitions, sometimes featuring historical and sometimes

displaying contemporary material. The growth of exhibition halls provides permanent spaces for presenting cultural production of all sorts, including art, film, performance, photography, and installations. Some of these institutions, like the Centros Culturais Banco de Brasil, are well funded and feature blockbuster shows, while others present more modest exhibitions, but the overall transformation here is one in which cultural production is institutionalized, not by and for the benefit of the state, but by private and semipublic initiatives for education, status, and visibility. In this sense, many of these institutions fit into the category that Katarzyna Pieprzak has labeled "marketplace museums" in her study of modernity and museums of postcolonial Morocco (Pieprzak 2010). "The Moroccan marketplace has fully embraced the museum as a way to generate income, investment and prestige," according to her study (37); this is a trend visible throughout the developing world.

Like the blockbuster, the *Kunsthalle* emerged in Europe in the nineteenth century as a means to present temporary exhibitions of art and science. According to Helen Meller, it was conceived as an alternative to the museum from the very beginning, originating in *Kunstvereine* (art associations), with the goal of educating the public rather than preserving art for the ages (Meller 2001). Naturally this meant that such galleries were relatively free in their exhibition strategy compared to museums with permanent collections. "A Kunsthalle puts things up for evaluation and discussion and deliberately provokes the clash of rival positions. It does not present art history, but contributes to it," Gerald Matt says (2001, 46). As such, the kunsthalle model is uniquely useful for presenting contemporary cultural production in locations where permanent collections and museum facilities are few.

It would be misleading to label all exhibition spaces that are not museums as kunsthalles, and the name is not common outside of German-speaking countries, so I will define kunsthalles as exhibition venues that present art and other attractions as a means to enhance the visibility of the arts but also to raise revenues for institutions rather than the artist and her representative (i.e., the dealer). In this sense, kunsthalles are sometimes private museums without the vanity element of showing off the collection of the founder, while at other times, they operate as nonprofit ventures in rented spaces that house the organization semi-permanently. They can be opened by artist collectives or by corporations, but the educational element is often mixed with the prestige of introducing new ideas or works to publics who have not previously had access to such material. Since the key aspect of contemporary

cultural production of all kinds is novelty or innovation, the exhibition hall is perhaps the most fitting place to present it.

This analysis will consider a handful of examples of how the kunsthalle model has landed outside of traditional art world capitals. On one hand, there are the private museum initiatives that function like kunsthalles by presenting a stream of special exhibitions, such as the Pera Museum in Istanbul, the Pinchuk Art Center in Kiev, Ukraine, and the Kiran Nadar Museum in Delhi, India. On the other hand, there are venues such as the Garage Contemporary Art Centre in Moscow and the Museum of Contemporary Art, Shanghai, that are private ventures focused on presenting the best international contemporary art in their respective locations. Finally there are the exceptional venues such as the Ex Teresa Arte Actual in Mexico City and the Beirut Art Center where artists and others have developed projects presenting contemporary art where venues for such material did not exist previously.

Three private museums that more or less follow the kunsthalle model, the Pera Museum, the Pinchuk Art Centre, and the Kiran Nadar Museum (figure 6), date to the first decade of the twenty-first century. The Pera Museum was opened in 2005 and has since featured exhibitions of art from its permanent collection (owned by the Kiraç family), as well as temporary exhibitions of both traditional and contemporary art. It presents not only historical European and Turkish art in exhibitions such as *Goya Witness of His Time* (2012) but also blockbuster-style modern exhibitions, such as *Diego Rivera and Frida Kahlo: Paintings from the Gelman Collection* (2011) and *Picasso: The Vollard Suite* (2010). This is rounded out with both monographic and thematic contemporary art exhibitions of international and Turkish artists. The Pera Museum's dynamic program of ambitious exhibitions dates from the time of Turkey's initial bid to join the European Union, which ties in with the museum's collaboration with European institutions and organizations such as Tate Modern and the Maeght Foundation. Its aspiration to the status of a major international institution is reflected in its wide-ranging program, the publications that accompany all its exhibitions, and its extensive English-language web site. "Pera Museum has evolved to become a leading and distinguished cultural center in one of the liveliest quarters of İstanbul," its web site says (Pera Museum n.d.).

Like the Istanbul Modern, the Pinchuk Art Centre is a private museum with global ambitions in the realm of contemporary art. It presents a series of distinct but interlocking programs called "Collection Platforms," which

FIGURE 6. "Is It What You Think?" Kiran Nadar Museum of Art, New Delhi, 2014. Courtesy Kiran Nadar Museum of Art.

elaborate thematically on the expansive collection of its founder Victor Pinchuk, retrospectives of major international artists (Damien Hirst, Takahashi Murakami, Vik Muniz), solo exhibitions by regional (Ukrainian, Polish, Russian) artists in the context of its collection, and the annual exhibition of the artists shortlisted for its Future Generation Art Prize, a global contemporary art competition for emerging artists. In this case, the considerable ambitions of the patron as an international collector combine with grand ambitions for Ukraine as a location to develop a new culture of artistic production married to the freedom and consumerism available in Eastern Europe since the fall of the Berlin Wall and the breakup of the Soviet Union. There are ample opportunities for local artists to exhibit and for visitors to see these artists in the international context of Pinchuk's world-class collection so that they comprehend the cosmopolitanism of the new crop of regional contemporary artists. The implicit goal of such an art center is to shift the conversation both regionally and globally, to promote international contemporary art in Kiev but also to promote regional art and patronage in an international context. Every other year, the Pinchuk Art Centre hosts a collateral exhibition at the Venice Biennale to promote the visibility of the prize and the center, while major artists and curators are brought to Ukraine to mentor artists, present lectures, and organize exhibitions.

The Kiran Nadar Museum did not open until 2010, but it bills itself as the "first private museum of art exhibiting Modern and Contemporary works from India and the subcontinent" (Kiran Nadar Museum of Art n.d.). This museum is smaller than the preceding two, currently occupying space in two locations, one in a mall in the Saket neighborhood of Delhi and another in the Noida neighborhood. It has already featured a host of important and innovative exhibitions of modern and contemporary South Asian art both in monographic presentations and in themed shows. One of the innovations introduced there is the blending of modern and contemporary work in a single project, which has the advantage of introducing viewers to the legacies, and intergenerational conversations, in contemporary South Asian art today.

This regional focus means that there have not been any blockbuster exhibitions or shows of international contemporary figures such as take place at the Pera and the Pinchuk Art Centre respectively. The advantages are clearly to promote the South Asian artistic context as a fundamental dynamic in the global art world of today. As such, the Kiran Nadar Museum represents a kind of rejoinder to other kunsthalle-style museums around the world that present internationally recognized figures and contemporary local artists in the same supposedly culturally neutral context of the white cube. The implication of the Kiran Nadar's program is that there is something to be learned about India when approaching Indian contemporary art, and that not only are successful contemporary Indian artists plugged into contemporary developments globally but more local concerns are an essential part of their works.

The Garage Museum of Contemporary Art in Moscow (figure 2), which opened in 2008, is very different. It was started by the nonprofit IRIS Foundation, a project of the Russian billionaire Roman Abramovich's partner Dasha Zhukhova. The Garage Museum aims to be a center of international contemporary art, but, unlike the Pinchuk Art Centre, it does not revolve around a private collection. The Garage has been the host of many imported and some homegrown exhibitions, as well as the Moscow Biennale and a more local project, the Museum of Everything, which presents folk art from villages throughout Russia. One of the main focuses at the Garage has been performance art—it presented the "First International Performance Art Festival" organized by Klaus Biesenbach and Roslee Goldberg in 2010 and a Marina Abramović performance retrospective in 2011. In fact, it seems that one of the main differences between the Garage and other similar kunsthalle-style museums internationally is its focus on multiple forms of cultural production—folk art, performance, and film—as opposed to restricting itself to

contemporary art. This is backed by an ambitious educational program designed to introduce new viewers to international contemporary culture. It is not strictly limited by location, but presents projects both in Moscow and abroad. The Garage Museum moved into a new building designed by Rem Koolhaas in Gorky Park in 2015 (figure 2). While there are certainly innovations here, it does seem that the Garage Center is borrowing the kunsthalle model from other European institutions that present international contemporary art. Many of the names of artists and curators could be found at any international biennial, and many of the shows presented have been developed at MoMA, the Pompidou Center, or similar venues. As curator, Joseph Backstein began by presenting Russian artists both there and at offsite locations (at the Venice Bienniale, for example), and the selection of Kate Fowle as chief curator in 2013 demonstrates that the institution will continue its role as a venue for presenting global culture, though it will likely continue to reach out to Russian contemporary artists and cultural producers. One manifestation of this embrace of young Russian artists is the awarding of an annual grant to a Russian artist aged from eighteen to thirty-five.

The Museum of Contemporary Art (MOCA) in Shanghai is an interesting counterpoint to the Garage, because, when it was founded, in 2005, it was the only museum of contemporary art outside of Western Europe and North America. Recreating this model in the center of Shanghai, in People's Square, the cultural center of the city that features the Shanghai Museum and the Shanghai State Theater, was a major development in China in 2005. Like the Garage Center, the museum is a nonprofit, run independently but funded by the Samuel Kung Foundation. Like Zhukhova, Fung plays the role of chair, and his foundation is the sole funder of the institution. MOCA Shanghai is also a venue for international contemporary art, but it is not the same brand as at the Garage Museum, underlining the flexibility of the term. At MOCA Shanghai, one finds more Asian perspectives (art from India and Indonesia as well as by Chinese artists). The program is less sophisticated—no theoretically infused, lingo-laden exhibition concepts here—but there are real efforts at global dialogue. For example, there have been exhibitions pairing artists both from Greece and China and from Belgium and China, and the Pixar exhibition was also presented there. Such projects, sponsored by Fung, a Hong Kong businessman, suggest that the museum has aspirations beyond the contemporary art. The rise of cultural diplomacy has had effects in both political and economic contexts, and one can see that art is not only a means to bridge cultural divisions but also a metaphor for how to integrate

international production that is valuable in multiple contexts. As the Pera Museum and the Istanbul Museum of Modern Art do in the case of Turkey, MOCA Shanghai signals, not only an interest in freedom and innovation, but the fact that China is building modern cultural institutions along Western lines in support of its claim to world-class cultural status.

So much for the worldly dimension of global kunsthalles. There is also a utopian dimension apparent in some of the new exhibition centers as well. In her research on Morocco, Pieprzak (2010) has considered festivals and the recently developed "nomadic museums" that emerge as an alternative to the bricks-and-mortar institutions funded either by the state, private individuals, or foundations. These challenges to institutional structures reframe the set of options available to consider and beg larger questions about how artists from the periphery might reposition the relationship of their works to the state and the market. While such discursive museums extend our imaginations and challenge widely held beliefs, they also suggest an opposition between ideal museums and the world in which such ideas find fleeting manifestation, but might eventually be institutionalized.

At exhibition centers such as Ex Teresa Arte Actual in Mexico City (figure 7) and the Beirut Art Center, artists and curators develop spaces with limited funds from the bottom up without the financial support of major single donors. These two organizations, while connected to local artists and collectives, are not a clear outgrowth of any one group, but respond to demands articulated by artists in an integrated global art economy. The histories of such organizations are specific to the cultural development of their distinct locales, and these are only two among a global profusion of such centers. Others are discussed in the Conclusion to this book, which focuses on artist-run spaces worldwide.

Ex Teresa dates from 1989, when a group of artists petitioned the government to make the baroque convent of Santa Teresa La Antigua available for performances, video and multimedia art. In 1993, it became a museum, Ex Teresa Arte Alternativa (now Ex Teresa Arte Actual), and as such it has ever since fallen administratively under the state's Instituto Nacional de Bellas Artes. Positioned in Mexico City's Centro Historico, near the Zócalo plaza, Ex Teresa is a very visible and accessible hub for alternative arts, music performances, and the like. It in no way resembles the sleek, redesigned historic buildings that house kunsthalle-type institutions elsewhere. The only changes made to the historic building have been cosmetic, and Ex Teresa has never opened a restaurant or a shop (exhibition ephemera are offered gratis).

FIGURE 7. Marcos Kurtycz performance. Ex Teresa Arte Actual, Mexico City, 1993. Photo: Monica Naranjo. Courtesy Ex Teresa Arte Actual.

The idea of hosting alternative and controversial performances in a deconsecrated Catholic church is one that could have only been invented by artists who sought a different kind of space to produce a new kind of artwork.

The 1980s saw many changes in the domain of contemporary art production in Mexico, and it was clear that there was no venue for showing cutting-edge work such as conceptual performance and video installations in Mexico City, so Ex Teresa filled a historical need for a group of younger artists (Lorena Wolffer, personal communication, April 19, 2012). The fact that many of the original participants, such as Francis Alÿs and Gabriel Orozco, are now art world superstars goes a long way toward demonstrating the need to develop new institutions for art presentation as new developments emerge within the field of cultural production. Ex Teresa was never focused on presenting only "art" events, but blended and mixed forms of art (music, video, performance) that had not been housed in the same institutional framework heretofore. While it is not surprising that such a grassroots effort would be co-opted by the government's cultural establishment and become a part of the national museum system, the loose method of organization that existed in the early years of the institution led to an open-minded approach to cultural production that seems to have been fundamentally sustained under the current direction. Ex Teresa still holds events that are little publicized, cost

nothing or next to nothing, and take place without marketing or merchandising of any kind. It would not be an exaggeration to state that Ex Teresa is the garage band of global kunsthalles and an important alternative to private and single-donor institutions.

Another alternative kunsthalle-style exhibition space, the Beirut Art Center, was opened in 2009 after years of planning by Lamia Joreige and Sandra Dagher. Joreige, an artist trained in France and the United States, returned to Beirut in 1995, and he and Dagher, the former director of a gallery (Espace CD), worked together to build a nonprofit from the ground up, without a single funding source, but with a board of directors that courts the private sector, as opposed to the foundation sources that support most art institutions in Lebanon (Rogers 2012, 41). This provides independence for the institution, setting it apart from most of the exhibition venues surveyed here, while also providing deeper ties to more sectors of the city.

The Beirut Art Center reflected a need for both exposing the local community to trends in international contemporary art and giving Lebanese artists an opportunity to exhibit in a monographic context (as opposed to in group shows). Unlike Ex Teresa, the Beirut Art Center is not only a location to present the newest work but has a significant educational aspect. following a trend developed by the Arab Image Foundation, the institution is engaged in archival activities and hosts a *mediathèque* to preserve documentation of the arts in Lebanon. It also hosts an annual emerging artist showcase, as well as offering public lectures and programming around its exhibitions.

Both the Beirut Art Center and Ex Teresa function as sources of international contemporary art and as incubators for local artists to develop experimental practices. In this way, they make space for the growth of a new generation of global artists that has continued to erode the dominance of traditional art world centers, helping provide an alternative to the international brand of art so present at art fairs and biennials around the world. While all of these global kunsthalles reframe the issues of contemporary art from the former periphery and present their programs to a broadening global middle class, institutions like Ex Teresa and the Beirut Art Center draw on local actors to demonstrate the particularity of Mexican and Lebanese artistic developments, and in so doing they establish a two-way form of communication with the global art world. "Contemporaneity itself has many histories, and histories within the histories of art," Terry Smith asserts (2009, 256). If so, we can look to organizations such as these to promote and distribute distinct versions of contemporary art, and of art history itself.

The question is not simply one of institutionalized versus experimental artists, art centers, or exhibitions. It is not a question only of multimillion-dollar blockbusters arriving from G-7 countries to propagate democratic values in the world at large versus local producers of cultural fabric quietly devising livable alternatives. To see the global art world as Walmart versus the mom-and-pop store is to miss the geographical dynamic of the way the contemporary world is experienced and transmitted. Art and money may be a union perpetually renewed, but there is a deeper transformation involved in the proliferation of blockbusters and kunsthalles globally and the way international art penetrates global cities from peripheral sources. Because contemporary cultural production interrogates and expands our transnational experiences, it explores not just the market mechanisms but the countless ways our perceptual systems accommodate ourselves to a constantly evolving world. When I hear a Bhangra-rap song, I am forced to reconsider the way I understand rap as a form of cultural expression in the United States and to imagine what it would be like to hear that music in Mumbai, both what it says and what it represents. Similarly, when I look at a work of contemporary Indian sculpture that appears to mirror the dynamics of post-minimalism in the United States, I have to ask myself what it means to see this work from my perspective as opposed to that of the artist who made it. These are difficult problems for contemporary consciousness, and such notions have been often theorized of late, but they are actually introduced into particular circumstances by institutions that present contemporary art and other forms of cultural production.

In exhibitions and kunsthalles devoted to presenting contemporary art, one encounters such challenges, which individual visitors must somehow resolve. This is also globalization: not simply the products and lifestyles marketed by multinational corporations, but the way in which consciousness is engaged in making sense of expressions of transnational experience. Artists reflect on these experiences and originate works, but without the exhibition or performance venue, there is no way to reach an audience or to participate in the generation of a global culture. So this examination of exhibitions and exhibition centers cannot rest on an inquiry into institutions but must extend into the domains of biennials and art fairs that have expanded so much in recent years to make room for the growing production and consumption of cultural exchange.

Emerging Art Center

MOSCOW

Valentin Diaconov

It is a grave mistake to look at Russia's recent history as a total break with socialist production toward consumer capitalism, or even neoliberalism. A form of a paternalistic capitalism that rewards loyalty over efficiency currently prevails, and this model is closer to late-phase Soviet economics than one might imagine from looking at the scope of changes to the commercial and cultural sectors since 1991. While the country slowly but surely drifts toward ever increasing authoritarian rule that promises to take everyone to simpler times, the USSR itself never emerges from the blind spot of contemporary state ideology. In fact, some tragic and/or heroic events of the Soviet era, such as The Great Victory of 1945, continue to formulate official Russian identity.

The educated class represents a strikingly different vision of modernity in Russia, one that rewards personal effort, urban sophistication and respect for culture. A subset of that class, the new left intellectuals, have their own modernity to counterpropose. Here the Soviet era gets mined for egalitarian social structures begging for reintroduction in increasingly monetized yet underfunded social and cultural spheres. But societies throughout the country today remain deeply rooted in the paternalism that serves as a default backdrop for Russia's stability and stagnation. Of course, current conflicts are no battle between good and evil, so this profile will explore the shades of gray between such divergent developments. Civil disobedience can take many forms, including sabotage, but such actions are not part of critical strategies to take internal conflicts out into the open.

That is why—almost without exception—one has to be critical of what is happening in politics or the economy in order to be part of the art world or, for that matter, of the intelligentsia in Moscow. The art world is also constructing an alternate modernity, its origin myth is founded on a few years of radical social and artistic experimentation that began before World War I and ended sometime in the 1930s. Still, the avant-garde has not entered the mainstream. After all, those active in the art world are just as obsessed with the avant-garde's glorious past as most of the aesthetically conservative audience is with nineteenth-century portrait and landscape painting.

Moreover, it is impossible to understand Moscow's art world without acknowledging the breadth of the chasm between the Soviet art industry and the present situation. A whole culture became legal overnight, going from political dissidence to commercial representation. First, private contemporary art galleries emerged—and the pioneers were brave enough to call themselves the First Gallery (Pervaya Galereya; 1990–93). Likewise, it is important to know that the infrastructure of socialist realism has never really gone away. And how could it? Just as the Soviet economy was never really socialist (at the end of the Soviet years the shadow sector took over almost half of all financial operations), the contemporary artistic culture has not quite reached uniform European standards that have been seen as the ideal.

Following this materialist discourse, another problem is present in the actual situation of institutions and works of Soviet and Russian avant-garde art. Russia has for the most part missed the moment to collect radical postwar art. The largest museum of Russian art, the Tretyakov Gallery, was founded by the cloth magnate Pavel Tretyakov in 1856 as a private enterprise, becoming a state museum in 1893. In 1977, the Tretyakov acquired a part of the legendary Russian avant-garde collection of Georgy Kostaki after he was forced to emigrate from the Soviet Union. In 2002, the gallery invited the prominent art historian and curator Andrey Erofeev to become head of the contemporary art division. Erofeev did not arrive empty-handed; he brought with him a collection of underground art that he had formed in a museum complex located in one of Moscow's eighteenth-century parks. Still, the bulk of the Tretyakov's holdings in twentieth-century art is ideologically driven painting and sculpture that was acquired from state-sanctioned exhibitions during Soviet times.

In 1999, Moscow MoMA, the first modern art museum in Russia, opened in Moscow. Since then, it has become a multipurpose exhibition hall with a curatorial perspective influenced by its first director, Zurab Tsereteli, who

also serves as president of Russia's conservative Academy of Fine Arts. MMoMA's second director, Vasily Tsereteli, is his U.S.-educated grandson, demonstrating that it's not only who you know in the Russian art world, it's also who you're related to. That is why it presents both intellectually rewarding shows that look and feel part of Western discourse and solo exhibitions by realist or postimpressionist artists who enjoyed stable careers in the Soviet era.

This interdependence of Soviet infrastructure and modern conceptions has never disappeared but, during the first years of the new millennium, the pendulum moved toward contemporary art. In 2005, the Moscow Biennale of Contemporary Art presented its first edition, curated by a hive mind of prominent curators—Rosa Martinez, Hans-Ulrich Obrist, Daniel Birnbaum, Yaroslava Bubnova, Nicholas Bourriaud, and Joseph Backstein, the latter being a prominent art manager and a personal friend of conceptualist Moscow artists. For a decade, the notion of a biennial was crucial to the art world's cognoscenti striving to put Moscow on the global map. Only after the economy stabilized somewhat during Vladimir Putin's first term as president could the state budget accommodate the cost of the biennial, and for most of its run it has suffered from various financial and logistical problems. One can use the biennial as a measure of the art world's condition, given the fact that since the very beginning nearly all of the museum and commercial institutions have tried to participate in the special and parallel sections of the Big Event, as it has been called, with their most meaningful and interesting projects. The biennial guide reads like a who's who of the Moscow art scene. If a gallery had a show in the parallel program of 2009 and did not return in 2011, most likely it had shut down. Professionals saw the biennial, with its assortment of guest professionals from all over the world, as a chance to be seen on the international stage. Even as the ranks of curious art world cognoscenti decreased with each new biennial, the Big Event still holds significance in terms of outreach for the Moscow contemporary scene.

And then there is the fragmented, constantly changing modus operandi of the biennial, which, like lightning, never strikes twice in the same place. The first biennial, entitled "Dialectics of Hope," took place in the former Lenin Museum near Red Square (since 1993 a branch of the State Historical Museum). The location has a symbolic heft: after erasing recent history by demolishing Lenin monuments and remodeling Lenin and Revolution museums, a new, global culture entered the former shrine of the first leader of the pioneering communist state. After its first iteration, the Moscow

Biennale entered a peripatetic phase, changing venues depending on the rent. The second biennial, "Footnotes: Geopolitics, Markets, Amnesia," took place in 2007 in a skyscraper that was part of Moscow City, a newly built financial district. The show—five sections by five groups of curators, several of them returning from the first iteration—shared exhibition space with a gallery opened by Marina Goncharenko, the wife of the tower's developer. The year 2007 was the high point for Russia's oil economy, and it seemed appropriate for the biennial to spread its wings as an avatar of financial growth. Unfortunately, the tower had not been finished in time, so visitors were required to take the construction elevator outside the building itself to reach the exhibition. Safety measures precluded going up to the eighteenth floor with children, so parents who brought their young ones could not gain access.

The year 2005 saw the emergence of the first and still the most successful case of gentrification in Moscow's city center. The previous year, the ship-building magnate Roman Trotsenko had bought a nineteenth-century wine factory near the Kursky railway station and put his wife, Sofia, in charge of the gallery cluster/creative technologies space there, called the Winzavod Center for Contemporary Art. Winzavod has been run by Elena Panteleyeva since 2012. Most of the prominent Russian galleries, some of which began operations in the 1990s, moved to this new compound and still rent spaces there. This complex solved the problem of getting around in a city that is famous for its long distances. Winzavod turned into a kind of Chelsea, albeit on a much smaller scale: the number of the galleries there never exceeds eight, and this is not only a question of ever-increasing rent, but also a realistic picture of the art market in Moscow. Anyway, Winzavod has become a go-to location for fresh takes on contemporary art, thanks in no small part to its debut program, "Start," established in 2009. Ironically, it is another self-produced event that has the most viewers—the annual Best of Russia festival, a national open-call photography exhibition. President Dmitry Medvedev, an amateur photographer himself (see his Twitter account, @MedvedevRussia), paid a visit, and audience numbers have exploded since. Best of Russia is usually a safe, predictable show with no hot topics or experimentation, and that is why it is popular with Moscow audiences that still prefer to see art as inspiring entertainment.

The Moscow Biennale and Winzavod have been the harbingers of an exceptional five-year uprising of contemporary art's fortunes. Post-Soviet Russia's oldest state organization for contemporary art, the National Center for Contemporary Art (founded in 1992) opened a new building in 2005 and

introduced "Innovation," Russia's first contemporary art prize, that same year, with total awards exceeding 100,000 euros for winners in five categories. Garage (now the Garage Center for Contemporary Art), a project funded by Roman Abramovich, a steel tycoon and prominent oligarch, took off in 2007 and hosted the Moscow Biennale in 2009. The first show in Garage was a total installation by Ilya and Emilia Kabakov. Run by Abramovich's wife, Dasha Zhukova, it is probably the best-endowed private institution in Moscow right now, and the opening in 2015 of its new building, designed by Rem Koolhaas, drew a lot of international interest. From the start, Garage successfully established itself as the place for those who want to indulge in a sophisticated pastime, bringing in a talented chef for the institution's cafe and opening a media library on contemporary art. The relevance of Garage for Moscow's young middle-class audiences is very high. Right now Garage is working to reinvent itself as not only a kunsthalle for traveling shows by renowned artists, but also a highly intellectual production site for new art. It also has a program of yearly grants for artists under thirty-five, a first for Moscow's art scene, which is generally short on financial benefits for local artists.

Another important player in the art world is the Victoria—The Art of Being Contemporary (VAC) foundation, funded by the gas tycoon Leonid Mikhelson. Until last year, this influential think tank and sponsor flagship did not have a location, preferring instead to produce individual shows both in Moscow and abroad (VAC was behind Massimiliano Gioni's 2010 showing of recent East European art at New York's New Museum, "Ostalgia"). VAC understands the internal opposition of the past and the modern and sometimes tries to infuse old institutions with new perspectives. Mikhail Tolmachev, a young artist who studies in Leipzig, put on a show on military representation right in the Museum of Armed Forces, a late Soviet relic of the Cold War. In 2015, VAC acquired not one but two future art centers, in Venice and Moscow. The latter is destined to become something like the Russian capital's Centre Pompidou, especially as they have the same architect, Renzo Piano.

And while the years 2005–10 were the time when institutions flourished, it was also a period of conservative backlashes that indicated the precarious status of contemporary art in today's society. Andrey Erofeev, Tretyakov's curator of the contemporary art division, was put on trial in 2007 after presenting "Forbidden Art," a show at the Sakharov Center for Human Rights that exhibited art works that would not pass self-censorship in state art insti-

tutions. Prosecutors asked the court for three years in prison for inciting religious hatred, but Erofeev paid only a $2,000 fine. Then, in 2011, political unrest escalated after Vladimir Putin declared that he would return as president in 2012, with half a million Muscovites taking to the streets to protest what they saw as backward policies. These demonstrations had two consequences. First, Moscow entered a new round of gentrification when Abramovich's former aide Sergey Kapkov took over the Ministry of Culture. He not only flirted with the liberal creative class, he gave them jobs and means to pursue their dream of making Moscow a modern city similar to their beloved European capitals. Kapkov's specialty was parks and embankments, but the educated portion of society from all walks of culture nonetheless saw hope in what he was trying to achieve. Kapkov's work has helped defuse the unrest of the intelligentsia, but it has also—and this is the second consequence—made the government into the main benefactor of cultural policies. This type of control has been very handy in the newest political development, one that has left the intelligentsia speechless—the annexation of Crimea and covert military operations in Ukraine, starting in 2014. This kind of political aggression has and continues to have severe repercussions for the art world. Exchange rates have skyrocketed, meaning that collaborations with Europe and the United States have become twice as expensive. More important, criticism of Russia's policy in Ukraine has made Western institutions very self-conscious about dealing with their Russian counterparts. For one thing, it has become much harder to request loans for exhibitions. If the federal law prohibiting "propaganda of untraditional relationships" (i.e., homosexuality) that passed in 2011 was not enough to disquiet Western observers and policy makers, the situation in Crimea has made things worse. This gradual closing of the borders leaves the Moscow art world with fewer means to engage in deep dialogue with other global art worlds. That is why right now we see a full-scale reappraisal of Soviet art, vast holdings of which still fill the vaults of state museums. It is fitting that the latest Moscow Biennale took place at the VDNKh, a Soviet version of a World's Fair, built during the harshest years of Great Terror, 1937–39.

This situation has called for a rethinking of what alternative spaces for alternative voices can be. So the past two years have yielded institutions new to Moscow's art world—artist-run spaces such as Electrozavod gallery and Centre "Red" that answer neither to the state nor to the oligarchs, but to the artists themselves. In their exhibitions you see a curious mix of political art and sober minimalism, critiques of capitalist logic as well as LGBTQ

activism. Exhibitions at these venues possess intellectual richness with almost no means to translate it into something commercially viable. These art labs are opportunities for art to be autonomous from the constraints of politically compromised organizations, making them alternatives to the former alternatives. Of course, the relationships between this new underground, official institutions, and the art market are not clearly defined, and that suggests some hope for the future of the contemporary art world in Moscow.

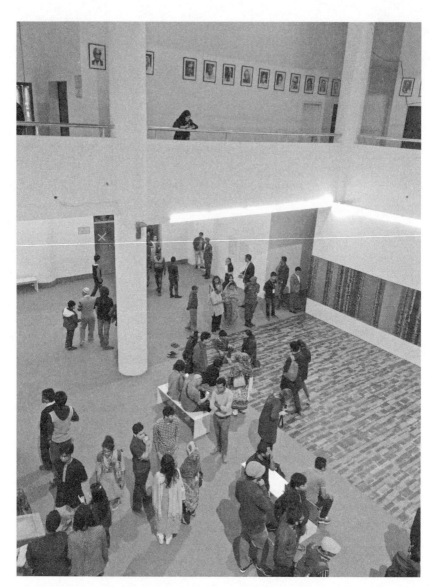

FIGURE 8. Dhaka Art Summit, Bangladesh. Photo: John Zarobell.

———

The Exhibitionary Complex

The economic imperative [of the Dakar Biennale 92] was embodied in the figure of the artist as someone who would not only need but also benefit from the authority, expertise and protection of critical as well as mercantile structures . . . Art was clearly the issue, but art was to be conceived as a powerful cultural commodity which needed to be properly initiated, presented, evaluated, invested in, purchased and preserved.

CLEMENTINE DELISS
(1993, 136)

The term "exhibitionary complex" was coined by Tony Bennett (1988), and though he was addressing the rise of World's Fairs and public museums in the nineteenth century, his theoretical reflections are highly relevant for a consideration of biennials and art fairs, the two most quickly proliferating forms of art exhibition in the twenty-first century.

Bennett sets out to develop a corrective to Michel Foucault's theory of modern power (Foucault 1977). Foucault traces the transfer of punishment from the public realm into the enclosure of the prison, resulting in a state-controlled "carceral archipelago," and Bennett points out that "the institutions comprising 'the exhibitionary complex' by contrast were involved in the transfer of objects and bodies from the enclosed private domains . . . into progressively more open public domains" (74). Such a transfer resulted in a different role for the public in relation to the power of the state and its elites. Bennett asserts that events such as the Crystal Palace Exhibition of 1851 and the national museums that came into existence in this period changed the role of the public by allowing them to experience the effects of power themselves and to side with them. "To identify with power, to see it as, if not directly theirs, then indirectly so, a force regulated and channeled by society's ruling groups but for the good of all:

this was the rhetoric of power embodied in the exhibitionary complex" (80). Thus the public were not, in this context, channeled into submission as Foucault asserted. Rather, they were "inveigled into complicity" (80).

The implication of Bennett's argument is that, during the nineteenth century, some part of state authority was transferred to culture, and that this was made available for the public, a sort of soft sell that allowed the state to "win hearts and minds" (Bennett's words), while apparently building a series of prisons for those who were not won over. Bennett's analysis of exhibitions as festivals is particularly significant here. If national museums operate to solidify state power through the ideologies of history, anthropology, and art history, exhibitions are inherently more flexible: "They made the order of things more dynamic, mobilizing it strategically in relation to the more immediate ideological and political exigencies of the particular moment" (93). Bennett's reflections apply equally, if distinctly, to biennials and art fairs, and the anthropologist Pascal Gielen has applied some of Bennett's ideas to contemporary biennials, as has Peter Osborne. Osborne (2015) sees this as a general condition—the "age of the biennial"—whereas Gielen (2009) addresses the development of biennials as a historical manifestation of the current "post-Fordist" economy, also known as the era of flexible accumulation. These key terms in the neoliberal economic lexicon help illuminate the particularity of exhibitionary structures at this point in history and their meaning will become clear in the exposition of his thesis.

Attempting to characterize the current state of the exhibitionary paradigm, as distinct from that prevailing the nineteenth and twentieth centuries, Gielen notes the passing of an explicit political agenda but asserts: "A certain amount of cynicism and opportunism seem necessary in order to continue operating in the global art system" (1). On the next page, he disavows any accusation of a particular individual being involved, stating that "cynicism and opportunism are now a structural component in our globalized society," and they "define not so much the actions of an individual but the mood of a collective" (2). His argument follows this trajectory: knowing that their dreams are fueled by the economics of globalization, curators' decisions to continue in these endeavors are motivated by a certain opportunism, in many cases the opportunity to present an exhibition that exposes the false promises of neoliberalism and offers an alternative by growing community interaction and engagement through the arts.

He also points to the speculative dimension of biennials, which are not so different from any start-up company. Cities bid to host the Manifesta bien-

nial, for example, banking on the tourist dollars they can benefit from if they line up some investment now. This investment may succeed or not, of course, depending on how the biennial is received. So, every biennial is a speculative venture for the organizers, who can never know if a certain curator's project will be a success or a flop, and the curator usually has no lasting connection to the location where the biennial will occur. Thus they are banking on what Gielen calls "a good idea" of a nomadic curator. The good idea is basically the concept organizing the biennial, but more important for my argument is the transition from material to immaterial labor that this situation represents for all involved. Tracing a general transition of the economic sphere from the 1970s, Gielen points out that while routine labor has not disappeared (though it has been offshored in many instances), the dominant paradigm for labor has become speculative. What this means for the art world is that all the work involved in a biennial is done with the promise of a positive outcome, on spec, so to speak.

The institutionalization of biennials is Gielen's most compelling point, and it serves to connect his work to Bennett's exhibitionary complex. If Bennett describes World's Fairs and museums emerging simultaneously as institutions of culture manifesting the power of elites and the state, Gielen sees the biennial as a post-institution that suits post-Fordist production. In an era when most laborers no longer work on an assembly line, but in an office online, the institutions change to comply. Gielen has an anthropological view of an institution, meaning that he sees it as a kind of domain, or conceptual structure, not as an individual brick-and-mortar affair. According to him: "The institution is primarily experienced as an external reality and objectivity. This means that it stands above manufacturability" (7). This assertion is compelling in many respects.

The first is that, if we see biennials and as post-institutional, they are all alike in some fundamental way, in staging the experiences of contemporary cultural production and unleashing its effects upon a local population. This means that, on some level, the similarities of biennials are more important than their differences. Given the festival dimension of biennials, the fact that various phenomena occur in an uncontrolled way, and visitors are free to interpret their experiences as they will, one may well ask what kind of institution (post- or otherwise) they might be thought to stand for. Don't biennials fundamentally subvert institutional culture? The answer here is slippery for a couple of reasons. The first is that Gielen's anthropological view of culture sees institutions and post-institutions as immaterial, made up of shared

practices and points of reference. It is abundantly clear that if one visited biennials all over the globe in any given year, one would come away with the impression of shared strategies for presentation, reception, the commissioning of new works, and the repeated presence of certain figures (artists or curators), as well as a whole series of human relations mediated through installations, openings, educational efforts, press relations, and so on. This is equally true of art fairs. The other point to make is that biennials the world over present themselves as innovative, as if this version were totally different from all the previous ones or those held in other locations because of the originality of the proposal ("the good idea") and its specific realization in this place at this time. They are all alike in their pretense to be unique.

Here the implications of Gielen's post-institutional assertion become clear. Unlike the institutions of the nineteenth century described by Bennett that asserted the authority of discourses such as history, anthropology, or the nation-state, the biennial as post-institution asserts the authority of the practice(s) of renegotiating these forces from the point of view of the present. In effect, history, the nation-state and all other discourses are put up for grabs, as if this contemporary moment were the point of reference for all else. Biennials as post-institutions introduce the sovereignty of the contemporary, obliterating former discourses and formulating a cosmopolitan, transnational present. Art fairs merely graft the dynamics of the market for works of contemporary art onto this sovereign contemporary.

The dominance of contemporaneity has been addressed by Terry Smith (2009). In this case, the effect produced by the current exhibitionary complex is one that overstimulates consciousness, effectively erasing any competing norm based on an established discourse including, but not limited to, discourses of art history, the avant-garde, culture versus politics, center and periphery. If the conceit of a biennial or art fair is that it is presenting the most important artistic contributions being made *at this point in time,* then when one attends such an event it is possible to perceive an image of the moment we are living in. Through this circular logic, viewers in the twenty-first century are "inveigled into complicity" and come to believe that the experience of the biennial or art fair is real, when in fact the real is actually obscured by it, because both biennials and art fairs are in fact manufactured for consumption.

In this way, one can circle back to the epigraph above in which Clementine Deliss teases out an "economic imperative" in the 1992 Dakar Biennale. Although art and the artist were central to the project, she asserts, the signifi-

cance of the cultural commodity was paramount, and such an abstract construction "needed to be properly initiated, presented, evaluated, invested in, purchased and preserved." The question at the heart of this assertion is how art comes to function in society, and what ensures that the process is "properly" devised. By reading these processes, Deliss points the way toward demystifying how contemporary art comes to have value in Dakar, and elsewhere. While viewers mostly accept the post-institution's structures as real, they are designed to make us feel liberated. However, if one attends to how the structures have been developed and sustained, it may be possible to see behind the proverbial curtain and understand just how contemporary art has developed a global following and a (post)-institutional authority. The biennial and the art fair, as exhibitionary structures, draw from the models of the museum and the blockbuster exhibition, but their exceptional proliferation in the past generation suggests that they constitute a potent and convincing formulation of contemporary experience through a carefully controlled mechanism. This chapter is devoted to analyzing and clarifying this mechanism at the core of the exhibitionary complex.

The chapters in Part II are divided evenly between the biennial and the art fair. Chapter 3 gives a brief history of European biennials to situate this cultural phenomenon in context, to explore some its intrinsic dimensions but also as a means to underscore the wide variety of biennials that have emerged. It goes on to look at biennials in the context of global development and compares how they are both a means to achieve global economic integration in line with export-oriented growth economies and a means to contest those very forces, tracing the shift from one kind of generic internationalism typical of diplomatic associations to another kind of internationalism that biennials can cultivate from a subjective position. Finally, it looks at two case studies, the Istanbul and Shanghai biennials, that emerged from the periphery, considering whether and how these new developments affect the global dynamics of the art world.

Chapter 4 explores the dynamics of art fairs as events that promote lifestyles, embedding the art market in a single location over the course of a week. Frieze is regarded as a paradigmatic art fair that allows the dynamics of art fairs to come into focus. The history of European art fairs is then explored, evaluating how the primary structures of the art fair were developed in the late twentieth century. In more recent years, the organizations that own art fairs have expanded to new markets, consolidated into corporations, and accelerated the market for contemporary art. The chapter goes on

to explore how art fairs developed in the former periphery and examines a question at the core of cultural globalization: When new players enter a market from emerging economies, do they follow the established model or do they adapt it and transform the model itself? How are norms affected by their constant reinterpretation, and do biennials and art fairs in formerly peripheral locations transform what one considers the norms to be?

Biennials, or the New Terrains
of Contemporary Art

1 A SHORT HISTORY OF THE EUROPEAN BIENNIAL

Sitting in what had formerly been an abandoned coal-processing plant on the outskirts of Genk, Belgium, I sipped a beer after a long day of biennial viewing and took in the scene before me: miners in their work clothes whose chorus had been commissioned to perform that evening for one of the community days sponsored by the Manifesta Biennial. The sincerity of their performance was unquestionably moving. The harmonies were strong, and the songs they performed had been sung by generations of miners while toiling down in the hole. They knew they bore the heritage of their ancestors on their shoulders but they wore it lightly. Other exhibition visitors who gathered around the café for the performance took photos with their iPhones, while friends and family members beamed with pride and took even more photos.

The biennial that I had spent the day viewing was complex in a variety of ways, but this was the icing on the cake. The fact that *Manifesta 9* would be held in a postindustrial ruin and that it would engage local performers who preserve working-class folk traditions is a telling sign that the biennial exhibition has come of age. *Manifesta,* first held in 1996 and changing locations every two years, represents a recent evolution of these contemporary art festivals. This unique structure brings world-class contemporary cultural production to communities that might not otherwise be interested, while simultaneously exposing those communities to the gaze of the press and the elite of the art world. Based on casual observations, I would say that the glitterati were more charmed by the locals than the other way around, because attendance in the gallery was light that day despite being free to those living in the

region. But the numbers tell a different story. The tally of visitors to *Manifesta 9* (2012) was around 101,000 during its three-month run, a considerable amount of tourism for a town of 65,000. The organizers proudly announced that community engagement in the project was a tremendous success, since 37,000 participated in the education programs that formed part of the biennial, and 20 percent of the population of Genk came to the exhibition. *Manifesta 10* (2014), in St. Petersburg drew 1.5 million, 70 percent of whom came from the region, but there were fewer participants in educational programs overall.) Manifesta also coordinated seventy-eight related events at cultural institutions throughout Belgium and the Netherlands. Of course, it is too early to determine whether there may be any lasting effect in terms of cultural tourism, but regional cultural institutions have begun to collaborate (Manifesta 2014).

Manifesta's innovations, while significant, are one small part of a broader story of a mad proliferation of biennials in the past twenty years. In 1990, there were fewer than thirty biennials worldwide, and currently the number stands somewhere around 150, though accounting varies (Montero 2011; Fillitz 2012, Biennial Foundation n.d.). While the largest cluster of biennials is in Europe, there is a greater acceleration of such events in the so-called periphery.

The question of whether international biennials held worldwide have changed the art world map is one that has been taken up by a number of authors (Fialho 2007; Hou 2007; Enwezor 2007; Basualdo 2010; Jones 2010) and the general consensus seems to be that global biennials have not shifted the dynamics of power and economics but have created interventions in specific situations. This is hardly a surprise, but there are deeper issues to consider here, such as the way biennials form a bridge between local communities and an international avant-garde (artists and curators) whose aim is to expand the domain of artistic production both typologically and geographically. Furthermore, there are the economic results that biennials themselves produce, and the desire on the part of localities worldwide to employ them as a means of economic development. The rhetoric of internationalization currently elaborated by biennials as a means of representing the underrepresented heralds an end to the protectionism that regional biennials once pursued. Biennials that once catered to specific regions, such as the Havana and Dak'Art biennials have sought to open the doors to all nationalities, resulting in a free market of producers. This turn parallels free market economics and so follows the process of opening up all localities to the develop-

ments of the international financial markets. At the same time, biennials in Europe and America (former bastions of internationalism) have been subject to deprovincialization, shedding the singularity of modernism, and have been equally ambitious in seeking to address a global artistic community in a more open way.

Manifesta reflects all of these trends. This festival has been theorized as much as any biennial and *The Manifesta Decade: Debates on Contemporary Art Exhibitions and Biennials in Post-Wall Europe* (Vanderlinden and Filipovic 2007) provides a single source where many of today's global curators have weighed in on its significance and methods. Before exploring the history of this biennial, it will be useful to expand on the particularity of biennial art festivals and the role that they play in the broader landscape of the art world.

The flexibility of the exhibitionary strategy can be seen even in a schematic history of biennials in Europe. The Venice Biennale was the first exhibition of its type dedicated to the regular presentation of international contemporary art. It was founded by the city council in 1893 and first held in 1895; subsequently, in 1928, Mussolini's fascist government put it under the authority of an "autonomous agency" (L. Alloway 1968). In 2004, the leadership became the responsibility of a foundation, which had become the norm for biennial exhibitions by that time. The first Venice Biennale was very popular and generated 224,000 visits; the 2015 Biennale drew around 500,000 visitors over a six-month period (Biennale de Venezia 2015). While it was originally a showcase to generate popularity and sales of contemporary art, the exhibition now exists without any explicit market element, but ostensibly as a celebration of global artistic culture, though the festival does have market effects (Velthuis 2011). The national pavilions funded and programmed independently (resulting in something like an Olympics of art) were added to the central presentation at the Palazzo delle Esposizioni for the most part between the two world wars of the twentieth century.

By the time Venice began planning its first Biennale, it had long been a center of tourism, and so the exhibition contributed, and contributes, to an industry already at the heart of the Venetian economy. Although works by Venetian artists have long been included in the Biennale, it has done little to encourage artistic production in the city beyond what the historical buildings and unique geography had already accomplished. But it has created an industry around exhibitions. Beginning as a showcase for contemporary art, it has now expanded to include film (Venice staged its first film festival in 1932), architecture, theater, and dance. In brief, Venice dramatically expanded

the domain of festival culture through the Biennale, which is thus a key site for exhibitionary innovation, organizing the logistics of such large-scale events and also producing a sense of glamour that makes them must-see destinations. Moreover, the emergence of changes to the exhibition structure over its long history, from the building of national pavilions to the 1968 protest that led to the closure of the sales office to the expansion to the Arsenale, demonstrate the flexibility of the exhibition in response to emerging demands and ideological structures. Currently, the international domain of the Venice Biennale is much wider than it was and the official Biennale itself is the centerpiece of a wide-ranging set of initiatives by independent actors, such as national pavilions housed in temporary spaces, foundation-sponsored exhibitions, and private museum shows.

The next biennial was not established until 1951—in São Paolo, Brazil. Staging such an event outside of Europe at this early date demonstrated Brazil's ambition to make the expanding industrial metropolis of São Paolo a world-class cultural center. Unlike the Venice Biennale, the Bienal Internacional de São Paulo is neither designed to integrate the local public into its structure nor located in the city's network of the public spaces. However, it adopted the Venice model of using diplomatic channels to bring artists from around the world to a large exhibition space on the outskirts of the city. The São Paolo biennial did not in its early days represent a major new development—other biennials around the world have generated more lasting innovations—but it has evolved in recent years to reflect emerging artistic trends, and it is now guided by a curatorial vision, rather than being merely a competition for prizes (Whitelegg 2013).

Although no less susceptible to the hype that typifies a major international art exhibition, documenta follows a different route than either Venice or São Paolo. It was founded in 1955 by the architect and painter Arnold Bode to accompany a national horticultural show at Kassel in West Germany, which then had a population of approximately 150,000 (Altshuler 2013). documenta is now overseen by a foundation, and funding includes many corporate and government sponsors. It is held only at five-year intervals, and while it currently features contemporary art, it was originally conceived as a means for Germany to "document" and to provide access to the modern art deemed "degenerate" by the Third Reich. Now organized by a new curator each time, the exhibition lasts for a hundred days takes place throughout the city, notably in the Fridericianum Museum (figure 9). Some 860,000 visitors attended the most recent dOCUMENTA in 2012, held at no fewer than

thirty-one different sites, with mini-pavilions for individual artists in Karlsaue Park, a former princely estate (dOCUMENTA 2012b).

The episodic elaboration of documenta has allowed the exhibition's goals to evolve over time and, while the notion of documentation is still essential, it takes a very different form in the twenty-first century, where documentation has expanded to an effort, most notably advanced by Okwui Enwezor in 2002, to take stock of the globe's cultural production and further to encourage international discussions (platforms) for the dissemination of information about this production from a variety of geographical locations. While this gesture is unquestionably utopic, it has also advanced global integration of the international art market and contributed to a series of discoveries of the cultural production of previously distinct centers of art production, such as China, India, and Eastern Europe. Most recently, the production of artists in the Middle East and North Africa was highlighted in the 2012 iteration curated by Caroline Christov-Bakargiev, reflecting a global fascination with the revolutions of the Arab Spring in 2011 (dOCUMENTA 2012a).

It would be hard to overestimate the effect that this exhibition has on the local economy during its run. Unlike Venice, Kassel does not possess the

infrastructure to handle such a huge number of cultural tourists, and it seems not to have really developed it in the years since 1955; after all, the show only happens for three months every five years. While there are a number of small museums that have sprouted up since 1955 in the city, making it something of a permanent cultural destination, tourist services such as hotels and restaurants remain quite limited, so the event is basically catered for its run, with an array of pop-up restaurants and cafés that provide full-time employment, but on a temporary basis. Kassel has a small art school, but it has not become more than a regional center for permanent artistic culture and, while the artists and curators have engaged the local population and even impacted the local ecosystem over fifty-eight years, the foundation employs fewer that one hundred people on a permanent basis. The moralistic foundations of the exhibition continue today and, while the goals have shifted over the years, documenta and Kassel have the reputation in the art world of presenting the most significant and avant-garde art of the present moment, replete with historical understanding and contemporary political significance. But it is ultimately a festival whose economic effects are considerable but always temporary.

Tony Bennett's reflections on the exhibitionary complex (Bennett 1988) match the intentions of Manifesta's organizers well. Conceived in the wake of the fall of the Berlin Wall to respond to an evolving historical framework, Manifesta bills itself as "the European Biennial of Contemporary Art". Accounts of its origins differ, but the idea clearly came from the Dutch Office of Fine Arts, where it was devised and shepherded by Gijs van Tuyl and Els Barendts, with the explicit support of Robert de Haas. The first Manifesta exhibition took place in Rotterdam in 1996, but has since been sited in a different location every two years. Even in discussion among the original organizers, accounts of the reasoning differ, but some of the main concerns were to develop a pan-European exhibition of contemporary art that featured younger, "emerging" artists, and that responded to the recent historical changes in Europe (the fall of the Berlin Wall and the Maastricht Treaty of 1992, which mandated a single European currency and the Schengen Agreement). The first event, curated by a Hungarian, Katailin Néray, took place in sixteen buildings throughout Rotterdam (i.e., it made use of existing facilities) and included seventy-two artists from thirty countries (Europe was defined in the most inclusive sense). It received only twenty thousand visitors, but the international group of organizers it attracted laid the groundwork for a lasting foundation, including an international advisory board, formally incorporated in 1999, that continues to govern the biennial. In

addition, there is a national commission for each manifestation that assumes responsibility for financial and organizational matters (Hughes 2000; Vanderlinden and Filopovic 2007).

The idea of the project is to engage a particular set of circumstances with a new curator and artists. Manifesta represents a maturation of both the biennial concept and the "idea of Europe." It seeks to promote younger artists and thus fills a gap left by the larger and more established biennials. Younger curators and artists have tended to engage significantly with the local community in order to bring together the domain of contemporary cultural production (art, but also performances, film, video, and sound art) to the local community and its particular historical situation. Genk, a waning industrial town at the center of a coal-mining region, is a good example but previous versions have been held in Murcia, Spain, and Ljubljana, Slovenia. So the organizers have intentionally avoided art world capitals and have opened up a competition for curatorial candidates. The director proposes not just a concept but also a specific venue in which to present it (Medina 2012). At Manifesta 9, an international contemporary art exhibition organized by Cuauhtémoc Medina, *The Poetics of Restructuring,* was linked with a historical exhibition on the culture of the region, *17 Tons,* and a modern art show featuring the subject of coal mining *The Age of Coal.* These were supplemented by educational programs, such as a series of performances by regional talent discussed at the beginning of this chapter.

There are several points to make about this iteration of the biennial to connect it to the notions of the exhibitionary complex alluded to above (Bennett 1988). First, Medina chose an avant-garde strategy for presenting the contemporary art by inviting other curators to develop supplementary projects that engaged both the local cultural history and the history of art. The fact of a Mexican curator, and his inclusion of a variety of non-European artists in the exhibition, demonstrates that the "Biennial of European Contemporary Art" has been deprovincialized. Moreover, there are market forces at work, because cities bid to the international committee to host the biennial, and in doing so they have to commit to raising money. They know they are in competition with other localities. Of course, the sponsors, whether they are local elites or government appointees, are willing to secure funding because they believe there will be a payoff for their community, bringing tourist dollars and putting their city on the map.

Manifesta's nomadic dimension is unique, and it is indebted in this to the French American artist Robert Filliou, who conceived of a nomadic Art of

Peace Biennial in the mid-1980s (Vanderlinden and Filopovic 2007, 195–96). Filliou would not live long enough to realize more than one iteration of the Art of Peace Biennial, but the nomadism he conceived is part of Manifesta's claim to originality amongst biennials, as well as a way for the exhibition to renew itself each time. One of the side effects, if not its intentions, is to distribute the benefits of a festival of contemporary cultural production throughout Europe. In this sense, it is similar to the European Union's Cultural Capital of Europe program, which changes city every year. Festivals increase visibility for a municipality and drive tourism, but they also draw together all the existing cultural resources to supplement the special programming that results. Such events may result in a temporary spike in cultural tourism, but they pass, and the effects can be fleeting. This dynamic has been reconfigured from above, when a municipality decides to stage a biennial to promote its identity and network with the available cultural resources. One example in Europe is another postindustrial city, Łódź, Poland, where the municipality itself decided to establish and to fund a biennial in 2004. This was not a lasting success, but Łódź has more recently emerged as something of a street art mecca, holding a street art festival every year which is also supported by the municipality (Rojo and Harrington 2013). Starting a biennial to attract international attention has also become a popular strategy in Africa and in Asia, with the Biennale Regard Benin in Benin (2010) and the Kochi-Muziris Biennale in India (2012), showing that the spirit of international artistic cooperation that arose in the nineteenth century still flourishes. The sheer proliferation of these festivals suggests that the ambition to hold a major art event and attract cultural tourists has become a common development in the contemporary world. Who could have guessed, in 1990, that art festivals would become a widely used tool of urban development around the globe?

2 THE CULTURAL ECONOMY OF BIENNIALS: CENTER AND MARGINS

To position biennials in relation to some of the concepts discussed in the Introduction, it is clear that current governing ideas of art and economic development include the "creative economy"; the cluster of ideas around "creative industries"; "cultural industries"; the "experience economy"; and, finally, "creative places." Brief definitions of each of these terms are provided below in order to be able to describe the variety of economic effects that

biennials can have, which will help to explain why they have expanded so much over the past twenty-five years. These are issues that are studied at every level of governance from the local to the global, so there are far more sources than can be discussed here.

According to the United Nations Conference on Trade and Development (UNCTAD), the creative economy is a concept with an evolving definition based on creative assets that have the potential to generate economic growth. Ideally, the creative economy serves to generate income, jobs, and export earnings, while promoting social inclusion, cultural diversity, and human development. Embracing the economic, social, and cultural aspects of a location, the creative economy is a set of "knowledge-based economic activities with a development dimension and cross-cutting linkages at macro and micro level to the overall economy" (UNCTAD 2010, 10). The term was first introduced by John Howkins (2002), but his definition of the creative industries is so wide that it extends well beyond the domain of the arts into science and technology. This underlines the importance of circumscribing a reasonable definition of creative industries.

The definition of the creative industries used by the United Kingdom's Department for Culture, Media and Sport elaborated in a recent report is the widest, including visual and performing arts, as well as broadcast and print media, advertising, fashion, and software (Department for Culture, Media and Sport, 2011). The French approach to what are termed "cultural industries" links publishing, audiovisual production, and related fields to their industrialization, thus excluding the art market, education, and IT, unless related to publishing and audiovisual activities. The "Nordic model," or experience economy, links cultural institutions with music, toys, fashion, and sports, and it is therefore cultural in a broader sense. While there are significant differences here, the aim here is not to apply any one of these models but to find common dimensions that apply to biennials. UNCTAD's report on the creative economy is useful for sorting out this variety of distinct models. According to its definition, the creative industries "constitute a set of knowledge-based activities, focused on but not limited to arts, potentially generating revenues from trade and intellectual property rights" leading to both tangible products and intangible services (UNCTAD 2010, 8).

Finally, the key term "creative places" refers to the way creative economies are manifested in specific locations, enhancing the desirability of some (mostly urban) areas and allowing for regional economic development. Basically, creative places are locations where the infrastructure for creative

production and dissemination are an essential component of the local economy, and such locations become desirable for businesses of all sorts to establish headquarters because, as Richard Florida argues, the creative class seek locations for enterprises that provide an array of cultural services (Florida 2002). Hence there is a multiplier effect for economic development around creative places. Of course, creative cities also attract tourists and support an economic infrastructure associated with this economy. According to an URBACT II Thematic Network report, "creative clusters in lower-density areas usually emerge organically in urban frameworks," and they "can be promoted in a top-down approach by national, regional, or local authorities who recognize the importance of their development" (URBACT 2008, 18). The Bucharest Biennale and the Liverpool Biennial will serve as examples here. The first of these does not follow an economic development approach, while the second pursues this angle more or less explicitly. In the subsequent examinations of the Istanbul and Shanghai biennials, the significance of creative places in the emerging global network will be reconsidered.

Launched by *Pavilion,* a journal of politics and culture, in 2005, the Bucharest Biennale, seeks to serve as a bridgehead for international avant-garde art in Romania. Its first iteration, curated by Eugen Rădescu, included nine artists and took place in a gallery. It lasted only a month. "A testament to the haphazard Bucharestian context, the exhibition . . . focused on artistic responses to issues of precariousness and uncertainty," according to one review (Pyś 2012). The most recent, in 2014, lasted two months, took place in five locations throughout the city, and included nineteen artists from ten countries. Curated by Gergő Horváth, a Hungarian artist living in Romania, and organized by a radical political journal, it promoted alternative views of contemporary art and culture through a collective, although dispersed, platform.

The Bucharest Biennale has been reviewed or noted in a wide array of periodicals. Some five hundred reporters attended the most recent opening. Attendance figures for 2014 are not available, but there were 42,000 visitors in 2012. Nevertheless, the Romanian Ministry of Culture and the Bucharest city council have declined to fund it. The list of its sponsors is spearheaded by a bank, UniCredit Tiriac, and includes the Romanian cultural institute and Bucharest University (it thus receives some government funding, albeit indirectly), as well as the embassies of the United States and the Netherlands in Romania. It does not seek economic development funding, though it may obtain this indirectly, and with a budget of only €124,000 in 2012, it is the

most underfunded biennial in Europe, according to its organizers (Bucharest Biennale 2012). No money was provided by the European Union. Where there is no state support or key patron, the economic stakes may be low for a biennial, but the autonomy of the organizers is the payoff.

On the other side of the coin is the Liverpool Biennial, which began presentations in 1999 and that has grown to be the most prominent biennial in Britain, with broad support of both the Arts Council of England and the City of Liverpool. Originally funded by the millionaire James Moores, the funding has since been diversified through a foundation. Though the first iteration in 1999 was held in multiple locations, by the second in 2002 there was a broad effort to integrate local cultural organizations such as Tate Liverpool, FACT, and the Openeye Gallery into the planning process. Further, the biennial aimed to create public art in outdoor spaces where it would became part of the urban fabric and meet the residents where they live, rather than expecting them to visit. The program has developed and has succeeded marvelously: it has commissioned more than two hundred works of art since 1999.

The biennial was the centerpiece of Liverpool's successful bid to become the European Capital of Culture in 2008, as a result of which the city attracted 9.7 million additional visitors, or 35 percent of all visits that year, contributing £754 million in revenue. There were 2.6 million European and global visits, 97 percent of which were first-time visits to the city. Furthermore, one-third of the audience for the cultural events was local, demonstrating a major impact in the region. In 2010, the biennial welcomed almost half a million visitors, generating over £27 million in tourist revenue for the city. Liverpool City Councilor Wendy Simon noted that every pound the city invests in culture returns twelve pounds in revenue (Garcia, Melville, and Cox 2010, iii–iv).

While these figures make a strong argument for the overall effects of festivals for cultural tourism, it is difficult to extrapolate precisely what part of this the Liverpool Biennial was responsible for, because the biennial did not conduct its own study that year. It does seem relevant to suggest that the Liverpool Biennial was not only part of the larger festival, but laid the groundwork for the European Capital of Culture by providing a biannual arts festival that brought together local cultural institutions with international curators and artists, attracted government funding, and explicitly sought to address the local population. Not only were these processes instrumental in Liverpool's successful bid, but the biennial continues to take place, thereby extending the impact of culture on Liverpool's tourist and cultural

economies, and solidifying the existing cultural industries. Though not alone in forwarding this project, the Liverpool Biennial has done something to help transform the city from postindustrial blight to rising cultural center. The biennial is evidently a key element in the program of the economic redevelopment of the city. This narrative is similar to that of Bilbao, Spain, but there are reasons it should give the reader pause.

Economic development requires a narrative. The aim of the planners and policy strategists who implement funding and develop scenarios is to benefit society and enhance the economy. Exchange, growth, and production happen by their own logic, however, and sometimes these forces can only be partially channeled, and developers can only predict the future based on studies of what has succeeded in the past. This is why municipalities everywhere embrace the Bilbao effect, where they can see the positive effects and study how that program was implemented. Neoliberals, beginning with Milton Friedman in the early 1960s, have long argued that the market needs to be allowed freedom to do its work and more than a generation of economic thinking has resulted in the hegemony of this model in institutions that manage and regulate the financial domain, everywhere in the world. This is the opposite position to the planning model embraced by bureaucrats involved in civic regeneration, but it forms the horizon against which they must operate, since most governments have embraced the neoliberal doctrine to a certain degree, whether willingly or not. They have been forced to do so by the globalization of economic competition, which has displaced the economic infrastructure that kept the wealthiest countries on top. These economic processes are equally inherent in biennials (Basualdo 2010).

If you are an artist practicing in a city such as Istanbul or Shanghai, or Genk for that matter, there are reasons for you not to be excited about the establishment of a biennial in your town. "Art worlds outside the urban network remained marginal in terms of globalization," Charlotte Bydler observes (2004, 156). I would extend this point to say that local artists are marginalized even in the cities where international biennials set up shop. In a local market, the artist and the market for her work exist in a relatively stable relationship. Artists can find a stability and equilibrium in a particular context, building their careers on the values of a community. This form of localization is a provincial anathema to the cosmopolitanism that reigns in the art world today, so such an artist would likely be of little interest to biennials—although there are always exceptions of course. Biennials bring a

world of art to your door and with it the extensive mechanism that distributes such a product globally to whoever has the money to afford it. In effect, this represents the liberalization of the market for artistic experiences (as opposed to objects themselves). As in commerce, it often occurs that those with the most resources are able to exercise the most powerful effects, and this is how the biennial game is played, with a host of global contemporary artists competing for relevance through their unique artistic strategies and products. The greater the impact on the viewer, the better.

This means that one might perceive anew the discreet charm of the local artist (like the one café in your neighborhood that is not a chain), but they cannot have the kind of impact that well-funded biennial celebrities are bound to produce. The art world is a free market, and at the biennial, the stars, backed by international marketing and outlandishly funded, are bound to win. As the Brazilian sociologist Ana Letícia Fialho has put it, the dynamic of international biennials "leads to a repetition and concentration of choices [of participating artists] instead of a diversification and democratization of the international art scene" (Fialho 2007, n.p.). Even more forcefully, Gerardo Mosquera has argued that

> The case of "international language" in art reveals a hegemonic construct of globalism more than a true globalization, understood to be a generalized participation. The main suspicion aroused by cultural phenomena dubbed "international" or "contemporary" is that, too often, they refer to hegemonic practices that call themselves "universal" and "contemporary," claiming not only the value embodied in these categories but the ability to decide what may be included in them. They form part of the conceptual apparatus of a system of power. This system claims to legitimize specific practices without conceiving of the international or contemporary world as a plural game board of multiple and relative interactions. Furthermore, both categories come to be superposed in practice, showing that there is no present that is not conceived of as "universal"—and vice-versa. (Mosquera 1998, 66)

The situation Mosquera describes is one which he knows from experience, because he attempted to disarm this mechanism and to subvert this logic through the Bienal de la Habana (Havana biennial) when he was on the curatorial team for the first three iterations of this event from 1984 to 1989. It is a particularly telling example because Mosquera can be seen as the figure who inaugurated the category of global art in what began as a regional showcase, the Havana biennial.

Founded in 1984, the Havana biennial was not a recent entry into the history of biennials. Yet, it maintains a legendary status because it was conceived as a rejoinder to the domination of Western-oriented market economics in a communist state at the end of the Cold War. It was begun as a state-sponsored effort to promote Cuban artists internationally, but it quickly evolved into an international biennial to celebrate artists from South America, Africa, and Asia, three continents that shared a history of postcolonial governments, countries in which sought to forge a nonaligned movement during the Cold War (Prashad 2008). The first meeting of nonaligned countries, hosted by President Suharto of Indonesia in Bandung in 1955, included major heads of state such as Nehru from India, Nasser from Egypt, and twenty-nine representatives from other formerly colonized states around the world. The purpose was to develop a shared strategy of economic and political cooperation in the depths of the Cold War, when the world was increasingly divided into the bipolar interests of the capitalist West and the communist East. In effect, this was the birth of the Third World, today known as the Global South, and it had many repercussions in terms of international power relations and governance.

The idea of liberating these newly formed countries, many of them democracies, from the chains of imperialist oppression from abroad and promoting a global interdependence was a utopian goal that was never realized, but it allowed for some forceful rhetoric to counter the bipolar global politics of the era. Many employed the anticolonial rhetoric in their subsequent liberation struggles, as Fidel Castro and Che Guevara did in Cuba during and after the revolution there in 1958–59. Castro briefly remained nonaligned, but he very quickly allied Cuba with the Soviet Union and became a satellite for communist aspirations in the Western hemisphere and a thorn in the side of the United States, culminating in the Bay of Pigs invasion and the Cuban Missile Crisis in 1961–62. Thus any claim that Cuba was a nonaligned power in 1984 would have been highly suspect. But that would not prevent Castro from subverting the imperial aspirations of the United States at every opportunity, and it would appear that the Havana biennial was conceived under the broader cultural politics of his administration (Mosquera 2011). As Anthony Gardner and Charles Green have pointed out, there were a number of predecessors to the Havana biennial that drew their language from the Non-Aligned Movement, beginning in the 1950s in Egypt, India, Vietnam, and Bangladesh, and their conception and execution was often guided by the state. For the most part, these were regional exhibitions, and their fundamen-

tal goal was not to make cultural contributions or impress international curators, but to promote state ideology in an international context (Gardner and Green 2015).

This broad internationalism, originally developed as a strategy in global power relations, also led to the creation of the Havana biennial. As its director Lilian Llanes put it:

> In search of a true universality where everyone may have their own space, the [Wifredo Lam] Center decided to promote a more thorough understanding of the artistic values in developing countries, to advance a closer integration among artists, critics and researchers, based on their common interests and on the defense of their art, culture and existence and, at the same time, to attract all those truly interested in a universal art everywhere in the world. (Llanes 1992, 7–8)

Historically, there seems to have been a culmination in the third iteration in 1989, a year that proved historical for global art and indeed for the entire world. The 1989 Havana biennial was the first substantial exhibition of global art, and though it parallels Jean-Hubert Martin's *Magiciens de la Terre* presented by the Pompidou Museum that same year, the Bienal de la Habana is considered the more meaningful and substantial challenge to the norms of the center/periphery model of the art world up to that point. As Rachel Weiss explains, the third Havana biennial, which opened just one week before the fall of the Berlin Wall, dispensed with the national pavilions and awards that were central to the officious internationalism that had reigned at biennials and also staged a major international conference to promote intellectual exchange in the arts (Weiss 2011).

According to Miguel Rojas-Sotelo, this turning point in the biennial's history involved refuting the prior language of artistic internationalism: "In 1989, the Biennale decided to cancel the competition and became a topical event in which a conceptual problem would determine the curatorial decisions as to what would compose the exhibitions and academic events. The first topic explored was 'Tradition and Contemporaneity' (1989)" (Rojas-Sotelo 2010, n.p.). This topicality was central because it put art above diplomacy and set forth an internationalism from below, and, in this context, it is also notable that the organizers brought many international scholars involved to Cuba including Geeta Kapur, Rashid Diab, and Pierre Rastany.

The 1989 Havana biennial offered a vision of the contemporary art world as revealed in a single international exhibition organized by a curator, or

curatorial team. There were precedents of course, beginning with documenta 5 curated by Harald Szeeman in 1972 and *Aperto '80*, curated by Szeeman and Achille Bonita Oliva at the Venice Biennale in 1980. Many developments had emerged in biennials around the globe prior to 1989: prizes were eliminated from the biennials at Coltejer in Medellín, Colombia, in 1968, in Tokyo in 1970, and in Sydney in 1973, and a new generation of biennial curators came from outside of Europe (Gardner and Green 2015). Beginning in 1989, however, the template changed. The most advanced biennials would be formulated by the highly partisan vision of an individual or group who could relocate the horizon of the art world and reposition the attention of art viewers to perceive anew the shape of contemporary cultural production through a topical inquiry. Rather than an automatic internationalism of representative nations promoted and funded by the diplomatic core, the new internationalism in art would be a projected globalization based on a subjective vision of the world at large. Needless to say, the vision of Mosquera's team at the Bienal de la Habana was distinct from the formulations that had emerged from the European context.

Though this broader vision of global art would come to be employed (some might say co-opted) by established biennials in Europe and elsewhere, it is easy to see why the opportunity to reconsider and represent global artistic production would be highly desirable to rising capitals in the Global South. Inasmuch as globalization allows any stakeholder to become an active participant in the evolution of the capitalist world system, biennials allow any city and group of curators to make universal claims about the current shape of global culture from the perspective of their unique position. What is more, the biennial exhibition is a festival that draws attention to the host city and is a draw for tourists and the revenues they bring. Given this array of enticements, is it any wonder that biennials have popped up all over the world at an incredible rate in recent years?

Yet these observations do not dispel Mosquera's critique that internationalism in the arts becomes part of a "conceptual apparatus of a system of power." Is it possible for any biennial to reposition thinking on contemporary art, as Mosquera puts it, to allow viewers to perceive global art as "a plural game board of multiple and relative interactions"? Is it possible to change the art world map and to valorize artists from the Global South engaged in alternative, regional practices, while deemphasizing the central hegemonic structures at work in the international art world? While some success in this regard can be attributed to the 1989 Havana biennial, the situation there changed radically thereafter. Within days of the opening, the

Berlin Wall fell, creating a very different environment in communist Cuba. In the ensuing years Mosquera himself, as well as many of the young Cuban artists featured in the exhibition, left the island for the United States. If biennials have come to serve capitalist development, is it possible for them to produce viable alternatives to our social and political norms?

3 GLOBAL BIENNIALS, OR, CENTER AND PERIPHERY RECONSIDERED

If the Venice Biennale and documenta demonstrate the norms that put biennials on the map, Manifesta and the Bucharest, Liverpool, and Havana biennials all manifest those norms in very different ways. Drawing on the ideologies of exhibitions elucidated through the notion of the exhibitionary complex, it is fair to ask if the norm has been altered by being taken out of context and what that means for the economies of formerly peripheral global cities. A comparison of the Istanbul and Shanghai biennials will serve as a case study to explore this issue in more depth.

The Istanbul Biennial began as an international exhibition, including many Turkish artists, that aimed to offer the local public "a temporary museum of contemporary art every two years in a city without a contemporary art museum" (Çelenk Bafra, personal communication, 2012). The biennial grew out of a series of art festivals in Istanbul in 1970s organized by the Istanbul Foundation of Culture and the Arts (İKSV), founded by Nejat Eczacıbaşı in 1973. Thus the Istanbul Biennial never followed the format of international biennials established by Venice and in the first two iterations, under the direction of Beral Madra, brought together Turkish and international artists. Both the first two versions of the biennial were titled "Contemporary Arts in Traditional Spaces" and were generally placed to appeal to tourists who might otherwise visit historic sites such as Hagia Sofia and the Topkapi Palace, as well as to engage Turkey's artistic community. With the appointment of Vasif Kortun for the 1992 iteration, the biennial was relocated to a nineteenth-century factory and a much broader array of international artists were engaged. This is considered the first version to bring forth a clear curatorial vision and a team of experienced art professionals (Yazici 2011).

From this point on, the biennial determined to engage a single curator each year and after Kortun, directors were sought from among the international curators who regularly produced such projects worldwide, such as Rosa

Martinez, Dan Cameron, and Hou Hanru, though Kortun returned to co-curate with Charles Esche in 2005. If this strategy sequentially reduced the proportion of Turkish artists by accelerating international participation, it also had the effect of raising the status of the biennial in an increasingly competitive field in the 1990s and 2000s. More important, for the organizers, it highlighted the status of Istanbul as a cultural capital and began to lay the groundwork for more lasting institutional presence for contemporary art in Turkey. Like Venice, Istanbul was already a center of historic culture, so adding contemporary art had the effect of diversifying its pedigree as a destination for culture.

Turkey has been an applicant to the European Union since the early 1990s, and the biennial has done much to advertise the cultural development of this secular Muslim state and to demonstrate Istanbul's ambition to become a world-class art capital (Kurtarir and Cengiz 2005). Many other cultural institutions have resulted (see Istanbul profile), either directly or indirectly, from the biennial, including the Istanbul Modern, also known as Istanbul Museum of Modern Art, founded by the Eczacibaşi family in 2004 and featuring a number of works purchased from the biennial itself. Istanbul Modern also hosted the Istanbul Biennial in 2015. The contemporary art space SALT is another permanent feature that graces Istanbul's burgeoning arts district, and its creative director is none other than Vasif Kortun. These developments demonstrate the long-term implications of the biennial for contemporary art and the urban spaces of Istanbul (Tan 2006, Jones 2010). Taksim Square has been a regular exhibition space for public projects tied to the biennial and a central location of the arts district, was reclaimed by protesters against the government of Prime Minister Recep Tayyip Erdogan in June 2013. We can see a public pressing for greater human rights and economic justice in a manner not inconsistent with artists who have staged events there in past iterations of the biennial (Batty 2013). While it would be naïve to assert that the biennial led to the protests of the summer of 2013, these events demonstrate the evolution of political participation in Turkey in a manner not inconsistent with its neighbors in both Greece and the Middle East in the wake of the Arab Spring. Of course, the biennial has responded to this upsurge of protest: the 2013 version was free to the public and was focused upon "public space as a political forum" according to the organizers (İKSV, 2013). For a time, it seemed that Turkey's elites have succeeded at fostering greater international status and economic development through the biennial and these have been paralleled by an upsurge in civil society there.

However, events following the attempted coup in the summer of 2016 have caused many to question the future of civil society in Turkey.

The story of the Shanghai Biennial is a very different one. Funded by the government like most cultural initiatives in China, this biennial is not a civic development funded by the native bourgeoisie but a government project initiated by bureaucratic elites. Yet both biennials have engaged both local and international curators, so there is a fundamental similarity in terms of both execution and the goal of globalization, in this case defined as bringing international notoriety of cosmopolitan artists to emerging economic and cultural capitals.

The Shanghai Biennial began as a regional affair for the first two iterations in 1996 and 1998 but in 2000, international aspirations became clear through the appointment of two curators from outside of China, Hou Hanru, who is Chinese, but was then based in France, and a Japanese curator, Toshio Shimizu. Until 2012, the Shanghai Biennial was held at the Shanghai Art Museum, a former colonial building (a racing club) that was transformed into a museum in 1950. As a government institution positioned in Shanghai's People's Square, where a variety of cultural attractions and city government buildings are housed in an extensive urban park, the Shanghai Art Museum occupied a central position in the city's cultural landscape. For the ninth Shanghai Biennial of 2012, the exhibition was held in a new museum, the Power Station of Art, a repurposed power plant with enormous open spaces, not unlike the Tate Modern. This recent transformation of locale represents another step toward a global posture by Chinese national art institutions (Xu and Li 2012).

The opening of this museum provided extensive gallery spaces, but the organizers nevertheless expanded their project into the city itself through the Zongshan Park Project, a mobile installation held at various locations throughout the city, but focused on Zongshan Park. The curators, led by Qie Zhijie, but including Boris Groys (Germany), Jens Hoffmann (Costa Rica, by way of San Francisco) and Johnson Chang Tsong-Zung (Hong Kong), brought an impressive international perspective to the event. Beyond the central exhibition, they added Intercity Pavilions, which functioned the way national pavilions do at Venice, with small curated exhibitions from cities throughout the world, such as Los Angeles, Mumbai, and Palermo (Xu and Li 2012). This original device allowed the organizers to play the host to a Venice-style cornucopia of artistic projects from throughout the world, but focusing on cities instead of nations allows for the specificity of location to

reenter the biennial. It also means that the international network of diplomacy was replaced by a contingent connection between cities throughout the world that could lead to increased visibility and the development of partnerships in the future. This new model explores a network of global cities and so is more responsive to the evolving paradigms of internationalization outlined by Saskia Sassen (1991, 2000) and numerous other social scientists who have pointed to a model of globalization based on cities as nodes of capital accumulation and labor diversification as opposed to the earlier framework provided by the United Nations and the Venice Biennale.

In 2000, the art historian and curator Wu Hung articulated the problematic of the Shanghai biennial in relation to the city of Shanghai:

> For the Shanghai Art Museum itself the 2000 biennale represents a huge breakthrough: it allows this official art institution to proudly announce its entrance into the global era. . . . The 1996 and 1998 Shanghai biennales were viewed as preliminary stages in a long-term evolution towards the established international norm. . . . This official, evolutionary approach to contemporary Chinese art was tied to [a] definite locality in 2000: Shanghai. In fact, only by linking the biennale with the city's Herculean effort to (re)assert its global, cosmopolitan identity can we understand the exhibition's true rationale and feasibility. (Wu 2000, 45)

Wu outlines that the significance of the biennial for others, such as artists in nontraditional media and independent curators in China, was quite different because it initiated a precedent for independent selection of curatorial content outside of government censorship. So one can see that the stakes in Shanghai were different than even in Cuba, another communist country, because the move from regional to international meant that certain forms of art and the messages art conveyed were allowed to take shape within China for the first time, despite the fact that contemporary Chinese art had already circulated internationally and met with receptive audiences outside of the country. Yet the incremental, evolutionary approach Wu describes is one that only emerges in the Chinese context, where state planning means that enormous goals can be realized through carefully laid plans and market structures can be introduced to exist side by side with central state control. In Chinese contemporary art, overcoming regionalism not only means adding a group of international artists to the biennial mix. It means fusing traditional cultural forms to emergent artistic practices and blending state control with the self-styled autonomy of the international avant-garde.

Comparing the Istanbul and Shanghai biennials, the most obvious difference is the fact that the Shanghai exhibition takes place in an institutional structure, specifically the state-run Power Station of Art, which is the first public museum in China created to feature "international" contemporary art, as opposed to Chinese art. Despite the fact that both biennials employ teams of international curators, the Istanbul Biennial is run by a foundation with an international advisory board, while the Shanghai Biennial is a state-sponsored project ostensibly guided by an academic committee. Both are intended as profile-raising ventures, as comments by Bafra and Wu clearly indicate, contributing to the international stature of the cities that host them and, in this sense, both are supported and themselves support a string of related cultural developments in those locations, from the opening of new museums and art centers to arts districts being developed in those cities. Whereas Istanbul is keen to capitalize on its historic buildings and districts, Shanghai is offering a break from the past and a new ambitious program to develop an international center for artistic culture from scratch. The ninth Shanghai biennial received 380,000 visitors over six months in 2012–3 (numbers for the tenth Shanghai biennial in 2014–5 are unavailable), while the fourteenth Istanbul biennial drew over 500,000 visitors over three months (Power Station of Art 2013; İKSV 2016). But the biggest differences are in the nature of the exhibitions and their use of spaces.

Looking only at recent manifestations, the 2011 Istanbul Biennial was held in a series of six buildings but the fourteenth biennial in 2015 was held in the Istanbul Museum of Modern Art, representing a break from past iterations that were often scattered throughout multiple venues. It is a coordinated effort, and had previously been very focused upon the public spaces of the city, and its flexibility in this regard is one of the defining characteristics of the exhibition. In this sense, the city is implicated in the exhibition and the art is brought to the public in a manner similar to other upstart biennials, such as Manifesta or Liverpool. Choosing to locate it at the Istanbul Modern allowed the curator, Carolyn Christov-Bakargiev, to promote the idea of "Speech Acts" in a project entitled "SALTWATER: A Theory of Thought Forms." In Shanghai, the exhibition was grounded at the Power Station of Art, with most of the intercity pavilions stationed there, though there was an attempt at geographical dispersion through the Zhongshan Park project, but this was not repeated in the next iteration. That meant that the energy of the biennial was concentrated and forceful but the spillover effect was significantly less. However, the state did bring school groups and even military

cadets (I witnessed this personally) to the biennial for their education. Further, at the opening of the 11th Shanghai Biennial (2016), the opening of the biennial was timed to coincide with an art fair recently relocated in Shanghai (Art 021) and the promotion of a new arts district, the West Bund Art Center, that features private museums and galleries.

To trace distinctions between these projects, it will be helpful to examine the 2011 Istanbul Biennial, *Untitled*, followed the work of the Cuban American artist Felix Gonzalez-Torres, who created a series of untitled installations that have become fixtures in the contemporary art circuit, employing five works by Gonzalez-Torres to anchor five galleries of work by international artists. The curators, Adrian Pedrosa and Jens Hoffmann, were veterans of multiple biennials and worked hard to develop a cutting-edge presentation of the best contemporary art currently being produced, organized into their rubric. They selected a handful of Turkish artists (10 out of 132) but the show represented the international avant-garde, including many well-known artists from the biennial circuit but generally focusing on younger, more experimental artists (Hoffmann and Pedrosa 2011). The ninth Shanghai Biennial (2013), *Reactivation,* was directed by Zhijie, with three other curators previously listed, focused upon the theme of energy in four interlocking sections (Resources, Revisit, Reform, Republic) that were not formally separated in the biennial presentation but only in the published material on the exhibition. Signage in the biennial elaborated these themes, but it was difficult to disaggregate them from one another in the exhibition spaces. International representation at this biennial was robust, but it represented the most regional biennial manifestation I have seen, since it featured thirty-six Chinese artists (including artists from Taiwan and Hong Kong) out of a total of eighty-eight projects in the thematic exhibition, hence 41 percent. If one adds other Asian and Pacific artists, the total percentage was 54 percent. This considerable presence demonstrates that the organizers maintained a strong interest in regional production in the context of an international presentation, and so there is some form of protectionism manifesting itself amid the globalization at China's newest contemporary art museum. However, if one compares Shanghai to other biennials, it is clear that it is by no means the most regionally focused biennial and is surpassed by Venice, Havana, and Benin (figure 10).

There are broader issues to consider around these biennials, namely, the question raised earlier of whether the art world map has changed as a result of the biennials and the associated events and institutions that they have

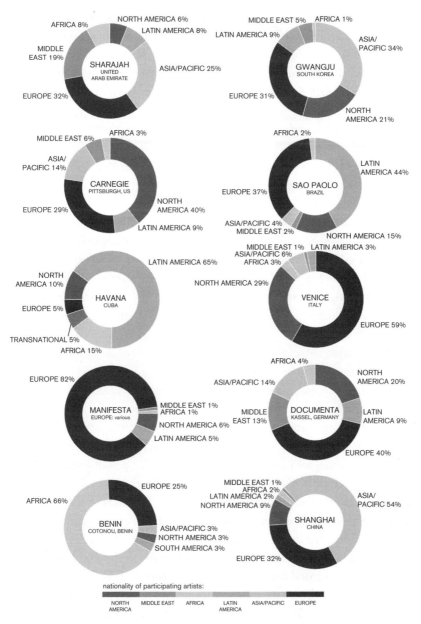

FIGURE 10. Nationalities of participating artists at biennials, 2013–14. Data from biennial web sites. © Eva Krchova.

spawned. Looking at figure 10 makes clear that many of the world's most diverse biennials, in terms of international representation of artists, are being staged outside of Europe and North America. These are not regional events. In fact, the most regional biennials are Manifesta (which is billed as a *European* biennial), Benin, and Havana, while Sharjah, Gwanju, and documenta are the most geographically diverse.

Istanbul and Shanghai may not be Paris and New York, but they could well be nodes of a decentralized global art world map of the future. How a city achieves as much can vary: local arts patrons in Istanbul have supported events and worked hard to establish an international reputation for the city they call home, whereas cultural administrators in the Chinese government have capitalized on international events, such as the 2008 Olympics in Beijing and the 2010 World's Fair in Shanghai to lift their two largest cities into the global consciousness. Istanbul has developed commercial art functions, such as the Istanbul Art Fair, premiering alongside the biennial in 2013, as well as auction houses and galleries that support a consistent arts capital workforce, including artists, dealers, curators, and the like. Shanghai has one of the longest-standing art fairs in Asia, but the sixteenth version held in 2012 was not timed to coincide with the opening of the biennial and was held at a convention center at the edge of town. However, two art fairs—one at the West Bund Art Center, a government-funded initiative, and the other, Art 021, an event sponsored by an international company— and exhibition openings at private museums and galleries were timed to coincide with the opening of the 2016 biennial (Forbes 2016). Shanghai is now beginning to develop a large commercial art network, and artists have been priced out because the real estate is prohibitively expensive and the main arts district, M50, does not support local artists as much as it did when it was launched in 2002, but now caters to tourists and businessmen for the most part (Zhong 2011). The West Bund Art Center promises to bring a higher profile to the city's art world.

Turkey benefits from its proximity to Europe to develop professional capacities for a cultural workforce in Istanbul (foreign transplants are legion but so are Turks who go to study in Europe and return to live in Istanbul). Conversely, China takes the project of training artists in its own educational apparatus very seriously, and its major art academies offer not only PhDs in art practice in various media but curatorial studies. Yet the professional standards of China's newly built museums are not always up to the level of other international exhibitions. Faulty English-language labels and oddly placed or dysfunctional video equipment throughout the 2012 biennial dem-

onstrated that more groundwork needed to be laid to bring the Shanghai biennial up to the level of presentation enjoyed by others.

There are a variety of factors at work, and commercial ones will be discussed later, but the evidence collected here suggests that biennials are a strategic asset to promote a city to international status as an art world capital. They operate in conjunction with other forms of creative development such as institution building and developing a market for the sale of contemporary art. But biennials function to introduce the world to the locality and the locality to the world. As in all romances, what might come of such an introduction is open to debate and contingency but, over the long term, biennials can lead to increased capacities in terms of both contemporary art and global traffic for burgeoning cities outside of the former West. Even this linguistic qualification suggests that history has a dynamic relation to geopolitical orders, and the biennials that have sprung up globally are another manifestation of the difficulty of maintaining clear geographical distinctions. Such festivals introduce contemporary art and produce a broad range of experiences, but they also bring north to south and east to west and thereby unsettle the hegemony of any country or region to dictate the terms of contact. In this sense, it would be correct to call them postcolonial.

The Dhaka Art Summit (figure 8) offers a perfect coda here because it is an example of a biennial created from scratch by Nadia and Rajib Samdani, a couple who are wealthy art collectors from Bangladesh. While Dhaka has become a regional center for global manufacturing, it does not have the visibility or the economic advantages of Istanbul and Shanghai. The Samdanis' vision was to create a biannual event that would bring visitors to Bangladesh but, more important, that would help to promote an art community where very little of one currently exists. These enlightened patrons basically sought to generate a world-class global and regional art event for the sake of the people of Bangladesh, and they went to great lengths not only to include Bangladeshi artists but to promote the event to the local population, providing free admission as well as other amenities. They hired an American curator, Diana Campbell Bettancourt, who worked with them to transform the Shilpakala Academy at Dhaka into a perfect showpiece for the works commissioned by the Samdani Art Foundation. In 2016, they staged a variety of exhibition projects, including a prize show for a Bangladeshi artist under thirty-five.

Such largesse may be exceptional but this represents a new utopian spirit visible in the creation of biennials in the twenty-first century: biennials can

be both events for a global art world to exhibit, discuss, and engage with works of art and their social context AND a space for the residents of a relatively poor country to appreciate the opportunities that art introduces in their lives and to aid the development of their economy. In such a case, it is possible to conceive of the biennial as a "plural game board of relative and mutual interactions," to use Mosquera's phrase, because it serves the needs of the international bourgeoisie and avant-garde, as well as supporting visual and performing artists in Bangladesh and promoting the artists and dealers trying to build an art world in their community. This art festival is not focused on economic development, and the effects on Bangladesh's economy would be marginal at best. Is it possible for regional capital, as opposed to a global city, to enter the art world by staging a biennial? Though the hegemony of the center has not dissipated, this initiative, and others that have developed around the world, may yet be an opportunity for artists, curators, and collectors from the periphery to redefine the art world map in their own terms. This may not be an alternative to the logic of the market, but the Samdanis employ their own wealth to expand the reach of contemporary art to new populations in Bangladesh. The game board may not be plural exactly, but the success of this biennial in Bangladesh is an alternative to the top-down internationalism of earlier festivals and contributes to the global conversation on contemporary art by presenting the largest exhibition of contemporary South Asian art, according to the organizers (Dhaka Art Summit 2016).

Emerging Art Center

ISTANBUL

Emma Rogers

Istanbul's bustling Taksim Square is a central hub of Istanbul's tourist and local life. It is a point of reference when meeting friends, so as to not get lost in the myriad streets, and it is the starting point when considering the contemporary commercial and cultural pulse of Istanbul. Taksim is the terminus of İstiklal Caddesi, "Independence Avenue," Istanbul's famous pedestrian shopping street, adorned with Ottoman and modern architecture and, more recently, art institutions. These museums and galleries are centers of activity at almost all hours of the day.

The summer of 2012 saw the beginning of the Gezi Park protests, in which demonstrators contested the government's plans for this landmark public park, which affected Istanbul's art scene and the city's culture overall. In response, the International Performance Association (IPA), based in Berlin, and Istanbul's Galeri NON hosted a performance piece in which two women, one German, one Turkish, discussed the importance of Taksim Square as a public space. This was presented at NON, located halfway down İstiklal in the historic Mısır Apartmanı ("Egypt Apartment") building, which houses galleries focusing on Turkish artists. Artists discussed gender inequality in Istanbul with international visitors and members of the local art community, and the two women then took their performance into İstiklal to perform for people in the street, reiterating the need for public conversation and discourse. In a more recent performance leading up to the thirteenth Istanbul Biennial, a Brussels-based duo, Vermeir & Heiremans, wore T-shirts with the

names of gentrified Istanbul neighborhoods on them and wrapped themselves in cloth printed with the names of companies that had contributed to the city's gentrification. Their performance that took place in the Marmara Taksim Hotel reflects the growing tension of an alliance between the government and corporate interests. Highlighting "the ways in which publicness can be reclaimed as an artistic and political tool in the context of global financial imperialism" (E-Flux 2013), the curator Fulya Erdemci titled the 2013 biennial *Mom, Am I Barbarian?* "What we are doing with the biennial is concurrently commenting on what's happening, not in the past or the future but in the present," she explained (Milliard 2013a) Even with all of the recent instability and conflict, the fourteenth Istanbul Biennial *SALTWATER: A Theory of Thought Forms* drew a record high of 450,000 visitors in one week.

Istanbul is known for its Islamic art, textiles, artifacts, and historic architecture, but in recent years it has made itself a prominent contender in the international art world. The city's contemporary art scene is rooted in its biennial, founded in 1987, which has flourished.

Wealthy Turkish families have primarily created the museums of Istanbul. The Pera Museum was inaugurated by Suna Kıraç a member of the Koç family, who also holds stake in Koç Holding A.Ş., the largest conglomerate in Turkey. Mrs. Kiraç and her husband co-founded the Pera Museum in 2005, around the same time the Istanbul Modern was inaugurated. Pera houses three traditional Turkish art collections: "Orientalist Paintings," "Anatolian Weights and Measures," and "Ceramics and Tiles." The juxtaposition of international and local art defines Istanbul's art scene, and the Pera Museum also exhibits Western artists like Rembrandt, Marc Chagall, Pablo Picasso, Andy Warhol, and Frida Kahlo. The contrast with Galeri NON is clear. Collaborations with international organizations are becoming more relevant than ever in encouraging art patrons to be participants in contemporary artistic activities.

The network of prominent private foundations providing the lifeblood of the Istanbul art sphere includes the Koç and Eczacıbası families. The Koç family are among the main sponsors of the Istanbul biennials. Among other initiatives, they also fund and run the ARTER gallery. In 2011, the Metropolitan Museum of Art in New York named two of its fifteen renovated galleries in its Islamic Art section after them (*Today's Zaman* 2011). The Eczacıbası family established Turkey's first private museum of modern art, the Istanbul Modern, which the *New York Times* has called "the changing

face of Turkey," and the Eczacıbası Group is the leading sponsor of the İstanbul Foundation for Culture & Arts.

Despite the fact that the majority of Turkish art collectors are Turkish, Istanbul has established itself as an international center for contemporary art. In 2014, the Contemporary Istanbul art fair showcased 108 galleries, which had 80,000 visitors. This contrasts with its founding year, when 49 galleries participated, with 150 artists and 37,000 visitors. The fair is geared to the international market, with over fifty exhibitors from abroad and works by the likes of Andy Warhol and Jean-Michel Basquiat selling for millions. Mari Spirito, a longtime director at the 303 Gallery in New York, says, "In New York it feels like the best years are behind us. In Istanbul it feels like the best years are yet to come" (Hansen 2012, n.p.). Others are worried that this exposure could have a negative effect. "This will become an international scene before it was even a Turkish one," one young local artist lamented (Hansen 2012, n.p.).

In 2012, Art Istanbul was launched as a week-long initiative devoted to contemporary art and culture and hosting activities in association with Turkish art galleries. Contemporary Istanbul (CI), in its tenth year, announced that its special focus would be on art from Tehran in 2015. Ali Güreli, founder and chairman of CI said that Tehran "has an incredible history and strong emerging contemporary art scene which we want to present to the world. It has always been the interest of CI and its collectors to discover new artists and promote exciting art scenes from around the world" (Abrams 2015). "Today, people are divided into eastward and westward-looking collectors," Güreli says (Ayad 2015.) In 2015, CI's rival fair AI started including Western artists and also sold a painting by the Japanese artist Yayoi Kusama for $912,000. CI, the older art fair, showcased more Turkish artists to support Istanbul's local creative economy. This is just one example of Istanbul's interconnectivity with contemporary art abroad and at home.

"Istanbul with its ever-increasing number of art centers, museums, world-renowned events such as Istanbul Biennial and Contemporary Istanbul, along with its cultural heritage and economic strength, has managed to attract both local and international recognition," Turkey's minister of culture and tourism, Ertugrul Gunay, has said (Art Istanbul 2012, n.p.). Government support is uneven, but a new law has been proposed "that would create an 11-person council appointed directly by the cabinet to fund the arts, project by project. . . . Although the law is still in draft form, cultural figures are concerned that the new council would be driven more by politics than by

art" (Donadio 2014). Essentially, government-funded programs would be supported if in line with government ideologies, and private art and culture programming would have freer rein if funded privately.

Koç Holding established its cultural arm—the Vehbi Koç foundation—in 1969. Since its establishment, the group has agreed to sponsor the Istanbul Biennial until 2017. At the time of the thirteenth biennial, however, it was reported that "protesters have been targeting the events over its sponsorship by Koç Holding, bringing up issues very much tied to the same anxieties over ruthless development that sparked the Gezi Park movement" (Davis and Roffino 2013). In 2013, the Koç family announced plans to create their own museum, Koç Contemporary. The museum, set to open in 2017, is designed by the award-winning international London-based firm Grimshaw Architects and is located in Istanbul's Beyoğlu district. "The new project has been conceived to fulfill the Foundations vision of showcasing the growing Koç collection to the broadest possible audience and to place these works in a national, regional and international context of contemporary artists," according to Grimshaw's web site (Furuto 2013). The layout and design of the museum will include a number of public spaces in order to connect the physical outside and inside worlds of the museum, which also reflects traditional Ottoman-style spaces.

The Koç Contemporary is not the only new private museum on the rise. The architect Zaha Hadid is designing a museum to house the private collection of the Demsa Group. The Demsa Collection owners are connected to the Sabançi family and also own a highly successful global fashion agency. They are another example of wealthy private benefactors who are developing Istanbul's ever-growing art scene. Private initiatives are undoubtedly linked to private capital because state arts funding is geared primarily to archaeology and cultural heritage projects. Although the absence of government support frees artistic communities from social and political regulations, it necessitates substantial private sponsorship. Even though there is much interest on the part of wealthy private foundations, artists and art institutes face increasing financial constraints. Tacit censorship is also a problem. "'There are these invisible boundaries," said the artist Iz Oztat, 33, who was asked to remove a mention of the Armenian genocide of 1915 in a booklet she wrote for an exhibition in Madrid last year that received Turkish government funding" (Donadio 2014).

In Istanbul, local art galleries prioritize educating the international art market about Turkish art. Neighborhoods in Istanbul are experiencing fast

demographic and cultural shifts. Twenty privately owned art spaces sprang up in the historically working-class neighborhood of Tophane just over ten years. The Istanbul art gallery Pi Artworks reports that 60 percent of its sales are now to international buyers. This international exposure is reflected in the gallery quota of the 2009 Istanbul art fair, which included fifty-four Turkish stands and twenty foreign dealers. This number has more recently shifted toward a focus on international galleries, and in 2015 the fair hosted twenty-eight Turkish galleries and forty-five international vendors. The fair still includes bigger museums like the Istanbul Modern Art Museum as part of its institutions section.

In Turkey there are practically no state-funded contemporary galleries or museums. There is virtually no public arts sector and no public money for the arts, which depend primarily on the support of wealthy families and foundations. New philanthropic groups, such as SAHA, consist of collectors and patrons who support exhibition projects and artists in a model similar to the British one. But some, like SALT's director of research and programs, Vasif Kortun, are worried about the insecurity of private funding and feel the urgent need for a source that is capable of providing more stable, long-term support. A member of the Eczacıbaşı family who also supports the Istanbul Modern is on SALT's board of directors.

SALT Galata is a nonprofit center that hosts exhibitions and conferences and engages in interdisciplinary research projects. Its $30 million space in a nineteenth-century Ottoman bank building in the Galata district is funded by Garanti Bank and open free to the public. SALT's contemporary art library has over forty thousand publications and exhibition space. The interior space incorporates the original function into the overall design of the museum, repurposing the bank archives to serve as housing for binders that include free material relating to the art history of the region. Art history programs at the university level are a recent endeavor in Istanbul, so SALT serves the community as an important museum of readily accessible art information for students or researchers. Salt is motivated by the fact that most information on Turkish art has been lost or was never recorded, Kortun says. "[W]e cannot recover whole histories of art, architecture and socioeconomy of the region ... SALT Research is not simply an amalgam of archive and library, and it is becoming a proactive research body" (McLean-Ferris 2012, 78). SALT has another space, in the Beyoğlu neighborhood, that contrasts with the neoclassical Ottoman architecture of SALT Galata. SALT gallery is modern in comparison, a nineteenth-century building with moving

glass in the lobby and wood fixtures. Together, SALT's two sites offer a walk-in cinema, rooftop garden terrace, and six floors of gallery space that hosts international contemporary and local artists.

Recent Sotheby's sales are a good indication that there is much interest in Turkish art in auction houses and in a global economy. Sotheby's second contemporary Turkish art sale in April 2010 broke sixteen records, and the international collector rate was much higher. In 2008, Sotheby's catalogue cover recorded skyrocketing prices for the Turkish artist Taner Ceylan, whose piece *Spiritual* achieved the price of £99,650, as against an estimate of £30,000–50,000. However, some people involved in the Turkish art scene accuse Sotheby's of manipulating the market, creating artificially inflated prices that are too high for most Turkish art buyers.

The past decade has led to an engagement with the arts and has shown Istanbul as a major destination in the art world. Places like Istanbul Modern and SALT are examples of privately funded museums that focus on Turkish art and contemporary international artists. The *New York Times* has called Istanbul Modern "the changing face of Turkey," which makes a very significant statement about Istanbul's image as a cultural capital and how Istanbul Modern, as well as other centers, are actively engaging with contemporary Turkish art and writing its history. The 13th Biennale in 2013 aimed to extend and investigate how the "booming" art world, and specifically its market, functions in Istanbul and elsewhere, and what traces of this impact we might find. Istanbul has already claimed global recognition as an individual art center, a place where Turks have formed important resources and foundations to house traditional and contemporary Turkish artists—as well as cultivate relationships with a broader global audience to make up for a lack of government or public funding.

The Art Fair

CULTURAL TOURISM IN A POP-UP FREE-TRADE ZONE

1 HYPING THE NOW

Art fairs have changed the nature of the art trade and reset the rhythms of art dealers' lives (Graw 2009; Tanner 2010). More important, they have also generated a new spectacle in the exhibition and promotion of contemporary art. Even leaving out of account the boost art fairs give the market, accounting for 20 percent of all sales, or €9.8 billion in 2014, their expansion has been dynamic (McAndrew 2015, 168). Though not all art fairs focus on contemporary art, most of them have devoted a majority of their exhibition spaces to this category, and this has helped accelerate the market for contemporary art in the twenty-first century. Art fairs are the crux where the exhibitionary complex meets the logic of the market in a climate of free trade. They are, in effect, pop-up free-trade zones where an international band of dealers meets a global clientele and works of art are exchanged in the abstract so that the actual purchase can take place in the most advantageous tax domain, whether in the country of the fair or the home country of the gallery that sells the work. The mere fact of the proliferation of art fairs has generated a whole industry in international shipping, including freight-forwarding, customs, and insurance, as well as installation and event promotion. The art fair is the epitome of the art world embracing the processes of globalization.

Art fairs were invented in Europe and have a shorter history than biennials—the first took place in Cologne in 1967—but, like biennials, they are now truly a global phenomenon. One of the main shared characteristics of global art fairs is hype. The acceleration of enthusiasm for contemporary art in all corners of the world can be associated with the enthusiastic embrace of the art fair as its marketing tool. Without exception, art fairs are fiercely

promoted to both the international art world and the inhabitants of the cities where they take place. This kind of self-promotion calls to mind the exhibition history of World's Fairs in the nineteenth century, but the trade fair model did not fully mature until the twentieth century, and so art fairs are distinct in a number of ways.

It is no accident that the art fair developed at a time when biennials were forced to distance themselves from the market. The protest against consumerism at the Venice Biennale in 1968 did not close down the festival, but it did cause the closing of the sales office associated with it. This shifted sales outside of the biennial exhibition model, and the art fair was generated just in time to take up the slack. Hein Stünke, one of the founders of the first contemporary art fair, Art Cologne, began by selling prints at *Documenta 2* because there was no money to pay his fees as a committee member (Graw 2009, 73). Art Basel came into existence in 1970, just when the Venice Biennale first opened without a commercial support structure. The timing was key, since Art Basel has traditionally taken place on the weekend after the opening of the Venice Biennale (though, as the calendar has become crowded with other fairs and biennials, the time lag has grown). With this movable feast model, all the commercial activity around the biennial could be transferred to the art fair while preserving the enthusiasm around international artistic competition introduced at Venice. The history of the fair will be elaborated more fully later, but the key point here is that the fair provided a commercial vehicle for capitalizing on the kind of artistic innovation being introduced in an international context and promoting it to collectors and the world at large.

Hype is linked to commercialization, and there is no end to this form of promotion at art fairs. Art is commodified there, and in the Marxian sense, object relations of price and market replace the social relations that went into creating the work and whatever social critique might be embedded in it (Kapferer 2010). The idea of commodity fetishism goes a long way to explaining how works of art are transformed at the fair, but the little writing on art fairs beyond news articles suggests that the fair itself not only benefits from social relations but creates new ones (Kessler et al. 2009; Barragán 2008). This could be due to an anthropological turn in recent social critique, but it is more likely the result of witnessing the kinds of class sensationalism that emerges at these events. It is not only the art that one goes to see at the fair, but the dealers and collectors who sustain its production. Of course, the fair introduces forms of stratification, separating the VVIP's from the VIP's from

the casual visitor by giving them earlier entries and a separate lounge in which to relax away from prying eyes (Thornton 2008). But where else can one see not only the prohibitively high-priced objects but also the global crowd of elites that can afford them congregating in one city for a single weekend?

Noah Horowitz has commented eloquently on this dimension of the fair: "One may even suggest that contemporary art fairs constitute near perfect embodiments of the experience economy's penetration into the cultural sector. Not only do they adjoin buyers and sellers of contemporary art goods and services, but they streamline the contemporary art experience into a tightly packaged event—a *lifestyle*—for the international business and social elite" (Horowitz 2011, 136–37). The word "lifestyle," italicized in the original, is the crux of what art fairs produce, which in some sense accounts for their ascendancy as a mode of access to contemporary art.

Beyond the functional aspect of the fair as a locus of an otherwise disembodied global market for art, the fair transforms this incongruous and shapeshifting market into a pleasurable experience that makes its participants look good and feel glamorous. This is the essence of the "experience economy," in which the staging of an event occupies the top spot on the hierarchy of economic value: "An experience occurs when a company intentionally uses services as the stage, and goods as props, to engage individual customers in a way that creates a memorable event." The memory of the event is as valuable to the purchaser as any work of art that she or he might acquire at the fair: "Commodities are fungible, goods tangible, services intangible, and experiences *memorable*" (Pine and Gilmore 1998, n.p.). In putting the experience ahead of the goods transacted, the service economy is a new form of economic growth, which has accelerated relentlessly in the twenty-first century.

For the wealthy collectors, there is a veritable array of opportunities (from late-night parties to artist talks over breakfast) to demonstrate one's membership in the cultural elite, and, for the rest, the idea of being close to the artists, the celebrities, and the wealthy patrons who sustain them is a mythic opportunity that propels the fascination of many (Adam 2014). Horowitz cites Artforum.com's "Scene and Herd" column, which was apparently designed to make the most of such social opportunities, and the de rigueur mention of private jets and celebrities in journalism describing art fairs is but one demonstration of the nature of these events.

Dolph Kessler's book of photographs *Art Fairs* (Kessler 2007) sizes up exactly this panorama of art and those that market and appreciate it, but

there is something less obvious than commercialization, glamour, and hierarchy at work here. Let's call it temporal self-love. By this I mean that, like the biennial, what the fair really encourages is the fetishization of the present and the hype that it generates is the hype of now. The experience economy idea hints at this, but the art fair brings it into full visibility. At an art fair, there are dealers and artists and collectors who have come from all over, not only in order to experience the latest developments in contemporary art, but also to see and to be seen. This leads to confusion between the state of the world (what is happening now) and the state of the market (what is being bought and sold), allowing participants to believe that the market is the world and that the experience of the best possible present is available for sale at the fair, but only for a limited time. So visitors just keep coming.

This centralizing power of the fair, bringing the world to its doorstep, is compounded in recent manifestations of the fair by organizing the entire city's cultural institutions around it. In this way, centrifugal force is added to the fair's pull, as so many of the museums, galleries, and art spaces in the city circulate around it, adjusting their exhibition calendars and hosting receptions all over town for the benefit of fair visitors. The best example is perhaps Frieze Week. The highly successful Frieze Art Fair, founded in 2003 by Amanda Sharp and Matthew Slotover, publishers of the art journal *Frieze*, has become the new normal for art fairs. Frieze has expanded to New York, but it is based in London, whose vast cultural riches—and the financial clout of the City, one of the world's banking capitals—are leveraged every October by the annual Frieze London fair to deliver a spectacle rivaled only by its stentorian competitor Art Basel and the latter's glitzier subsidiaries Art Basel Miami Beach and Art Basel Hong Kong.

Every year, the Frieze Art Fair produces an entire week of programs. There is an endless list of events, lectures, openings, and private parties to keep a VIP in town for most of a week, and there is no shortage of museums and galleries to visit. At the VIP events, one has the chance also to meet the artists, and to hear from major dealers, curators, or directors at symposium events. A VIP visitor could hop from event to event, beginning at breakfast and ending in the wee hours, and one could even do so in a borrowed BMW made available to VIP's for the length of the fair. Yes, there are corporate sponsorships for art fairs too. Not just BMW, but Deutsche Bank has been the longtime sponsor of this fair. These sponsorships signal coalescence between the bling of the fair and the multinational corporations that seek to be associated with its popularity, both of which seek to promote

their products globally. This is another dimension of the experience economy.

Yet Frieze represents another innovation in terms of cultural production: the marriage of a commercial spectacle with a nonprofit foundation (the Frieze Foundation) that produces the programs that complement the fair. Given the success Frieze enjoys, the implications of a nonprofit cultural festival attached to an art fair are not insignificant. In effect, this is the answer to some of the questions posed in the introduction to this book, to wit, what does all this economic impact do for artists? The fact that Frieze Projects is a nonprofit organization means that it plows some of its profits back into the fair by expanding it and enriching the proceedings with art commissions and symposia. Basically, it returns a portion of its earnings to the artists it commissions, curators who select booths for subsections of the fair and assemble public art projects, and scholars and educators who participate in the multiple educational initiatives that Frieze supports during Frieze Week in order to benefit the local population, especially school-age children. Without question, one can perceive in this art fair an impulse to produce beneficial social effects through contemporary art. The surprising thing may be that all this is connected to art's commercialization, and the more successful the commercialization, the more money the Frieze Foundation contributes to artists and art education.

The civic spirit of this fair also produces lots of value-added activity beyond visiting the booths. Frieze commissions art works, called Frieze Projects, inside the tents in Regent's Park as well as outside, in a temporary makeshift sculpture garden (serviced by participating dealers, of course). Moreover, coordinating with other cultural institutions around the city means that a wide swath of art events take place throughout London during this week. The proof of Frieze's popularity is that it has regularly hosted more than 60,000 visitors annually, averaging over 12,000 visitors a day, and therefore beating the most-visited museum exhibitions reviewed by the *Art Newspaper* every year. Frieze blends the dimensions of commerce with the utopian idealism of art. No matter how one takes it, Frieze demonstrates that commerce does make the world a better place. Perhaps Adam Smith was right and humans were made to truck and barter.

Or maybe not. Commerce and culture are not the same, and Don Thompson's comparison of art fairs to high-end shopping malls does not completely miss the mark (Thompson 2014). Even with Frieze Foundation putting money back into supporting artists and staging conversations about

their work and its significance for society and politics, this ought to be understood as one dimension of its spectacular allure. Is it that commerce exists to nurture culture, or is it rather that the force of culture has been harnessed to feed the evolving dynamics of consumerism, in which the highest-value item is the production of a rich and memorable experience? Perhaps the truth is darker still. An alternative analysis of the fair would consider art as not the point at all but rather the purported reason to assemble High Net Worth Individuals (HNWI's) and to promote social cohesion among an international elite. As wealth accumulates around the world, and as the wealthy class grows faster in the formerly colonized parts of the world than in Europe and the United States, the art fair is a model for bringing together this emerging class of transnational capitalists to shop and to party (see pp. 194–95). Since London is one of those global cities where such individuals invest in properties as well, it serves as an ideal location to assemble this class at an art fair.

Though it is clearly one of the most successful, Frieze is but one example of the art fair phenomenon in which promotion of contemporary art and global commerce are coordinated throughout a tourist-friendly megalopolis. Whether one loves commerce or loathes it, there can be no arguing with the success of this model and its connection to the wider popularity of contemporary art among both collectors and viewers. It is worth considering whether the current flowering of art fairs will expand, hold steady, or taper off because a phenomenon that rises to prominence so quickly and is adopted in so many different contexts so rapidly may dissipate in a hurry if conditions change. But as the flurry of emails to my inbox about events happening this week in Miami demonstrate, art fairs are the nexus where the social processes of contemporary art are developing now, and anyone who ignores their significance, or avoids their meretricious invitations, may find that they have been left behind.

2 HISTORIES OF THE ART FAIR: FROM COMMERCE TO CONTENT

Don Thompson counts the first art fair as taking place in mid-fifteenth-century Antwerp (Thompson 2008, 170). Clearly, commercialism in art has been around for a long time. However, the modern art fair has a rather shorter history. According to Olav Velthuis, such events began in 1967 when the art dealers Rudolf Zwirner and Hein Stünke assembled a group of eight-

een colleagues into what was called the *Kunstmarkt* (literally, "art market"), now known as Art Cologne, which was held for five days between September 13 and 17 (Velthuis 2007, 53). The price range of works sold was only between 20,000 and 60,000 Deutsche marks, but all in all, the fair made an impressive beginning, netting a total turnover of a million DM. In order to receive the city's support for the fair, the dealers formed themselves into an organization called the Verein progressiver deutscher Kunsthändler (Association of Progressive German Art Dealers), and the original deal with Cologne stipulated that the fair's entry fees would go to the city (Herzog n.d.).

Prospect '68, a competitor in the Rhineland, opened in 1968 in Düsseldorf, and in 1970, Ernst Beyeler, Trudi Bruckner, and Balz Hilt launched a more ambitious fair in the Swiss industrial capital of Basel, conveniently located on the borders of both France and Germany. Their first effort included ninety galleries and thirty publishers from ten countries. Though the sales figures have not been published, the total number of visitors reached 16,300, a major success (Art Basel 2014). A comprehensive history of the art fair has yet to be written, but through the innovations that each fair added, one can find a kind of history of the development of the fair over a generation and more.

In Cologne, the Kunstmarkt Köln renamed itself the Kölner Kunstmarkt and, notwithstanding the competition and the advent of the more ambitious Art Basel fair, opened a second fair, the Internationale Kunst- and Informationsmesse (IKI), in 1970. Both of these were held under the directorship of the Verein until 1973. By this point, it had built up a list of thirty-nine galleries and began a prize to an individual who has worked to promote contemporary art. In 1974, it was turned over to the new European Art Dealer's Association (EKV) and the fair was revamped in a new trade fair space taking up 10,000 square meters with eighty exhibitors. In 1975, the fairs were joined into one, the Internationaler Kunstmarkt Köln (IKM) and the first auxiliary programs were begun, including a circus, a theatrical performance, and musical performances, curated by Elizabeth Jappe (Herzog n.d.).

Meanwhile, Art Basel hosted its first special exhibition, *American Art after Jackson Pollock* in 1973, expanding the fair outside of the dealers' booths. In 1974, it launched the *Neue Tendenzen* ("New Trends") series to highlight the work of younger contemporary artists, which by 1975 hosted three hundred galleries from twenty-one countries and welcomed 37,000 visitors.

In 1975, too, the Pictura Art Fair opened for the first time in the Netherlands, which would eventually grow into the European Fine Art Fair (TEFAF), established as a foundation in 1989, when a music and lecture

program was added. The difference here is that the art fair was dedicated to old master paintings at first, adding antiquities and textiles soon afterward. Recently, even TEFAF has turned to exhibiting modern and contemporary art to take advantage of the global trend of that expanding market. This fair was not originally as big a draw as the contemporary fairs—in the first year for which it collected data, 1988, it welcomed 17,672 visitors, whereas Basel had had 37,000 as early as 1975. In 2016, TEFAF reported "around 75,000 visitors in ten days (TEFAF 2016), while Art Basel had 92,000 visitors in six days and Art Basel Miami Beach hosted 73,000 in five (Art Basel 2014a, 2014b).

Looking at these three early art fairs provides a sense of how short the history of the art fair is, but it also demonstrates the volatility of this model, inasmuch as some fairs have receded, while others have become visible global brands, even expanding into international chains. One issue to consider is the increasing corporatization of the art fair (Gerlis 2011; Schjeldahl 2012). Though these fairs were all started by groups of dealers, they were incorporated in different ways: Art Cologne and Art Basel are owned by corporations, whereas, TEFAF is run as a foundation, like most biennials.

Anyone who has been to an art fair knows that the key to the fair is the map, allowing a visitor to orient herself before, during, and after the experience. Entering a space, no matter how cavernous, that contains thousands of art works generated by some of the most fertile minds is bound to be a mind-expanding experience for even the most jaded professional. As in a department store, a consumer must ignore 99 percent of the product to find what she actually wants. So much for the targeted shopper, but how about the flâneurs among us who are seeking to stroll and discover, and, in the process, might end up buying a painting or three? Either way, one needs the map.

The map does not just enable visitors to find their way, it shows how the art world is organized. Nothing could be more explicit than the plan of Art Basel, in which the fair is organized with a circular structure in the center (the restaurant), around which are clustered lateral avenues lined with gallery booths. The large booths at the main intersections and near the center are the most prominent dealers, who have paid the most to secure the most trafficked areas and they are, not coincidentally, those who charge the most for works available by the most visible and marketable artists. These galleries are predominantly from art commerce capitals such as New York, London, Berlin, and Zurich. Along the outer perimeter, there are major galleries on the interior, and opposite them are arrayed a series of smaller spaces tucked in to

allow for smaller galleries and spaces for the *Conversations* and *Salon* series that Art Basel has offered to diversify its offerings beginning in 2004. These are formal and casual conversations among artists, curators, dealers, and collectors. In another building, Art Basel offers *Art Unlimited* (begun in 2000) a curated open-plan exhibition where installations and performances are staged. Also apart from the main building is the *Edition* section, for prints and multiples, and the *Statement* section, a space where young galleries can offer monographic presentations of a single artist (Art Basel 2014a).

All of these progressive innovations that have been added to Art Basel have kept the fair fresh over the years, during which competing, innovative new fairs have sprung up, like Frieze and New York's Armory Show, launched in 1994. Art Basel has continued to develop in order to stay on top of its game. But no innovation has been more important than the creation of Art Basel Miami Beach, which brought all the strengths of the big fair to a new location in 2002. If there were any questions as to whether the Swiss business model would succeed in this new environment, it surpassed expectations marvelously, dispelling any doubts, and Art Basel Miami Beach is arguably more prominent at this point. Art Basel thus become a global brand, serving new markets in both North and South America, and in 2013, it acquired Art Hong Kong to give it access to Asian markets. With the proliferation of art fairs globally, Art Basel is certainly working to ensure that it loses little business to upstarts, and it remains the most elite art fair globally.

To discuss only these central art fairs is to ignore other new developments. The proliferation of art fairs in emerging art centers globally will be discussed later; meanwhile this is an opportune point at which to address the accumulation of satellite fairs that cluster around the larger events and offer opportunities for less-established galleries, nonprofits, and artists' collectives to exhibit, stage, perform, and sell works that are beyond the scope of even the gargantuan, hydra-like art fairs already discussed. Satellite fairs like VOLTA, Scope and NADA have themselves grown into chains that are manifested in multiple locations over the season, parallel to the run of larger fairs in New York, Miami, or Basel. This has the effect of adding further depth to the fair experience for the visitor, but it also risks becoming too much of a good thing, since human perceptive capacity can only be stretched so far.

VOLTA, which was begun in Basel in 2005 by a group of dealers (Kavi Gupta, Friedrich Loock, and Uli Voges) and the art critic Amanda Coulson, now its artistic director, is perhaps the oldest of the satellites. It is dedicated to emerging artists and also takes place in New York during the week of the

Armory Show. Exhibitors have largely focused on presenting solo exhibitions of emerging artists, thus complementing the offerings of the larger fairs, while carving out VOLTA's own brand identity. VOLTA is not just a little tag-along; in 2013, the fair included seventy-eight galleries in its Basel presentation, making it more of a detour than a shortcut. It has also attracted the attention of corporate interests and now belongs to MMPI (Merchandise Mart Properties Inc.), a property developer and trade-show operator that also owns the Armory Show and Art Platform Los Angeles. Though VOLTA aims to provide an alternative to the major fairs, Coulson has been quoted as admitting that art fairs have become "much more corporatized; pretty much every major fair is owned by a massive company and that tends to change the flavor slightly" (Gerlis 2011). Though some nonprofit art fairs still exist, the general trend is both proliferation of new fairs and corporate ownership of successful ones.

VOLTA is also treated significantly in Paco Barragán's *The Art Fair Age* because it was one of the innovators of the curated art fair. Coulson was the editor of *Flash Art* and a curator at P.S. 1 before becoming artistic director, and she has modeled VOLTA in a different mold to qualify the commercial core of the fair with a content-driven model borrowed from biennials and contemporary museums. There are two levels at which curators can enter into the art fair—most often one finds them working with dealers to develop a separate section of the fair that offers an exhibition-like presentation of works by artists represented by dealers in the fair. This is exactly what Art Unlimited offers at Art Basel Miami Beach as well. The other curatorial intervention is through the vetting of dealers for the fair. Barragán writes:

> I sincerely believe that it is the curator who nowadays, in collaboration with the artist and gallery owner, is capable of relaunching the art fair in an attempt to make it more arresting and interesting. Progressively, more curators are finding a place on selection committees, which stems from a sense and desire for "transparency" in order to avoid polemics directed at the selection process. (Barragán 2008, 40)

His view is that curators will not only balance the needs of commerce and content, but also that curators will be able to employ their creative capacities in order to avoid "polemics directed at the selection process," implying that they will provide a critical, as opposed to a crassly manipulative, means of determining which gallerists are presenting meaningful, as opposed to merely valuable, contributions to the fair.

This is no small feat, because art fairs, with their guarantee to bring an enormous public to the gallerist in a short span of time, are competitive domains that attempt to shore up their reputations through a rigorous selection of applicants. Needless to say, this means that many galleries will be turned down, and they will not be happy about it, leading the aforementioned polemics. A curator can protect a selection committee made up of art dealers by providing an outside perspective not based solely upon inter-dealer rivalries. Barragán is adamant that curators are not debasing themselves by engaging in commercial fairs, but giving themselves another platform with a captive audience. It is a trade-off like so many others, but it allows the fairs to straddle the divide between commerce and significant content, something that has been remarked upon by many, but never more directly than in Carol Vogel's "The Art World, Blurred" (2012).

Gone are the days when one could confidently separate art commerce from art production and the autonomy of museums and other public institutions. The fact that curators see art fairs as another potential platform means that role of the curator has sufficiently expanded to mean something significantly different than it would have a generation ago (Balzer 2014). The intellectual and creative role of the curator is now becoming as much a part of the market as it is part of the museum.

Art fairs, like biennials, represent an evolution of the ideology of the exhibitionary complex. Unlike in the biennial, however, there is no effort to disguise the market forces at the core of the art fair. Instead, the idealistic alternative is to enhance that market activity through a creative form of cultural distribution. In other words, the biggest contribution of art fairs has been to temper their implicit commercialism with programs, art installations, and curated projects that shore up their own validity by engaging critics, artists, and curators respectively. In effect, one begins to see discussion, creation, and judicious selection as value-added dimensions of the consumer fetishism manifested by trade.

The fact that art fairs have innovated so much in such a short period of time demonstrates that the market forces in this arena have accelerated, with a variety of new competitors constantly entering the field and forcing each art fair to define and perpetuate its brand in order to distinguish itself in an increasingly competitive marketplace. As the market for contemporary art has accelerated so much in the past fifteen years, representing a much larger share of the art market overall, the contemporary art fair has become a kind of focal point for those values to be created and disseminated throughout the

now global market for contemporary art. If these major fairs are the locus for the elaboration of the contemporary market, trendsetting and innovation must be present at each iteration in order to ensure the advancing progress of this market and the corresponding increase in values for contemporary art overall. Of course, everyone involved wants a piece of this action, because, at the fair, various actors in the art world, from celebrities to curators, can shape the market's valuation process and connect it to something that possesses symbolic value through their memorable experiences.

The difference between an art fair and any other trade show is not only in how the products are presented to the public or offered for sale, but in the way that the goods are conceived to be above and outside of any market that may exist for them, and the very commercial transactions that are their reason for being there in the first place. As is true of product development in other areas, contemporary artists must constantly innovate in order to shore up their reputations and disarm would-be imitators. But it is the dealers and fair organizers who are reinventing the market at the fair to generate the product called contemporary art, employing a range of specialized programs and the curators who develop them. This is the ideological dimension of the art fair, the manipulation that it does not need to hide. The art fair constantly beguiles visitors. and it has so far succeeded in advancing the significance and value of contemporary art in the current globalized era beyond any previous one.

3 HOMOGENIZATION OR INDIGENIZATION?
ART FAIRS IN EMERGING ECONOMIES

In a review of the first iteration of Frieze New York (May 2012), Holland Cotter wrote:

> Somebody, someday will write a social history of 21st-century art fairs, which will also be a history of the art of an era. I hope that history will give a sense of how engulfing the phenomenon is and of the Stockholm-syndrome-like mentality it has produced: almost everyone says in private how they hate art fairs, but everyone shows up at them, smiling anyway, and hangs out, when they could be visiting studios, or going to offbeat spaces, or taking trips, to Kolkata, say, or Bucharest, or Rio, or Cape Town, where all kinds of serious, in-touch-with-life work is going on.
> But the fairs say: don't bother. We'll do the editing. We have what you need. (Cotter 2012)

No one has yet written this history. Sarah Thornton (2007) and Don Thompson (2008, 2014) have provided some vivid imagery, and a list of must-knows (people, locations, firms), and along with much journalistic criticism, these fragmentary accounts make up the predominant corpus of writing on this subject. Books by Paco Barragán (2008) and Dolph Kessler (2007) introduce some critical discussion of the art fair's most salient elements, and Kessler is one of the many artists who have taken up the task of representing the fairs through photography. Such images can appear honest, or even objective, and they show us what few have been able to explain. The art fair age (as Barragán calls it) produces some of the most bizarre juxtapositions of cultural signifiers to be found in our current era of globalization.

Visually striking though these images are, they do not explain much about how the art fair works. The fairs themselves are so dazzling, it is almost impossible to conceive of how such events are produced through the economic processes of globalization, such as free trade, globalized logistics services, the cross-fertilization of creative ideas, and innovations that have developed there both in art and in the business of selling it. For Cotter, it is as if the art fairs are telling us that we need not explore and discover the world beyond our immediate purview, because the art fair will deliver it to us as if by an invisible hand. Point taken, but it should not be forgotten that what he describes blithely as going off to Rio, Kolkata or Cape Town to explore the art scene is work, work that someone else has done so that they can present these goods to you. Yes, the fair does the editing, as does each gallerist who brings art from far-flung locales. In some sense, it is the labor of the dealer that paradoxically is made invisible in the showcase designed for them. The commerce is visible enough, but the work of discovering unsung artists far from the gallery, nurturing them, and bringing their work to market is elided by the seamless white cubes where they present their work at the fair.

The dealer's business model has been transformed by the rise of the fair (Thompson 2008; Tanner 2010; Horowitz 2011), but an analysis of the fair also needs to attend to all of the support mechanisms that make art fairs possible, not only in New York, but in such locales as Rio, Kolkata or Cape Town. These are the same mechanisms that support globalization, and in this case the theoretical implications have been more studied than the basic processes. Free trade is a kind of mantra among neoliberal economists and business leaders, but the spaces that free trade creates are particular (Sassen 2000). Furthermore, the logistics services that enable the transportation of goods worldwide—an enormous, essential industry—are rarely

contemplated from the point of view of cultural presentations such as art fairs, biennials, and special exhibitions. The transportation of goods generates spaces that conform to the demands of the industry and the practicalities of free trade are responsible for many unique domains, among them the art fair.

On the outskirts of major cities one finds airports and around the airports, countless warehouses have been situated. These buildings are low, flat, and surrounded by asphalt. and they encircle the extensive territory of the runways. At an international art fair, most works of art pass through one of these warehouses, which, taken together, comprise a kind of suburb for every major air hub. (Of course, if the location of the art and the location of the fair are on the same continent, works can be trucked.) These transit zones are everywhere, yet they are rarely seen by most air passengers, because they lie just beyond the rental car pickups in numbered industrial sites. In these zones, there is generally no commercial activity, nowhere even to buy a coffee or snack, but from a machine. They are places meant for passing through, and many works of art do just that. Unlike seaports, these zones cater to the niche market of international shipping; they are only for goods valuable or perishable enough that they need to be shipped via air, and so they represent only a small fraction of the goods shipped internationally that pass through ports and railyards before they arrive on store shelves.

International art shipping is a business that has grown exponentially in the past generation, yet it has not fundamentally changed. Each work of art must be crated in a wood or plastic crate, usually individually, and loaded in a truck. The gallery must deliver the goods to the airport, where they are handled by a freight forwarder, who consigns them to an airplane after filling out the requisite shipping, insurance, and customs forms and making sure that each work is pre-cleared, so that the customs personnel will not open the crates and begin to inspect the contents before departure or after arrival. This requires extensive paperwork for each object shipped, including pictures of it in the crate. All the paperwork must be on hand by the receiving freight-forwarder so that the shipment will clear customs, be released by the airline, and be loaded on a truck and taken to the fair. As one might guess, this process is neither quick nor cheap, so it counts for a large portion of a gallerist's outlay to attend a fair. The amount of art necessary to fill a booth requires considerable planning to deliver to the booth by the day the fair opens. Considering the fact that sometimes as many as three hundred galleries will have their work delivered to the same location for a fair that is assembled in

a few days, and you begin to understand the logistical challenge of an art fair. It takes a small army of shippers, freight forwarders, and art handlers to pull this off. This is but one of the many miracles of globalization. International shipping makes it possible to relocate an array of contemporary art produced in a variety of countries to one place for a weekend.

The principle of free trade, simply stated, is that one should reduce all the barriers in place to prevent restrictions on international exchange, and art fairs enthusiastically embrace this revolution in distribution. The atmosphere of intense competition among galleries nestled cheek by jowl in a finite space means that each seeks to enhance its reputation and visibility by showing the best work it can find. At the art fair, free trade is not just the removal of barriers, but the intermingling of an international group of galleries with a global assortment of consumers, who come from many countries to find what they want. Although this is the ideal, and not all such events draw a global clientele, the fair is fundamentally a hub promoting international commerce.

What about the trade itself? Many dealers work with artists who live in countries other than where the gallery is located, and so they ship the art directly to the fair and, if it sells, they ship it directly to the customer, so that the art never actually goes to the dealer's gallery. While this may be a necessary expedient, it is also an opportunity for arbitrage. With the countless regulations that pertain to international shipping, in addition to the various tax regimes of individual states, the fair can become the perfect opportunity to exchange art objects internationally in the best possible circumstances. Art fairs are not cash-and-carry (now that's a thought!), so the transactions that take place do not need to be finalized on site, but can take place in a mutually beneficial territory where the regulations and taxes will be minimal. Considering that some of the larger fairs held outside of Europe take place in tax havens such as Dubai and Hong Kong, it becomes clear that there is more than civic pride at stake when it comes to hosting an art fair.

Yet money is not the only thing exchanged at art fairs. Works of art may be ensconced in the domain of neoliberal economics at the fair, but art carries meanings beyond the price tag. Artists, gallerists, collectors, curators, and casual visitors are able to benefit from all this art being brought to one place at one time because it enables cross-fertilization, which has both positive and negative effects. Obviously, if the art world really is a global phenomenon, it has to turn up, not just everywhere, but somewhere. Much has been made of the internet as a virtual global domain, but art needs to be seen in the flesh, so to speak, especially if one is trying to decide whether to buy it. The location where

the art turns up may be a market, but it is also a place to witness the world of contemporary art converge. Want to know what is happening in South Africa? Ask the dealer from Johannesburg. One can trace emerging global trends, compare new uses of digital photography emerging from practitioners all over the world, or see which artists are taking up ink painting. In brief, there is a lot of information changing hands at the fair, and it means that artists and all the others are a lot more attentive to what is happening in the world around them. Artists and dealers are able to build on the innovations of others, while collectors and curators keep a careful eye on one another to spot who is talking to whom, buying what, organizing which exhibition or biennial.

The downside of this process is what Cotter calls "art fair art" (Cotter 2012), a term coined by an editor of *Artforum,* Jack Bankowsky, who incisively addresses a particularly spectacular form of market consciousness simultaneously embraced (ironically) and eschewed (symbolically) by a new generation of artists, such as Tino Sehgal and Maurizio Cattelan (Bankowsky 2005). Despite these timely innovations, the architecture of the fair is not suitable for the display of all creative activities, efforts of Frieze and Art Basel to innovate programatically notwithstanding. Painting, sculpture, and photography dominate. Small- or medium-scale works are really the only ones suitable, and there is a certain monotony to the stands that calls out for colorful, dramatic, or sexy images to engage one's attention.

The more artists and dealers look at the art of the fair, scanning for new artists and developments, the more the work starts to look alike. Cross-fertilization produces hybrids—often more resilient than the originals—but they tend to become more alike all the time, albeit with surface variations. While completely innovative combinations do arise, they are quickly pirated, and, in the main, a handful of strong trends come to dominate. Besides, any market prefers success stories. The term for this process in the field of communications is homogenization, resulting from cultural imperialism (Appudurai 1998; Movius 2010). In any global market, leaders will emerge and others will attempt to copy and outperform their rivals, leading to a process of market self-selection. The more art fairs there are, and the more time dealers and artists spend at them, the more the experiences of all those individuals will come to mirror one another. In this way, the incredible complexity of artistic production worldwide starts to seem far narrower at the fair than it actually is.

However, this homogenization presents another problem. Art fairs are now creating a constant demand for artistic production to fill the booths.

With 250 art fairs in existence at this point (roughly five take place each week), the amount of art that dealers need to fill their booths is exceptionally high, and they regularly request work from artists to present at the multiple fairs they attend. The problem is that artists already have to create work for gallery shows, and, if they are successful, biennials, museum group shows, and other projects. This means that no matter what one might consider the norm of artistic production to be, it is constantly being tested by the capacity of the market, and the result is a reverse engineering of artistic value based on the festival schedule of the fairs. If the ideal once was for an artist to develop a body of work to present every other year at a gallery show, imagine what it is like for an artist to be juggling dealers in multiple cities who expect not only a gallery full of pictures every two or three years but a couple of paintings every time they go to a fair. Not many artists are in this position relative to the general population of artists working, but an artist who attempts to live from selling her work will be required to increase production to meet the demands of this market schedule. Since the consumption side is so advanced, leading to ever-increasing prices for contemporary art, production must keep up. This hypertrophy of artistic production is simply not good for the development of most artistic careers, and it will likely require an artist to hire in help to make more work. No matter how creative an artist is, it is very different to innovate artistically while directing a staff the size of a small business. This is another dimension of homogenization and the other side of art fair art.

Arjun Appadurai juxtaposes indigenization to homogenization, suggesting that as Western forces are brought into new contexts globally, their ideas and practices, from housing styles to terrorism, are remade in a local manner (1990, 295). This is relevant to the discussion of art fairs because, as with biennials, a European model has been exported to countries with emergent economies with mixed results. On one hand, fairs such as Zona Maco in Mexico City (figure 11) and the India Art Fair in Delhi follow the model established in Basel and London in terms of both conceptual and spatial organization, as well as programming at the fair and at other venues around these cities. However, adopting the art fair model at these two locations leads to divergent results, since the model gets reinvented to suit the local contexts. These examples will serve to introduce some of the new global dynamics as art fairs expand into the former periphery.

Mexico City is known to have a vibrant community of art collectors among its population and this has led to the development of a selection of prominent private museums, a thriving gallery scene, and a major art fair

(see Mexico City profile). There is enough wealth created in this emerging market for a small segment of the population to engage in the global art market, and of course, there is a major history of artistic production in the modern period by artists such as Frida Kahlo, Diego Rivera, and José Clemente Orozco. So the Zona Maco art fair was not created from scratch but is the confluence of three essential elements: (1) a history that leads to the valuation of artistic culture and patronage, (2) an emerging economy that produces enough wealth among the upper segments of the population to allow for (3) a local art market supported by an active art-collecting clientele. These same elements are in place in Delhi.

Like Art Basel and many others, Zona Maco is held in a vast convention center on the outskirts of the city and primarily features contemporary art. There are also a handful of galleries that bring significant modern Latin American art to anchor these offerings. Although Zona Maco is highly international, it features galleries from throughout Mexico and Latin America more generally. Even among the international galleries that participate, one finds predominantly Latin American Art, with a few cosmopolitan gestures. A few galleries also bring in international art stars, such as Damien Hirst and Lawrence Weiner. There were 130 galleries in the 2013 iteration, but only 71 of these were based in Europe or the United States (55 percent). In contrast,

87 percent of the galleries at Art Basel Miami Beach in 2009 were in one or other of these locations (Horowitz 2011, 136). Following the Freize model, events and openings are held through the city during the week of Zona Maco. The local art scene is vibrant, and the fair as well as other opening events were well attended by the locals, as well as the international crowd that showed up.

The India Art Fair emerges in a very similar context in another of the world's most quickly growing economies and a thriving environment for contemporary art (see Delhi profile). That fair is held in tents in a wooded area on the NSIC Exhibition Grounds at the Okla Industrial Estate and in 2016 a controlling interest in the fair was purchased by MCH Group, the company that owns Art Basel. While there are fewer galleries for contemporary art in Delhi and museums in India have only recently begun to display work by the younger generation of artists, the art fair has provided an impetus to these developments through its enormous popular appeal. The fair hosts a sophisticated program of lectures and discussions and also commissions for display at the fair, thanks to munificence of key donors. The fair is a movable feast, with events happening in the new gallery district of Gurgaon and also at two prominent private museums, the Devi Foundation and the Kiran Nadar Museum of Art. The participation of KHŌJ, one of the most prominent artists' collectives in the world, constitutes an alternative to the market orientation. In 2013, for example, KHŌJ presented a well-attended opening of *Auditions,* with a dozen sound artists, as the culmination of a month-long international residency.

While it would be easy to characterize these fairs as chips off the block of the European fairs, it is clear that a similar model and norms are being adapted here to new contexts, and in that process, the model itself has seen changes. Zona Maco brings Mexican modernism to bear on contemporary art, but its location makes pedestrian attendance almost impossible, and the exceptional traffic in the city thwarts efforts to participate in several events in a single evening, which is the norm at Frieze and Art Basel Miami Beach. The India Art Fair requires participants to be bused to events, because the streets are sometimes in deplorable condition, and addresses in Delhi can be hard to find, even for an experienced driver, so there is feeling of collective involvement for the VIP's quite distinct from the individualization that reigns in most fairs, and it is much easier to develop connections with people from everywhere.

If the Art Cologne regional model was superseded by the global model of Art Basel, there is a new regional character to these other fairs, which tap

into regional markets where burgeoning wealth has led to greater affluence but also an interest in collecting art that emerges from a regional context. Latin American collectors simply collect more Latin American contemporary art, and ditto for South Asia. This regionalism was the reason that Art Basel bought Art Hong Kong—to gain access to a Chinese and South East Asian clientele that may outpace markets in Europe and the United States in the near future. Here indigenization may achieve its most visible form: the art fair model is adapting to suit the situation, and the market. This flexibility is a fundamental dimension of both economic and cultural globalization often overlooked by those who see neoliberal economics, as well as the production of value in the art market, as spreading from the United States and Europe to dominate the rest of the world.

Alain Quemin and Stefano Baia Curioni represent this view most emphatically in the literature on the economics of the art market and, in particular, on art fairs. These authors use empirical research to demonstrate the continued centrality of the United States and Europe in the art market overall through their assessment of the *Kunstkompass* and Art Basel respectively. Quemin concludes his analysis of the artists in the *Kunstkompass,* a German periodical's ranking of the most important artists in the world, by unpacking several definitions of globalization: "A strong hierarchy of countries controls the organization and participation in the international contemporary art world and market.... Empirical data [reveal] that cultural globalization appears mostly as an increase in transnational exchanges that neither erase national borders nor the impact of national units" (Quemin 2011, 70–71). Baia Curioni sets out the "center-periphery logic" of the art world in 2011 equally stridently, but, after an exhaustive study of artists and galleries that participated in Art Basel between 2005 and 2012, his claims are more restrained:

> Within the overall frame of the progressive inclusion of non-Western artists in Basel, the consideration of the three cases of Brazil, India, and China indicate the presence of different networks, stories, and power positions. One pattern is nevertheless common: the growth of centrality of the artists, when it occurs and wherever it occurs, is mainly driven by the connection of local galleries with international gatekeepers. (Baia Curioni et al. 2015, 74)

In effect, Baia Curioni notes that the number of artists from these three countries has significantly increased over the period, and that each case is significantly distinct, but "international gatekeepers" are the key to prying open the door for artists from the periphery.

What these economists have elaborated is a system that is dominated by a handful of important art-world players whose opinions are extremely valuable in terms of the consecration of value in the domain of contemporary art. Though the *Kunstkompass* may be obscure to readers outside of Europe, it has its parallels in *ArtNews*'s list of the World's top 200 collectors, as well as top artists to watch, the best exhibitions of the past year, and other such ranking systems that sell magazines and become fodder for the art world's gossip machine. The *Kunstkompass* is derived from a survey sent out to art-world professionals, like the Academy Awards, and so it is supposed to be empirical in its own terms. Yet the centrality that Quemin ascribes to it is an error of perspective. If an economist is basing his notions of globalization on the artists listed in the *Kunstkompass,* it is fair to say that he may understand the self-selectivity of the art world but has missed the big picture, namely, that economic and cultural globalization have eroded the significance of the *Kunstkompass,* because none of those art world professionals from the periphery have ever read it. In fact, the magazine that published the *Kunstkompass* has gone bankrupt, and it is now published only online.

Art Basel is somewhat distinct, because it is the most prominent and expensive international art fair and the masthead for a global chain. Velthuis and Baia Curioni write of "Art Basel, which is considered the world's most global fair ... " (2015, 17). "Considered by whom?" I would ask. In fact, Art Basel does not dominate if one looks at the regional distribution of dealers who attend art fairs, and, as Baia Curioni asserts elsewhere, 94.1 and 90.5 percent of the galleries at Art Basel in 2005 and 2012 were from North America and Europe respectively. In contrast, the data compiled for this study (figure 12) show that Zona Maco was actually the most geographically diverse fair in 2014 in terms of gallery representation, with 42 percent from Europe, 19 percent from North America, and 36 percent from Latin America, and Art Basel Hong Kong also completely outperformed its parent in terms of national diversity, with 47 percent from the Asia Pacific Region, 40 percent from Europe, and 10 percent from North America. It is clearly true, however, that all of these fairs have a regional bias, noted by Baia Curioni, but is that a reason to consider them less global, or less significant, than Art Basel?

Quemin and Baia Curioni are correct in saying that a handful of countries have very established art market systems, and that they will tend to dominate in art as they do in economics by establishing norms and setting the terms of success. However, if a scholar looks only at European institutions to

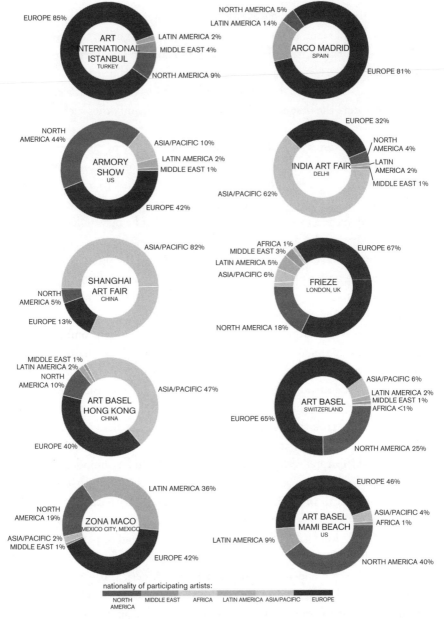

FIGURE 12. Nationalities of participating dealers at art fairs, 2014. Data from art fair web sites. © Eva Krchova.

determine the validity of the globalization hypothesis, they are themselves falling prey to and reinforcing the same set of effects they are describing. In taking *Kunstkompass* and Art Basel as the points of departure, Quemin and Baia Curioni neglect many developments that are going on right under their feet, so to speak. The art market is often misjudged in exactly this way. In order to fully understand the effects of economic and cultural globalization on the art market and the art world, it is self-evidently necessary to look beyond Europe.

A more convincing appraisal is provided by Tamar Yogev and Gokhan Ertug, who have also sought to understand whether the art market is more globalized and to evaluate various data points, including the geographical distribution of art fairs, the distribution of galleries from various continents, and the proportion of Asian-born artists at galleries in art fairs. Their data lead to a number of conclusions, notably that "[t]hese findings support the cultural flow model, indicating that there is a counter-flow of cultural actors and products between continents. We find a clear indication of a global network of flows of cultural and economic exchange of artists, galleries, and artworks are at work" (Yogev and Ertug 2015, 208). The "counter-flow" they describe traces an impact of Asian artists and galleries in the domain of international art fairs. Not only are Asian countries seen to be adapting the norms of the art fair to their own purposes (indigenization), but they are also finding recognition in fairs in Europe and North America. While national histories and relative economic strength are relevant, there is a broad transformation at work at the 250 art fairs around the globe. As art fairs have spread throughout the world, the world's artists and galleries have dispersed themselves through these art fairs, generating a "counter-flow" of art works and influence.

FIGURE 13. Museum of Islamic Art, Doha, Qatar. Photo: Grace Murray.

Emerging Art Center

DOHA, QATAR

Grace Murray

After arriving in Doha, Qatar, the first experience for many visitors is driving along the Corniche, the seafront road in the center of the city, and coming upon the Museum of Islamic Art. At night this is especially dramatic, because a long bridge lined with illuminated date palm trees leads to the museum, which is built on an artificial island just offshore and lit up by golden light, appearing to float over the waters of the Gulf. Just beyond the I. M. Pei–designed museum are the futuristic shapes of Doha's skyline, with fifty-story office towers lit garishly in blue, orange, and red lights, a landscape both beautiful and surreal. The museum has come to define art in Doha and to serve as a symbol of the city itself. It showcases art works from Islamic civilizations ranging across three continents and 1,400 hundred years. The museum galleries are packed on weekends, as is the park that surrounds the museum, which includes walking paths, fountains, gardens, cafes, and playgrounds. The grand scale of the museum and its wide-ranging collection reflect the ambitions of the state of Qatar. They are an attempt to reshape the image of the city through art and culture.

Although the Museum of Islamic Art has become a landmark, in the news, Qatar is more closely associated with contemporary art, as Sheikha Al-Mayassa Al-Thani, the sister of the country's current emir, or ruler, is one of the best-known art collectors and patrons in the world. Over the past ten years, she has played a prominent role in the international art world, hosting major exhibitions and commissioning public art by well-known international

contemporary artists. Sheikha Al-Mayassa also oversees Qatar Museums, which operates a range of museums and exhibition spaces in Doha, including the Museum of Islamic Art and Mathaf: Arab Museum of Modern Art. In addition, the Department of Public Art within Qatar Museums is responsible for Al Riwaq Gallery, an exhibition space on the Corniche, the Qatar Museums Gallery in Katara Cultural Village, and art in public spaces such as hospitals and the new Hamad International Airport. All of these art initiatives are meant to serve as symbols of Qatar's wealth and openness to innovation to the outside world, and to inspire local creativity, which is much needed as the country attempts to transform itself from a "carbon economy" into a "knowledge economy." However, there has been criticism both from abroad and from the Qatari community that these art initiatives have focused too much on importing international art and not enough on developing the local art scene. This is slowly beginning to change. The new Firestation: Artists in Residence Project, opened in 2015 by Qatar Museums in a repurposed building just off the Cornice, is now hosting residencies for Doha-based as well as international artists, and the expanded National Museum of Qatar, set to open in 2017, will highlight the country's unique heritage and traditions.

Exhibitions by contemporary international artists including Takashi Murakami, Damien Hirst, and Richard Serra have taken place in Al Riwaq, a warehouse-like temporary exhibition hall on the grounds of the Museum of Islamic art, and have been very popular with visitors. Art works have also been installed around the city by Qatar Museums Public Art Department, including sculptures by Subodh Gupta, Urs Fischer, Louise Bourgeois, El Seed, Damien Hirst, Sarah Lucas, and Adel Abdessemed. Most of these art works have been received positively, with the exception of Abdessemed's sculpture *Coup de tête,* which was quickly removed after a public outcry about its figural nature and supposedly immoral subject matter. However, contemporary art and its role in this society is still being debated. Traditionally, poetry, music, textiles, and jewelry were all important local cultural forms. Today a major concern for Qataris is that they are a minority in their own country, some 85 percent of whose population are expatriates. This naturally leads to questions about place and identity that younger artists, such as Ameera al Aji and the collective See My Culture, are exploring in their work.

Traveling around the city, visitors will find that most of Doha is currently under construction. With a metro system being built for the 2022 World Cup, much of the city is in a state of rapid change and upheaval. One huge

construction site near the Museum of Islamic Art is the new National Museum of Qatar, designed by Jean Nouvel. Its huge disc-like shapes are rising next to the Corniche, an incredibly complex and costly design meant to look like the shape of a "desert rose," a kind of salt crystal native to this area. Also nearby is the current site of Qatar Flour Mills, a massive group of buildings on the waterfront that Qatar Museums plans to develop into a museum of nearly 1 million square feet. A design competition for the "Art Mill" project is under way, and this new museum is widely rumored to be the future home of the royal family's collection of primarily Western modern and contemporary art.

Another important space of art activity, Katara Cultural Village, is a pedestrian area filled with restaurants and exhibition spaces located further up the coast beyond the skyscrapers of Doha's central business district of West Bay. When entering Katara, visitors park and are then chauffeured in golf carts to their destination through the narrow lanes of this faux-traditional Arab city, complete with calming streams of running water on either side of the sides of narrow streets, and tent-like fabric gracefully covering the passageways. A glow of hidden lights illuminates the winding pathways. Here you can find Katara Visual Art Center, run by the government Ministry of Culture, which hosts workshops with local and international artists, among other exhibition spaces.

Qatar's already small nongovernmental spaces for art have become even fewer since the transformation of Katara Art Center, also located within this complex. This space, founded by the Qatari art collector and businessman Tariq al Jaidah and run by the curator Mayssa Fattouh, combined both commercial and noncommercial elements and had an active schedule of exhibitions and events, but closed abruptly in June 2014 due to a withdrawal of financial support by its sponsors. The space has reopened, but with no full-time staff and a reduced level of programming. Al Markhiya gallery, one of the oldest galleries in Doha, run by Heather al Nouwairy, was also recently forced to move from its previous home and is currently holding temporary exhibitions in the Katara Art Center space. The gallery represents the best-known local artists of the older generation, including Yousef Ahmad, Salman al Malik, Faraj Daham, and Ali Hassan, as well as artists from other parts of the Gulf and the Arab world. A new gallery called Anima opened in 2012 at the Pearl Qatar, a major real estate development also built on an artificial island just past Katara, which includes a lounge/café and holds exhibitions by both Qatari and international artists. In addition, the work of Qatari

artists working in media such as painting and photography is often exhibited at the Souq Waqif Art Center on the Corniche. This very small group of commercial contemporary art galleries reflects the fact there are not enough art collectors in the country to sustain more. Although the country is the richest in the world per capita, many of the local citizens have not yet taken an interest in collecting art. Sotheby's has held annual contemporary art auctions in Doha since 2009, but the bids come largely from international buyers rather than local Qataris, whose business the company would like to cultivate.

Although there are only a few nongovernmental art spaces in Qatar, Qatari artists are extremely active online. The profusion of local artists sharing their work on social media platforms is crucial and often overlooked in discussions about art in Qatar. People voice opinions about new art on Twitter. Instagram is used to communicate visually, and it is the primary place where many creative people show their work. This digital community of artists, photographers, and designers is one example of an art ecosystem that exists in Qatar on the local level but that may not be evident to outside observers. There is an art scene that is developing, although it lacks some elements that could make it more dynamic, such as more artist-run spaces, which could move interactions from social media into spaces with a more tangible presence in the country. More writing about art and culture in the press would also be a welcome addition to the scene. Very little local critical art writing exists, and Qatar Museum's exhibitions are not reviewed; newspapers generally publish the text of press releases about exhibitions. The well-known local blog *Doha News* does cover exhibitions and controversies related to art closely, but it does not have specialist art critics.

More boundary-pushing thinking about art and museums can be found twenty minutes inland from Katara in Qatar Foundation's Education City, a complex of foreign universities on the edge of the city in an area that was until recently nothing but flat desert. Here hundreds of young artists are training in fine arts, art history, and design at Virginia Commonwealth University in Qatar's School of the Arts. Originally founded as a college of design in 1998, VCU-Q has evolved to offer degrees in fine arts and art history, with courses that engage directly with contemporary art theory and practice. Other universities in Education City also have focuses related to the arts, including Georgetown University School of Foreign Service in Qatar's undergraduate major in culture and politics and University College London–Qatar's MA course in museums and gallery practice, which is already producing graduates

who are infusing new criticality into the cultural scene in Doha. Far from only being interested in major museums, UCL student research projects have sought out cultural heritage in Qatar in everything from sculptures in traffic roundabouts to the conspicuous consumption evident at Qatari weddings. However, the overall number of students enrolled in these programs is small. Additionally, Northwestern University in Qatar is developing a new experimental gallery space focused on digital media and communication called the "Media Majlis," which is currently overseen by the scholar Pamela Erskine-Loftus. After withdrawing art education from the school curriculum entirely several years ago, Qatar's supreme education council has recently introduced new K-12 arts education standards, which should encourage more widespread and rigorous arts classes in government schools. Continuing and building on these advances in art education along with institution building is essential for Qatar to achieve its goals of fostering local talent and encouraging students to become creative, innovative thinkers.

Next to Education City, just past a traffic roundabout with a sculpture of the word "Realize" in large yellow plastic letters, lies Mathaf: The Arab Museum of Modern Art, in a simple white building formerly occupied by Al Wajba School for Girls. Also part of Qatar Museums, Mathaf is quite physically isolated in the middle of several large construction sites, and it is relatively inconspicuous and difficult to find for those not familiar with its location. Arriving at the museum can feel bizarre and disorienting, since the road is winding and the view on all sides is blocked by construction barriers emblazoned with logos of Qatar Foundation ("Think, Create, Innovate"), making it impossible to see any of the surrounding landscape. In the future, the museum will be more closely linked to Education City by a tram system, but it will also be surrounded by a golf course, a stadium, and a new mall, which will certainly change the atmosphere for experiencing art in ways yet to be determined.

Founded by Sheikh Hassan bin Mohamed bin Ali al Thani in 1994 as a private museum to house his collection of Arab Modern Art and as a residency space for artists in the Madinat Khalifa area of Doha, Mathaf opened in its current location in December 2010. The museum (where I worked during 2012–15) has hosted exhibitions of art world stars such as Mona Hatoum and Cai Guo-Qiang, but generally has more of a regional focus than other art venues run by Qatar Museums. An installation of the permanent collection on the first floor tells a nonlinear history of modernism in the Arab world, allowing visitors to make their own links between works made by a

hundred different artists from 1850 to the present. More than ten Qatari artists are represented here, including Jassim Zainy, the founder of modern art in Qatar, and young artists like Aisha al Misned. For those able to make the trek here, Mathaf can provide both inspiration for local artists and historical context for those interested in understanding the contemporary art on view elsewhere in the city.

Traveling back to the heart of the city near where our journey began, a huge real estate development called "Msheireb Downtown Doha" is taking shape. Strangely, although founded by a real-estate development company, Msheireb Properties, one of the most community-oriented art projects in Doha is Sadaa al Thikrayat, the Echo Memory Art Project. Originally housed in the Msheireb Art Center located in the Al Asmakh area, the collection is now on view in the Mohammed bin Jassim House, one of four heritage houses on the construction site that have been preserved and turned into museums. Consisting of a group of objects collected as the surrounding neighborhood was being demolished to make way for this massive urban regeneration project, the Echo Memory Project is intimately linked to the primarily South Asian merchant community who have lived in this area for more than fifty years, and their possessions tell Doha's history in a real and direct way. Among the photographs, hand-painted street signs, and other everyday objects, a message about Doha's past and its future can perhaps be found.

Art and museums are central to identity of this rapidly changing city, but more work needs to be done to create a dynamic, multilayered arts infrastructure in Qatar. The growth of museums and contemporary art initiatives here raises a number of questions: Is it possible to create an audience for contemporary art, or a future generation of globally connected artists, in a conservative Islamic state? What types of friction result from the gap between the art favored by the royal family and the traditional values of many citizens and residents? Can museums and other government arts institutions alone create a dynamic and sustainable arts community in Doha without more grassroots initiatives? And, finally, how can art institutions ensure that voices from all of Doha's diverse communities are heard? Qatar's museum building spree moved ahead at full speed from 2008 to 2012, but with the coming to power in the summer of 2013 of the new emir Sheikh Tamim, priorities have shifted, and many arts projects have been put on hold while government spending is reviewed and reassessed. This pause can provide a time for reflection before moving forward, and could be a chance for institutions in the country to

revisit and refine their missions. The museums and other cultural initiatives here have the *potential* to be sites for debating and negotiating aspects of local identity, engaging in critical thinking around challenging new ideas, and inspiring young artists and cultural producers. However, realizing that potential will require building more sustainable institutional structures, as well as encouraging the development of more nongovernmental organizations. Hopefully in the future it will be possible to see more art that is made locally in Qatar rather than purchased or borrowed from abroad, as artists of many nationalities who call Doha their home respond to the astonishing range of cultural influences and traditions that exist in this Gulf state.

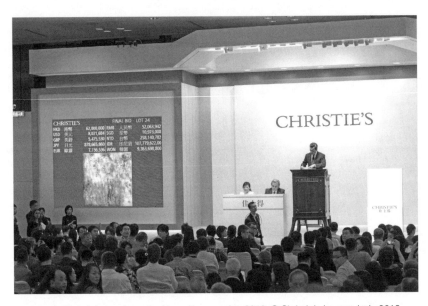

FIGURE 14. Christie's evening sale, Hong Kong, spring 2016. © Christie's Images Ltd., 2016.

Art and the Global Marketplace

The art market is one of the most established received ideas in the art world, and Part III of this book inquires into its characteristics and its mechanisms in order to offer a more complete picture of what constitutes this ostensibly singular construction, and how many transactions can be attributed to it. The first aspect of the art market that needs to be interrogated is its singularity (Graw 2009). Is there only one art market in the world? "One of the most important features for investors to remember is that that there is no such thing as 'the art market.' It is the de facto name given to the aggregation of many independently moving and unique submarkets that are defined by artists and genres, and that often behave in significantly different ways," Clare McAndrew notes (2010, 87). McAndrew is a cultural economist specializing in the art market, and she is challenging its fundamental economic logic in favor of more focused analysis of business practice in a broader analysis of "art risk" here. The mere fact that the term "art risk" exists demonstrates the broader trend toward what John Lanchester (2014) has called securitization, or the process of reconfiguring just about everything as though it were an asset class. Like any other asset, fine art is subject to investment risk, and such risks can be studied, analyzed, and, to a certain degree, mastered. The art market(s) may be a complex of processes and prices, but it exists as a category, and its shape and patterns can be elucidated in an effort to capitalize on its exchanges.

Other economists of culture have focused on how the art market sorts supply and demand to create value (Heilbrun and Gray 2001; Nikodijevic 2010), the way art market prices interact with the equities market (Goetzmann et al. 2010), or the way the contemporary art market is affected by globalization (Codignola 2006). Noah Horowitz has studied the performance of art

investment funds in great detail (Horowitz 2011). All of these nuanced and compelling economic analyses have to some degree relied upon a fundamental conception of the market based on the classic definition of markets offered by economics: a market is an abstraction in which buyers and sellers meet to exchange goods or services. So by this standard, yes, there is only one art market, because all art bought and sold anywhere in the world would be part of the art market. Therefore, art auctions, art dealers, artists selling their works directly from their studios, and all the different consumers, from museums to patrons to anyone who wants to decorate her home, is engaging in the art market. This basic premise does not hold up on its own, since most of the authors so far mentioned have attempted to analyze the particularities of various segments of the art market, but both business and economics assume an "art market," even if they recognize that there is no such thing.

Based on the thematics of this book, it makes sense to juxtapose this notion of the market with another definition of market: the variety of locations where markets take place (as in marketplaces), whether they be art auctions, fairs, or sales. Globalization may have produced a single market for art, but this looks quite a bit different depending on where you engage in this market and what the overall economic picture for artists, merchants, and collectors is in that location. This is a major consideration, which taken up in relation to galleries in chapter 5 and to auction houses in chapter 6. But I want to set it aside for the moment, because it is more of a qualification than a critique of the logic of the market mechanism as it is applied to art.

The two main problems with the idea of the art market as a singular entity are problems of circumscription. How does one determine what counts as art when it comes to the art market? How does one measure it? The first question introduces a fundamental problem at the heart of any discourse on the arts, be it art history, art criticism, or even "the art world." The second question is more specific to the context of the art market, because in order to construct an art market, one has to be able to know which transactions are a part of it. I argue that the writings on the so-called art market, be they academic analyses or journalism, do not only assume, but in fact *manufacture* an art market. The art market is a result of discourse, a tacitly understood boundary of the art trade that is reinforced every time a writer types the words art market. Readers understand what the art market is by reading about events or exchanges that contribute to it and so the art market accrues through repetition. Iain Robertson has said as much, but puts it somewhat differently. He writes: "The art market is a mechanism, which through concatenation

manufactures a monetary value for the art commodity" (2016, 35). In other words, art market experts derive and agree upon prices through a system of mutual acceptance, and this is called the art market. For my purposes, the art market's boundaries are the main question, and for analysts, it is primarily a matter of determining a frame of reference. Whether the method is to model or to count, the question is where to stop and this problem takes us back to the first question: What counts as art?

A singular example will provide an illustration of some of the complexities. As a child, I watched a lot of television in the 1970s, and the independent networks that broadcast endless reruns of cartoons and sitcoms also aired what might be called bottom-of-the-barrel commercials. One particular advertisement that seemed to appear regularly was for the "Starving Artists Liquidation Sale," to be held in some conference room of a hotel on the edge of Denver "for one weekend only!" The images that I remember featured cavernous spaces with framed paintings stacked against the walls, presumably for visitors to browse through. If memory serves, prices started "as low as $9.99!" Where these paintings came from, who made them, and what kind of merchants were involved in the business remains a mystery to me, but I am certain of one thing: they would not have been included in a contemporary analysis of the art market. They may have been mass-produced (I later had a job working in a sculpture factory/studio), and if the sellers were renting hotel conference rooms, one imagines they were fly-by-night operators ("All sales final!"), but the sales would not have continued if people did not show up and buy the stuff. So, yes, it was a market and, debatably, an art market, but who was keeping track? My guess is probably not the IRS, and there are no regulatory agencies in the art world, so that leaves no one.

It has been estimated the 20 percent of all economic activity globally is in the black market (Gilman et al. 2011), and a full 50 percent of all employment globally is informal, that is to say, off the books (Neuwirth 2011). This has staggering implications for any economic analysis, from GDP on down, but my single example demonstrates that not all buying and selling of art is captured in analyses of the art market. It is not only that there are more manifestations of the art market than one could possibly count, it is also that models can only account for what they know they don't know. The variables that allow economists to calculate for unknown or uncontrollable factors (externalities) are determined by the patterns they observe and the developments they follow. But if a significant element of the market is off the books, that makes it invisible in calculations of the market, because it literally does

not count. This brings us back to the previous two questions, but with a slight qualification: the first is that someone has to decide what constitutes art, and the second is that one has to determine what constitutes an exchange. Despite the advances in economic understanding of the art market that has developed in past decade thanks to the work of arts economists like Clare McAndrew, art historians such as Noah Horowitz, and sociologists like Olav Velthuis, there exist some fundamental assumptions at the base of this complex that need to be explored in an analysis of the changing nature of the art market under globalization.

Whether one looks at the merchants (gallerists, auction houses, art advisors) or the artists (fine artists, designers, painters of reproductions in factories in China), the art market has a number of uncontrollable elements that challenge its coherence. There are "galleries" in malls across the United States that sell only paintings by Thomas Kinkade, auction houses that specialize in estate sales, and art consultants who advise real estate developers about decorating their lobbies. There are artists who only produce "social practice," designers of public art works, and art students who are occupied all day knocking off Old Master and Van Gogh copies. One of the most useful distinctions commonly used is to separate commercial from fine art, so one does not confuse the designers of Hallmark cards with printmakers who generate large editions. Even here, categories are eroding: the illustrators who work for the animated film company Pixar (now owned by Disney) have been featured in a large-scale exhibition that has traveled to art museums internationally, including the Museum of Modern Art and the National Gallery of Scotland. Examples like these sometimes make headlines, but they do not turn up as part of the discourse around the art market, and particularly the market for contemporary art. The general practice in writing on the art market is to dismiss any ambiguities, to categorize this economic activity as not part of the fine arts market, on grounds that might be called aesthetic. Even if one accepts the logic of that supposition, there are still lacunae: What about the works of art that successful artists give as gifts to dealers, critics, and friends? These transactions are not part of the art market either as it is currently defined.

So one is left with the sense that the art market cannot be objectively determined, and this leads to two opposing trends. On one hand, economists have an academic perspective and attempt to work out a theory that will hold in most cases, so they can make estimates and predictions about the present and the future. On the other hand, participants in markets simply engage in

transactions as they go along, trying to balance their books in a highly competitive and constantly evolving industry. There is an undeniable gap here between theory and practice. In either approach, the market is not a thing that actually exists and can be factually determined. It is more an idea that allows us to come to terms with any art transaction. Among academic economists, this leads to a systematic structure governed by certain principles and an arena for the development of innovative practices of exchange among artists, dealers, and even auction houses. It is something like an estimate— perhaps projection would be more accurate—about what economic activity is subtended by the production of art. The art market, then, is a heuristic device that categorizes the exchanges and the art and serves to police the boundaries of both. Part III will work to break apart the singularity of the market, not only to explicate its structures and mechanisms, but also to bring attention to what it hides or obscures. For the purposes of this analysis, the art market will not be taken as a given, but as a means of producing an economic sphere specific to the visual arts.

If there is a split between economists and actors in the market, it will be valuable to consider two of the most important authors treating the art market currently, Clare McAndrew (2007, 2010, 2012, 2014, 2015) and Olav Velthuis (2005, 2012, 2015a). McAndrew is the preeminent economist of the visual arts. She has published two books on the art market, and her firm, Arts Economics, annually produces the *TEFAF* macro-economic report on the global art market published by the European Fine Art Foundation. This means that she is the most active scholar consolidating data from the art market and determining what is important to know, to make known, and to count. If one concedes that it is impossible to know everything about the art market, it is also true that McAndrew follows the whole of financial transactions in the visual art world more than any other scholar. Velthuis's book *Talking Prices* (2005) introduces a valuable alternative to the macro approach represented by McAndrew. Velthuis is himself an academic (a sociologist) and not a dealer, and he introduces new tools for examining the economics of dealers, particularly around the topic of prices and pricing, using quantitative methods and employing multivariate analysis to examine price trends. He introduces his readers to an unprecedented perspective on the economic determinations made by dealers and provides other models for analyzing their behavior. In effect, he explores their practices and the narratives that sustain their business models. So examining the work of these two scholars will illuminate more effectively the various mechanisms at work in the art

market, as well as differing ideas of how to capture the dynamics of this market.

Clare McAndrew does not hide her own speculative interest in the art market as an economic advisor. Her first book, *The Art Economy* (2007), is subtitled *An Investor's Guide to the Art Market*, and she has also edited a volume, published by Bloomberg, titled *Fine Art and High Finance* (2010). Both of these books came out after she began her own consulting company, Arts Economics. Despite her understanding of economic theories, it would not be accurate to describe her as someone to whom business decisions in the art world are foreign. She is clearly staking her career on the business of visual art, and she makes it her business to be the best-informed specialist on this subject. She derives her data from a variety of sources, including the Artnet database and the Artron Art Market Monitoring Centre, as well as from international and national dealers associations, auction houses, and surveys of individuals working in the market (McAndrew 2014, 158–59). Though she is a consultant, she is focused on macro-economics, and she has developed a rigorous method for evaluating, not only the most important information for a collector to know, but what the broader sweep of the economic data suggests. Thanks to this interest, she is particularly attentive to trends in the global market.

One of the most valuable observations that McAndrew has contributed is one of the guiding principles for my own investigation of the economics of art. "Apart from its rapidly increasing size, the art market has undergone an intense period of globalization since the turn of this century. The distribution of sales has changed fundamentally over the last ten years, with significant changes in the size and distribution of world wealth, leading to the emergence of new markets and buyers," she writes (2014, 21). This assertion is backed up by research on the distribution of the art market in emerging economies, import/export figures among the most active countries, and, in the 2015 *TEFAF* report, an analysis of global wealth distribution patterns. She also points out that the share of Postwar and Contemporary art sold at auction is 48 or 40 percent, depending on whether one looks at value or volume respectively. These data make it quite clear that, at auction houses at least, the contemporary art market is far larger than any other category, whether Modern (28/28 percent), Impressionist and Postimpressionist (12/13 percent), or Old Masters (9/8 percent) (McAndrew 2015, 69). Thus, the much-discussed growth of the contemporary art market is given precise valuation thanks to her research and presentation, which makes the global art market visible in a way no other author has.

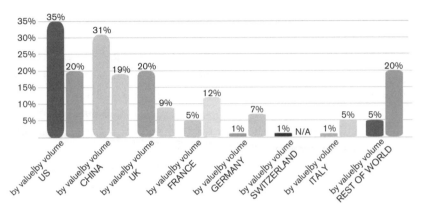

FIGURE 15. Global art auction market by value and volume, 2014. Data from McAndrew 2015. © Eva Krchova.

Looking at the global art market means examining cross-border trade and the comparative statistics of various countries, and McAndrew's research guides its readers to a more complete understanding of the impact of globalization on the buying and selling of art (figure 15). There are also other advantages to her analysis that set her work apart from other economists of art. She looks at sectors of art and produces data that allow for cross-sector analysis. If you want to know how modern art is selling in the UAE, or Old Masters in China, she provides these statistics. Furthermore, she examines not just the art market itself but the economic impact that it produces in her annual surveys. She thus merges the assessment of the value of the market itself with the value it produces outside of the market in a broader context, and this allows readers to conceive of the art market as a kind of industry. Her first two books (2007, 2010) outline the contours of an emerging industry by detailing various financial dimensions of the art market, such as art risk, art insurance, and taxation. These studies remove the market from the domain of economic abstractions like price indexes and provide more dimension to an understanding of the art market in terms of its business functions, and the services and processes necessary to make it possible. Finally, McAndrew was the first to attempt an estimate at the percentage of the market represented by private galleries, as opposed to that represented by the auction houses, whose sale figures are public. Sales by dealers hover around 50 percent in McAndrew's estimation, topping out at 52 percent of sales in 2014 (2015, 41). These figures are derived from over six thousand surveys of dealers on six continents. McAndrew is working hard

to assemble her data and to produce the clearest picture to date of the real value of the art market overall.

McAndrew has effectively resolved the question of which transactions count as part of the market without touching on the problem of which art works count. The surveys she employs and the statistics she deploys all involve a process of self-selection, both in her own thinking, and in the thinking of those surveyed. If I think you count as an art dealer, I will send you a survey. If you think of what you sell as art, your sales all count as part of the art market. This leaves out the artists who are not represented by galleries and whose works do not appear at auction, however, and thus excludes the majority of twentieth- and twenty-first-century artists. If one were, for example, to compare a list of the graduates of art schools with degrees in fine and decorative arts with a list of the artists whose works fall into McAndrew's categories of the art market, there would be a major discrepancy. Though many of those individuals would have undoubtedly found their ways into other professions, they may yet make art and sell it to collectors from their studios, or at fairs or marketplaces throughout the world. In other words, McAndrew's numbers favor the self-selected victors in the art world, both the artists and the merchants, whose activities are prominent enough to be included in a calculation of the art market. But the theory that emerges from this work is that the value of the art market is divided between auction houses and dealers, mostly growing over time, though various countries' relative positions in the market change. She also postulates an entire global industry focused on the global art market, despite the fact that its financial value is paltry compared to the global trading of other assets.

If the acceleration and diversification of the art market seems very recent, Velthuis argues that many elements have remained the same: "I will show that the interrelated trends of commercialization, globalization and financialization have produced new regimes of value within the market and have reconfigured pre-existing market logics. Nevertheless, I will subsequently make the case that the art market can be seen as a market in stasis as well. . . . In order to bring the equally valid accounts of flux and stasis in line, I will propose the notion of cyclical change" (Velthuis 2012, 17–18). His argument for stasis rests on primarily structural grounds, namely, the perpetuation of the so-called critic-dealer system first elaborated in the 1960s (White and White 1965). Also important is his argument about "circuits of commerce," which suggests that an art market is not a singular entity, but is "in fact composed of a plethora of smaller circuits, which have their own actors, regime of value, and logic of action" (Velthuis 2012, 38). This assertion is borne out

by his earlier research on prices in the art market, which is organized as a sociological study of mechanisms employed by dealers to value art works through various processes, including the architecture of the gallery and the scripts dealers use to price works sold in their galleries (Velthuis 2005).

While Velthuis's contribution to our understanding of the art market can at times look like an overall theory of the market, in fact it undermines such fanciful abstractions by attending to particularities. In the case of his first book, *Talking Prices,* the study involves gallerists in New York and Amsterdam and the way they construct and maintain value for the works of the artists whom they represent. This study was groundbreaking in a number of respects. Various other sociologists have examined the art market, including White and White (1965), Howard Becker ([1982] 2008), and Raymond Moulin (1967), but none of these have examined the divide between the primary and secondary markets and recorded the fundamental attitudes and concerns of dealers in establishing prices for works of contemporary art, including both avant-garde and traditional art works, as Velthuis does in his research.

The picture that emerges is complex, because Velthuis introduces rhetorical and spatial mechanisms into the lexicon, as well as producing the first quantitative analysis of prices in the primary market, thanks to a data set that comes from a government program in the Netherlands that allows art buyers to take out interest-free government loans. This research points out commonalities between dealers in the largest commercial market for works of art (New York) and those in a much smaller regional market (Amsterdam), but of course the difference between these two domains also underlines the circuits-of-commerce position that he adopts. More than anything, Velthuis's research points to relationships that sustain the primary art market (contemporary works of art being sold for the first time, as opposed to the resale of contemporary or historical works). These relationships might be between an artist and a dealer, or a dealer and a collector, but they could also be between artists or between dealers. The point is that such relationships are not just personal, but governed by "scripts" that direct various actors toward particular behavior. In his own words: "Contemporary art dealers mark and symbolize social relationships with artists and collectors by framing economic transactions in different ways and by redefining the meanings which their transactions generate" (2005, 75).

Velthuis is openly taking on neoclassical economics, which he describes as "imperialistic," by qualifying the nature of the art market abstraction and

demonstrating that supply and demand are not nearly adequate terms to comprehend the logic of the art market. By attending to the particularities of the primary market, he picks several bones with broader theories of supply and demand. Notwithstanding, he has elaborated a theoretical model for understanding current developments in the art market that balances moments of crisis with an interpretation of a market in stasis through recourse to the theory of cyclical change. As he wrote in 2012, "the art market's logic of action is in flux" (31). This means that (1) the contemporary artist's calendar has contracted so much that contemporary art now resembles the fashion industry, (2) contemporary art has, like pop music, become a locus around which fan and celebrity cultures have developed, and (3) the contemporary artist has been transformed into a brand manager (32–33). However, he believes that art market structures have remained intact, since a few industry leaders dominate both the primary and secondary markets, globalization has not fundamentally altered the geography of art market centralization, and, in effect, the art market has not been transformed in the same way that, for example, the music and journalism industries have been by technological innovations (34–38).

In order to disaggregate these large-scale observations and to explain their inherent contradictions, Velthuis employs the notion, mentioned above, of circuits of commerce, "which each have their own actors, business practices, regime of value and logic of action" (38). Adopting the theory of cyclical change allows Velthuis to assert that there is not a single progression, but changes in various circuits that create new patterns without generating a fundamental shift in the market for works of art. Globalization is thus bracketed by boom-and-bust cycles and self-correcting mechanisms designed to protect the value of the market itself. Despite the significant differences in approach, Velthuis's conclusions tend to normalize market developments as much as McAndrew's economic lens does and, while they may disagree on the impact of globalization, they agree on the continued coherence of a self-regulating and self-selective art market. While I present a variety of specific arguments based on this model here, there is a broader case for looking beyond these theories elaborated by McAndrew and Velthuis.

The question that demands attention pertains to the function of the art market within the field of cultural production. Whether or not one believes that a market logic should be applied to cultural production, the fact of living in a capitalist world means that the metaphor of the market will be applied to any and all assets. At various point in the twentieth century, artists

attempted to break out of the stranglehold of this system through utopic gestures—from Kasmir Malevich's black square to Jenny Holzer's *Truisms* in Times Square—that aimed to reframe their activities outside of the system of ownership, patronage, even the ontological truth of the art object. If it is possible to reclaim such gestures for a collective cultural memory, such can only happen through the logic of the market, though it may in fact be another market than the one so far elaborated. Drawing on the theories of Roland Barthes, Malcolm Bull (2012) has asserted two economies of world art, one of which is financial and the other based on attention, which he analyzes through financial transactions and museum attendance respectively. I am not sure that the subtleties involved can be so easily explained, and this study goes into rather more depth than Bull's. But I do accept that our understanding and appreciation of cultural production is susceptible to market norms. The market serves not simply as a container of transactions but as a way to produce meaning, and indeed to determine significance, functioning as a form of aesthetics without judgment, in which values simply accrue by virtue of interest, and of market value. In order to understand the art market, it is necessary to think also of this aspect of it, and to look at what it does.

"Power is intrinsic to great art; it is not created by the market but [by] the artist," a transnational art dealer and sometime critic has written (Talwar 2013). In order to understand how the market harnesses that power and puts it to use in a social context—one that has taken on global dimensions—it is essential to examine not just how much but in what ways the market has come to be a vehicle of artistic production and dissemination. Part III of this book will take on this challenge through an examination of the primary market (dealers), the secondary market (auction houses), and the invisible market (the informal economy).

The Global Gallerist

ERUPTIONS IN THE PRIMARY MARKET

1 THE ART DEALER AND THE NEW NORMAL, THE FAIR AND THE FRANCHISE

I don't feel good about it [the proliferation of art fairs]. I don't think any gallerist does feel good about it, but there's no avoiding participating in it, because it's now an important part of the market. The paradigm has changed. It has changed the habits of the way the public engages with art. Although there are still many collectors who value galleries highly as places where they have a chance to see work in depth, fewer people come to the galleries. Many prefer to shop at fairs. They are often the same people who buy at auctions. That's not always true, it's not a black and white situation, but business has taken over the art world.

MARIAN GOODMAN
(Lewellen 2014, 102)

The term "primary market" refers primarily to the art world's basic retail unit, the gallery, though, as addressed below, galleries also engage in the secondary market. The gallerist or dealer—there's a distinction, but I use these terms interchangeably here—plays one of the main roles in the art world. Dealers invented the market for modern and now contemporary art. Their primary role is to connect artists with collectors, and if possible with institutional collectors, such as museums and corporations. Thus they serve as the connective tissue in the body of the art world. Gallerists nurture living artists and help them to shape the trajectories of the their careers, determining pricing, cultivating a group of collectors interested in their work, and promoting their careers to the world at large. Art galleries are private businesses, owned and

operated by a single, often charismatic, figure (though with financial backers in many cases), and whatever transactions happen at a gallery are therefore not a matter of public discussion, though of course gossip will leak out.

Not all galleries specialize in contemporary art, and some galleries focus on the secondary market, the reselling of art work that has already been collected. These galleries are boutiques that offer discretion and fixed prices to their clients to counter the openly public department-store experience of the auction house. Galleries that are active in the primary market often succeed financially as a result of their engagement in the secondary market, or the reselling of works by "their" artists (Velthuis 2005). There are a number of established dealers that broker high-end deals between buyers and sellers. Since most art collectors value their privacy, very few know who owns known works by established artists in private hands. This is a competitive advantage that long-standing, well-connected galleries possess, and so buyers seek them out to find works that they desire, and they are willing to pay the premium for this knowledge and the discretion that accompanies it. These galleries have experienced major changes in the past generation—many are turning to contemporary art, since they perceive that is the most quickly growing sector of the market. Some long-standing galleries have closed; Knoedler, in New York, closed as the result of its involvement in a major forgery ring, and Wildenstein, caught up in scandals in France, sold its prime gallery building on Manhattan's Upper East Side to Qatar (Maloney 2014).

Not all contemporary art galleries are businesses, and the business model of the contemporary gallery has undergone tremendous changes in the past generation. It therefore makes sense to revisit traditional models and ideas about galleries and their role in the art world. The number of contemporary galleries has exploded in recent years, and the most prominent galleries are expanding swiftly primarily through two means: the fair and the franchise. The idea of a gallery as a family business, with a headquarters in a single location, serving a local clientele by selling the work of regional artists, is by now more or less obsolete. In order to remain viable in the era of globalization, galleries have sought to expand their positions in the industry by making connections to artists and collectors outside of their region, primarily through the access provided by the proliferation of international art fairs. Many galleries have also expanded their physical proximity to a variety of local markets by positioning brick-and-mortar storefronts in multiple locations. Gagosian is the leader in this domain, with thirteen galleries internationally, but even medium-sized galleries have opened spaces in far-flung

locales or even in the same city in order to introduce work to new audiences and to engage a more diverse clientele (Adam 2014).

This is by no means the full extent of recent innovations among contemporary galleries to expand their presence. The internet is an exceptional tool for extending the visibility of a gallery to the world (Horowitz 2012), and the phenomenon of the residential or pop-up gallery represents another challenge to established business practices. From the perspective of the second decade of the twenty-first century, it is clear that the contemporary gallery as a retail unit is experiencing unprecedented innovation while maintaining the fundamental cultural construct of the sympathetic gallerist who constructively promotes her artists to a group of art enthusiasts. Such a view ignores many rising sectors of the art market, like the increasing prominence of art consultants or advisors and the financialization of the art world as a result of new investment strategies being implemented in that domain (McAndrew 2009; Coslor and Velthuis 2012). So the most remarkable element of the contemporary gallery at this point may not be all the changes that have occurred, but the persistence of the cultural construct of the contemporary dealer as one of the structural supports of the art market. In order to better comprehend how this model has withstood challenges to its coherence, it will be valuable to look at the rise of the contemporary dealer in historical context.

A variety of authors have provided the blueprint for how we understand the role of the modern art dealer, who emerged in the nineteenth century to promote innovative art made in periods of great transformation. Harris and Cynthia White (1965), Raymond Moulin (1967), and Howard Becker (1982) are the sociologists of culture who have provided the image that still reigns in many respects today. The early independent dealers were connoisseurs who understood the full range of artistic production in their epochs and who carefully selected a group of artists to represent (i.e., to sell) at their galleries. Most of the early dealers in nineteenth-century Paris, London, Brussels, or New York focused upon the artists who were in favor in the state patronage system of the era, or who produced picturesque and marketable alternatives (images of hard-working peasants, for example, or flower paintings). In the second half of the nineteenth century, a new crop of dealers came to prominence who sought to expand the market by introducing innovative artists to their clientele and promoting their work through exhibitions and sales. In this way, the first breakout group of modern artists—Manet and the Impressionists—found a means of supporting their work through the enlightened patronage and market savvy of the dealer Paul Durand-Ruel

(Patry 2014; Zarobell 2014). Durand-Ruel courted bankruptcy on multiple occasions before he found a ready market for these artists disdained by the Academy and the state patronage system that dominated the French art market of the time, but he found his audience with his first exhibition in the United States in 1886. Jealous American dealers pressured the U.S. Congress to pass an import levy against foreign art dealers like Durand-Ruel, forcing him to open his first gallery in the United States in 1887, beginning the franchise model for contemporary art that is still expanding today.

Durand-Ruel did not keep up with the times as he aged, ceding the avant-garde to later dealers like Ambrose Vollard and Daniel-Henry Kahnweiler, but with his acute business sense, he initiated a model for promoting the work of apparently undesirable artists and turning his awareness of the historical significance of contemporary artists into a very successful business. Though his galleries in Paris and New York eventually focused on the secondary market for Impressionism until they closed in 1974, Durand-Ruel stood out as a man of exceptional audacity and a complete commitment to the art of the present despite the undeniable derision that "his" artists at first received from the public at large. He was the model of what Olav Velthuis has described as "the promoter" (2005), a dealer who is committed to the artists in his stable and who will bend the world to his perspective in order to enshrine their names and works in history. The fact that Durand-Ruel was so successful at promoting legendary status for Manet and the Impressionists is the model for every contemporary dealer who feels that her artists are the most important working today and that their works will be both significant to history and valuable for the collector in the future. This model has survived multiple generations of dealers, and though it has oft been abused and tested, it remains because it offers an explanation for the art dealer as someone whose passion for contemporary art excels beyond the obligations of running a successful, or even solvent, enterprise. In a word, dealers are not business people, they are passionate collectors and careful observers who share their enthusiasm with the public and make it possible for artists to keep working by providing them with an income through sales of their work.

This idealization has been carefully scrutinized by Olav Velthuis in *Talking Prices* (2005, 53–76). He terms the perceived antagonism between the act of producing art and the market the "Hostile Worlds" view. From this perspective, the market corrupts the purity of the artistic purpose to create freely without the imposition of outside forces (whether it be the hungry mouths of the artists' children or the demands of their patrons). In this sense, he looks at two different

economic models: the neoclassical view, which describes all objects as possessing exchange value, and the gift economy (Hyde 1983), which suggests that art can only be made without commodification, as a gift to the world. Thus, art possesses a kind of exclusive cultural value. These two economic models intersect at the point of the modern art dealer. Velthuis looks at various examples, from Theo Van Gogh to Leo Castelli to Mary Boone, but he sees the necessity for an alternative explanation to the neoclassical view. The relationship between artist and dealer is based on a mutual exchange of gifts, despite the reality that dealers do commodify the works of the artists they represent and run businesses that earn a profit as a result. As Velthuis explains "the distinction between a non-market logic which equals sociability and a market logic which equals anonymous exchange, is ultimately a false one" (75–76).

As the epigraph to this chapter from Marian Goodman makes clear, even prominent dealers are now facing changes in the gallery model that has put pressure on this careful balance that dealers have maintained for almost 150 years. It may seem odd for a prominent gallerist to declare that "business has taken over the art world," but Goodman is representing the traditional view and bemoans that the relationships around the gift economy are losing ground to the neoclassical economic view of galleries existing to move merchandise (Tanner 2010). With these public remarks, she is promoting herself and her gallery, of course, but they were made in response to a question about the rising prominence of art fairs.

One of the causes of the rising prominence of art fairs, clearly stated by Goodman, is that more buyers prefer to shop there. What business can reasonably afford to lose established and potential customers by avoiding a trade show? On one level, this is a no-brainer. However, it is not a question of one trade show, but of hundreds—not a matter of *whether* to go to a trade show, but of *which* trade shows one should go to? Where? And how often? This is one arena where the questions around globalization of trade start to permeate the art market. If new customers are coming to the contemporary art market from traditional art centers like London and New York, as well as new ones in emerging economies (the BRICs, the G-20 countries), how does a gallery position itself to maintain a clientele that might otherwise depart for trendier markets and how can it cultivate the new elite art collectors currently arriving in the market? New York continues to reign supreme, as both the center of finance capital and the art market, so why do New York dealers feel that they have to travel to fairs all over the world every year and open franchises in other cities?

The simple answer is that the self-conception of the market, followed by the self-conception of the art world, is in a period of transformation and has been for a generation, though many of these changes are only beginning to become clear now. The transformation of the contemporary art gallery as a result of art fairs is one of the most concrete examples of globalization at work in the art world (Bowley 2013; Adam 2014; Thompson 2014). It is no longer enough just to sit pretty at the center of the art world; galleries must not only appear in, but also engage and represent, the periphery. Dealers report that 30 percent of their business is with clients new to them, according to Clare McAndrew (2015, 145). Even if almost all of one's customers are in the United States and Europe, if a gallery does not court alternative markets, one loses both potential income and a degree of cosmopolitanism that is currently the sine qua non of the art world's cultural identity. In brief, if a gallery is not global, it will not be a market leader. While many galleries survive as regional businesses, the galleries that have come to prominence in the past generation have become global through travel to art fairs and bringing artists from far-flung locales onto their roster. In order to maintain inflows of capital in a volatile market, contemporary dealers must sustain an image of currency to make the impression that they are on the top of their game. There are many ways to achieve a global identity, but attending art fairs, opening galleries abroad, and partnering with foreign dealers are among the most popular.

Olav Velthuis has argued convincingly that the retail dimension of contemporary art has not fundamentally shifted in the way it has for other cultural products like music or books (2012, 34–38). There is no Amazon knocking out all the local art galleries, after all, though not for lack of trying (Art.com has at last emerged in McAndrew's 2015 *TEFAF Art Market Report,* however). It is important nevertheless to consider the changes that have taken place in contemporary galleries and the primary market overall, because they have shifted the way art comes to market, who buys it, and the way reputations and valuations are constructed for contemporary art. As a front-page article in the *New York Times* declared: "Their [art fairs'] disruptive economics are not only shaking up dealers' lives, they are also shaking up the art market, especially for galleries below the top tier" who cannot afford the hefty costs of participation (Bowley 2013). The author reports that dealers in 2012 earned 36 percent of their sales on average through art fairs (3), but 2014 figures reported by McAndrew show an uptick to 40 percent, with 46 percent of sales happening in the gallery (2015, 166). McAndrews's figures account for both contemporary galleries and those that specialize in the

secondary market, but these numbers still suggest that a large section of the primary art market has shifted to fairs, while only 5 percent of sales were made online. Clearly, fairs have impacted a gallery's bottom line, but what about the larger structural changes in the cultural sector? At fairs, it is not only art that gets exchanged.

First, there is exchange of cultural capital (Bourdieu 1986)—seeing all the other art world people in this place at this time and reinforcing the sense of a shared purpose. This manifestation of cultural capital could take the form of competition for select works of art, riding around to VIP events in the same tour bus, or touring the museums or other sites in the host city. But the most important forms of cultural capital are exchanged at receptions and dinners where a select few are invited and everyone knows whether they are in or out, and thereby what their role is in the vast complex of the contemporary art world. Second, professional exchanges between different players who come to know each other through the unique social milieu of the art fair can be more significant than the actual selling of works of art, because the economic effects of finding a new collector who is active but may start by purchasing a small or inexpensive work can be far greater than making a quick sale. Of course, relationships between dealers are also nurtured at the fair. Partnerships are struck, and dealers may help promote each other within their networks, so a relationship begun at one fair might lead to later acceptance and a larger, more prominent fair. Cultivating artists from the region can open up new commercial possibilities for gallerists in their own countries, but also among collectors in the region. Finally, art fair travel is a dimension of experience that simply did not exist until the 1990s. The curiosity that motivates travelers to journey to new locations to see contemporary art and meet dealers from the region is a novelty introduced by the global market for contemporary art and the concomitant proliferation of high-net-worth individuals throughout the world in the twenty-first century.

The fair compresses both time and space, pushing hundreds of booths representing international galleries into a finite convention center space, and is only open for a limited (usually four-to-five-day) run. It allows a gallery, whether from the host city or elsewhere, to be transnational for a brief span of time, because fairs in traditional capitals like London or New York bring visitors from all over, while many fairs that may serve a regional audience import galleries from abroad. While some authors have challenged the "global" or "international" dimension of art fairs by counting the galleries from various countries (Baia Curioni 2012; Baia Curioni et al. 2015; Yogev and

Ertug 2015), no study exists that has actually considered the nationalities of visitors or buyers. Since Art Basel bought the Hong Kong art fair in 2012, the primarily European and American dealers who attend have clearly been making an effort to cultivate a new clientele there, attracting those buyers who shop regionally. Attending even a handful of the existing 250 or so international art fairs creates a chain of disruptions in a gallery's schedule, and a fair like Art Basel Miami Beach can actually drain a significant portion of the art world from any other city. For example, openings are no longer held in New York, Los Angeles, or San Francisco during the first week of December, even though this is traditionally the last opening weekend of the year and was formerly one of the most lucrative. That money is now being spent in Miami, and a dealer would be wise to pursue it there.

Compared to the transformations of the gallery enterprise by the explosion of art fairs, the growth of a handful of franchises with a slew of international galleries seems like a minor shift in the primary market (Chong 2011; Adam 2014). Outside of the empires of Gagosian, Pace, Zwirner, Marian Goodman, Barbara Gladstone, and Hauser & Wirth, what difference does the franchise make to the rest of the primary market? The question of branding was earlier in relation to museums, and it is a considerable shift that has been introduced to the gallery domain as well. As noted above, many commercial galleries are headed by one or two charismatic figures after whom the gallery is named, and the implication is that when one makes a purchase of new contemporary art from a dealer, her name is the guarantee of the authenticity of the work, as well as of aesthetic sensibility. If a buyer likes a dealer's discriminating taste, she will probably frequent that person's establishment. The franchise introduces branding into the equation, in which a dealer allows others to select on her behalf, provided the person in charge has the final word in the gallery on inclusion. The idea, fundamentally, is that Larry Gagosian is not only a man but a principle that can be reproduced in New York, Rome, or Hong Kong (Crow 2011). A gallery is thus depersonalized, and the dealer himself is commodified. A work bought at Gagosian is simply worth more than a work bought at almost any other gallery.

A growing trend is the opening up of multiple galleries in a single art center, a trend especially prominent in New York. Galleries such as Barbara Gladstone, David Zwirner, and Jack Shainman—longtime Chelsea residents all—have opened additional spaces in Chelsea since 2010, following larger galleries like Gagosian and Pace, which have added Chelsea outlets in addition to their existing Upper East Side galleries. Taking this trend even

further, Hauser & Wirth opened a Chelsea space in a former ice rink, with 24,700 square feet of gallery space (Adam 2014, 52). These new spaces allow the galleries to develop multiple projects at once, showing, for example, two incompatible media (like sculpture and video), or younger artists and estates of more established artists, or artists from totally different geographical areas (i.e., Africa and Canada). In this case, the multiple storefronts do not diversify clientele so much as allow the galleries to show, and to sell, more diversity in material at one time. It is also true that it affords these galleries a greater proportional representation of storefronts in Chelsea, which is the most competitive gallery neighborhood in the world.

International expansion is becoming more common, not only in the growth of the mega-galleries previously mentioned but also among galleries that want to establish permanent locations in two different markets. These, including the previously mentioned Gladstone and Zwirner galleries, have primarily opened spaces in the United States and Europe, the two primary markets for contemporary art. However, as the Chinese market has grown, various Japanese and European galleries have opened branches there, such as Beijing Tokyo Art Projects, Urs Miele, and Galleria Continua. Tang Gallery, of Beijing and Hong Kong, has also expanded to Bangkok, where it shows Chinese contemporary art. With the international franchise model, a gallery benefits from establishing businesses in various countries with distinct import and export regulations, which allows them, like Durand-Ruel in the nineteenth century, to perform arbitrage and avoid tariffs designed to protect cultural heritage or local artists. In effect, these galleries have learned lessons from multinational corporations that operate in multiple countries and exploit the local legal limitations to their best advantage.

However, a larger challenge to the norms of the contemporary art market has emerged from the grass roots of what was once the periphery of the art world. As more and more formerly colonized or marginalized countries are making strong economic gains, new galleries emerging in these economic centers have expanded the nature of the art market and challenged its singular logic.

2 GLOBAL GALLERIES: ONE MARKET OR MANY?

Some theorists see globalization as a form of neocolonialism, in which the powerful extend their reach to achieve domination over an ever-expanding

sphere of production and consumption. Speaking to concerns about a global conversation about art marginalizing those who do not read, write, or understand English, Jonathan Harris calls its use as a lingua franca a "damaging, homogenizing and flattening effect of globalization processes dominated by Anglo-American culture" (Harris 2011, 7). The implication is that globalization imposes norms on people who may not share them. Of course, globalization processes do primarily emerge from centers of wealth and power, and this is true in the art world as well. But globalization also includes a transformation of those same constructs, including the English language, by those who are subject to them, what Arjun Appadurai (1998) calls "indigenization." In such cases, those norms may be transformed in the process of adaptation, and art galleries (a Western construct to be sure) can take on distinctly indigenous features when they pop up in distant locales. The norms they develop in their own contexts are likely to be hybrids that might encourage the further elaboration and development of the gallery idea. In effect, the art market that has developed in what was once the periphery may begin to change the terms of the art market overall.

"The universally accepted gold standard which judges the accepted properties of international contemporary art and measures those judgments by a market price may not, in future, be the yard-stick by which the value of core art from emerging markets is determined," Iain Robertson writes. "Major civilizations like Greater China, the Persianate realm and Hindustan will determine the future pattern of the art and culture of their regions to the exclusion of the West" (2011, 13, 197). Robertson advances economic and political reasons for this, but he mostly avoids discussion of contemporary art galleries, and focuses chiefly upon artists, collectors, and auction houses..

Robertson's analysis serves as a demonstration of Olav Velthuis's assertion regarding circuits of commerce in the art market. "Rather than conceiving the art market as a single, homogenous entity, one needs to recognize that it is in fact composed of a plethora of smaller circuits, which each have their own actors, business practices, regime of value, and logic of action," Velthuis says (2012, 38). This is instructive because what one finds, if she scratches the surface of the global market for contemporary art, is not a single coordinated market, but a fragmented yet integrated domain for the construction of value. Seen this way, Robertson's conclusions do not suggest a wholesale transformation, but rather that the differences between various circuits will become more divisive and might undermine the implied consensus around the international art market, leading to more pronounced regional divisions based on divergent cultural understandings of art and of commerce.

One point that demands immediate recognition is that globalization has differential impacts and effects. Just as American dominance of the art market means very little to most of the residents of Peoria, Illinois, say, China's recent rise to the second-largest art market in the world means very little to most of its 1.35 billion residents. The global cities model developed by Saskia Sassen and many other social scientists over the past fifteen years accounts for how certain locations absorb the effects of globalization—both good and bad—far more than most because they are uniquely positioned to obtain the benefits of this economic model. "The point of departure for the present study [her book *The Global City: New York, London, Tokyo*] is that the combination of spatial dispersal and global integration has created a new strategic role for major cities" Sassen wrote a quarter of a century ago (1991, 3). Though the cities she qualifies as global have long been centers of trade and banking, they function in four new ways: as "command points" for the world economy; as key locations for finance and specialized service firms; as sites of production, including the production of innovation; and as markets for these new products and services (3–4). It is clear that at least the last three of these functions pertain to the commerce in contemporary art.

Whereas the three cities that Sassen's study focuses on are all capitals of G-7 countries (Frankfurt and Paris are also mentioned), more recent studies of global cities have expanded to include many cities in the emerging world. A "Global Cities Index" has been produced biannually since 2008 by the global management consulting firm A. T. Kearney, which in 2014 for the first time added an "Emerging Cities Outlook," listing twenty cities in emerging economies that are experiencing the global integration formerly limited to the world's capitalist powers. A. T. Kearney's 2015 report lists seven cities in the Global South among the top twenty-five. "The Wealth Report," a survey by another management consultancy, Knight Frank, that lists the cities "most important to the world's wealthiest people" in 2015 located five of the top ten in the developing world. Questions might be raised about the methods used for ascertaining these rankings, but the fact is that between a quarter and a half of global cities lie outside of the West.

Robertson provides some idea of how galleries from the former periphery will shape the art market in his chapter on China. He notes that the first galleries in mainland China, in Beijing and Shanghai, were run by Westerners "to sell contemporary Chinese art to international collectors" and were housed in hotel lobbies. However, by the time he wrote his book, "gallery districts in both cities [had] also become magnets for cultural tourists" (Robertson, 2011, 76–7).

Currently, homegrown contemporary galleries have sprung up to cater to the tourist market, but there are also serious galleries with international profiles run by Chinese dealers. These gallery districts (798 in Beijing and M50 in Shanghai, among others) have come into existence since 2000 with the aid of the regional governments (Currier 2008). The idea was to repurpose postindustrial sites in developing residential areas of cities, and though these districts are not exactly marketed to tourists, those interested in the arts are able to find them.

As with any other gallery district, there are some galleries that focus on avant-garde developments and others that are more commercial ones. The commercial element is especially pronounced in M50. Ferdie Ju, a Chinese national who runs Gallery 55 there, brought the gallery from Thailand in 2005 and has recently opened an experimental nonprofit space in one room of his gallery called YELLOW.ANTS.ART.LAB, demonstrating the overlap that occurs in many areas of the cultural sector in China, where commercial and institutional worlds are often blurred. "YELLOW.ANTS aims at bringing out focused experimental proposals in order to provide a battleground for artists to organize the main thread of their artistic creation, and to offer a chance for them [to] expose their work on the international contemporary art stage," he has said (Gu 2013). Ju, who spent years in the banking industry in London, Hong Kong, and Bangkok before starting a gallery, typifies a particular kind of global dealer who is aware of the norms of Western galleries and institutions and seeking to introduce them in China. But he is also a gallerist who goes beyond the limitations of his Western counterparts with his nonprofit experimental project space, which occupies a space adjacent to his commercial gallery.

A similar interest in experimental art can be perceived in the gallery Nature Morte, opened by the American Peter Nagy in Delhi in 1997 (figure 16). There were no other avant-garde galleries in Delhi at the time, and Nagy provided a platform for younger artists, many of whom are now quite famous, to present their work. Like its contemporaries in China, Nature Morte promoted new forms of self-expression in India and introduced artists whose work was palatable to international collectors, but at rates well below prices that would be paid in Western art capitals. Such galleries, in China and India, but also elsewhere, were the first in developing economies that went beyond traditional media, such as painting and sculpture, as well as cultivating artists whose work had been inspired by contemporary developments in Europe and the United States from the 1960s and later, such as Minimalism and Pop art. Chinese and Indian artists had long been international in their approach, exhibiting in art

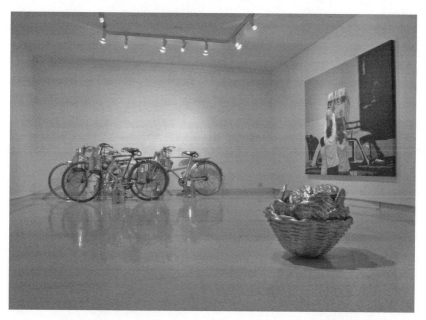

FIGURE 16. Subodh Gupta, *Saat Samunder Paar* solo exhibition, Nature Morte Gallery, New Delhi, December 13, 2003–January 15, 2004. Courtesy Nature Morte, New Delhi.

capitals and attending residencies around the world, but these new galleries introduced a whole new range of artistic experimentation, which would change the dynamic of the art world in these countries.

In Latin America, such experimentation had been the norm, and one might argue that at several points in history (Mexico in the 1930s, Brazil in the 1960s), Latin American artists were ahead of their North American contemporaries in terms of aesthetic experimentation. For this reason, and thanks also to the government's strong support of the arts in many Latin American countries, there is a long-standing presence of galleries in cities such as São Paolo, Buenos Aires, and Mexico City. There were around a hundred galleries in Buenos Aires in 2008, and thirty prominent galleries are listed in São Paulo and Rio in the same study (Goodwin 2008, 49,85). Mexico City has a number of long-standing galleries, but its recent growth has been exceptional (see Mexico City profile). One gallery that deserves particular attention is Kurimanzutto.

José Kuri and Monicà Manzutto, the two Mexican owners of Kurimanzutto, began exhibiting contemporary Mexican artists at a market stall in Mexico City in 1999, and they opened a large (4,200 sq. ft.) gallery space in the

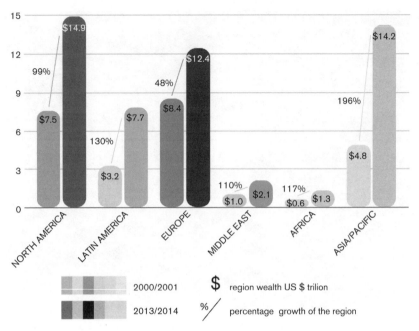

15
12
99%
9
48%
$14.9
$12.4
196%
$14.2

$7.5 $7.7 $8.4
6 130%
 $4.8
3 $3.2
 110% 117%
0 $1.0 $2.1 $0.6 $1.3

NORTH AMERICA LATIN AMERICA EUROPE MIDDLE EAST AFRICA ASIA/PACIFIC

2000/2001 $ region wealth US $ trilion

2013/2014 %/ percentage growth of the region

FIGURE 17. Wealth of high-net-worth individuals, 2000–2001 and 2013–14 compared. Data from McAndrew 2015. © Eva Krchova.

Chapultepec neighborhood in 2008 (frontispiece). The couple first met in New York, where Monicà Manzutto worked at the Marian Goodman Gallery to learn the business. Now they not only represent many of the most prominent Mexican contemporary artists but have embraced international contemporary artists such as Rikrit Taravanija (Thailand), Adrián Villar Rojas (Argentina), Pavel Althamer (Poland), whom they represent in Mexico. They show often at international art fairs in Mexico, but also in Miami, London, and Basel. Though their clientele was primarily international collectors at first, that has changed since their artists have secured some of the most prestigious international exhibition venues (Yablonsky 2011). In a brief time, Kurimanzutto has gone from a gallery without a permanent location to become an international leader in representing contemporary art. Though it is only one example, Kurimanzutto's history reveals a couple of major trends in the evolving art market in global cities: the growth of a new wealthy class, dubbed high-net-worth individuals (HNWIs) and ultra-high-net-worth individuals (UHNWIs), and the need to improvise in order to bring art to the public in crowded, expensive cities.

The rise of HNWIs and UHNWIs is a major development, and these have become the most common terms for describing the new proliferation of global wealth. The category of high-net-worth Individuals, meaning people who have assets totaling $1 million or more (not counting the equity in their homes), was introduced by the global consulting firm Capgemini and the Merrill Lynch investment bank in 1996. A report on these individuals and their distribution around the globe is now published annually by Capgemini and RBC Wealth Management. The most recent report shows that, as you might expect, the largest percentage of the world's wealth is concentrated in the United States, but emerging economies have accelerated their wealth acquisition much more quickly (figure 17). Between 2000 and 2014, the total global population of HNWIs went from 7.1 to 13.7 million, and, in the same years, emerging markets have seen their share of global wealth increase from 12 to 21 percent (Capgemini and RBC 2014, 2015). Clare McAndrew analyses their figures in her 2015 art market report. HNWIs portfolios include 10 percent of investments for "passion," and 17 percent of that amount is invested in art globally (McAndrew 2015, 125–37). A back-of-the-envelope calculation would suggest that, since the total wealth of HNWIs globally is currently estimated at $52.6 trillion, approximately $5.26 trillion is invested in desiderata, of which 17 percent, or $894 billion, is invested in art.

Needless to say, if the emerging economies' share of global wealth has almost doubled, that means that there is a lot of money coming into the art market from HNWIs in emerging economies. This fact, coupled with the trend of explosive growth of the contemporary segment of the market, adds up to an appetite for contemporary art in the emerging global cities where wealth is being created. While it is true that Kurimanzutto has increased its sales to Mexican collectors as a result of the rising prominence of its stable of Mexican contemporary artists, it is also true that a rising class of wealthy investors in Mexico, including the world's richest man, Carlos Slim, is interested in buying art. The primary market is fueled by contemporary galleries that have come to prominence as a result of this rising wealth, but there are many others, such as LABOR, Gaga, and the venerable Gallería de Arte Mexicano. In the case of Mexico City, Eugenio López Alonso, who started the Jumex Foundation for Contemporary Art, has perhaps done more to support and to promote Mexican contemporary art than any other individual. A broader trend, in which both Kurimanzutto and the Jumex Foundation are participating, is traced in the various profiles of emerging art centers in this volume.

Emerging Art Center

MEXICO CITY

Mariana David

Mexico City is at a compelling crossroads between the nationalist model that institutionalized Mexican art and the neoliberal model of privatization. Cultural projects are promoting political positions in a context of systemic violence and social unrest. But will the gap between reality and representation perhaps grow even larger?

Boasting the largest concentration of Spanish-speakers in the world, Mexico City is among the most important financial centers in the Americas. Despite its bad reputation as a highly polluted, dangerous, and chaotic place, in recent years there has been a rise in migration of highly skilled persons from developing countries, mainly working in the creative industries. Mexico ranks eighteenth in the world as an exporter of creative products, and is the only Latin American country in the top twenty (Mendoza Escamilla 2013).

It is no coincidence that creative capital is one of the five industries that are key to the country's international image. As an urban society, Mexico is about seven centuries old, and its cultural heritage is seen as a basis for selling products of considerable cultural weight, adapting them to the dominant Western culture. This gives way to many contradictions, such as indigenous people living in extreme poverty and treated with discrimination while their pre-Colombian past is praised in museums, exhibitions, and auction houses. The National Institute of Anthropology and History (INAH) has long been a major public institution in Mexico. It was established in 1939 to guarantee

the research, preservation, protection, and promotion of the prehistoric, archaeological, anthropological, historical, and paleontological heritage of the country. Its creation has played a key role in preserving the Mexican cultural heritage that has been crucial for cultural exports.

The tendency to privatize all sectors including the arts and culture is a global trend, but Mexico's particularity lies in a historical ability to capitalize on its folklore and cultural diversity in order to create a national identity and to establish all sorts of institutions to promote the arts. Institutions are an essential part of Mexican culture. The Mexican Revolution ended with the foundation of the Institutional Revolutionary Party (PRI), which governed the country for more than seventy years and has recently assumed the power again.

Despite its federal structure, Mexico's political and economic systems are highly centralized. In 2011, the Greater Mexico City area marked a gross domestic product of U.S.$411 billion, making its urban agglomeration one of the economically largest metropolitan areas in the world. The city itself was responsible for generating 15.8 percent of Mexico's gross domestic product, and the metropolitan area accounted for about 22 percent of total national GDP.

Mexico City's boom as a trendy location is directly related to how the city has been publicized through its art institutions and cultural assets. The city's name itself is handled as a brand, with a recent political reform changing its name from México Distrito Federal (Mexico Federal District) to Ciudad de México (CDMX; Mexico City). With its own political constitution to be developed through 2016 and 2017, CDMX will remain the country's capital, but will count as the thirty-second federal entity. There is much talk by politicians of public participation, but the fact is that decision making is largely influenced by corporate interests which are clearly changing the city's image. Located in strategic public squares, the letters CDMX have been erected as sculptures so that people can take snapshots in front of them. The recent victory on the part of citizens seeking to stop the construction of a High Line–style park on historic Chapultepec Avenue, promoted as a "cultural and commercial corridor," is an example of fast-growing forms of public participation that counter political interests aligned with the neoliberal project. Culture and the arts serve as incentives to win the citizens' approval, even when the real purpose for construction is to privatize public space and generate the majority of benefits for investors. The project's planning process was held behind closed doors, with the city's mayor and corporate stakeholders deciding on it before opening it for public consultation (Bliss 2015).

President Carlos Salinas de Gortari (1988–94) signed the North American Free Trade Agreement (NAFTA) with the United States and Canada, officially bringing Mexico into the neoliberal period. Neoliberal policies have resulted in a growing precariousness of working conditions, rising costs of food and services, and the decline of the welfare state. A body independent of the Ministry of Public Education, the Consejo Nacional para la Cultura y las Artes (CONACULTA; National Council for Culture and the Arts) was thus created in order to promote, support, and sponsor the arts and culture. For some decades, this government agency benefited artists, curators, and independent arts projects with a system of grants and was responsible for promoting several blockbuster exhibitions on Mexican art abroad. CONACULTA recently acquired secretariat status, again without public consultation. Many experts have suggested that these developments follow economic policies, typical of globalization, that aim to increase production and consumption without addressing the cultural richness and diversity of the nation through education. For workers in the public sector, there is a legitimate concern as to how they will fit into this model that seeks the private sector's increased participation. Facing the violence of recent years, CONACULTA's official discourse has been that culture is a means of repairing the social fabric, even as labor conditions become more precarious for its workers. The mode is changing from state benefits to outsourcing and recurring budget cuts.

Furthermore, the CDMX government also has a cultural secretariat, which came into being as a social service and slowly moved into the cultural domain. Its general objective, in the institution's own words, is to develop, coordinate and execute public policies that guarantee the full exercise of the cultural rights of people and communities, therefore giving way to an integral development and strengthening the democratic conviviality in a framework of free expression of ideas, equitable access of goods and cultural services and the recognition and protection of the diverse identities. The idea of culture as a social instrument is very much rooted in Mexico City's institutions. Opened in the year 2000, the Faro de Oriente (The East Lighthouse) is the most successful of a series of arts and crafts workshops established in Mexico City's peripheral neighborhoods to combat insecurity. There are genuine intentions on behalf of cultural workers to change social conditions through the use of arts and culture, but bureaucracy and corruption stand in the way.

Mexico City's incursion into the international art circuit had much to do with the success abroad of the Mexican artist Gabriel Orozco and his

becoming a public figure in Mexican society. The "do it yourself" approach of independent spaces and the impact of foreign artists living and working in the city in the 1990s generated much interest from the international art community. The discourse of alternative spaces gave way to the internationalization of Mexican art and the welcoming of a counterculture into the mainstream as part of President Salinas de Gortari's agenda.

Since 2003, the Simposio Internacional de Teoría sobre Arte Contemporáneo (SITAC; International Symposium on Contemporary Art Theory) has brought a wide range of renowned artists and theorists to Mexico City. In 2015 the symposium dealt with the construction of justice through contemporary art, proposing to include actors outside the field who address the need to contribute to more just societies in the context of the international crisis we currently experience. Many questioned the effectiveness of identifying art and justice as though they were equivalent categories. Panelists argued about the conditions in which contemporary art is legitimized in relation to political and economic power structures that cause injustice and corruption.

In the past decade, Mexico City has seen the opening of numerous art galleries, owned both by locals and foreigners, whereas the market was previously concentrated in a very few. Zona Maco has established itself as the leader in Latin American art fairs, satisfying the need for artistic goods in the region and the curiosity for a newfound creative force in Mexican art production. "A lot of that must have to do with a difficult social condition of this city and country, so there's a lot of things that artists are taking responsibility for discussing. It's challenging, they're really asking us to think about things. I'm not seeing that happen anywhere else right now," the Los Angeles–based gallerist Marc Foxx said in an interview (Stromberg 2015a). But where is all the money coming from when the number of people living below the poverty line is increasing? The lack of regulation in the global art market opens the door for money laundering, and at the same time the fast-growing Mexican bourgeoisie is finding it attractive to invest in contemporary art. Between 2006 and 2012, the Secretariat of Finance confiscated 191 works of art, including a Van Gogh painting that had sold for U.S.$82.5 million in 1990 (Garza 2013).

Private art collections such as the Colección Isabel and Agustín Coppel and the Colección Jumex have given contemporary art a high value as an investment and as a medium for social status. The Coppel family owns a company founded in 1941 in the state of Sinaloa that has developed into a chain of department stores offering credit with few requirements and free delivery,

very popular with migrants sending money home. The couple started their collection in 1990 mainly buying Mexican modern art, establishing a civil association some years later in order to reach a larger audience.

Jumex is a brand of juices and fruit nectar very popular in the Hispanic community in the United States. Established in 2001, the Fundación Jumex Arte Contemporáneo has since supported contemporary art practice with a special interest in education, both through publications, grants and scholarships of which many Mexican art specialists have benefited at some point. Designed by British architect David Chipperfield, its museum space is located in a new corporate neighborhood developed by the billionaire Carlos Slim.

Another major cultural institution is the Universidad Nacional Autónoma de México (UNAM; National Autonomous University of Mexico), the largest public university in Latin America. UNAM has been defended as a space for scientific research and freedom of expression, being independent of the federal government. Sadly, it hasn't been able to avoid political influence, but it is part of Mexico City's proud identity. Its Coordinación de Difusión Cultural manages the university's radio and television broadcasts, publications, film festival and archives, museums, and dance, music, and theater departments. The Museo Universitario Arte Contemporáneo (MUAC; University Contemporary Art Museum), a long-standing project, was finally completed in 2008 as "the largest public institution in Mexico to accommodate a collection of national and international contemporary art." Located within UNAM's cultural enclave at the south end of the city, MUAC has launched the prize-winning program "El Muac en tu casa" (MUAC in your home), lending works from its collection to students, who proudly exhibit the artworks temporarily at their homes. MUAC also has an academic program that considers the museum not only as an exhibition space but as the site of production of critical knowledge. Both MUAC and Museo Rufino Tamayo (Mexico's first major museum build with private funds in 1981) have consolidated a network of collaborations with international museums through their exhibition programs. Also, they have recently presented blockbuster exhibitions that broke attendance records. It is a fact that museums face the challenge of integrating marketing strategies in a world of corporate logic. Critics point to the strengthening relations between these institutions and the market, transforming the dominant aesthetics of contemporary art into concepts like product, originality and discourse.

Artist-run spaces that value the process over the product search for alternate forms of production. Crater Invertido (Inverted Crater) is organized as

a cooperative that understands art practice as a means of social engagement. This collective was formed by ten artists and activists who run an archival space and DIY publishing workshop in Mexico City's Obrera neighborhood. The need to have spaces for collective work and exchange has become so evident that most artist-run spaces are looking to go beyond the exhibition format and into the working-class neighborhoods before they start to be gentrified. As Mexico City's historic neighborhoods are quickly changing due to mega projects imposed by the local government and the accelerated rate of the real estate companies, are artists conscious of their role in these urban processes?

Beyond the art circuit there seems to be the intention of finding a transcendental motive for culture and the arts, a place free of the contradictions the art world creates. Many artists and cultural promoters are evidently looking to community work to activate the symbolic where it is needed. Palo Alto, one of the oldest housing cooperatives in Mexico City, was chosen to represent Mexico in the Venice Architecture Biennale 2016. Palo Alto is a community of immigrants from Michoacán who arrived at the beginning of the twentieth century to work in the sand mines of Santa Fe. When facing displacement they organized a cooperative to fight for their housing rights. Today they stand surrounded by Mexico City's most exclusive residential and corporate areas. Another example is Permanecer en la Merced (Remain in La Merced). After a fire burned a great part of one of the oldest public markets in the American continent, the local government has tried to move the merchants out without their consent. In collaboration with Left Hand Rotation and Contested Cities, a group of merchants participated in a series of workshops and filmed a documentary that has been screened internationally.

Citizens, including some art professionals, are searching for more effective ways for culture and the arts to develop. The problem about public institutions is how they serve the government to validate its own right to power, a government that keeps promising security, better working and living conditions and justice. Meanwhile, the private sector follows the rules of the free market, which undoubtedly seem to oppose the common good.

Expansion and Diversification of Auction Houses

1 CHRISTIE'S AND SOTHEBY'S IN EMERGING MARKETS

Most of the press on the art market begins and ends with two names: Christie's and Sotheby's. Though there are other international auction houses, such as Phillips and Bonham's, none come close to the volume and value of sales of the two titans of the industry. Together they controlled 42 percent of global fine arts auctions market share in 2014, with combined $14.4 billion in revenue. In the past, their market shares have been roughly equal, but in 2014 Christie's pulled ahead of Sotheby's, with $8 billion and $6.4 billion respectively (McAndrew 2015, 26–27).

These two auction houses are often in the news, usually for "record-breaking prices" paid. There are so many categories, it seems that it is not unusual to break a record, or a few, with every major sale, but the fact of increasing prices paid for the most desirable lots suggests a steady increase in value in the art market. In fact, Christie's and Sotheby's are so ubiquitous in the media that it is not surprising that many confuse their sales with the art market, for every trend they establish is an art market trend. However, the fact remains that most fine art that is bought and sold worldwide, even at auction, does not pass through their hands.

That said, if one wants to understand the development of the art market in emerging economies it is crucial to look at what Christie's and Sotheby's have done to expand the global market for art. If a handful of dealers have begun international franchises, they are following a model already perfected by these established titans of the industry whose histories go back to the eighteenth century. As Noah Horowitz makes clear in his analysis of growing contemporary art markets in emerging economies, Christie's and Sotheby's

are always part of the story, even if they are not the first ones to get in on the action (Horowitz 2011, 204–6).

A few facts about the secondary art market overall are worth recounting before diving into an analysis: Auction sales account for 48 percent of the global art market (€24.6 billion) and have increased 150 percent in the past ten years. "Global public auction sales have more than doubled in the decade from 2004 through to 2014, with high prices in the fine art market, the emergence of China's auction market and strong sales in the US all driving prices higher," Clare McAndrew writes (2015, 26). In auction sales, the United States led, with 35 percent; China had 31 percent, and Britain 20 percent by value (27). By volume, the United States had 20 percent, China 19 percent, and France was third at 12 percent; "Rest of World" (i.e., everyone but the top eight) had 20 percent (28). China is the only emerging economy that has developed into a major player in the secondary market, where it has already nudged out all competitors but the United States. In fact, in 2011, China briefly became the largest auction market and this was the case without the presence of Christie's and Sotheby's in mainland China. So one central issue to address here is how the Big Two have leveraged their auction houses in Hong Kong and have made strides into the Chinese market on the mainland.

Among the other figures given above, the most curious to me is the fact that, as a category of the auction market, "Rest of the World" is the largest geographical sector by volume, beating out every major auction market (figure 18). Needless to say, that category is diverse and diffuse, including both Switzerland and South Africa, but it suggests that the centralization of the art market may have reached a peak and is now moving in the opposite direction. Though there are no direct comparisons for auction volume over time, the U.S. auction market share by value decreased from 57 percent at its peak in 1997 to 29 percent in 2011, while China's percentage rose from 1 percent in 2002 to 30 percent in 2011 (McAndrew 2012, 69). Other emerging markets have also grown, if not so dramatically, in the same period, so it should not be a surprise that the past twenty years have seen the expansion of Christie's and Sotheby's into many new markets, and this is a story that will be investigated here. They are, in effect, the multinational corporations of the art world and, in the language of globalization, they are market leaders whose activities have connected previously discrete portions of the earth into a pair of vast commercial empires.

The categories that Christie's and Sotheby's use to aggregate their sales data make it difficult to determine which emerging markets are really taking

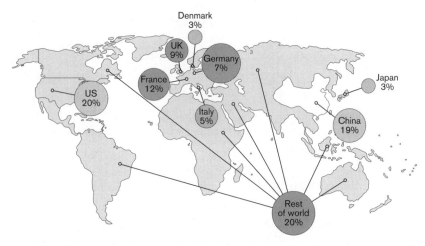

FIGURE 18. Fine art auction market global share by volume, 2014. Data from McAndrew 2015. © Eva Krchova.

off, since both divide sales into Europe, the Americas, and Asia. The Asian sector, clearly derived from emerging economies, increased considerably for the two houses in 2013, but it has decreased (or flatlined) in 2014, likely a result of slowing economic growth. Christie's reported $806.2 million in auction sales in Asia in 2015, down from $977.5 million in 2013 (Christie's 2014, 2016), and Sotheby's reported "over $900 million" in 2014, as opposed to $931.4 million in 2013, with sales in China not reported in 2015 (Sotheby's 2015). It should be noted that even though Sotheby's and Christie's both achieved their first auctions in mainland China in 2012 and 2013 respectively, their Asian totals are roughly equivalent to the largest Chinese auction houses, Poly and Guardian, operating in the domestic market with €908 and €621 million in fine art sales respectively (TEFAF 2015). In the summer of 2016, Bloomberg reported that Chen Dongsheng, founder of China's Guardian auction house had disclosed a 13.5 percent stake in Sotheby's, and another Asian investor, Singapore-based Shanda Payment Holdings Ltd., was poised to increase its current 2 percent stake (Jinks 2016). Christie's notes that its Chinese buyers were responsible for 27 percent of auction sales worldwide, a staggering figure (Christie's 2015a). Meanwhile, Chinese investors are acquiring a portion of publicly traded Sotheby's.

Christie's holds auctions in Dubai, Hong Kong, Mumbai, and Shanghai, and Sotheby's does in Hong Kong, Beijing (partnering with the state-owned

GeHua Art Company), and Doha. The two houses also have offices worldwide—Sotheby's has seventy-two; Christie's, fifty-three. (However, these are often staffed by only one representative, so it is best not to overemphasize their reach.) Through its extensive network of experts in various departments, these large firms are able to source material and collectors throughout the world. The specialists in various departments are the connective tissue that brings global art and global buyers to market: the firms' South Asian departments, for example, employ experts (usually art history PhD's) who can understand and evaluate the historic and potential economic value of older works of art in private collections, whether they are housed in New York, London, Mumbai, or Dubai. Expertise is a little more elusive for contemporary art than with traditional art, and both houses have this staff as well. Regional experts in specialized departments are often the pathway to collectors of contemporary art in emerging economies. Though these specialists are headquartered in New York or London for the most part, they travel to wherever there are collectors to see, often living in hotel rooms and eating at receptions and power lunches. While their work is driven by business, and there are always reproductions on their laptops, most visits are not determined by a specific objective but are designed to pave the way for more intimate acquaintance and future deals. There could hardly be a better picture of the global service economy than a Christie's or Sotheby's specialist.

This image of the auction house experts who travel the globe to enhance their portfolio of art works and collectors introduces a geographical issue that is lurking behind the discussion so far offered. Christie's and Sotheby's were both companies begun in London, and they are primarily housed there and in New York, but they are expanding from these centers to encompass a new emerging market. Put this way, it sounds a bit like the history of colonialism, in which European explorers ventured afield and found new lands and peoples and subjugated them, making them part of the European domain of property, labor, and taxes. While there are arguments to be made for an imperialist line in Christie's and Sotheby's as multinational corporations seeking to maintain their market dominance, the question of geography (center/periphery) is actually one that is undermined by their practices. As Manuela Ciotti, writing on a contemporary Indian art exhibition, *The Empire Strikes Back,* on view at the Saatchi Gallery in London in 2010 put it: "The epicentre of this [contemporary South Asian art] market is not Europe and the US—despite the 'west' still playing a major role in this story. At the same time, this is not a fully Indian story either; it is in fact a truly global one

made up of galleries, auction houses, art fairs, business enterprises, buyers and artists operating at several geographical nodal points" (Ciotti 2012, 639).

If globalization has been sometimes described as the spread of a very particular style of neoliberal economics from New York and London into the world at large, the story of Christie's and Sotheby's provides a different point of view. Sure, they are global brands with clear business strategies to open up the world and expand their commercial activities. But in so doing they displace their own dominance and have to come to terms with the interstitial spaces where transactions take place as well, as the relative dispersal of power, money, and art across the surface of the globe. By following this transit, new patterns are formed that remake the periphery and the center, despite the fact that profits realized go to shareholders primarily in the United States in Sotheby's case, or to an already very wealthy Frenchman in the case of Christie's (François Pinault, who has owned the company outright since 1999). Ciotti's "geographical nodal points" are not defined further, but it may be assumed that they align closely with what I have been calling global cities.

Mukti Khaire and R. Daniel Wadhwani, who have studied the growth of the art trade in emerging economies and the role played in it by Christie's and Sotheby's, observe of the market for "modern Indian art" that has sprung up since 2000: "The works that are today characterized as modern Indian art were produced between the early 20th century and the 1980s; yet for most of the 20th century, these same works were usually classified and traded (if at all) as part of the traditional or provincial art of the Subcontinent. The major international auction houses either ignored the work or lumped it in with other South Asian art in auction catalogs and exhibits (Khaire and Wadhwani 2010, 1289).

Auctions turn out to be essential in the development of the market for this material. Auction catalogs both trace and craft a new consensus about modern, as opposed to provincial, art in India. Institutions such as the Tate Modern and New York's Museum of Modern Art played a role, Khaire and Wadhwani note, but the rapid changes in prices for modern Indian art at auction were also significant. Between the late 1990s and 2007, the average price for a work of modern Indian art grew more than sevenfold—from $6,000 to $44,000. The record-breaking prices paid in New York for modern Indian art at Christie's and Sotheby's in 2005, when works by Tyeb Mehta sold for over $1 million, were a watershed. Christie's Modern and Contemporary Indian sale the next year garnered over $17 million, a huge

surge from the first such sale in 2000, which brought in just $600,000, according to then Christie's specialist in modern and contemporary Indian art, Yamini Mehta (IANS 2006).

This is especially impressive because prior to 1997, there were neither sales for nor experts devoted to modern and contemporary Indian art at Christie's and Sotheby's. In fact, Yamini Mehta helped to start the Christie's Indian Art Department, and in 2005, she was made the first director of its new South Asian Modern and Contemporary Art Department. Since 2012, she has worked as the international head of South Asian Art at Sotheby's. This is a sign of the increasing prominence of the contemporary art market in South Asia. Now Christie's has opened a salesroom in Mumbai. Its first auction there in December 2013 was devoted to modern and contemporary Indian art, and the auction total was $15.5 million. Sotheby's has not yet held an auction in India, but it held the first sale devoted to modern and contemporary South Asian art (the Herwitz Collection) in New York in 1995. Sales of this material take place in New York or London and are irregular, depending on unique opportunities for the sale of entire collections. After initial the Herwitz sale, Sotheby's continued to sell works from that collection in 1997 and 2000, and in March 2013, it sold works from the Amrita Jhaveri Amaya collection.

Christie's and Sotheby's auctions and catalogues were a structural component in driving the rise in values and the concomitant rise in prestige for Indian modern art, according to Khaire and Wadhwani. For both Christie's and Sotheby's, as well as for other auction houses, the acceptance and valuation of modern Indian art has occurred simultaneously with the valuation of contemporary Indian art, and these categories are inextricable in the history of art auctions of Indian art works. Indian art has been grouped with the art of other nations, including Pakistan, Bangladesh, and Sri Lanka in the category South Asian modern and contemporary art. Bundling discrete and antagonistic nations into a single regional category has the advantage of looking at art developments outside of the narrow context of nationalist conceptions, but it also serves to create a single comprehensible market for modern and contemporary artists in the region.

Looking at Christie's and Sotheby's other regional departments reveals a recurring pattern, with a possible exception being Latin America. Despite growing concentrations of wealth in Latin America, no sales have been held by Christie's or Sotheby's south of the U.S. border. But the Big Two do time their sales of Latin American art, held twice annually, to coincide with

an art fair devoted to Latin American art (PINTA) held during the sales in November. They have thus contributed to the branding of a new multidisciplinary cultural platform, Latin American Culture Week in New York, which began in 2006, under the auspices of Pan American Musical Art Research. Like Frieze Week, Latin American Culture Week brings together a variety of cultural institutions to participate, making New York a destination for Latin American culture vultures. Asia Week, held in March, began in 2009 and was organized by a group of dealers at the time of Sotheby's Asian auctions. These events market art, culture, and lifestyle, targeting specific art-collecting populations, and they serve as important points of entry for new collectors from emerging economies to engage with the auction market.

One can also perceive echoes of the Indian contemporary art story in the Middle East and in China. Christie's opened their first office in Dubai, UAE, in 2005, and in 2006, it held its first auction there, which has led to a string of more auctions happening annually and then semi-annually, whose presence in the region has driven up prices for modern and contemporary works by Arab and Middle Eastern artists in general. Christie's claims in a promotional video (2014b) to have broken more than 350 sales records for artists in its Dubai sales. Meanwhile Sotheby's has established itself in neighboring Doha, Qatar, where in 2013, it brought in more than $15 million, a record in Middle East art auctions. Both Sotheby's and Christie's have long-standing Islamic art departments that have worked over the years with Middle Eastern clients. In their Middle Eastern sales, however, they have presented modern and contemporary Middle Eastern artists alongside Western artists (the most expensive pieces at the record-breaking Sotheby's sale were works by Donald Judd and Julie Mehretu) in order to entice local collectors. Michael Jeha, managing director of Christie's Dubai, estimates that half of the buyers in Dubai are from beyond the region (Christie's 2014b).

Owing to restrictions on foreign ownership of businesses in mainland China, the situation there is a bit more complicated, so Hong Kong has long served as the Asian hub for the two auction powerhouses. But both have recently held sales in China (Christie's in Shanghai and Sotheby's in Beijing), blending a variety of modern and contemporary art and other luxury items, such as watches and jewelry. Chinese auctions have been plagued by a variety of problems specific to that market, such as authenticity challenges and purchasers who are slow to pay for their items (Barboza et al. 2013), and though no problems have been aired publicly at Christie's and Sotheby's, it would seem unlikely that they would not have to confront such challenges. Perhaps

for this reason the thrust of recent auction sales has been on contemporary art. Nevertheless, the growing wealth in the Asia Pacific region has led to increased consumption of luxury goods, including art, so Christie's and Sotheby's find that they must engage in this surging market or be left on the sidelines.

The last major point to make about the recent geographical expansion of Christie's and Sotheby's is that it has been accompanied by a general diversification of their business model, including art shipment and storage, as well as other financial services, including financing and credit cards, real estate, and luxury goods such as jewelry and wine. There are two kinds of expansion happening here as Christie's and Sotheby's try to capture of greater share of the market in luxury services that has emerged as a major global growth trend (Kapur et al. 2005) in the past generation. On one hand, they are pursuing vertical integration, or capturing the entire value chain of their service sector by offering art appraisal, photography, storage, transport, and financing. In other words, they are trying to consolidate all of the other art services industries into their own businesses.

The Big Two are also now commissioning works directly from artists, as in the Damien Hirst sales at Sotheby's in 2008. Whether this will become an ongoing trend is anyone's guess, but it does raise hackles in the primary art market, because just about any dealer could easily be plowed under by one of these multinational auction houses. After Christie's bought the London contemporary art gallery Haunch of Venison in 2007 ("Smoked Venison" 2010), it decreed that it would no longer represent artists, but would instead concentrate on private sales in the secondary market (Milliard 2013b).

On the other hand, these auction houses are also diversifying their service offerings. Though fine arts is what they are best known for, like all auction houses, they have handled estates throughout their existence and so it is not surprising that their furniture and jewelry departments cater to luxury tastes. Recently both Christie's and Sotheby's have expanded their real estate businesses, though Sotheby's expansion is far greater in this regard, and it has become something of a realtor for expensive, not only luxurious homes. The auction houses now operate like banks to a certain degree, offering loans against works of art, price guarantees on works going to auction (though these are also being offered by third parties), and now even credit cards (ostensibly for the ultimate luxury shopper). And given that all of this luxury spending involves jet-setting, it is perhaps no surprise that these companies offer travel services as well.

These vertical and horizontal expansions in the growing luxury-services sector make good business sense for the big auction houses, and extra services may keep these large ships afloat in the turbulent waters of the twenty-first century economy. But the auction market is expanding globally, and auction houses in emerging economies are developing their markets as well.

2 RISING AUCTION HOUSES AND THE SHIFTING SANDS OF THE GLOBAL ART MARKET

According to Clare McAndrew's Art Market Report for 2015, the United States and "Rest of World" tied for the largest geographical segment of the fine art auction market, each coming in at 20 percent of total sales by volume. China was in third place with 19 percent (figure 19). Aside from Japan (at 3 percent), all of the other countries listed were in Europe, so a full 42 percent of the fine arts auction market by volume was thus outside Europe and the United States in 2014, and, needless to say, that percentage has been growing in recent years (McAndrew 2015, 28). In 2011, it represented only 35 percent of the global market share (McAndrew 2012, 25–26). These data are a powerful challenge to anyone who asserts that the underlying geography of the art market, even the art auction market, has remained fundamentally unchanged by globalization (Baia-Curioni 2012; Quemin 2012; Velthuis and Baia Curioni 2015). At this rate, one would expect the Global South to overtake Europe and the United States for art auction transactions by 2020, but the economic cool down among emerging economies in the 2010s may well put the brakes on this trend. If one examines art auction sales by value, the story is somewhat different, with higher prices paid in the United States, China, and Britain, but the trend is equally one of expansion of the market in the Global South.

In order to understand how this change has come to pass, it is necessary to consider how auction market innovations have overtaken traditional flows of capital in the era of globalization, particularly the acceleration of these trends in the twenty-first century. One important fact to consider is the rise of the contemporary sector of the art market in general and the art auction market in particular. The other main factor is the global rise of Christie's and Sotheby's, which cater to an increasing clientele of affluent individuals worldwide. Such individuals tended to shop for art in market centers like New York and London, but one now finds them shopping more regionally.

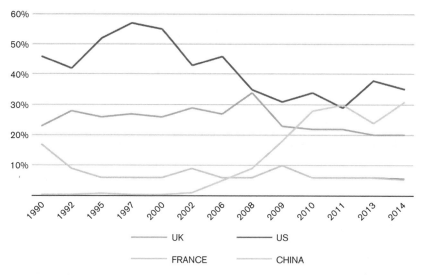

60%

50%

40%

30%

20%

10%

1990 1992 1995 1997 2000 2002 2006 2008 2009 2010 2011 2013 2014

———— UK ———— US

———— FRANCE ———— CHINA

FIGURE 19. Global art auction market share by value: fluctuation 1990–2014. Data from McAndrew 2012, 2014, and 2015. © Eva Krchova.

Moreover, with new auction houses, new art, and the increasing number of high-net-worth individuals in emerging economies, new collectors are entering the market. There are also new categories being forged for understanding and situating previously undervalued works of art. Khaire and Wadwani note that "[a]uction house texts played an important role in defining valuation in the new category. By introducing a set of key constructs derived from the broader discourse, auction catalogs not only helped generate an understanding of the new category, but also established the bases for comparing the aesthetic value of the works within it. Moreover, by presenting these constructs at the points of sale, they helped translate aesthetic value into economic value" (2010, 1294).

Auction houses thus help to innovate in the market system not only through the creation of new market categories but also in how they connect aesthetic to economic value. Khaire and Wadwani are highly creative in their application of discourse analysis to auction catalogs, revealing some of the structural principles that enable auction houses to develop broader commercial opportunities around undervalued art works that lack conceptual structures making them desirable to collectors. Modern Indian art, the category Khaire and Wadwani track, was introduced in 2000 by a new player in the art auction field, Saffronart. Now one of the world's largest online retailers of art,

Saffronart draws on a global clientele, but it is devoted to art from South Asia, particularly modern and contemporary art. It is but one of the most visible examples of the way the world of art auctions is shifting from a center/periphery model to one of regional clusters and global dissemination.

Since both Christie's and Sotheby's date back to the eighteenth century and Saffronart was launched in 2000, it would not be inaccurate to think of it as an upstart, but, like so many upstart businesses that have now become dominant global players (Google, Facebook, Uber), Saffronart is not only a challenge to accepted practices but a new business model founded on a distinct platform that did not exist previously. While it has borrowed from older auction houses in significant respects, by producing auction catalogues, for example, it has remade the industry for its products and set trends to which the industry leaders must adapt or face ever-decreasing percentage of market share at best. There is a range of innovations around Saffronart to consider here and all of them are significant in terms of understanding where the auction market is going today and how it will be transformed from within and without. The first is its platform, online sales. Secondly, this new auction house successfully introduced new aesthetic categories to market testing (and generated positive results). Finally, Saffronart continues to decentralize the market in favor of an alternative art auction sector that is gaining in prominence globally.

The New Platform: Online Sales

Online art sales have clearly not yet transformed the market for art in the way that, for example, the iTunes store has changed the market for music and Amazon has impacted book publishing (Velthuis 2012). But a series of concerted attempts have led to some promising developments, and the online sector of the art market has increased and is expected to do so further in the future. Estimated at €3.3 billion in 2014 (6 percent of the market), online art sales might conceivably increase by 25 percent per annum, with perhaps a €5 billion increase over the next three to four years (McAndrew 2014, 28; 2015, 177). Sotheby's sought to pioneer the field, partnering with Amazon in 1999 and eBay in 2003, but both of these efforts failed and closed in less than a year. However, Sotheby's web site allows viewers to follow auctions and bid online. In 2006, Christie's introduced online bidding as well, and though the online part of its business amounted to only 2 percent in 2014, there were seventy-eight online-only sales that year. According to Clare McAndrew,

"32% of buyers on the online platform were new, with buyers from 69 countries and 42% under the age of 45 years" (2015, 190). In 2015, Christie's digital sales were up 12 percent over the previous year, and in the first half of 2016, Sotheby's online sales represented 3.6 percent of total auction sales (Christie's 2016; Maneker 2016). Online auctions, then, would seem to constitute another strategy by the industry leaders to diversify their global business model (Kinsella 2010).

Christie's and Sotheby's efforts alone are strong evidence of a new global clientele entering the art market through online sales, and efforts by Amazon to grab a piece of the online art market share in 2013 support realistic projections that this is a burgeoning area of online retail. But a host of new portals have entered the online art market, including Artsy, Paddle8, Artnet Auctions, Artfact Auctions, and Auctionata (which recently merged with Paddle 8, indicating consolidation in this sector). Most of these are online auction houses, employing auction software to connect sellers and buyers, but some conduct their own auctions (or, in the case of Paddle8, act as proxies for non-profits conducting online auctions) and Artsy focuses instead on established galleries and follows art world events in real time. There are also online virtual art fairs, such as the VIP Art Fair, which was held twice, in 2011 and 2012, before closing, and the India Art Collective, launched later in 2011 and held one time only. However, although online art auctions and portals are expanding, and seem to be growing in scope and significance, these online art fairs have not achieved the desired results (Esman 2012). What makes one business model a success while others fail?

The rhetoric around online art portals and auctions is driven by democratization, an expansion of access and audiences that drives any online-based company. The problem of course is that the art world is, by and large, an elite domain and so conflicts arise with regard to how to generate the one-of-a-kind experiences that the art market thrives on, while introducing such experiences to a wider audience. But there are forces that seem to indicate that a drive toward broader access to art online could be productive. Noah Horowitz, writing on the rise in online art sales, has noted: "In short, we seem to be witnessing a paradigm shift away from conventional forms of connoisseurship and towards more overt forms of speculation, trophy hunting, and lifestyle consumption: the newer and trendier, the better" (2012, 91). This captures a new sensibility, often remarked upon, that collecting art is simply not as elite as it once was and has been embraced by a larger swath of the affluent population worldwide.

Online art portals attempt to increase circulation in various ways, some of which reinforce, rather than undermine, established social and market structures in the art world. Sites such as Art.com, Heritage Auctions, and Amazon Art seek to democratize art collecting, but the work they present is not the kind of art that gets shown in fine art galleries, and it is not taken seriously by the art world, though the existence of these sites delineates a market segment, acknowledged or not. In any case, one finds few works sold online priced in five figures, let alone six or seven, so this does not capture the most lucrative or successful elements of the art market. Sites such as these represent art by and for the masses, and there is no conflict between the elite market and democratic distribution of what are primarily multiples (prints or editions). There is another parallel art market here, with a successful business model, although one as yet not taken into account by art economists.

Artsy actively seeks to expand the reach of existing institutions and dealers, whether to popularize an international art fair or to offer direct connections to dealers or nonprofits that make sales. As such, it provides marketing and outreach tools, and, although it was originally available by invitation only, to secure the exclusive preserve of established art world insiders, it is now available to all online seekers. Funded by and focused on the currently dominant players in the art world, Artsy claims seven million visitors since its 2012 launch, with a quarter of a million registered users in 186 nations. Though algorithms guide searches for works of art on Artsy, one finds, as on Google, that one's taste is reinforced and consolidated rather than extended to unknown domains. As Iain Robertson points out, this site has changed the auction game: "The platform makes connections between the members of its online audience. The site acts as an educational tool and also assists the market in the transaction and logistics of art buying and selling. It is, in short, an alternative and virtual means of discovering new participants, educating a fresh audience, and completing a trade" (2016, 216).

Paddle8 merged with the online European Auction Portal Auctionata in the summer of 2016, but this partnership proved to be short-lived. This is another online art auction site that conducts its own auctions with now widely available auction software, but it also has developed a new market: publicizing and promoting art auctions for nonprofits, some of which are art world institutions, while others, like Teen Cancer America and the Human Rights Center at the UC Berkeley School of Law, are clearly not. The interesting point to make here is that those who might not already be art collectors could, by supporting their favorite charity

through an online benefit auction, end up finding more art that they are interested in purchasing. Paddle8 and Artsy are both art world expanders supporting art world institutions, but the scope of their product is limited in a geographical sense, being primarily sourced from traditional art centers.

Saffronart, K-Auction, Seoul Auction, and other auction houses in India and Korea that hold online auctions are a new development. The online platform is more democratic than an auction held in the lobby of a fancy hotel, which is the norm among auction houses in emerging economies. As with Artsy, there is global market penetration, since sales come from all over the world. But the product is distinct, because these auction houses focus their online sales on South Asian and Korean art respectively, extending that art into a global market. They are using the same formats and tools; in fact, Saffronart, which originated in 2000, was the pioneer of many online art auction developments. The work they promote has been traditionally undervalued, but the online auction venue adds both market transparency and broader access. Democratization of modern and contemporary art meets an international clientele and a burgeoning middle class in these postcolonial nations. National self-representation gets a boost from these online platforms in India and Korea, but they also compete with online art auction platforms that privilege established galleries and institutions in the West. In this sense, the internet helps these new auction houses to challenge established players and their networks of global power. Thanks to online platforms, transnationalism is not owned only Western multinational corporations like Christie's and Sotheby's; it is, in fact, a tool to challenge their hegemony.

The Development and Cultivation of New Categories

In 1989, when Jean-Hubert Martin organized the notorious exhibition *Magiciens de la terre*, he employed the term "magician" to refer to all the artists he described, partly in an effort to upset the hierarchies in the art world between the kind of art normally shown at the Centre Georges Pompidou in Paris, where the exhibition was staged, and the work of artists from non-Western countries. Many took this to be pejorative, but the problem he faced was that the notion that artists from Zaire or India were in fact contemporary artists was an open challenge to the system of art historical categories at the time. The very term "contemporary African art," which rolls off the tongue so easily now, was a revision to the way artistic production was then understood and categorized. That an artist like Cheri Samba would be

included in an exhibition organized by France's national museum of modern art was a radical departure. Happily, this is no longer the case, but the current situation masks a complex, if brief, transition to recognition of the creative significance of artists of the Global South whose contributions have done so much to revolutionize artistic production in the twenty-first century. Visionary curators contributed to making a museum like the Pompidou recognize these artists, but the very categories of artistic production had to change, and this was accomplished in no small part through the market for contemporary global art and the auction houses that promoted it.

In 1993, the China Guardian Auctions Company Limited conducted its first auction in Beijing, and in 1994, its first auction of modern and contemporary Chinese art took place. The rise of this auction house, now the fourth-largest in the world, with a total of €533 million in sales in 2015 (Artprice 2016), closely parallels the rise in the Chinese contemporary art market in the 1990s, which created a recurring pattern of artists from various corners of the world being "discovered" by the art world and having their work revalued and given broad exposure in art centers like New York and London. When asked on the company's twentieth anniversary about new trends to watch in the Chinese art market, the then president of China Guardian, Wang Yannan, asserted: "The Chinese art market is growing at an unbelievable pace, and it's developing more specific categories" (Art + Auction 2013). Indeed, the pace of the Chinese art market expansion has been astonishing; between 2007 and 2013, China Guardian grew 1119 percent, according to Bloomberg. The implication is that alongside this growth, the auction market in China is evolving and that new subsections of the market will be revalued in the future, requiring new categories to be developed and tested.

Khaire and Wadhwani have elaborated an excellent exposition of how this process operates in their study of the emerging market for modern Indian art in the first decade of the twenty-first century. Their stated goal is "to examine the process by which art historians and critics challenged the institutionalized ways of characterizing 20th-century Indian art as 'provincial' or 'decorative' and to explore how the art was defined and valued as a variety of modernism. We find that art auction houses capitalized on the changing discourse of modernism by introducing constructs and criteria for judging individual Indian artists and their works that were adapted from conventions used in judging modernist works of Western artists" (1282).

The findings they reach after examining scores of auction catalogues, web sites, and a broad range of academic and critical writings on Indian modern

art point to certain intellectual antecedents before 2000, but there was a major shift after Saffronart began to hold auctions of modern Indian art in 2000. Sotheby's and Christie's, which had previously lumped modern Indian art together with mixed auctions of "South Asian art"—including everything from ancient sculptures to contemporary prints—began in 2003 to devote auctions exclusively to modern Indian art. The authors likewise assert that subcategories continued to be refined and specialized until 2007. They dissect the evolving discourse of auction catalogues into four segments: originality of aesthetics, careers, moments and movements, and internationalism. In three out of four sections, Saffronart was the first auction house to spell out the application of such discourse in their written materials about works of art, creating trends that were followed by the industry leaders.

Prices were also studied in Khaire and Wadhwani's analysis. They found that the average price of a work of modern Indian art at auction rose sevenfold from late 1990s to the years between 2001 and 2007. Record prices were reached in 2005: $1.6 million was paid for a painting by Tyeb Mehta at Sotheby's that year, and over $2 million was reportedly paid in a private sale for a painting by M. F Husain. In discussing the mechanics of the market, Khaire and Wadhwani observe that "price signals hence served as an important mechanism by which the new category's value and identity were institutionalized" (1295). This clearly applies to the market for contemporary art, because, if Mehta and Husain have certainly reached record prices, so have Subodh Gupta, Nalini Milani, and other South Asian contemporary practitioners.

The category distinction here is the difference between seeing artistic developments outside of Europe and the United States as "derivative" of Western precedents or as elaborating new paradigms for contemporary artistic practice. The question of how such contributions ought to be situated is tricky, since problems arise from distinctions such as "the periphery." In the cosmopolitan parlance of contemporary art, no one wants to be considered an Indian contemporary artist or an African contemporary artist, but simply a contemporary artist. This is evidence of a wish to evade a perceived parochialism that undermines the universality of artistic aspirations as much as the value of the products created by these artists. Many artists have relocated from countries with emerging economies to Europe and the United States for a wide array of reasons, but the upshot would seem to be that they move their activities from a peripheral to a more central location in relation to the art world. However, their transit between locations, from one home to

another, or to other countries to exhibit in international biennials and art fairs, undermines clear distinctions. While contemporary artists from the Global South are evidence that these boundaries between center and periphery are eroding, it is usually the case that their work is most often seen and marketed in their region of origin or in exhibitions devoted to such regions or nations. Therefore terms like "contemporary Pakistani art," and "contemporary Brazilian photography" continue to be renewed both through exhibitions and through the market. Alternative auction houses such as those discussed here do reinscribe the work of contemporary artists into a particular location through their focus on the artists of a nationality or region. Through their auction platforms, they make such categories more globally available and contribute to their market testing.

The Decentralization of the Art Auction Market

Manuela Ciotti argues that commodification has generated a renaissance for contemporary artists in India, making their work both valuable and available as a symbolic presence for India in the global art market. Though her focus is the renegotiation of the dynamics of empire by works of contemporary art, she elucidates many interesting dimensions of collecting of South Asian art. If this category of the market has accelerated, both powered by and empowering Saffronart, where is the art being bought and by whom? She quotes Saffronart's co-founder Minal Vazirani as saying that about 80 percent of its customers are from the Indian diaspora, and 25 percent are in the United States (Ciotti 2012, 637). So, yes, decentralization of the market is evident thanks to Saffronart's online platform, and customers have even paid more than a $1 million for works sight unseen, disrupting the normative logic of the art market. While it is worth considering why the VIP Art Fair went belly up while Saffronart continues to thrive, it is important to investigate the neoliberal dimension of this art market. The fact is that live auctions, whether online or not, seem to be able to capture a broader interest among online buyers.

The logic of neoliberal economics undermines national distinctions, explicitly suggesting that a broad distribution of capital globally and this economic framework is the underlying structure that facilitates art market decentralization in the twenty-first century. In other words, virtual markets that function transnationally through digital exchange and are open to all lead to the possibility of a fully dematerialized art market. Whether this is connected to an office in New York, Mumbai, or the Virgin Islands hardly

matters. Nor does it matter from where the funds are wired. The art that changes hands, however, is situated in space and needs to be shipped, and customs duties paid if it crosses borders. This means that the art market is not really virtual, even though a mechanism exists to produce a completely decentralized market and it is being used by auction houses outside of the West to do just that. They reach a new audience, whether composed of diasporic nationals who are "buying themselves" (Ciotti 2012) or not, and, more important, they are able to use the tools of neoliberal capital to undermine the established centralized art auction market hierarchy.

Obviously, the increasing number internationally of high-net-worth individuals is also contributing to this trend. It is not simply that wealth is distributed across borders in this era of neoliberal globalization, it is also the wealthy who are distributed around the world. These individuals are very likely to have multiple homes on multiple continents and bank accounts in tax havens around the globe. Nevertheless, these figures are also tied into various circuits of commerce (Velthuis 2012) in the art world, not the least of which are in their home countries. Thus it is not only Christie's and Sotheby's that have prospered as a result of increased global investment in art but a wide variety of auction houses around the world. A list of the major auction houses in emerging economies would be lengthy, and a few examples will serve to demonstrate the distribution of art auction bounty around the globe.

In Asia (excluding mainland China and Japan), 33 Auction in Singapore is a new company (2009) that achieves regular sales in six figures (even when converted to U.S. dollars), and Larasati Auctioneers, a multinational house with headquarters in Jakarta, but sales in Singapore, Hong Kong, and Amsterdam as well, netted $18.7 million in sales in 2012. Larger still are the two South Korean auction houses already discussed, K-Auctions and Seoul Auctions, as well as Ravenal Art Group based in Taipei, with offices in Beijing, Hong Kong, and Shanghai, which netted $35 million in sales in 2013, according to Bloomberg. Elsewhere, there is Strauss and Co. in Johannesburg and Cape Town, South Africa, with over $16 million in turnover in its fifth year (2013), and Arroyo Gallery is the leader in Argentina. Bolsa de Arte, founded in 1971, with galleries in Rio de Janeiro and São Paulo, is the oldest among these (Goodwin 2008; Art + Auction 2013).

These auction houses represent the secondary market in these various circuits of commerce. Surveying their web sites, it is clear that there are a variety of distinct approaches being developed by one or more of these companies, including holding auctions in hotels, promoting their works only in

the native language of the country, and forming international outlets in the region to source more consumers. All report their sales figures and represent artists native to their respective countries. Some of these practices are taken from industry leaders, but others are developed based on local networks and practices. From these networks, some important differences emerge.

An auction may seem like a neutral construct, equal in any context, but that is not always the case. Cultural determinations are at the bottom of financial transactions, and auction house rules originally developed in London in the eighteenth century by Christie's and Sotheby's should not be expected to reign in the twenty-first-century art auction market. As emerging economies get into the art market, the universal conceptions that undergird it will be tested and new means of speculation will be developed, based on culturally specific traditions.

Emerging Art Center

JOHANNESBURG

Kai Lossgott

Johannesburg, born spontaneously of a Euro-American-led gold rush in 1886 (van Onselen 2001), is South Africa's industrial heart and Africa's wealthiest city, a young, sprawling, polycentric people magnet motivated by opportunity and riddled with challenges (van Onselen 2001). It is also known as Jozi, Joburg, or eGoli, depending on which of its almost four and a half million inhabitants you ask. Today this thriving metropolis continues to fuel the subsistence and lifestyle needs of the southern African subcontinent and its various social classes. Few of these have any direct contact with institutional "fine" art, but with a vibrant visual culture making visible its mixed histories, cosmopolitan spaces, and constant intermingling and improvisation, Johannesburg today inspires the reexamination of urban theory itself. Residents of Johannesburg have the capacity to generate "their own cultural forms, institutions, and lifeways, but also with the ability to foreground, translate, fragment, and disrupt realities and imaginaries originating elsewhere" (Mbembe and Nuttall 2004, ix). For those in the fine art industry, this is the place to be. It is where the major section of the market as well as access to funding is concentrated (Hagg 2010).

White minority rule and legally enforced racial segregation (apartheid) have been removed institutionally since the first democratic elections in 1994, and economic divisions seemed to be very slowly shifting at time of writing. South Africa's black middle class, though only 2 percent of the population, has more than doubled since 2004 (ten years after democracy),

accounting for 4.3 million people in 2012, and is gaining increasing economic power—also as art lovers and buyers. In annual household spending, it now outranks its white counterpart group (Unilever Institute of Strategic Marketing 2012). A black super-wealthy elite ("black diamonds") forms part of this, with rising visibility. The Black Collectors' Forum, founded 2014, aims to promote the buying, investing, and appreciation of visual art in the emerging black-middle-class market (Mabandu 2015).

Johannesburg is continually being torn down, renovated, and rebuilt—evidence of rapid economic expansion for some. Socioeconomically, however, after over twenty years of democratically elected African National Congress (ANC) rule, 47 percent of South Africans live in poverty, in fact, a sad 2 percent increase since 1994. South African unemployment formally stands at 25 percent, and 50 percent among young black men. Despite affirmative action and black economic empowerment (BEE) laws, black citizens continue to earn on average six times less than their white counterparts (Statistics South Africa 2011). All this is not good news for the art world, which often exists not because but in spite of these conditions, through a machinery that still largely operates through white gatekeepers, affecting the power relations reproduced by all art institutions. The 2010 HSRC Report on the Visual Arts Industries found 58 percent of respondent practicing artists to be white, with black women (12 percent) being particularly poorly represented.

Speaking ten years after democracy, in 2004, the curator Khwezi Gule summed up the art world's challenges:

> It is obvious that some people would gauge the significance of the past 10 years in terms of South African artists' ability to become part of the global (read European/American) art elite. Others would gauge it in terms of the degree to which art institutions within the country have been able to achieve transformation in terms of demographics, aesthetic biases, discourses, rules and processes. Others still would like to understand how the various groups of elites have contested the terrain left open by the demise of apartheid and how the politics of aesthetics have mediated these contexts. (Gule 2004, 6)

Twenty-five years of my life have been spent in Johannesburg, and more are to come. My paradoxical city continues to surprise me, fascinate me, and elude my understanding. I will attempt to tell this history as inclusively as possible, knowing that I do not speak for all. Moreover, as an artist, it is considered taboo for me to comment on the market forces that determine our survival. I can only do so minimally.

During my first decade, the 1980s, my parents sold art in the park at Zoo Lake. Unusually for the times, this artist-run initiative also hosted black artists, and eavesdropping on adult conversations when families shared a shade cloth, I first got acquainted with black people who were not domestic servants. I remember the social awkwardness of attending an all-black birthday party in Soweto, or secretively visiting the painter Mokgaba Helen Sebidi in a commune in then whites-only suburban Troyeville. It had to be explained to me that it was illegal for her to be there. Although I attended progressive, mixed-race schools, I only began to understand the national implications of our isolated white privileges when in 1994, at the age of fourteen, I experienced the euphoric fall of apartheid. Only a year later, at the 1995 Johannesburg Biennale, curated by Lorna Ferguson, I was able to have my first experience of international contemporary art; 250 artists from eighty countries were represented, on a platform aspiring to equality, alongside white and black South African artists. The Biennale encouraged suburban whites to explore abandoned inner-city venues they had last visited in their youth and to puzzle over artworks that none of their cultural-boycott-era high school art education or limited art institutions had prepared them for. After approximately four decades of isolation, the world had come to us, and adults educated or well-travelled enough to understand showed themselves deeply moved. I encountered the work of artists like Marlene Dumas, who had left South Africa in 1976, and Berni Searle, whose career as a local woman of color was just beginning to attract visibility in South Africa. In a review on the event written in 1995, the artist Candice Breitz sums up the challenges of that decade: "The Biennale could not and did not redress the imbalances entrenched . . . over decades of discrimination. . . . It provided a forum in which a vocabulary more pertinent to the South African context began to emerge" (Breitz 1995, 94).

The second Johannesburg Biennale in 1997, curated by Okwui Enwezor, far more polished than its predecessor, was officially closed a month ahead of schedule, citing financial challenges of the city of Johannesburg. There were to be no further Johannesburg Biennales. These must have been enormously expensive but very important exercises. It must also have become clear that the audience was very small, elitist, and white. I remember being almost entirely alone in big industrial halls aside from the security guard.

Public funding for the arts in modern democracies depends on tax money from a large middle class. In 1995 and 1997, the white middle class in South Africa was a dwindling fraction of the population, and the black middle class

lacked the muscle to contribute economically, and therefore ideologically, to state visual arts funding. (Minimal public funding remains one of the arts sector's biggest setbacks.) The power of the large exhibition format known as the biennial is of course that its intention is not to profit; it is conceived as a gift to society—but someone must bear the cost. Striking a compromise between profit and cultural value, the *Spier Contemporary* exhibition, brought to Johannesburg from Cape Town in 2007 and 2009, styled itself as a biennial produced with private corporate funding. It did not survive economic hard times.

Having personally grappled with the discontinuation of such formative events in South African art history, I have come to accept that perhaps this elaborate biennial format does not cater to the most pressing needs of a young postcolonial democracy, which should prioritize employment, running water, and basic sanitation. Supporting an international art event would have seemed impractical and hopelessly pretentious to some municipal decision-makers in 1997. This disconnection from local contexts and audiences is noted by the Nigerian curator Bisi Silva in her review, which concludes: "For future Biennales, Johannesburg needs to find a format that will connect to its African neighbors without the forfeit of its global aspirations" (Silva 1998, n.p.).

In contrast, eleven years later, post-apartheid South Africa has created the Joburg Art Fair, a glamorous contemporary art fair staged annually since 2008 by Artlogic, a privately held company, with funding from First National Bank (FNB). Drawing all South Africa's large galleries, as well as influential individual market players from Europe, it boasts a full program of talks, an art prize, and guest artists of global standing. More recently, the annual Turbine Art Fair, supported by AngloGold Ashanti, has sought to create a market for emerging art. These events financially support themselves, and as private initiatives independent of political goodwill, they seem to have evolved as the only form currently practicable in South Africa. Artlogic won the government tender for the curation and exhibition of the South African pavilion at the Venice Biennale in 2015 and 2017, a move that would seem to reflect the muscle of private capital in such matters.

Privatization and gentrification are general themes that will remain part of the consequences of economic upward mobility in South Africa. In the 1990s, as apartheid fell in a South Africa celebrating democracy, neoliberalism and globalization triumphed internationally, posing drastic threats to democracy as we know it (Bond 2014). Beyond the scope of this article, such corruption scandals defined the Jacob Zuma presidency starting in 2009, a

legacy that will take the country decades to recover from. Johannesburg's inner city in the 1980s and 1990s was deserted by big business due to fears of crime and the influx of rapid immigration from the African continent. I watched the city change on daily bus commutes to the National School of the Arts in Braamfontein, on the edges of the inner city, also home to the University of the Witwatersrand (Wits). Middle-class people started to trickle back into "Braam" in the late 1990s. During this time, property developers started buying up lofts, and Johannesburg acquired the reputation among artists of being Africa's Berlin. An independent German curator who had lived there in his early twenties once told me Jozi was his favorite city in the world. I am regularly amazed at how international newcomers move into the city to take full advantage of the broad spectrum of nightlife and entertainment, given the reluctance of many suburban South Africans of all ethnicities to venture into town due to the distance, lack of night-time public transport, and the ever-present fear of crime. Statistically, perhaps in part to its conscientious data collection, South Africa dubiously tops the list when it comes to violent crimes on the African continent (Harrendorf, Heiskanen and Malby 2010). Today Braamfontein is the home of WAM (Wits Art Museum), and a growing number of small independent galleries, as well as the Johannesburg branch of Stevenson, one of South Africa's most prominent galleries for contemporary art, with a wide international distribution program.

Within thirty minutes' drive through the crowded inner city lies the private property development Maboneng, part of the formerly run-down light industrial neighborhood of Troyeville. Black and white upper-middle-class people can afford to live and work in this now trendy neighborhood in the city, something almost unheard of during apartheid. Developers invited adventurous creative individuals to occupy studio space in their buildings there, starting with the mixed-lifestyle space "Arts on Main," using urban renewal models tried and tested in London, New York, and Berlin. William Kentridge is the anchoring tenant here, with warehouse-size studio space. David Krut has a branch of his printmaking studio and bookshop. A number of galleries have come and gone. The one that has showcased the most independent work has arguably been the German-funded Goethe on Main, hosting a number of young black artists' first solo shows.

Ahead of migrating to a nine-month residency in Paris in October 2015, I house-sat a loft in downtown Johannesburg, not far from the fashionable gentrified Maboneng precinct, with stunning views from the roof of the

building. It was the base of Ayana V Jackson, an American artist who calls Joburg home. Like a growing number of international artists, having lived in New York, LA, and Berlin, she enjoys a lifestyle she told me is no longer possible anywhere else in the world. Working in Johannesburg with Gallery MOMO, South Africa's only black-owned gallery, which put Mary Sibande on the map, and somewhat notoriously paved the return of South Africa to the Venice Biennale, Jackson is perfectly positioned as a woman of African American descent to participate in the global market for African contemporary art.

Mary Sibande's character Sophie first attracted public attention featured on billboards across Johannesburg. Making historical reference to the oppression of black women in South Africa, but restaging it as heroic celebration, Sophie is inspired by Sibande's great-grandmother, grandmother, and mother, all domestic workers, whose labor contributed to sending her to university. In South Africa, and in the global diaspora, as intellectual currency, the work of these artists grappling with blackness as "body" has the power to anneal the fissures of colonial history. It may even fulfill the function of nation-building, which is one of the criteria for funding prioritized by the government Department of Arts and Culture. Further, it currently seems evident that a private self-funded black-owned entity like Gallery Momo can politically and economically participate in foreign markets through *both* commercial and public exhibition formats. In 1995, the world had to come to us, but twenty years later, we are actively exporting our newfound South African cultures.

The question remains of how African art with activist intentions is read in the oversaturated white, ironic mainstream art world of Europe and America, centers African art and artists must utilize in their quest to participate in global flows of power, as Nicholas Bourriaud outlines in *The Radicant* (2009). Bourriaud makes the point that the desire for a peaceful multicultural society, in order to fulfill the dream first popularized by the United Nations, requires the participation of artists who obviously represent those nations in the limited understanding one has of them. In the hard, fast, and expensive international art world, South African art is often reduced to the keywords "indigenous tradition, apartheid and Mandela" (as an observant Swiss curator once remarked to me), and exhibition selections are made to reflect this. The desire to be "inclusive," in true liberal form, is still a superficial "us" and "them" approach in which white people take it upon themselves to include "the others," never considering their own alterity. Bourriaud argues that to include people on the basis of their ethnicity is in fact

patronizing, since the intention is to demonstrate how they can all be brought together in these central places of power. He further suggests that it can be cruel encouragement to foreign artists who do not understand on what basis they are being selected, and that their work is in fact not necessarily regarded as "equal" in the discourse of international contemporary art debates according to the centers of power. The *Magiciens de la terre* exhibition organized by Jean-Hubert Martin at the Centre Pompidou in Paris in 1989 is often cited as an early example, in which the desire to be inclusive results instead in unspoken alienation.

Today, this is a factor consciously motivating the critical work of a number of young black artists in South Africa, often to great irony. Athi Patra-Ruga's tapestries, often referencing ethnic souvenir kitsch in deliberately "bad" taste, are an example, sold with great success to foreign collections.

These overdeveloped centers are, as the Slovenian philosopher Slavoj Žižek among others argues, postpolitical. In such neoliberal societies emerging post–Cold War, political choice is reduced to giving consent to being managed and policed, and "politics proper is progressively replaced by expert social administration" (Bryant 2015). Civic participation is at an all-time low. Young people stop voting because their consent is not needed, and any illusion of choice, even right-wing, begins to seem desirable to voters. Affected by global neoliberalism, ANC-led South Africa also shows aspects of this consensual politics. However, as the nationwide student protests of 2015 and 2016 again showed, young black South African intellectuals are passionate about forging their own independent African and decolonial identity. Democracy remains a relatively recent and hard-earned right. The very struggle for a modern individual identity is one that must be defended, and can get you killed by older social structures. Zanele Muholi has highlighted an example in her "Faces and Phases" portrait series making visible the independence of lesbian and transgender lives in townships, where lesbians are often subject to "corrective" rape or even murder by male relatives who wish to silence them. In 2016, Muholi made number 95 in Art Review's Top 100 List, ranking her as the most influential woman in the African Art world that year (van Niekerk 2016). What meaning a photograph of one of these women, possibly nude, selling at a high price at Basel Art Fair, is able to have when bought and transferred into a private collection on another continent in a postpolitical society remains hotly debated among South African intellectuals, but publicly discussing such topics is taboo, since it is bad for business. Does it empower the artist or does it devalue the context of the work?

While there have been efforts in all economic sectors to transform corporate ownership through black economic empowerment (BEE), it remains a logistical challenge that the South African art market is based on export of black artists (representing 80 percent of the population) by white gallerists (representing 8.9 percent) (Statistics South Africa 2011), mainly selling works to non–South African collections through the fairs in Basel and Miami. It is the work of the Black Collectors' Forum to redress this within South Africa. The open secret is also often remarked upon in private conversations, such as a discussion I had over breakfast in October 2015 with Molemo Moiloa, national director of the developmental nonprofit Visual Arts Network of South Africa (VANSA), which conducts industry research, lobbies the state, provides educational talks, and has and builds information resources for and about artists in South Africa and on the continent.

As a proposal and grant writer for VANSA Western Cape from 2008 to 2011, much of my time was spent advocating for art as a viable economic activity, and therefore worthy of funding support. Government knowledge when it comes to visual art has been limited. The Arts and Culture Ministry, once considered a safe "training ground" for higher government positions, has only recently begun to attract employees with working experience in other institutions. State-commissioned reports going back to 1998 identify music, publishing, and particularly the craft and film sectors as suitable for the task of rural and urban job creation, and current policy remains informed by this (CAJ 2007). Visual art has not been a priority for the ANC-led government beyond the craft sector. In 2002, Brand South Africa reported the craft sector as being estimated to employ 1.2 million people, contributing R3.4 billion to the South African economy every year (Russouw 2002). More recent figures focusing on the visual arts after the rapid growth initiated by the Joburg Art Fair and Turbine Art Fair are not currently available.

Given the facts of economic hardship, it is easy to come up against the accusation that visual art is elitist and expensive, but this opinion has been shifting in recent years. The Johannesburg Art Gallery (JAG) was built in 1915 with a British colonial patron's funding to house the nation's treasures (read the history of white people) in a once trendy area that is currently still considered an inner-city slum. JAG and cultural institutions like it have sought to ensure social transformation through a representative exhibition program, affirmative action staff appointment policies, and educational initiatives. It was already collecting art by black artists in the 1930s and holds major contemporary works of local and international importance (R. Sassen

2015). Research by VANSA positions JAG as the most visited art museum in Africa, with 90 percent of visitors being black and young. It can barely operate under the comparatively small amount of state funding it receives, which was highlighted in 2012 when a burst sewage pipe flooded the basement and threatened to engulf two storerooms containing artworks with an estimated worth of R500 million, and the gallery could not even afford to call a plumber (Kuper 2012).

There have been further efforts citywide to break the stereotypes that visual art is elitist through the adoption and implementation of a public art policy by the city of Johannesburg. Between 2005 and 2010, the year of the FIFA World Cup, R15 million was spent in the city by local and provincial government funding, as well as corporate funding (Hagg 2010).

If the interest in investment art is growing among the general population, this may have something to do with its private utilitarian value. South African art from the 1980s now commands a high price on local and international auctions. Acting on well-considered political concerns, the private art dealer Andile Magengele, one of the initiators of the Black Collectors' Forum, concentrates on selling West and Central African painters to his black South African clients.

A quick glance through a trade publication like the *South African Art Times*, or the accessibly priced Turbine Art Fair, will show that the majority of South African galleries live off the interior decor market. Certainly the distinctions blur, but while some like to include more ambitious works and artists in their shows, these do not have access to buyers that will support this market. There are still relatively few South African galleries presenting at international art fairs, or that have branches in both Johannesburg and Cape Town. The gallery triumvirate, as they are often called by art critics, are Stevenson, Goodman, and increasingly Everard Read, which has built a market for modern contemporary art through the prominently placed and architecturally noteworthy Circa Gallery in Johannesburg, soon to open a duplicate in Cape Town. By sheer financial ability, these exist in contrast to the reach and scope of institutional spaces such as the national galleries, university-run galleries, and project spaces operated by French and German cultural organizations. Openings at artist-run galleries such as Room, Kalashnikov, Sosesame, and No End Contemporary are filled with hopeful 20-something intellectuals and aesthetes, providing opportunities for a generation rising in independence. Sadly, such artist-run spaces are often short-lived, most often the experimental ones aligned with exploring critical discourse. The curator Gabi Ncobo's

collaborative platform "Centre for Historical Reenactments" (founded in 2010) provides a vital experimental research platform for the development of relevant debates on the challenges faced by black artists in South Africa today. It staged its own suicide in 2012, and currently finds a home within the Wits University School of Arts. More recently, her work in Johannesburg has taken place through "NGO—Nothing Gets Organised," a project space co-operated with the artists Dineo Bopape and Sinethemba Thwalo.

The fact that they continue to exist in Johannesburg must be celebrated. Even the former township Soweto, from whence many black artists, like the painter George Pemba (1912–2001), once departed into exile, boasts the beginnings of its own locally supported art scene, in the form of pop-up exhibitions run by the young curator Zanele Mashumi (Memela 2013).

The 2010 HSRC report on the Visual Art industries acknowledges certain entry barriers. "Occupations in the sector are generally knowledge-intensive and the majority require comparatively high levels of both formal education and on-the-job experience before significant professional validation and concomitant economic reward is achieved, whether as an artist, administrator, curator, gallerist or dealer. . . . While [it is] easy to enter the industry . . . it is difficult to sustain entrepreneurial activity in the absence of patiently nurtured networks of artists, suppliers of services and—most importantly—buyers" (Hagg 2010).

For early-career artists, considering the sheer size and resources of the international art world, what may be considered avant-garde and worth historical notice is a matter of institutional perception, and visibility is far too often only possible through good marketing budgets that are beyond personal means. I shared a studio at the artist-run organization Assemblage in Newtown with Minenkulu Ngoyi and Isaac Zavale, who together are Alphabet Zoo. They were trained at the legendary Artist Proof Studios nearby, where students travel in daily from homes often many kilometers outside the city to learn their trade. The tourist clichés of shacks in dusty streets, crowded minibus taxis, and exclusive cocktail parties at exhibition openings form part of the contrasting urban playground of these young printmakers. Mini, as he is known, likes to keep some zines in his pocket, something Alphabet Zoo is known for. Inspired collaboratively, using any found ideas or materials, from the Lion matchbox cover to the city's ubiquitous leaflets promising penis enlargement or the return of lost lovers, their playful approach and biting sense of humor has attracted attention internationally, but at time of writing, in 2016, none of the artists based at Assemblage

had regular gallery representation. The case is similar at other inner city artist hubs like August House and Nugget Street Studios.

I see artists like Mini and Zak as foot soldiers in a young democracy. Like many of the successful young black men who are their peers, their prints are economically and aesthetically affordable to the growing black middle-class art buyer. This is where the value of the European import of "fine art" needs to be interrogated and cultivated if a truly inclusive and representative support base for more challenging South African art practices is to be established—a task currently taken on by the Black Collectors' Forum.

Eventually, since my income was not based on art sales, I could not longer afford the rent and moved out of this studio space, relying on a number of international residencies in the following years. Zak and Mini, who never attended university, really struggle to make it happen. Today their partnership with Assemblage, the artist-run Prints on Paper printing studio, which they manage and own shares in, allows them to stay put. In their milieu, they are currently unlikely to be introduced to players in the upper echelons of the art world, such as the museum, biennial, or art fair circuit, who go shopping at university graduate shows and would expect them to justify their work in art historical theory. The irony is that they are perfectly placed to grow with the rapidly emerging private South African market for their work, whereas most local university fine arts graduates are unable even to cover their production costs from art sales and the minimal public funding available. In our young democracy, the grand ambition of the publicly funded biennial exhibition for society has proved untenable, while the privately funded art fair model has sustained itself. Similarly, self-funded practice and the challenges of engaging with commerce and corporate funders seem like the most realistic way forward for the majority of individual artists working and living in Johannesburg today.

The Art Market in the Margins

1 THE OFFSHORE MECHANISMS OF THE ART MARKET

In December of 2014, the think tank Global Financial Integrity released a study claiming that capital outflows from the developing world to offshore financial centers totaled U.S.$991 billion in 2012 (Kar and Spanjers 2014). Concluding an examination of ten years of transactions, the authors indicate that $6.6 trillion had escaped from emerging economies in the years between 2003 and 2012, 77.8 percent of it transferred as a result of "trade misinvoicing." While the hemorrhage of just under $1 trillion from the neediest countries into private offshore accounts is a dismal fact of contemporary life across the developing world, one might think it would have nothing whatsoever to do with the art world. That would be naïve.

In fact, art is one of the most unregulated industries on the planet. Auction houses provide a space for exchange with prices determined in an open public forum, but many aspects of the auction house business are completely hidden from the public and government regulators. They are not required to release the names of their consignors or their bidders and though they make good-faith efforts to provide the most complete provenance for a work of art, they are often forced to accept documentation provided by the owner, and very few provenance records are without lacunae. Art auction news is annually sprinkled with items pulled from auctions at the last minute when some claim is made against them, and as long as the auction houses acted in good faith, they have rarely been held accountable for errors resulting in losses (though they have made payments in negotiated settlements).

Private dealers are of course even less regulated, because their sales are not public and most do not have offices in multiple countries or jurisdictions. In

many cases, the reputation of the dealer is the buyer's only insurance against fraud. The recent case of Knoedler, a gallery that operated in New York for more than a century but has gone bankrupt as a result of a forgery scandal, demonstrates that no matter how established the gallery, there is little protection of the buyer in the case of fraud (Halperin 2011). A series of recent cases involving some of the most venerable and important galleries in New York, such as Knoedler, Wildenstein, and Nahmad caught in a web of scandal provides a miniature window on some of the less-than-savory business opportunities open to art dealers. But that should not blind one to the fact that as the art market expands internationally, many honest, principled dealers are also engaging in a business that has few rules and even fewer standards.

Particularly in the red-hot market for contemporary art, values are in constant flux and both auction houses' and private dealers' business models are based on quick turnaround. The most successful gallery exhibition is of course the one that sells out on (or before) opening night, but even in the secondary markets for works of art, dealers come upon good deals and then sell the works as quickly as possible so that they can pay creditors and feed demand. The margin is so thin for galleries that they cannot afford to sit on stock for very long, and dealers in the primary market will return works to artists if they do not sell quickly. In the secondary market a work that cannot find a buyer will likely be unloaded at auction. Alongside speculation, this is another reason why art works may return to the auction market numerous times in a span of a few years.

Global trading increasingly means that art works are constantly crossing borders, and every country has a distinct legal framework for regulating the import and export of works of art. Sending works overseas basically means paying customs duties, unless one can find a way to avoid it. In our current global art market, many actors are doing just that. Of course, there are the outlandish cases of brazen fraud. A recent one involved in the import of a Jean-Michel Basquiat painting, *Hannibal,* from London to the United States. The customs forms claimed that the art work inside the crate was worth $100, and therefore was below the value for a duty payment. The painting was actually worth $8 million and was part of an elaborate money laundering scheme set up by a Brazilian embezzler (Cohen 2013). No doubt this $8 million was part of the count in the study listed above. But we should not think only of the black market when it comes to averting customs duties, because arbitrage is an important part of the legitimate global economy, and it is used by not only dealers and auction houses but collectors and investors.

In brief, gaming the global legal patchwork is part of effective business practice today, and if Apple and Starbucks use tax avoidance strategies to lessen their fiscal liability, why not sellers and buyers of art?

There are two terms that will help to capture many nuances of the hidden aspects of the global art trade: offshore and informal economy. "Offshore" is a word full of complexities, but it can be summed up as the transfer or exchange of assets beyond regulatory authorities. The informal economy is usually defined as the part of the economy that is unregulated or unrecorded or both. While the offshore metaphor directs one's attention to the money squirreled away by the wealthiest, studies of the informal economy more often focus on how those at the bottom of the economic pyramid find the means of survival between domains of legality. At first glance, the global art trade—currently valued at $63 billion or so—is a miniscule piece of global economic production. But due to the unregulated nature of the art market, it serves a key function within the larger network of the accumulation and distribution of capital worldwide. The art trade can serve as the proverbial canary in the coal mine. Examining offshore economic activity will, paradoxically, allow the reader to locate some of the hidden mechanisms that allow the global art market to flourish.

Freeports

In nineteenth-century Switzerland, an innovation emerged that would eventually serve the art industry very effectively, and today as a result there are "freeports"—extremely secure storage facilities "offshore" where valuable commodities can be kept with the utmost discretion and no one can enter without an appointment—all around the world. Moreover, of course, there are also many art works stored in bank vaults.

A freeport is a storage facility that exists formally outside of the territorial jurisdiction of any country, though recent scandals have required the government of Switzerland to seize control of the Geneva Freeport, for example. This facility was originally created in 1888 to store grain and other agricultural products in transit. The essential aspect of the freeport is "the temporary exemption of taxes for an unlimited quantity of time" (Segal 2012). While one cannot store grain for an unlimited period, more valuable commodities such as art and wine, to say nothing of gold bars, could be stored much longer. In the era of offshore expansion in the late twentieth century, tax loopholes and secrecy domains acquired a much greater significance in

the global economy, and for art, the freeport became the physical equivalent of a Swiss bank account. Invisible to tax authorities, foreign governments, and even the insurers of the art works themselves, art could be stored there with complete anonymity and sold without any taxes being paid.

David Segal's *New York Times* article in 2012 broke open the topic, which was little commented upon in the following years, aside from an article in *The Economist* two months later ("Art Insurance," *Economist*, 2012), until the Panama Papers story broke in April 2016 (Bernstein 2016; Bowley and Carjaval 2016; Sutton and Voon 2016). The implications are staggering. *The Economist* compared the size of the Geneva freeport to twenty-two soccer pitches, and Segal had just reported that a new 130,000-square-foot warehouse was being built there. In Switzerland, there is another large freeport in Zurich, which is also expanding internationally. Luxembourg was building a 215,000-square-foot freeport in 2012, and the Singapore freeport was reported to be undergoing expansion at the time. A new one was planned (and has since been built) in Beijing, near the airport. The newest freeport opened in Delaware in 2015. According to *The Economist* the freeports in Geneva and Zurich are each "believed to hold well over $10 billion worth of paintings, sculpture, gold, carpets, and other items" (n.p.). Such an estimate is an obvious shot in the dark, but it is the best anyone is likely to get, given the secrecy of these zones. Nothing is on view, of course, Segal writes, but one can see empty crates and frames scattered in the hallways outside of the storage areas. If the consignor is leaving the frames in the hallway, one might imagine that the space is too full of paintings for the frames to fit. This is an insurer's nightmare.

On the other hand, it might just be an investor's dream. To hold valuable works of art tax-free means that the foundations for speculative ventures are firmly in place. The freeports in Luxembourg, Monaco, and Singapore are all held by one company, Natural Le Coultre, owned by Yves Bouvier. This fact came to the attention of the media in 2015, when Bouvier was accused by a Russian oligarch, Dmitri Rybolovlev, of cheating him in the sale of a Picasso painting through double-invoicing, and Bouvier was formally accused of fraud and complicity in money laundering by the authorities in Monaco ("Brush with the Law," *Economist,* 2015; Sallier and Haeberli, 2015). From the press that emerged, the figure of Bouvier, who is a prominent actor in the art world, but who operates in a very private domain, was made public.

It is difficult to imagine a reason to keep art works in a freeport unless there is speculation going on. If you are collector of fine art, you want to be able to

see and to appreciate what you own. But if you are a speculator, all you need is private and secure storage, since you are betting that the work is going to increase in value. So the freeport is the perfect place to park your speculative art purchases, because they cannot be traced to you and no government can tax you on these assets. Of course if you want to corner the market on the work of a certain artist and wait for it to escalate in value, the freeport is your best bet. Everyone in the art world has heard stories of exhibitions of young contemporary artists being bought out by enterprising collectors; Charles Saatchi's early purchases of works by Damien Hirst and his clique of YBAs is one of the most famous examples. Such works had to be stored somewhere, and the freeport is the most secretive place to do so, with the advantage that if the work changes hands there, no sales tax needs to be paid either. It could be argued that this is all anecdotal, but opportunities are being seized and growth is expected: "28% of both the art collectors and art professionals surveyed said they had already used or had a relationship with a freeport provider, and 43% of the art professionals said that their clients were likely to use a freeport facility in the future, versus 42% of the art collectors who said they were likely to use such a facility," according to Deloitte and ArtTactic (2014, 20).

If more than a quarter of collectors and art professionals are already using freeports, speculation is not a minor factor in the art business, and these same collectors and professionals expected to use a freeport more often in the future. This coincides with another major finding of the report, namely, that 76 percent of art collectors are buying art "for collecting purposes but with an investment view" (16).

These developments are only part of the story, however, because the works of art, now reduced to tax-free assets, behave like any other asset and there are a string of potential derivative investments that can be made in relation to them. The most basic scheme would be to create a leveraged position by borrowing money for further acquisitions using the value of these works as collateral. This strategy can of course pile up, leading to the need to strip frames and put them in the hallway. On the flip side, there is the risk that these works of art could lose value. So an investor might seek a hedge, selling the risk as an asset, the way banks did with mortgages, leading to the onset of the global financial crisis of 2008. The risk of a work of art losing value might be a problem for an insurance company, but in the deregulated era, a bank that also deals in insurance could hedge its risk by selling that risk as an asset to investors. This is called a credit default swap, and while such investment vehicles were given a bad name by the real estate market meltdown, they are

still very much in use and in fact were brought in to remove toxic assets and hold the value of the euro during the subsequent debt crisis involving Spain, Italy, and Greece (Alloway 2011). Rachel Campbell spells out how they might work in her section on "Art Price Risk" in McAndrew 2010 (110–11).

Olav Velthuis and Erica Coslor have explored financialization in the art market, a process more commonly called securitization (Velthuis and Coslor 2012). The trend here is for art works, or indeed any product, to be reduced to its value as an asset alone. While such values are the stock in trade of auctioneers and dealers, the fixation on value is not the result of entrepreneurial venality, but a transformation in the nature of capitalism, and particularly the growth of the service industries, the financial services industry chief among them.

As an offshore mechanism, the freeport is an expansion of the concept of free trade that, despite its name, actually tends to benefit the most privileged investors at the expense of others. This is especially visible in the development of the global economic system in the second half of the twentieth century. At this moment in history, as countries were throwing off their colonial shackles and attempting to compete in the increasingly globalized world of trade, one of the main limitations was that colonial economies were largely dependent on raw materials and cash crops and therefore, after independence came, many countries struggled with the challenge of economic independence. The biggest success stories of these years were a group of mostly small Asian countries known as the Asian Tigers, which transformed their economies through export orientation, in effect, creating, packing, and shipping what consumers in wealthier nations wanted (Kim 1999; Prashad 2007). Singapore, Taiwan, Korea, and Hong Kong created strong economies partially through opening tax-free zones, called export processing zones, special economic zones (SEZs), or other euphemisms for providing services tax-free in certain areas in order to lure foreign direct investment from multinational corporations. If these countries could provide the infrastructure for foreign companies headquartered in the United States or Europe to relocate their factories and guarantee them freedom from foreign duties, international corporations would invest, build factories, employ workers, and generally produce a newfound prosperity in Asia. Of course, this success often came at the expense of union labor in the countries where these companies were headquartered. This trend has accelerated globally in the twenty-first century and has created political backlashes around the world.

The mechanism of the special economic zone (SEZ) was an essential component of this transformation, because if the countries were not willing to

waive their potential customs revenue, the wealthy companies would not have improved their bottom lines, and therefore they would not have been willing to invest. The burgeoning string of freeports around the world is an echo of the SEZs, demonstrating that many countries are expanding their tax-free services not just to manufacturers but to investors in luxury goods. These duty-free zones are often placed at airports to facilitate the acquisition and storage of vast quantities of luxury goods that wealthy investors do not have to pay tax on. These spaces, outside of the jurisdiction of any national regulatory body, allow art to be securitized and moved offshore, and their operations parallel in many ways the offshore financial transactions that have grown so numerous in the past decades (Palan 1998; McCann 2006; Shaxson 2011).

The first characteristic freeports share is the concept of "secrecy jurisdictions" (Shaxson 2011). In his expansive account of the development of the offshore financial world, Nicholas Shaxson underlines how certain countries, beginning with Switzerland, have regulated financial secrecy as a means to ensure the discretion of the banking industry and protect assets held in these countries from external regulatory mechanisms. This means that if you made a lot of money that you don't want to report to the tax authorities, you can park it in a secrecy jurisdiction, and the authorities will not be able to find evidence of fraud, because it is against the law for such jurisdictions to report the contents of their accounts to the authorities. This does not mean, of course, that all money in Swiss (or Cayman) banks amounts to ill-gotten gains, but it does mean that no one can ever find out whether it does or not. The Panama Papers leak of 2016 led to many revelations about the use of secrecy jurisdictions by prominent businessmen, politicians, athletes, and art world insiders. A number of articles spelled out how dealers like the Nahmad family and collectors such as Joseph Lewis and Diana Ruiz-Picasso used offshore companies to secret away art and money that could not be traced to them due to the structure of these offshore mechanisms. What is noteworthy in retrospect is that these revelations have not shown that laws were broken, nor have they exposed a complete picture of how offshore mechanisms have altered the art market (Bernstein 2016; Bowley and Carjaval 2016; Sutton and Voon 2016).

The same is true of what is known about freeports. No one can tell if the art held in them was stolen, bought with drug money, or simply a prudent investment expected to yield great returns in time. The secrecy of freeports, combined with offshore corporate entities and the unregulated nature of the

art market, means that it is very difficult to connect owners with works of art that are stored in a freeport. No government can regulate, tax, or investigate property stored inside a secrecy jurisdiction, and so, for all intents and purposes, the art in freeports becomes invisible.

This secrecy and lack of regulation are a kind of loophole in the regulation of the global economic system and international law. If you are a national government, you can charge excise tax on works of art leaving the country and traveling to another, and based on the rate you set, it is possible either to incentivize the export of works of art or to provide barriers to their export. Some countries, like Mexico and Nigeria, make it illegal to extract any artifact from the ground and send it to another country. After centuries of archaeological looting, such legislation to defend potential national treasures is not surprising. But to put a work of art into a freeport is not exporting it, in legal terms, because it is not entering another country. So no duties need to be paid and no laws are actually broken. Such a loophole is an inducement to arbitrage; it actually suggests to an individual how he or she can skirt the law and get away with it. Tax avoidance is the reason offshore financial centers exist, and this also true of freeports. By generating the means to avoid duties in a quasi-legal framework, it becomes very difficult indeed to enforce national laws. Individuals and corporations can game the system to ensure that their interests are served best. The art market is a system that operates on visibility in the sense that publicity and purchases at a public auction cement the value of works of art, but the freeport allows collectors to employ secrecy to their advantage to dodge customs duties and potentially to manipulate the market by taking works of art out of circulation.

Admittedly, the presentation of offshore financial centers so far has not related the complexity of the processes that are involved in generating secrecy. It is not simply that banks do not reveal who owns accounts and how much money is stored there. There are a variety of mechanisms in place that allow individuals to hide their assets and avoid national regulatory systems, including trusts and international business corporations (IBCs). While some offshore financial centers focus on banking, others focus on the registration of companies headquartered in the offshore jurisdiction subject to the regulatory environment of that country or state (McCann 2006). In 2008, presidential candidate Barack Obama called out Ugland House in the Cayman Islands as a building that is the address of 12,000 companies, but, as *The Economist* later pointed out, Delaware, a state with a population of slightly fewer than a million residents, is the jurisdiction of record of 945,000 companies ("The

Missing $20 Trillion," *Economist*, 2013). These are shell companies created to shield individuals from investigation and responsibility. They serve the purpose of transferring assets through a complex system of subsidiaries so that the owner of an asset is impossible to trace, and any added value gleaned from an asset or its transfer remains as tax-free as possible.

Turning back to freeports, it is not simply that the individuals who own the works are not revealed, it is also that the assets in a freeport are likely held by a trust or IBC that is not directly connected to the owner of the work. This allows for works of art to be transferred from one owner to another without their hands ever getting dirty, so that works cannot be traced back to those who are making a profit in the transaction.

Money Laundering

Given the offshore nature of freeports, it seems not unreasonable to inquire whether there might be money of an unseemly nature slipping in and out of them in the form of solid assets and whether such objects, art works among them, might not be part of criminal money-laundering schemes. Money laundering and art brings the argument back to the relationship between the two invisible forms of economy discussed earlier, offshore finance and the informal economy. Money laundering is something of a hinge between these two domains and will explored in both contexts below.

Much ink has been spilled by economists, the OECD, and the United Nations on how to protect legitimate offshore transactions from abuse by criminal elements. While some might think that offshore financial transactions, often designed to hide money from investigators and regulatory agencies of any country, were invented in order to shield ill-gotten gains, there is a broad consensus that there are good and bad uses of such instruments. A 1998 report produced under the auspices of the United Nations by a group of economists and criminologists suggested that the problem was rampant: "The international narcotic trade [alone] launders a minimum of $200 billion a year. A substantial portion of that money moves through the bank secrecy, financial center jurisdictions. Law enforcement effort in the best of years recovers amounts in the range of $100–500 million. Although some participants in laundering schemes are arrested and convicted, the vast majority of professionals who assist are not" (Blum et al. 1998, 110). Since the vast majority of these transactions are undetected, it is impossible to say how much of a role art may play in money laundering.

The scholars who produced the UN report introduced "ten laws of money laundering" to help law enforcement spot the traces of money-laundering activities, and it is telling that six of these can be applied to the international art market. Of course, many of these laws could apply to any business enterprise. The first law states that "the more successful a money-laundering apparatus is in imitating the patterns and behavior of legitimate transactions, the less the likelihood of being exposed", (Hampton and Levi 1999, 648). A principle such as this has no more applicability to the art market than any other business, but other characteristics of the art market can be more directly correlated to money laundering through other laws they list and a book by a Brazilian judge, *Money Laundering through Art: A Criminal Justice Perspective* (de Sanctis 2013), provides numerous examples.

The tenth law reminds us that "the worse becomes the current contradiction between global operation and national regulation of financial markets, the more difficult the detection of money laundering" (Hampton and Levi 1999, 648). In other words, the fact of arbitrage in the global market means that international auction houses and dealers are finding ways to skirt national regulation for the benefit of their clients at least, if not their own bottom lines. Businesses worldwide have been following this trend steadily since the 1960s, so it would be rather uncharacteristic for the art industry to eschew such practices. The authors of the UN study of money laundering simply remind us that, as this gap between national regulation and international commerce widens, so does the opportunity for criminal elements to engage in otherwise legitimate forms of exchange. As the art market has embraced globalization of finance, it has adopted elements of the offshore financial system, and the result is that there is a burgeoning art economy that is invisible, undetectable, and so far unmeasured. There is no telling just how large a portion of the art market the offshore system hides.

2 MONEY LAUNDERING AND ART DEALERS

Nothing makes art dealers slip into paroxysms of denial more quickly than discussions of money laundering in the art world. "The Art Dealers Association of America dismissed the idea that using art to launder money was even a problem," a 2013 article in the *New York Times* noted. "'The issue is not an industrywide problem and really does not pertain to us,' said Lily

Mitchem Pearsall, the association's spokeswoman" (Cohen 2013, n.p.). In the *Art Newspaper,* Richard Feigen, a Manhattan dealer of considerable stature commented: "I've honestly never heard of using art for money laundering," (Burns and Gerlis 2013, n.p.). The reason that these dealers were being asked to comment on money laundering in the art world is that Helly Nahmad, a scion of the founder of one of the world's most respectable art dealing empires, the Nahmad Gallery, had just been convicted of running a gambling and money-laundering ring for Russian, Ukrainian, and American millionaires and billionaires (Glanz et al. 2013; Adam 2014). Clearly, other dealers were on the defensive for good reason, but can we take them at their word? Even if they were being entirely honest, it is possible that they are not completely informed on the many ways in which art and money laundering may be combined in practice, and therefore would not even know if it were happening to them.

Later in the *Art Newspaper* article, one dealer, James Roundell, then chairman of the Society of London Art Dealers, confessed: "We are much more aware of the issue now than we were 20 or 30 years ago. . . . Around 20 years ago, people used to turn up with cash in suitcases to buy old masters and no one really cared." Well, it is good to know they are not selling art to unknown individuals with suitcases of cash *any more.* But in the era of art advisors and offshore financial transactions, how can a dealer really know whether the anonymous client being represented by an agent arranging the purchase is a drug kingpin or a real estate developer, or both? Given this reality, it is laughable that dealers so unequivocally state that they have nothing to do with money laundering, but who can blame them? If they follow the law, and if any potential criminal activity is hidden from them, they have done nothing wrong. There is nothing illegal about accepting a transfer of funds from an offshore account held by a company or trust, nor is there anything suspicious about shipping a work of art to a freeport or foreign bank. Furthermore, any money launderer worth his pay would of course shield the identity of the purchaser in layers of subterfuge, so it would not be easy, and perhaps not even possible, for a dealer to determine what sort of transaction she might be engaging in. Besides, discretion is the nature of their business and protecting a client's identity is an accepted protocol of the industry. In fact, every point so far made about dealers would be equally applicable to auction houses. Like an offshore financial center, the exclusive high-end domain of the art market is a secrecy domain, and in that world, an informal economy thrives.

What is an informal economy? Informal is one of the numerous monikers given to economic transactions that are unrecorded, literally off the books. As early as the 1980s, sociologists and economists began to study the gap between official economic production and the traces of a shadow economy that supplemented its capacity by a significant margin. Hernando De Soto (1989), Alejandro Portes, and Edgar Feige are some of the key thinkers to consider a new hypothesis about global economic production. The multiple manifestations of the informal market around the world are explored in Mörtenböck et al. 2015. "In brief, the [underground income] hypothesis suggests that a large and growing segment of economic activity may escape the elaborate measurement system that government agencies have established to measure economic activity," Feige says (1989, 14).

The term "informal economy" was first used by Keith Hart (1973) to describe how individuals in developing nations invented new economic devices in order to survive in a world with very few "regular" employment opportunities (Portes 2010). Since then it has been a term employed to describe bottom-up efforts to generate a livelihood among those without secure financial footing in the global economy. Feige has broken the underground economy down into segments: the illegal economy, the unreported economy, the unrecorded economy, and the informal economy (Portes 2010). I use the term "informal economy" here to refer to any transaction that is unrecorded, untaxed, and unregulated but not explicitly illegal. This is also described as the "gray market" to distinguish these economic activities from the explicitly illegal "black market." The number of synonyms alone testifies to the prevalence and diversity of this economic sphere, but the question that everyone wants to answer is: How big is it?

In a recent book, Robert Neuwirth cited an OECD report asserting that half of the world's employees (some 1.8 billion in 2009) were employed in the informal sector, and that number was expected to rise to two-thirds by 2020 (Neuwirth 2011, 18–19). Alejandro Portes has discussed a variety of measurement systems for the informal economy, all of which are flawed to a certain degree, but he presents research counting informal employment sectors—including domestic servants, micro-enterprises, and so on—in various countries, including the United States. These numbers are as high as 44 percent in Brazil and 40 percent in Argentina, while in the United States, they vary between 7 and 9 percent, depending on the state (Portes 2010, 151).

Such sector analysis may be the most effective method of getting an overall estimate, but it masks the interpenetration of the formal and informal domains of the economy. In reality, it is impossible to entirely pull these two domains apart, because they are often blended together when, for example, subcontractors do piecework for garment companies or workers took assembly work in the home for semiconductor companies in Silicon Valley, before this production was moved offshore (Neuwirth 2011). Mark P. Hampton and Michael Levi point to the mixing of the formal, informal and illegal economies in offshore financial centers. They develop the following example to demonstrate their point:

> The masses of street vendors in the metropolis of developing countries sell goods that might be smuggled, branded counterfeits or stolen from legitimate enterprises, may pay no sales or income taxes, but make protection payments to drug gangs that control the streets where they operate. The drug gangs might use the protection money as operating capital to finance wholesale purchases of drugs or arms, perhaps using International Business Corporations (IBCs) established in OFCs to channel the funds, perhaps paying cash. The results of these and many similar forms of interfaces is an economic complex that can no longer be divided neatly into black and white; rather it forms a continuum of different shades of gray. (Hampton and Levi 1999, 647)

While this description does not seem to apply to the sales of art works in financial capitals such as New York or London, there are a number of characteristics of the informal economy that would be important to consider when assessing the size and the nature of the global art market.

The most essential aspect is the blending of black and gray markets with legitimate, if less regulated, markets such as the art market. In the projection used above, given present offshore financial mechanisms employed by high-net-worth individuals who invest in art, it would be difficult for a seller of a work of art to determine whether the money transferred to cover the art work was "clean," because money launderers are known to employ the tactic of "layering" to hide the origins of assets and blend "dirty" money with legitimate investments (Zagaris 1997, 125; Adam 2014, 176–77). It is also important that legitimate enterprises sometimes subcontract with informal enterprises in order to make their bottom lines, and we should look for this dynamic in the global art world as well. Web sites that facilitate art auctions and private art sales are a perfect example, but there are others. Finally, artists are the perfect example of an unregulated labor pool, performing work at

home and thereby evading workplace regulations, consigning and sometimes selling it without a formal contract, and working on the margins of the formal economy. With these considerations in hand, it will be possible to elaborate how the global market for art engages the informal economy, and what the effects of this are for the market itself and also for the artists who supply it.

When art world insiders think of the art market, they generally consider international auction houses and dealers who follow the model of those in New York or London, though they may be active in Mexico City, Moscow, or Dubai. But this is not the whole of the art market and, even if one leaves aside art produced solely for commercial purposes, there is a considerable gap between the estimated art market scale as measured, for example, by Clare McAndrew in her annual survey for TEFAF, and the actual markets for art and art-related products. This gap would include everything from the "starving artist" liquidation sale to regional art fairs where artists market and sell their own work, to the factories in China that manufacture painted reproductions of Old Master and Impressionist paintings. It is tempting to see such activities as marginal to the main event of the art market, and, like the informal economic activity described above, they are marginal. But the question remains: How big is this part of the art economy? Is it 7 or 44 percent? Furthermore, the blending of black and white economies is an issue of increasing importance to the art market, which few commentators have addressed. Were sales taxes paid in the reported $250 million private sale of one of Cézanne's *Card Players* paintings to the royal family of Qatar (Peers 2012), and if so, in which country? Were customs duties assessed? Was the painting sent directly from the seller to the buyer, or did it pass through duty-free port? What was the commission that the dealer was paid? Were there middlemen who also profited from connecting the parties, and if so, did they pay income taxes on this income, or was it transferred to an offshore company or trust?

No one would answer these questions in public and so the public will never know, but the point is that the global art market is so little regulated that it would be impossible to assess the size of the informal portion of these transactions, even in the case of a "legitimate" sale. Given the presence of offshore financial mechanisms, there are enough means to avoid national regulations that it would seem likely that there is an informal tail to many formal transactions. Just because a transaction is unregulated does not mean it is illegal, and if informal practices are hidden, it is not because they are

explicitly illegal. There is a clear legal distinction between tax avoidance and tax fraud.

This is slippery territory, because journalists (and academics) are interested in shedding light on hidden practices, and the implication is often that the invisibility of these economic activities is evidence of wrongdoing, if not law-breaking. But the informal economy is not the same as the illegal art economy, in which looted antiquities change hands and cross borders, for example. No business wants to be implicated in the black market, and no one would admit to doing so in the gray market either. While the art market is highly differentiated, in general its proponents assert that the goal is to advance the cause of art and artists, and anyone perceived to be speculating in the art market may be blackballed by other dealers. There are norms that sellers of art follow and a bespoke code of conduct. However, the art market's transactions are imbricated in a network of deregulation and arbitrage, and it cannot make the offshore financial system go away. So the informal market for money and financial services works hand in hand with the art services market.

One knows of the black market because criminals occasionally get busted, as in the case of the forger of fake abstract expressionist canvases that were brokered by an unscrupulous agent and sold at New York's Knoedler Gallery (Halperin 2011). Black market activities are not a separate sector in developing economies, but can be present anywhere, and the line separating them from the informal economy in the art market can sometimes be very fine indeed.

"Forging an Art Market in China" (Barboza et al. 2013) points to the tradition of *lin mo,* or imitating the masters, which in China is considered a very important dimension of artistic education. By emulating past masters, a student does justice to the authority of past art, while developing her own skills. This has been a part of the teaching of art academies in the West up to the present day, but it is not embraced as thoroughly in cultures that value innovation as highly as the United States and Europe. In China, there is no clear boundary between emulation and interpretation, and this has led to the production of forgeries and a rampant trade in them. In a country where 70 percent of the art market takes place at auction, this means that auction houses are being flooded with fakes. A Chinese expert quoted in Barboza et al. 2013 (n.p.) estimated that 80 percent of the works sold at small and medium-sized auction houses were replicas. Looking back at the art auction numbers presented by Clare McAndrew, these sales are being counted as part of the Chinese art auction market despite the dubious authenticity of the

works involved. Such are the limits of our economic tools. While we can assess the value of the market, it is more difficult to ascertain if numbers from China are actually comparable with those from the United States, its biggest competitor in the art auction market.

Few concrete examples of the informal economy in the art world are more visible than the gift economy, which in some cases is clearly a graft economy. Through this system, prices and auction markets, regional or international, can be manipulated and other purposes can be served through a gift of works of art. Gift exchanges in a market context solidify social relationships, and these "social relationships have instrumental economic value and enhance rather than [impeding] efficiency [as neoclassical economists would claim]," according to Olav Velthuis (2007, 60). In discussing the relationship between artists, dealers, and collectors, Velthuis points out the various ways in which the market for contemporary art in New York and Amsterdam can serve itself more efficiently by not being a free market open to the highest bidder. This author has proposed that the art market is not free, but a modified market that unevenly distributes information and transactions resulting in advantages for insiders. In other words, simply by believing in an emerging artist or favoring a client, dealers make gifts that facilitate their business in the particular domain of the market that they inhabit. As a sociologist, Velthuis sees social relationships at the core of the market for contemporary art, and the gift economy, in which the commercial nature of exchanges is marginalized in favor of "trust relationships" cemented through generosity, is central to this development.

The gift economy works differently in distinct cultures, and a couple of recent episodes will illuminate how it produces informal art economies in Russia, China, and Brazil. All of these countries have an established tradition of gift giving, which can enhance or detract from a market, since they cut across economic sectors and alter behavior at the top end of the market, where the slightest tremor will have larger implications. An investigation by the London *Sunday Times* of two gifts of art by Russia in connection with the failure of Britain's bid to host the 2018 World Cup—a competition Russia won—shed much light on what nations will do in order to gain such high-profile sports events for themselves (Dickinson 2014). Apparently, they are willing to marshal national resources, including large-scale economic deals, as well as using national security instruments, such as MI6 in order to compete. But no revelation was stranger than two reported bribes involving paintings given as gifts to voting members of the FIFA committee.

According to CNN, a painting believed to be a Picasso was offered to the European Football Association's Michel Platini, a claim Platini has denied. In a related case, another FIFA voting member, Michel d'Hooghe has admitted to accepting a landscape painting as a gift from Viacheslav Kolokosov, "a former Russian executive committee member working for his nation's attempt to host the 2018 tournament" (Gittings 2014, n.p.). D'Hooghe has described this painting as "ugly," said that he believed it had no value, and protested that he had not voted for the Russian bid. Nevertheless, his case is one of the rare instances when malfeasance of this sort comes to light, and it indicates how works of art can be employed as gifts in order to secure favors (or not, in this case) that have nothing to do with the market for art. The integrity of FIFA officials at the highest levels was further compromised in a huge scandal in 2015, including multiple indictments in U.S. federal court, so more information on art gifts and FIFA competitions may yet emerge, but the use of art works as gifts in the 2014 exposé points to the presence of powerful and wealthy individuals attempting to grease the wheels of the FIFA selection process using art as a form of currency. One allegation suggests that the Picasso work offered to Platini came from the collection of the State Hermitage Museum in St. Petersburg. If this turned out to be true, it would have large implications, since the raiding of a national art collection to secure a World Cup bid would be a scandal of unimaginable proportion in the art world. While this claim cannot be substantiated at this time (and perhaps never will be), the transfer of art in an attempt to secure favors has been exposed in d'Hooghe's case and it is likely that this is not the first time that such a transaction has occurred. The gift economy has transmuted into a graft economy.

Art exchanges also played a role in the unfolding of the Petrobras scandal in Brazil, which involved deals that began as far back as 2004 as a huge kickback scheme, but erupted into public consciousness in 2015. This has had enormous economic and political consequences and led to the resignation of numerous cabinet ministers and even the impeachment and removal from office of President Dilma Rousseff, who headed the board of Petrobras before becoming president in 2011. More than $2 billion in bribes was paid. The *New York Times* reported:

> Prosecutors and the federal police have been seizing cash and assets, including fine art. Because storing expensive paintings and photographs is not a law enforcement specialty, the entire haul has been handed over to the Oscar

Niemeyer Museum in Curitiba. Since April, the works, mostly by Latin American masters such as Heitor dos Prazeres and Vik Muniz, have starred in an exhibit called "Art in the Custody of the Museum." (Segal 2015, n.p.)

The fact that so much art has been seized as evidence in this scandal demonstrates that either art was being given as bribes or the recipients were using cash from bribes to purchase art. Either way, the Petrobras scandal demonstrates how illicit capital flows are entangled with the art market. The fact that these seizures have led to an art exhibition demonstrates that art institutions are capable of making the best of this situation and have also been involved in making such practices public.

An exposé of the Chinese art market also published in the *New York Times* introduces more complexity and more systemic risk into the art market as a whole. According to the authors, "the [Chinese art] market. . .has become a breeding ground for corruption, as business executives curry favor with officials by bribing them with art" (Barboza et al. 2013, n.p.). Such bribery schemes have involved public officials, such as Wen Chiang, an official in the city of Chongqing whose country house contained more than a hundred works of art when it was raided by the authorities in 2009. The authors describe how these bribery schemes can operate: "In some cases, an official will receive a work of art with instructions to put it up for auction; a businessman will use it as the currency for a bribe, purchasing the art at an inflated price and giving the official a tidy profit" (n.p.). This is termed *yenhui,* which translates as "elegant bribery." The Chinese example demonstrates not only how art works can be used as luxury currency but further how this currency can be laundered through the art auction market.

The gift/graft economy is not the full extent of the gray zone of the Chinese art market, however. Price manipulation is supposedly rampant and, though this is the case in all markets where certain parties seek advantage over others, it is not legal in stock markets. But the art market, particularly in China, is less regulated. There is a fundamental tension in the primary market between the dealer, who wants to set fixed and stable prices for her artists, and the auction house, which offers works to the free market in which demand determines price. In China, it is far more common than in the United States and Europe for living artists to sell their works directly through auction houses, skipping the dealer system entirely and driving up the prices of contemporary Chinese art in general. If others are colluding with artists (or operating independently) to drive up prices through the market, the

stability of the primary/secondary market system is at risk, and this risk is not limited to China.

To a certain extent, dealers in contemporary art work through the auction house mechanism to stabilize the prices of "their artists." If someone has put a work up for sale by an artist represented by a certain gallery and it appears that the work will not sell, or will sell below the dealer's established price, the dealer will often bid on and buy the work around the set price. This practice has been in place for more than a century and is accepted in the art world, but the auction market can also be used for more active price manipulations: "Price manipulation is rampant, analysts say, as collectors and investors, perhaps an art investment fund with large holdings in a particular artist, bid up a work to boost the value of their entire inventory. Sometimes, experts say, auction houses themselves throw in fake bids. The Chinese have a name for the price-boosting process. They call it 'stir frying'" (Barboza et al. 2013, n.p.).

Such "stir frying" to heat up the value of an artist's work is an example of the informal dimension of the Chinese art economy. Value is created through means that are not explicitly illegal, but neither are they entirely legitimate. As the Chinese art market expands, more works by these artists are finding their way into Western collections, and over the past ten years, many Chinese artists have muscled into the top ten highest-grossing artists at auction, so that one finds Qi Baishi and Zhang Daqian alongside names such as Picasso and Warhol as the top sellers globally. Thus the art economy is clearly seeing the signs of stir-frying techniques. Given the meteoric rise in prices for contemporary art over the past decade, informal price manipulations like these appear to be part of this story.

Artists and The Informal Economy

These last three examples, as well as details emerging from the leak of the Panama Papers in April 2016, are provocative and potentially scandalous, but the informal art economy has broader implications beyond these sensational aspects. One of the most important is that the artistic work is being redefined and artists are confronting market processes head-on. Artists have been in the informal economy for a long time, making sales of their own works in unregulated contexts, such as selling work out of the studio or at an art fair. In such contexts, it is not common for them to charge sales tax, for example, and it does not seem unreasonable to suggest that they might not report this

income on their tax returns. If a dealer or curator gives an artist an emerging artist an exhibition, it is common for an artist to gift a work of art to her and this kind of gift might not turn up as a transaction on anyone's books. These are the kind of gifts that Velthuis describes as cementing the social relations of the art world. They are based on mutual generosity that cannot be measured, and so there is an argument to be made that it should not be.

In fact, artists have long attempted to turn away from the market for art by creating works that are fundamentally unmarketable. In the 1950s, there were "happenings" and, in the 1960s, Fluxus artists in Europe and conceptual artists in New York created "works" that had no objective character. While the happenings became performances and performance art occupies a unique arena in the domain of art production, works that had no palpable dimension but were simply, for example, a set of instructions or words on a wall, were originally designed to undermine the commodity character of a work of art. Such practices followed a long line of immaterial artistic production beginning with Dada and Russian Constructivism. So artists have long sought to undermine the commodification of their artistic work while, on the other hand, dealers and institutions have worked to co-opt anti-institutional art works in their own interests. Now any modern museum worth its salt owns a set of instructions that it bought or at least accessioned as an art work, and an artist like Tino Seghal is selling his performances as art without even a script or contract. One might say that the more the artists protest against the market, the more the market redoubles its efforts to rein them in, and artists like Seghal and Andrea Fraser are complicit with the market even if they are trying to push the bounds of what it could possibly mean to sell the work of an artist when it takes no tangible form.

But the production of unsellable art continues notwithstanding, as the evolution of the social practice domain of artistic production demonstrates. Biennials do much to promote and support the artists who produce this kind of work, because they want to make timely statements but are not compelled or required to sell art works to survive. Biennials are supported by nonprofit foundations and through state support, but they are directed toward creating an experiential event, instead of generating sales through the event like an art fair. Museums also sponsor unsellable art, inviting artists for a residency as opposed to commissioning a work or planning an exhibition of objects. These cases demonstrate a structure of patronage outside of the market to support artists who make immaterial works and this is necessary if such artists are to continue to produce. But they also suggest an aesthetic

economy in which ideas are exchanged, rather than currency, and the more one engages in this economy, the more opportunities to contribute to it will follow. By seeing these kinds of works, viewers generate their own responses. Sometimes these responses are actions taken in everyday life, sometimes they involve writing and publishing reviews or criticism, sometimes they make other works of art. This too is a kind of informal economy, because since it is formless, it could really not fit "on the books," so it must be off of them (Viegener 2015).

There is a utopic idealism in this aesthetic economy harbored by many artists and their followers, and such notions turn up frequently in the context of artistic collectives and artist-run spaces that will be addressed in the Conclusion. This is only one way in which artistic labor is being redefined, however, and a host of events considering the value of artistic labor have turned up, including a memorable Open Forum in the Sunday *New York Times*, "The Cost of Being an Artist" (2013) and symposia held internationally (Keeffe 2014). At the heart of this questioning is: Why do so many artists (and other participants in the art world) work for free in order to realize their projects or get their work into public view? Doesn't artistic labor have a monetary value like other forms of labor? And then the inevitable: Who owns artists' labor? All of these questions revolve in some way around Marx's notion of alienated labor and whether any class of worker, artists included, own their own means of production. Based on the discussions of the art market so far generated in this chapter, the answer seems be no, since for the most part artists are not central agents in the market for their works, and the more they become so (think Jeff Koons), the less their work appears to have aesthetic autonomy. Rather, artists in this position are perceived to be courting a market and promoting their product.

At this stage in history, one wonders what choice they have. In discussions of post-Fordist production in previous chapters, it was noted that curators of international biennials function as opportunistic entrepreneurs even when they criticize the very system that supports them. Artists are much the same, because one cannot simply go back to state support for contemporary artists. Artists have long been producing their own innovations on spec and waiting for the market to catch up to them. If they don't want to sit in their studios toiling away and hoping that some curator or dealer will discover them, they do need to court the market. That could mean going to openings and talking to other artists, dealers, curators, and collectors who attend, but these days it usually means going to art fairs and biennials as well.

Artistic production in this period of service-dominated capitalism is speculative in nature, and it is no surprise that dealers make matches between speculative artists who are working to increase their reputations and speculative investors who are looking for investments whose values will increase. If they all share a love for art, then all of the necessary ingredients are there to produce a market. If there happen to be unprecedented levels of capital in circulation, it is also no surprise that it finds outlets like collecting art that may be risky but will provide pleasure, increase one's stature amongst peers, *and* increase in value.

The informal economy in the art world is not only a series of shady business deals, though it does include these, but also a way in which the distant and objective art market is personalized and made immediate. It is a symptom of the shrouded financial transactions of the offshore economy and a salve to soothe the wounds that capitalism inflicts on those whose labor eschews its financial logic. Artists, curators, and nonprofit directors, among others, work for free because they want recognition and want to participate in a public conversation, but also because they do not want their labor to be monetized. Their actions provide a surplus that cannot be quantified, and the rewards they receive are not the kind of thing you can claim on a tax form. No one wants to be poor, however, so artists, and all other participants in the art world, turn to the market to provide the means for their existence.

But the market for art is no simple thing. Though it is being measured with more precision than ever before, there are countless immeasurable transactions. What we think of as the art market is only a passing glance at what actually exists. Certainly, there are market manipulations that are invisible to the general public, if more accepted within a smaller coterie of participants. But there are also uncalculated domains of financial exchange, sales that are off the books, and generous contributions to the development of the aesthetic dimension of the human spirit that could never be quantified. If all the artists and other art world agents who perform labor for free were to bill for these services, how much would it come to? This is a question that no economist can answer with any precision.

FIGURE 20. Centro Cultural Banco do Brasil, Rio de Janeiro. Photo: Lucia Cantero.

Emerging Art Center

THE CONTEMPORARY CARIOCA ART SCENE

Lucia Cantero

As classic tropes of Rio de Janeiro would have it, the city is the home of samba, sandy beaches, and sculpted bodies. A distinctly urban paradise nestled in a tropical rainforest, its sweeping views and rich popular culture have long sold the city. And while much of Rio de Janeiro's lively and vibrant art scene draws on the sinews of major global events like the 2016 Olympics, a Brazilian renaissance reflects the changing nature of deeper structural shifts in its political economy. Within this shifting landscape, creative expression, the arts, and the subsequent economy have opened up in novel ways. Artists are becoming more enterprising around their practice, mainstream galleries more receptive to subversive and avant-garde art, and this scenario has also led to a burgeoning group of sophisticated young investors in art.

For decades, the arts industry in Brazil was heavily censored by dictatorships, but "[i]n the 25 years since the restoration of full democracy, Brazil has become a major player on the world's stage, and contemporary art in Brazil has acquired similar importance," the curator Christiano Tejo proudly notes ("Brazil's Burgeoning Art Scene," *Technosyncratic*, 2014, n.p.). Brazil is rising along with other BRIC nations, and holds fifth placed in the global art market, after China. Almost a third of Brazilian art collections are fifteen years old or younger, reflecting the inchoate growth of the market (Art Media Agency 2015). Some 27 percent of all Brazilian art in private collections was bought after 2001.

Not only is the emergent Brazilian art market growing, it accounts regionally for 57 percent of South American collectors. These numbers reflect the

measures that keep collectors buying national in Brazil, since import taxes on foreign art remain high. On the other hand, export sales have increased by 350 percent since 2007 ("Brazil's Burgeoning Art Scene," *Technosyncratic*, 2014). Fostered by new laws that create incentives like tax breaks for corporate sponsorship of cultural activities or businesses venturing into the culture and arts industry, this boom has led to increased participation from galleries and the growing prominence of art fairs. Since the passage of the Culture Incentive Law, major national banks like Banco Bradesco have heavily sponsored more and more art-centered events. "Money makes art grow," the Carioca photographer Claudio Edinger is quoted as saying at SP-Arte, a leading São Paulo art fair (Garcia-Navarro 2013, n.p.). And it is clear that the creative economy is responding to this momentum.

For most Brazilian artists, the standard for success is showing in São Paulo. But the dynamism of Rio de Janeiro's linkages to global events has increasingly placed it on the art map. Today art fairs like ArtRio not only count on both local and global representation from around the world, but feature events and programs that seek to intensify arts culture. ArtRio was launched by Brenda Valansi, Elisangela Valadares for the Brazilian Exchange/BEX group in 2009, and since 2011, it has been BEX's pet project, the chief aim being the production, display, and distribution of Brazilian art (ArtRio 2016). Beginning in 2011 with eighty-three galleries, it had 46,000 visitors. By September 2015, it had an area of 20,000 square meters and showcased more than 2,000 artists from over eleven countries (Meinicke 2015). Generating networks through curatorial programs, lectures, and outreach, international fairs like ArtRio bring new waves of viewers and buyers of art to a city long culturally overshadowed by highbrow São Paulo.

However, Rio de Janeiro has always had its own unique artscape, and the former colonial port, now a metropolis with some six and a half million residents, also has the weight of its history to back it up. Before the creation of modernist Brasilia, it was the national capital, and its stately mansions and cultural institutions long served the arts. Built during Rio's *belle époque,* and inaugurated in 1937, the Museu Nacional de Bela Artes is considered the leading art museum in Brazil. It houses over twenty thousand works and is remarkably rich in nineteenth-century painting and sculpture. The recently overhauled Teatro Municipal, erected in the early twentieth century, and recalling the Paris Opéra, is deemed one of the most beautiful of buildings in the country. This region of the downtown center, known as Cinelândia, was once the hub of buzzing theaters (hence the name). The main square contains

the Biblioteca Nacional, Palácio Pedro Ernesto, and the Tribunal Regional Federal superior court. The plaza's metro station opened up in 1979 and is the midway point on a subway line that connects the affluent southside Zona sul to the more modest northside Zona norte. North of this square, the Centro Cultural Banco do Brasil (CCBB) hosts traveling exhibitions, such as the recent *Impressionistas* blockbuster, which topped the charts worldwide for museum turnout (figure 20). Surrounded by some of Rio's most magnificent Catholic churches, this art deco building housed the federal bank (hence the name) before its operations moved to Brasilia. Along with cultural centers in São Paulo and Belo Horizonte, the CCBB serves as a hub for galvanizing culture by offering the public free access to a range of events and exhibits.

A short walk south from the downtown center and through the Lapa neighborhood, where night owls can visit the very dance halls said to have given birth to the samba, leads to the Gloria area, where the Museu de Arte Moderna (MAM), Rio's premier modern art museum, is to be found just north of Flamengo Park, and yachts and other sailboats line the marina. Occupying a stunning concrete building designed by Affonso Eduardo Reidy and erected as part of a larger urban renewal project in 1967, MAM holds a selective collection of modern and contemporary art, in which works by Gilberto Chateaubriand and Joaquim Paiva dominate. Currently, the in-house library is being updated to encourage scholarly research. The annual PIPA awards program, created in 2010 to promote MAM and Brazilian art, showcases four finalists from among a cadre of artists nominated by a prestigious committee consisting of from twenty to forty Brazilian and international art experts.

Across Guanabara Bay in Niterói, the Museu de Arte Contemporanea (MAC) shows a selective array of contemporary art. Completed in 1996, the saucer-shaped building, designed by the renowned Carioca architect Oscar Niemeyer,* offers stunning panoramic views of Rio de Janeiro. Inside, a highly architectural space houses traveling exhibitions in spatially innovative ways, much like the Guggenheim in New York. The 2,500-square-meter building, often likened to a UFO, is purportedly a tribute to a blooming flower (Hearst 2012). MAC was originally launched when João Leão Sattamini Neto donated twelve hundred art works to the city, and many of

* Carioca, the native Tupi term for "white man's houses," was the name bestowed upon the Portuguese settlement during colonization. Today it refers to all residents of Rio de Janeiro.

the museum's exhibitions are thus dedicated to him. Franz Weissmann, Artur Barrio, and Lygia Clark are a few of the popular Brazilian artists whose work is found here. MAC is also dedicated to the local mission of arts education. In 1999, it started an art environmental action program to give more opportunities to underprivileged youth (Enciclopédia Itaú Cultural n.d.). The museum boasts a high-end bistro offering international cuisine, with live contemporary performances.

The LURIXS Contemporary Art Gallery, just a bit south of Flamengo Park, was founded in 2002 by the art collector Ricardo Rego to encourage dialogue between artists, critics, and the public in the hope of rising above the commercial aspect of art transactions. LURIXS shows fine art from a variety of traditions, including work by Hélio Oiticica, Renata Tassinar, and Raul Mourao. The Artur Fidalgo Galleria, well established near the beaches of Copacabana further south, is briefed with showcasing newcomers in the art world and cutting-edge work pushing the boundaries of conceptual and aesthetic innovation. The gallerist Artur Fidalgo, formerly an economist, began with the salon-style "Escritorio da Arte" and opened his namesake gallery in 2000. He still has "renewal" as his main objective and shows both local and international emerging and renowned artists, such as coveted Umberto Costa Barros and Claudio Paiva. The best smaller galleries with outstanding collections and hybrid design in the Zona sul include Luciana Caravello Arte Contemporanea, the Galleria de Arte Ipanema, and the powerhouse Anita Schwartz gallery in the Gavea district, which puts on rotating exhibitions in its multilevel space that have made it a key institution for both emerging and established Brazilian artists for over twenty-five years. The more recently inaugurated Galeria Laura Marsiaj has created a yet another space and cultural center for new voices in art.

The general northward push beyond Rio's southside in order to democratize art spaces, practices, and ultimately art production is exemplified by the northside Praça Mauá fair (Art Rio). The Gentil Carioca gallery, a hybrid art space in the historic Saara district, was begun by the "underground" artists Marcio Botner, Ernesto Neto, and Laura Lima to the staging ground for a new perspective on the political "cartography" of high art in Rio today. We have even begun to see museums—such as the Museu da Maré—crop up in Rio's favelas, or slums. The spinning of gentrification into new visual forms is perhaps most hyperbolic in the aesthetics of the Rio Art Museum (Museu de Arte do Rio–MAR) launched in 2013. Designed by Bernardes + Jacobsen Arquitectura, the structure unites several buildings of competing

architectural styles under one undulating roof. A visual cacophony, it seeks to wedge together Old Rio with the new one, reminding the public that the newness is on the horizon. It is a meeting of old profane and new sacred, along with a new class of consumers too, bridging the new artistic divide.

This new middle class and a subsection of the younger population who thrived on Brazil's recent gold rush are now investing in art as a market that is ultimately less volatile. Cariocas fluctuate between anticipation and disenchantment over the changing conditions of their urban metropolis and the country at large. Today, in the aftermath of the pronounced euphoria of economic growth over the past few years and the 2014 World Cup, Brazil finds itself in the doldrums of an economic depression. Nevertheless, the art market for both domestic and global consumption continues to grow. "We're seeing a significant expansion of *carioca* cultural life," Vanda Klabin, a Rio historian and art curator, says. "And that's going to continue beyond the upcoming international events" (Phillips 2013).

Oscar Niemeyer once said: "I pick up my pen. It flows. A building appears." His impulse, the following of flow, also led to a particular appreciation for curves. "Curves are the essence of my work because they are the essence of Brazil, pure and simple," he asserted. "I was attracted by the curve—the liberated, sensual curve suggested by the possibilities of new technology yet so often recalled in venerable old baroque churches" (Basulto 2012). For Niemeyer, Rio was both fertile and voluptuous, and his work reflects the buoyant possibilities the city still aspires to. Like his landmark buildings, Rio de Janeiro's rich art scene undulates, coexisting in beauty with the natural scenery. The Carioca combination of art and scenic landscapes makes a warm canvas, with art accessorizing an already idyllic cityscape. Niemeyer left a legacy of creative work for his city and beyond. "My work is not about 'form follows function,' but rather 'form follows beauty,' or even better 'form follows feminine,'" he said. Given the natural sweep of the market, Brazilian art is also likely to follow a curvaceous new trajectory.

FIGURE 21. Ackroyd & Harvey, *Art Ecology Science*, 2011. KHŌJ International Artists Association, Delhi. ©KHŌJ International Artists' Association, 2015.

Conclusion

COLLECTIVIZATION AND THE NEW GEOGRAPHY
OF THE ART WORLD

One of the most transformatory things in the last two decades
has been the way in which the thematics of visual representation
have been massively rewritten from the margins, from the
excluded; and this is precisely the contest being played out
within that global circuit of cultural production.

STUART HALL
(Hall and Hardt 2004, 135)

The new collaborative movements have sought to take an active
role in social change, not by means of radical intervention or
critical reflection, but through the mediation of new forms of
public knowledge.

NIKOS PAPASTERGIADIS
(2011, 285)

Chapters 5, 6, and 7 position the artist in the market, but the question that
demands attention is: What are artists doing to create alternative structures
outside of the market to support their own activities? Despite this study that
illuminates various ways that the market has inserted itself into the social
relations of the art world, it must be acknowledged that a large sector of the
art world exists outside of, or parallel to, the market. Whether one discusses
nonprofits, artist-run spaces, or artist collectives, it is clear that like so many
of the other domains treated so far in this study, the development of alterna-
tives has a long-standing history. So a second question arises (perhaps no

more than a qualification of the first): What are the most recent innovations in terms of artistic collectivization and is it possible to see an emergent set of practices that has altered substantially in the past generation?

Based on the general course of this book, the reader will guess that the answer to the last question will be affirmative, but the challenge is to demonstrate how these new practices coincide with the development of globalization. In this conclusion, the argument builds on previous chapters but it takes a new turn in order to explore how the breakdown of the center/periphery model as a result of globalization dovetails with challenges to the market structure and the "powers that be" in the world, and the art world. If one turns the tables and takes the artist as the primary agent in this art world, what is the effect of this geographical decentering? The goal in this inquiry is to connect Stuart Hall's assertion in the epigraph on rewriting culture from the margins to the ideas on collectivization implicit in Nikos Papastergiadis's assessment of the political goals of artists' collectives. Does rewriting history, culture, even the market, from the margins lead to the production of alternatives to these tired yet persistent norms? Looked at the other way: If artists are mediating new forms of public knowledge in a cosmopolitan sphere, how will this be experienced in distinct locations around the world? In what follows, I mean to show that artists are upsetting our international norms and the power dynamics they manifest, not merely what has been perceived as a center/periphery structure. The new geography that emerges is a form of resistance to the dominant forms of politics, economy and culture that are transmitted through normative representational forms, through traditional and new media. Migration and nomadism are two central practices of critique that have recently emerged to describe how globalization transforms our spheres of experience and it is important to consider how those critical terms have been manifested in the art world. While these challenges are based on traversing spaces of power and representation, artists' collectives have put down roots in unlikely locations around the planet. These institutions sprout in global cities, but also in rural enclaves where the terms "artist" and "collective" may have never previously have been in use.

Many examples are described by the authors of the city profiles included in this book, demonstrating a profusion of such collectives. These organizations tend to be most visible as local developments but, taken together, there is a broad trend toward artists collectively generating alternative exhibition venues and institutions of their own devising. As Nikos Papastergiadis has written, "One of the most distinctive features of contemporary collaborative practice

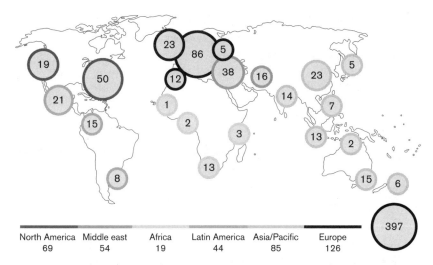

has been the shift in the mode of institutional engagement. Artists have sought to rethink the museum or the gallery as part of a broader communicational system" (Papastergiadis 2011, 278). Two exhibitions in the United States have looked carefully at the effect that artists' collectives, or independent art spaces, have had on the production of art around the world. *Six Lines of Flight,* curated by Apsara diQuinzio at the San Francisco Museum of Modern Art in 2012 (DiQuinzio 2012), an exhibition drawn from an investigation of six artists' collectives on five continents, provided a forum for discussion and writing about global artists' collectives, as well as sharing information. More ambitious still was the 2012 New Museum Triennial, *The Ungovernables,* curated by Eungie Joo, which networked almost four hundred independent art spaces through the "Museum as Hub" initiative (New Museum n.d.). The interactive map produced through this project is, of course, incomplete, but it is one of the best sources today on artist-run spaces internationally and demonstrates the spread of such spaces around the world (figure 22)

This is not an entirely new development; indeed, artists' collectives have been challenging orthodoxies of the art world ever since Impressionism, and have been associated with the modern spirit in the arts. The communications made possible through globalization allow one to perceive this trend in cities large and small around the world and, as Oliver Watts has written of collectives in Australia, there is a new psychology among artists and collectives in the digital age:

The artists' collective, or ARI, reinscribes an artist's practice, registering it as having some function within a community of practice that may or may not be associated with a style or philosophy. In the traditional model, the ARI was the experimentally free world of cultural agency insulated to a greater or lesser extent from the reactionary world outside. Yet at the same time, with the digital revolution, the ARI, as with any young individual, finds itself immersed within mechanisms of approbation. (Watts 2013, 23)

In other words, even an artists' collective or artist-run space perceives the need to use digital tools to network in the larger art domain today, and the result is a kind of authority, or at least a point of access among these artists to a realm of authority represented by institutions and institutional culture.

There is much literature about artistic collectives and the collective production of works in the twenty-first century (Kester 2004, 2011; McQuire and Papastergiadis 2005; Papastergiadis 2011; Barkun 2012) but less has been written about contemporary artist collectives who create artist-run spaces. A handful of articles have appeared in a variety of art periodicals chronicling recent developments, many of which are addressed below, but the Institute for Applied Aesthetics has produced a handbook of sorts that it distributes on the web, "The Artist-Run Space of the Future" (Institute for Applied Aesthetics 2012). This is a manual for utopians, but it is full of realistic advice, including fund-raising strategy and instructions on how to start a nonprofit or limited liability corporation (LLC) in the United States. This does not represent a global vision per se, but it provides a window on how to imagine the alternatives to the market that artists might create of their own initiative. Comparing artist-centered endeavors to a mushroom, they write: "The artist-run space of the future will be found below our feet, in soil and nutrient deposits, inhabiting cracks and places that otherwise prove uninhabitable; vacant lots, abandoned buildings and unlikely storefronts" (n.p.).

This is the kind of activity one could see occurring in the aftermath of the economic crisis of 2008, when many commercial spaces were abandoned and arts organizations were able to inhabit them, creating pop-up spaces that were sometimes completely ephemeral but, at other times, more lasting. An article in the *Art Newspaper* from 2009 reported at least ten nonprofits with pop-up galleries in New York City (Goldstein 2009), and such opportunities were seized around the country, and indeed around the world. The innovation of the pop-up is fundamentally opportunistic, because artists have to work with property developers and landowners to receive permissions and make arrangements about insurance and other practicalities, but they fundamentally

represent an artistic success in the face of a market that fails. While such opportunism among artists is not unprecedented, it has blossomed since the advent of the financial crisis, and given how little has changed in its wake, the pop-up trend promises to be a lasting feature of arts landscapes.

Such creative opportunities envisioned by artists' collectives do not end with underutilized property. One example is recorded in Barcelona, where artist-run spaces have given up their buildings in order to bring their ideas and projects out of the white cube. Jeffrey Swartz writes: "The practice of using existing sites . . . instead of running one's own space has been taken to extremes by what could be called 'critical collectives' who base their activity on the trafficking of ideas rather than on conventional exhibiting" (Swartz 2010, 6). In cases such as these, it is not simply putting art into public spaces coded for other uses, but creating work that contests the norms of artistic engagement in a fixed location. Shukla Sawant has discussed artists' collectives active in Bangalore/Bengaluru that worked specifically against commodity capitalism to develop collective projects in public in the late-twentieth and early twenty-first centuries (Sawant 2012). These practices of working outside of institutional spaces are what Grant Kester describes as the "collaborative" approach to art making, which he defines as "the ability of aesthetic experience to transform our perceptions of difference and to open space for forms of knowledge that challenge cognitive, social, or political conventions" (Kester 2011, 11).

Such a turn has also been theorized in terms of relational aesthetics (Bourriaud 2002), but Kester focuses the reader's attention particularly on the immediate implication of developing engagement in an art work *with* the public as opposed to *for* the public. In his book *The One and the Many* (2011), he also tells of how such practices have spread globally, from Senegal to Myanmar (Burma). The implications of pop-up spaces, or making art in public spaces, allows artists to recode these spaces as locations of creativity, rather than commerce. As such, these interventions within the structures of the art and real-estate markets globally point to alternative modes of engagement with public space that allow for creativity to predominate over the market orientation of both art and space. In this way, artists' collectives can formulate new economies of space and human engagement.

A new appraisal of the most recent developments in art and society must also contend with the process of migration that has become the greatest challenge yet to the interstate structure of power, whose origins date from the fifteenth century. Migration is a form of popular resistance that hardly needs

to produce a manifesto, and its causes are plainly evident, but it nonetheless produces a forceful challenge to the legal and practical forms of authority that govern the world. There are artist migrants aplenty in our globalized world, but I want to look more carefully at how change can emerge from the bottom up, as it does when a migrant picks up and moves, crossing borders and embracing the fluidity that results from abandoning the comforts of home, rejecting national and international law, and perhaps generations of history. This radical reconfiguring in which individuals enter into a state of destabilization and force themselves to make do in haphazard and impermanent conditions seems to me the best metaphor for conceiving of the way geopolitical norms are upset through globalization. Such a challenge is just as relevant in the artistic domain as it is to legal or economic ones and, as one finds artists mediating their social worlds more and more in order to elaborate new terms of engagement through their art, the institutions of art must innovate to accommodate new forms of art practice with explicit social aims. As a result of the developments visible in artistic collectives in formation around the world, it becomes apparent that the art world is not the same enclosure that it is often thought to be.

A formidable example of the emergence of artists' collectives responding to dramatic economic and social changes was catalogued by Andrea Giunta in Buenos Aires after the economy ground to a halt, eliminating the market for art in a global city. Working with an oral history class in December 2003, Giunta and her students catalogued a series of artists' collectives that emerged as a result of the 1998–2002 *crisis económica argentina*. Her team of students invited responses to a survey they developed from all of the artists' collectives then active, many of which had been born from street protests, creating one of the most comprehensive studies there is of such collectives.

What they found was a series of shared practices "production dynamics based on consensus, open admittance, networking, the search for economic autonomy, rotating activities, an aspiration to achieve political efficiency" (Giunta 2011, 117). Collectives' activities included printing political posters and t-shirts (Taller popular de serigraphia), organizing shows, publications and events (Suscriptión), consolidating a network experimental community of artists, intellectuals, and scientists (Venus), and organizing benefit events where admission was a liter of milk to be donated to a soup kitchen for children (FeriaHipie, Buena Leche, and Discobabynews) (117). Art is contingent upon the financial resources to sustain it, and the eruption of artist collectives in Buenos Aires in response to the dramatic change in the economic

fortunes of the population at large showed that artists' energies can be redirected into productive activities unconstrained by the market. Faced with the Argentinian economic crisis, artists and intellectuals in this global city reorganized themselves to pursue radical alternatives. Nevertheless, it is important to ask: What are artists to do in cities where there is no market structure for contemporary art in the first place?

This was a problem faced by artists in Saigon and Phnom Penh, and it was they who developed some of the first spaces for exhibiting contemporary art in these cities. In this sense, they served a key institutional role in learning about both local and global contemporary art in those cities. Sàn Art (literally, Platform for Art), is a gallery and reading room in Saigon started in 2007 by four artists (Dinh Q. Lê, Tiffany Chung, Andrew Nguyen, and Phunam) who were born in Vietnam but grew up abroad and chose to return as adults. Such returnees are known locally as Viet Kieu. Prior to Sàn Art, an artists' collective in Hanoi, Nha San, was an important institution for local artists, and it continues to thrive. Though there were spaces for contemporary art in Saigon, including the artists' collectives Atelier Wonderful and Mogas Station, which were begun around the same time, there was very little information about what artists were doing elsewhere both inside and outside of Vietnam. So the goal of Sàn Art was to create a meeting space and to provide resources for to artists to educate themselves. Other artist-run spaces have also come onto the scene in Saigon (including little blah blah, Zerostation, and Tran's dia/projects), so it appears that artists themselves have developed an infrastructure to support contemporary art in Vietnam in the absence of a viable market for it there (Butt 2012). Since the artists involved in Sàn Art (Lê, Chung, and the Propeller Group—a collective for artistic production) are now established figures in the international contemporary art scene, with gallery representation in the United States and Europe, their reputations promise to have an impact on the international renown of their nonprofit space and for Vietnamese contemporary art in general.

Artists have pooled resources to lay the foundation for a contemporary art scene to flourish in Phnom Penh too. Stiev Selapak, also founded in 2007, is a collective of artists who came together as a result of local challenges and limitations in the Cambodian context, such as the lack of reliable education, of an older generation of artists (since many had died), of arts infrastructure, and of resources in general. Its activities have also recently included starting an experimental artist residency program (Nelson 2013). Following the closing of the Reyum Institute of Art and Culture in 2007, the group started the

FIGURE 23. Pete Pin, Amy Lee Sanford, and Seoun Som, *Traversing Expanses,* curated by Vuth Lyno. Sa Sa Bassac, Phnom Penh, Cambodia, 2014. Installation view, SA SA BASSAC.

Sa Sa Art Gallery in 2009, and after both that gallery and the curator Erin Gleeson's BASSAC Art Projects closed as well, Sa Sa Art Projects collaborated with Gleeson to found SA SA BASSAC in 2011. These initiatives provided space to show contemporary Cambodian art and also to improve the educational opportunities for contemporary artists there. Like Sàn Art, SA SA BASSAC (figure 23) also has a reading room and provides educational opportunities for artists and the community at large. Sa Sa Art Projects is now in its sixth year of programming, directed by Stiev Selapak's co-founder Vuth Lyno. This community-based, knowledge-sharing platform came to be rooted in experimental residencies called Pisaot and increasingly continues to engage with the former purpose-built cultural district of the Independence era/1960s in the Tonle Bassac area called the White Building. Vandy Rattana, recently shortlisted for the Hugo Boss Asia Prize, was the most visible member, but he left the collective and Cambodia for Taiwan in 2012. Other members of the collective, such as Vuth Lyno and Khvay Samnang, are active internationally as curators and artists. Samnang is slated to be included in documenta 14 in 2017.

Both of these bottom-up efforts demonstrate the power of contemporary artists to pool their resources and to develop alternatives to the market. and

they may ironically have the effect of stimulating a market into existence through locally focused collective action. In locations such as Saigon and Phnom Penh, artists' collectives came to serve an institutional function in the absence of equivalent government or corporate bodies there.

In addition to the economics of globalization, politics impacts the collectivization trend in contemporary art, though not in the way that this might have been understood during the Cold War, when ideology could be read into an artist's choice of, for example, figurative or abstract painting. There is a political implication to the foundational institutions one finds emerging as a result of artists' collectives and artist-run spaces throughout the world. The foundations that have sprung up are sometimes grafts of foreign plants onto native roots, in which artists raised in postcolonial nations and trained in the West return to their points of origin in order to foster innovations in nations with few alternatives. In other cases, collectives emerge from embedded social or institutional practices, such as performance troupes, whose social functions have never been fully co-opted by the state. Examples of the latter are visible in other Southeast Asian countries such as Indonesia and the Philippines, as well as in Latin America. In such cases, community involvement takes on a new relevance in an era of international competition and export-oriented national economies. The significance of colonial history and postcolonial nationalism cannot be overstated here. In countries such as China and Vietnam, communism persisted alongside the market after the collapse of the Soviet empire and the end of the bipolar world order in 1989. On the other hand, in India and Argentina, the idea of protecting one's nation from the vagaries of the market through subsidies, tariffs, or state control of the national economy rapidly evaporated in the heated economic developments of the 1990s. Art fairs and biennials sprang up as cultural tourism exploded and countries worked to secure their positions on the roster of destinations worthy of foreign direct investment. This very openness to neoliberal reforms directed by global institutions in Washington and New York also enabled artists to engage in unprecedented forms of political and artistic expression without the support of their own governments, as discussed above in the Vietnamese and Cambodian examples.

Arguably, the same Western centers of finance and art were calling the shots, directing global developments in predictable ways. The more things change, the more they stay the same, it is contended: the powerful will find ever more creative ways of controlling the world's resources, be they financial

or artistic. There is more than a grain of truth in this, but I would suggest that something unexpected has emerged from this confluence of historical developments. As struggling postcolonial nations have found themselves to be more and more bound to the strictures of global capital, some of their people have conceived alternatives that emerge from the gap left when national governments focus their energies on export-led growth and governmental reforms to support the influx of international capital. Under such conditions, opportunities emerge for independent and collective self-expression, since the entrepreneurial spirit of a population can be perceived as an asset. Nascent national bourgeoisies seek outlets in which to demonstrate their increasingly cosmopolitan sensibility. Younger generations who are eager to overcome prior or current limitations imposed by authoritarian or military governments value their independence and the opportunity to generate an identity. Among the fortunate minority of global elites, they are able to subscribe to global models of opportunity and self-expression. However, even if those models are espoused by collectors, they may be less available to artists. Cambodia is an example here. Under the Khmer Rouge, 90 percent of the country's artists were killed in the late 1970s, and Stiev Selapak's artists were all born in 1980 or later (Nelson 2013, 47). Growing up either in, or in the shadow of, refugee camps, and with extremely limited resources, those who sought creative expression in Cambodia did not have the same access as the elites to opportunity, locally or internationally, and so they shared available resources.

Collectivism in art production or distribution underlines the gap between the elite and the citizens of postcolonial (or neocolonial) states, but it would be entirely too pat to argue that globalization comes from above, while localization emerges from below. Globalization has economic and cultural dimensions, among others, and they are intertwined. If the artists of Stiev Selapak and other local collectives have succeeded internationally, it is a result of the impact of local conversations on global art discourse. These collectives are not inherently communist or capitalist. The politics they espouse exists between the possibility for self-expression and the strategic advantages of sharing a vision of contemporary art with a community. In so doing, as suggested by Nikos Papastergiadis in one of the epigraphs to this chapter, collectivities mediate new forms of public knowledge. The success of collectives and their individual members demonstrates that these new forms of public knowledge have international currency, and their messages of self-determination are transmitted through the same tools of globalization that serve to concentrate wealth in the hands of the few. This is one of the fundamental paradoxes of

globalization: it leads to new forms of economic domination, while at the same time providing novel means to overcome the structural inequalities it distributes. As the Palestinian artist Khaled Hourani observes: "With the notion of globalization and domination of transcontinental markets, contemporary artists have had to understand their role in this region of the world [the Middle East] and the importance of change. . . . Therefore artworks' values have changed in a particular way from being a clear visual impression, responding to ideological and emotional directions, to a cultural activity and a critical action within society" (Hourani 2011, 301).

Addressing the artistic institutions in Palestine and Iraq in the wake of military re-invasions by Israel and the United States respectively, Hourani directs attention to some of the most punishing conditions for the production of art. In such circumstances implicit ideologies that undergird cultural production are no longer tangible, and artists turn to "critical action." One example is the organization of the Riwaq Biennial, beginning in 2005, devoted to highlighting artists and addressing architectural heritage in Palestine in the context of the Israeli military strategy of bulldozing buildings to subdue resistance in the Occupied Territories. It echoes the earlier establishment of the Arab Image Foundation, an institution based in Beirut, but also nomadic in character, founded by artists in 1997 and aimed at historical preservation (Rogers 2012).

Hourani himself organized "Picasso in Palestine," a project in 2012 to bring one Picasso painting to the Occupied Territories. This would seem a simple enough task for a museum to facilitate but in the precarious political context of Palestine, it took two years to be realized (Baers 2012). Is it art to bring a Picasso to the Occupied Territories, or is it rather a very small loan exhibition realized by a provisional organization? Either way, it is an activity that serves a social and political purpose, which is to underline the limitations of Palestinian experience, including (but not limited to) a lack of access to cultural products that is taken for granted in developed "democracies" and the lack of institutions to secure any hopes of normalcy in the Occupied Territories, which are not officially part of any country. Charles Esche, director of the Van Abbe Museum in Eindhoven in the Netherlands, the institution that supported the project and organized the loan, has referred to such actions as "modest proposals," speculative gestures made real in the here and now of history (Esche 2005). Such would not be possible if institutions like the Van Abbe Museum were not willing to collaborate with artists to decenter their authority and participate in a crossing of boundaries in which

the institution becomes nomadic as a productive response to global inequalities.

In the Palestinian situation, it is a wonder that there is any initiative to make an art work at all, given the countless challenges faced by Palestinians, but the visibility of opportunity that is a result of globalization—including an awareness of institutions, events (such as biennials), and opportunities to work abroad in residencies—demonstrate the rewards that can emerge from cultural production. If the significance of making art had not already been underlined through the closing of galleries and cultural centers by Israeli forces in Palestine since the 1967 Six-Day War, the opportunity for artists in Palestine to see how culture supports society elsewhere has only strengthened their resolve to be part of the local *and* global conversation on art, society, and politics. It might be argued that they are on the front lines of the struggle to reconsider the relations between these terms, and through collectivization or collaboration, they are able to achieve results that would otherwise be impossible. A Palestinian Museum opened in 2016, but at the time of writing, all of its exhibitions have been indefinitely postponed, again demonstrating the limited capacity of fixed institutions to overcome fundamental limitations.

But nomadism of institutions and collectives also allows them to remake the map of contemporary art by challenging national boundaries and notions of individual subjectivity. This nomadic turn is visible in a variety of collective projects, some of which have been discussed above. The nonprofit gallery L'appartement 22 in Rabat, Morocco, run by Abdellah Karroum, has taken this idea on explicitly since its inception in 2002. As Karroum has described it: "L'appartement 22 is a laboratory that continually experiments with the inscription of art in the social space, with round trip movement between the space of exhibitions and that of actions" (Karroum 2008, 5). Though Karroum is a curator (as well as a museum director since 2013) and not an artist, his activities before and at L'appartement 22 have sought to connect the space of the artist to the public. Working with Moroccan and French artists, he staged a series of "expeditions" beginning in 2000, by taking the artistic process to the mountains and the coasts of Morocco, and even as far as Mont Sainte-Victoire outside of Aix-en-Provence in France. "The expedition is a fundamentally nomadic practice that resists the static and monumental edifices of the traditional museum for active strategies of expanding public contact with art, its ideas, and its overtures to discussion," according to Katarzyna Pieprzak's study of art and modernity in postcolonial Morocco (Pieprzak 2010, 155).

Pieprzak cites other organizations in Morocco, such as the artists' collective La Source du Lion, as establishing precedents for the kind of engagement with the public that Karroum propagated. But these nomadic practices, intentionally undermining the stability of the bricks-and-mortar institutional space, are unique. Altogether, Karroum initiated nine expeditions between 2000 and 2011, lasting from one day to one month. The terms were relatively straightforward: accompanied by one or two artists, Karroum would take up residence in a mountain or coastal town, often in the Rif mountains, and they would engage the public in discussions about art and life, not offering particular objects for sale, but instead interacting with the participants as ideas emerged. Describing the first project, Karroum explains that they selected a terrace "as a location for meetings and experiments and also for various collaborations" (Karroum 2000, n.p.). It is clear from this and other writings by Karroum that he had no particular plan of action in mind. Rather, the goal of this collaboration between Karroum, Jean-Paul Thibeau and Younès Rahmoun was to engage with the residents of this mountain town in an open-ended way, allowing whatever came out of the interaction to be seen as an artistic activity. They did not "bring art to the people" but consulted with people about their ideas of art and artists, and these practices constituted their artistic form. By displacing artistic activities away from the gallery and the city, they manifested a nomadic formulation of artistic engagement. Since the art had no material form, but was a result of human interactions, it was possible to make it happen anywhere and indeed to move it from one place to another, as happened in later expeditions.

Such a transitory model for artistic production and dissemination rejects most of the norms that connect art to the market and to the forms of social control that result from the capitalist and nation-state systems. The fact that there is no end product and only a vague trace of these expeditions left today should not lead us to question the value or relevance of such projects. There might also be countless other such projects whose traces are similarly lost to the world. In contrast, for example, to the sheer spectacle of, and intellectual fascination with, Francis Alÿs's *When Faith Moves Mountains* (2002), a work in which participants performed the task of moving a few feet of a dune in Peru (Alÿs and Medina 2005), Karroum and his collaborators engaged in an almost invisible intervention in tribal villages in Morocco, leaving behind little more than stories. The question is not whether Karroum's expeditions, like Alÿs's, should have made him famous, but whether it is important to make an enormous spectacle of achieving so little, and whether such a project

contributes to or undermines the very norms it aims to question. The most successful nomadic artistic work, or institution, may be the one that leaves no trace.

The KHŌJ International Artists' Association, which began as a provisional, artist-organized residency project, but developed into a permanent fixture of the Delhi art scene, illustrates the opposite tendency (figure 21). That said, it has always had a transnational character, with the specific intent of bringing artists to Delhi from around the world. As a residency program, it is one of many nodes of international exchange among artists that have thrived in a variety of locations globally. The basic idea behind an artists' residency is to provide a space for artists to work, so that they can separate themselves from their daily concerns and have time to focus on their own projects and to meet other artists in the same position. The beauty of residency programs is that everyone is away from home, and so there are no insiders or outsiders. As the world has become more networked, these programs have become more global in their scope, such as the project by the British artists Ackroyd and Harvey shown in figure 21, drawing artists from a wider range of geographies. Like so many other structures in the art world, modern residency programs were first devised in Europe, and, as artists' retreats evolved, they operated to promote artistic activities among global artists. So the development of a residency program based in Delhi was an ambitious regional endeavor at first, but it has tipped the scales somewhat, and now brings global artists to an artistic and political capital in the Global South.

Previous artistic collectives in South Asia had promoted collaboration between artists and writers, and the Kasuali Art Center in northern India is an important precursor. Founded in 1976, this artists' collective over time brought together some of the most important figures in the South Asian art world today, including Vivan Sundaram, N. N. Rimzon, and Geeta Kapur, and launched the *Journal of Arts and Ideas* (Kapur 2010; Wong 2014).

KHŌJ (a word meaning "[to] search, hunt, explore, discover, discern, seek, inquire, trace, track, quest, research, investigate"), began in 1997 in Modinagar, on the outskirts of New Delhi, as an annual workshop to bring together artists to give them the opportunity to advance their careers without institutional support, which was lacking for contemporary artists in India. It was initiated by Robert Loder (KHŌJ n.d.), a British businessman and art collector who was the co-founder of the Triangle Arts Trust (now the Triangle Network), an organization that promotes artists' workshops around the world, with an emphasis on Africa and the Caribbean. The creation of

such an organization in 1982, which originally focused on bringing together British and American artists, but now sponsors workshops held around the world, is a fascinating development in itself. Working with Anthony Caro, Loder fostered the workshop idea in locations as far-flung as Namibia, Nepal, and Bolivia. In Delhi, KHŌJ became a leader in its own right, developing residencies with an international focus beginning in 2000 and fostering other organizations throughout South Asia through the South Asia Network for the Arts. It held its first Delhi residency with three artists, from the United Kingdom, Sri Lanka, and India. According to the organization's web site: "At a time when Indian artists felt isolated and unsupported, Khoj provided the possibility for young practitioners to create an open-ended, experimental space for themselves on their own terms. Khoj would be space where they could make art independent of formal academic and cultural institutions and outside the constraints of the commercial gallery" (KHŌJ n.p.).

Geeta Kapur is more poetic is her account: "The poverty of means adopted by Khoj workshops, the consciously depleted objecthood of artworks with a quotient of wit sorely lacking in the Indian art world, gave us what we are accustomed to call *alternative art practice*" (Kapur 2010, 49; emphasis in original). In other words, KHŌJ did not simply allow artists to connect and to experiment; it fostered the production of a wholly different kind of art. A second residency was held in 2001, focusing on artists working in film and photography, initiating what would become the centerpiece of the KHŌJ model, media-focused residencies in such fields as performance art, sound art and public art, many of which now happen annually. By this time, KHŌJ had already hosted five workshops, and it moved to new frontiers. In 2001, it collaborated to foster a similar workshop organized by the Karachi-based artists' collective VASL, outside of Karachi, Pakistan. By the end of 2001, the first public conversations about a regional network of artists from South Asia were staged by KHŌJ and Triangle Arts Trust in Delhi (Sood 2010, 35). This meeting would become the basis for the South Asian Network of Artists.

In 2002, KHŌJ also devised the idea of itinerant workshops around India, and that year a workshop was held by KHŌJ in Mysore, the cultural capital of South India, followed by another in Bangalore the following year. Later nomadic manifestations appeared in Mumbai in 2005 and Kolkata in 2006, and in 2007, KHŌJ held a workshop in Kashmir, the politically con- tested area in the north of India where Indian and Pakistani troops have had regular skirmishes since the Partition of 1947 (Sood 2010, 13–14).

Also in 2002, a new building to house the organization was opened in the Kirkee extension in South Delhi, an area that, according to Pooja Sood, "is a microcosm of the multiple and stark dichotomies that constitute India's rapidly globalizing capital city" (2010, 22). In 2003, KHŌJ turned its attention to art students from India and initiated the PEERS Residency program. As KHŌJ's director Pooja Sood explained it: "The KHŌJ working group felt that we could not justify being building-based with just three international residency programmes annually and needed to do more for local artists" (Gupta et al. 2008, n.p.). Art students were drawn from throughout India for a one-month residency that allowed them to experiment outside of the academic context and to develop professional connections. Looking at the list of practitioners who have passed through KHŌJ residencies, it is clear that some part of the esteem that Indian artists enjoy today in the global art world is derived from the social dynamics initiated by this artist-run institution. The first group of residents in 1997 included Anita Dube, Subodh Gupta, and Surendran Nair, among other notables (Sood 2010). This is a strong argument for artists' collectives as one of the essential building blocks for the creation of an art world center.

One of the implications of the story of Triangle Arts Trust and KHŌJ is that with artists' workshops and residencies, as in so many of the other domains explored in this book, one can perceive the migration of cultural forms, artistic language, and domains of authority. In other words, though the idea was fostered by a British businessman in a postcolonial context, the cultural form of the international workshop took hold in India and was directed by Indian artists, and, from there, the organization spread. Of course, international artists' workshops, like biennials and art fairs, also made possible the migration of artistic languages, so that artists were empowered to learn from other artists beyond their familiar domain. Transferring ideas from one artist to another, such encounters lead to innovation, and mutual collaboration in a collective environment leads to new forms of artistic language. There is also a migration of domains of authority in the sense that while Triangle sponsored KHŌJ, KHŌJ sponsored the South Asia Network of Artists (SANA), continues to promote international exchange, and draws artists from well beyond the region to be part of its global community. When I attended an opening of a KHŌJ soundscape exhibition in 2013, I spoke with artists from Taiwan and Eastern Europe, among others, and saw William Kentridge from across the room. KHŌJ is neither a provincial nor a regional organization. It is a global leader, located in Delhi.

This is not just the story of shifting geography, replacing one art capital for another as the periphery migrates to the center. The BRIC economies (Brazil, Russia, India, and China), first spotted as future world leaders by Goldman Sachs in 2001, are showing signs of economic and political strain in 2016 after decades of impressive growth, but that will not change the effects of globalization, which have fundamentally altered these countries and the rest of the world in the past generation. Not only is this world much more thoroughly integrated than ever before but it cannot be directed from any single center. Economic centers such as New York, London, and Hong Kong continue to dominate international finance, of course, and these cities reign in terms of trading art for money. But perhaps the time has come to leave colonial topologies of centrality, control, and universalism in the twentieth century. In our current era, art and the commerce it generates force us to think more about the migration of practices, institutions, and the means of communication about them. As all of these dimensions of artistic experience transit from one nation to another, from one region to another, their meanings shift, while their values exist in a state of suspension.

Artists and their works are today in transit. In this sense they flout authority, whether that is a system of international law, the nation-state system, or the territorial dominions of any state. Israel may be suppressing Palestine, but Palestinian and Israeli artists and curators have worked together to develop artistic dialogue. India and Pakistan may yet go to war over Kashmir, but KHŌJ works with VASL in Karachi to promote the concerns of artists and collectivization. Brazil may be rocked by a financial and political scandal, but the Oscar Niemayer Museum in Curitiba has organized an exhibition of the art works seized by the state. China's economic growth may be slowing, but the significance of China's artists and collectors to the art market will not evaporate. In fact, it shows signs of increasing, since Chinese investors have bought stock in Sotheby's.

Artists, and the art world as a whole, are embedded in the globalized capitalist system, and this has led to some difficult realities. Here and elsewhere I have sought to demonstrate, however, that an artist's (or a curator's, or a dealer's) imagination is channeled by economic globalization, yet their combined activities also introduce conflicting meanings to that overused and misunderstood term (Zarobell 2015). In some cases, artists have invented new forms of capitalism, or brought it to parts of the world where it had not previously thrived, but in other cases artists have developed alternatives to this system. And these ideas are on the move. When they cross borders, they

morph into other forms and they continue to circulate, moving and changing from node to node. The processes of globalization that have been addressed in this book, give these individual and particular transitions and translations a global character, because they are fundamental to our economic, political, and cultural life right now. The spread of information about art and artists in far-flung locales, the mutual recognition that emerges from this global conversation, has the effect of amplifying the visibility of alternatives and promoting sharing of information and strategies across borders and boundaries. In global time, this process never ends, and the art world is much richer as a result.

This assertion will not make neoliberal economic policies go away or improve the bond rating of formerly colonized countries, and globalization will likely remain a system that provides a global distribution of social and economic inequality. Yet it can help artists to dismantle another ideological structure, which one might call geographical topology, that seeks to distinguish and contain their collective efforts. Mobility of thought, of political communication and action, of human bodies, opens the domain of art to more manifestations of self-expression and collective action than artists, and others involved in the art world, have ever known. The central question then is: What will we do with them? It is not possible to escape our historical context or the capitalist system that has spread across the planet, but it is possible to read these social and economic realities against the grain and to find in them the means to transform our individual and collective existence. If anyone has a chance of re-forming our world, it is the artists and those who are inspired by them.

WORKS CITED

Abrams, A.-R. 2015. "Market: Contemporary Istanbul Announces New Focus on Iran." *Artnet* News, September 2. https://news.artnet.com/market/contemporary-istanbul-focus-on-tehran-328670.

Adam, G. 2014. *Big Bucks: The Explosion of the Art Market in the Twenty-First Century*. Burlington, VT: Lund Humphries.

Alexander, V. D. 1996. *Museums and Money: The Impact of Funding on Exhibitions, Scholarship and Management*. Bloomington: University of Indiana Press.

Alloway, L. 1968. *The Venice Biennale, 1895–1968: From Salon to Goldfish Bowl*. Greenwich, CT: New York Graphic Society.

Alloway, T. 2011. "Eurozone Crisis Piles Pressure on Credit Default Swaps." *Financial Times*, November 6. www.ft.com/intl/cms/s/0/ba554c8c-0494-11e1-ac2a-00144feabdc0.html#axzz3QzvTIdTJ.

Altshuler, B. 2005. *Collecting the New: Museums and Contemporary Art*. Princeton, NJ: Princeton University Press.

———. 2013. *Biennials and Beyond—Exhibitions That Made Art History, 1962–2002*. New York: Phaidon.

Alÿs, F., and Medina, C. *When Faith Moves Mountains = Cuando la fe mueve montañas*. Madrid: Turner, 2005.

American Alliance of Museums (AAM). 2012. *Developing a Collections Management Policy*. www.aam-us.org/docs/continuum/developing-a-cmp-final.pdf?sfvrsn=2.

Americans for the Arts. 2012. *Arts & Economic Prosperity IV*. Washington, DC: Americans for the Arts.

Appadurai, A. 1990. "Disjuncture and Difference in the Global Cultural Economy." *Theory, Culture & Society* 7 (1990): 295–310.

———. 1998. *Modernity at Large: Cultural Dimensions of Globalization*. Minneapolis: University of Minnesota Press.

Araeen, R. 1989. "Our Bauhaus Others' Mudhouse." *Third Text* 3, no. 6 (Spring 1989): 3–16.

Arselan, S. 2009. "Corporate Museums in Istanbul." In *The Global Art World: Audiences, Markets, and Museums,* ed. H. Belting and A. Buddensieg, 236–55. Ostfildern, Germany: Hatje Cantz.

Artprice. 2016. "The Art Market in 2015." Artprice.com and AMMA. http://imgpublic.artprice.com/pdf/rama2016_en.pdf.

Ashenfelter, O., and K. Graddy. 2003. "Auctions and the Price of Art." *Journal of Economic Literature* 41 (September): 763–86.

Art + Auction. 2013. "The World's Top Auction Houses: China Guardian." *Blouin Art Info*, August 12. http://blouinartinfo.com/news/story/943265/the-worlds-top-auction-houses-china-guardian

Art Basel. 2014a. "Facts and Figures about Art Basel in Basel." www.artbasel.com/-/media/ArtBasel/Documents/Press_Facts_and_Figures_EN/Facts_and_Figures_about_Art_Basel_in_Basel_Sep_13.pdf.

———. 2014b. "Facts and Figures about Art Basel in Miami Beach." /www.artbasel.com/-/media/ArtBasel/Documents/Press_Facts_and_Figures_EN/Facts_and_Figures_about_Art_Basel_in_Miami_Beach_Jan_14.pdf.

"Art Insurance: Paint Threshold." 2012. *Economist,* September 1. www.economist.com/node/21561924/print.

Art Istanbul. 2012. *It's LIQUID.* November 19–25. www.itsliquid.com/art-istanbul-1925-november-2012.html.

Art Media Agency 2015. "The Future of the Global Art Market: Emerging Art Scenes of Today and Tomorrow." Private Art Investor, April 30. www.privateartinvestor.com/art-business/the-future-of-the-global-art-market-emerging-art-scenes-of-today-and-tomorrow.

ArtRio. 2016. "Quem somos." www.artrio.art.br/pt-br/quem-somos.

ArtTactic 2014. "Indian Art Market Confidence Survey." December 2. www.arttactic.com/market-analysis/art-markets/indian-art-market/678-indian-art-market-confidence-survey-december-2014.html?Itemid=102.

A. T. Kearney 2014. "2014 Global Cities Index and Emerging Cities Outlook." In "Global Cities, Present and Future." www.atkearney.com/documents/10192/4461492/Global+Cities+Present+and+Future-GCI+2014.pdf/3628fd7d-70be-41bf-99d6-4c8eaf984cd5.

———, 2015. "Global Cities Index." In "Global Cities 2015: The Race Accelerates." www.atkearney.com/documents/10192/5911137/Global+Cities+201+-+The+Race+Accelerates.pdf/7b239156-86ac-4bc6-8f30-048925997ac4.

Ayad, M. 2015. "Market: Why Istanbul Contemporary Could Become One of the World's Big Art Fairs." *ArtNet* News, November 11. https://news.artnet.com/market/istanbul-contemporary-2015-art-fair-361490.

Baers, M. 2012. "No Good Time for an Exhibition: Reflections on the Picasso in Palestine Project, Part I." www.e-flux.com/journal/no-good-time-for-an-exhibition-reflections-on-the-picasso-in-palestine-project-part-i.

Baia Curioni, S. 2012. "A Fairy Tale: The Art System, Globalization and the Art Fair Movement." In *Contemporary Art and Its Commercial Markets,* ed. M. Lind and O. Velthuis. Berlin: Sternberg.

Baia Curioni, S., L. Forti, and L. Leone. 2015. "Making Visible: Artists and Galleries in the Global Art System." In *Cosmopolitan Canvases: The Globalization of Markets for Contemporary Art,* ed. O. Velthuis and S. Baia Curioni, 55–77. Oxford: Oxford University Press.

Bailey, M. 2012. "Coming to a City Near You . . ." *Art Newspaper,* no. 234 (April). http://old.theartnewspaper.com/articles/Coming-to-a-city-near-you-/26129.

Baker, K. 2004. "New York MOMA Finds New Expression in Enlightened Renovation." *San Francisco Chronicle,* November 19. www.sfgate.com/entertainment /article/New-York-MOMA-finds-new-expression-in-enlightened-2635307.php.

Balzer, D. 2014. *Curationism: How Curating Took Over the Art World and Everything Else.* Toronto: Coach House Books.

Bankowsky, J. 2005. "Tent Community: Art Fair Art." *Artforum,* 44 (October): 228–32. https://artforum.com/inprint/issue=200508&id=9500.

Barboza, D., G. Bowley, and A. Cox. 2013. "Forging an Art Market in China." *New York Times,* October 28. www.nytimes.com/projects/2013/china-art-fraud.

Barboza, D., and J. Kessel. 2013. "The New Collectors." *New York Times,* December 17. www.nytimes.com/projects/2013/the-new-collectors.

Barker, E. 1999. "Exhibiting the Canon: The Blockbuster Show." In *Contemporary Cultures of Display,* ed. id., 127–45. New Haven, CT: Yale University Press.

Barkun, D. 2012. "The Artist as a Work-in-Progress: General Idea and the Construction of Collective Identity." *Forum for Modern Language Studies* 48, no. 4: 453–67.

Barragán, P. 2008. *The Art Fair Age.* New York: Charta.

Basualdo, C. 2010. "The Unstable Institution." In *The Biennial Reader,* ed. E. Filipovic, M. van Hal, and S. Øvstebø. Bergen, Norway: Bergen Kunsthall; Ostfildern, Germany: Hatje Cantz.

Basulto, D. 2012. "Quotes from Oscar Niemayer 1907–2012." *ArchDaily,* December 5. www.archdaily.com/303376/quotes-from-oscar-niemeyer-1907–2012.

Batty, D. 2013. "Istanbul Biennial under Fire for Tactical Withdrawal from Contested Sites." *Guardian* (London), 14 September. www.theguardian.com/world /2013/sep/14/istanbul-biennial-art-protest-under-fire.

Bauman, Z. 1993. *Postmodern Ethics.* Cambridge, MA: Blackwell.

Baumgartner, A. 2015. "Face to Face with the Museumification in China." *Happening,* March 20. www.happening.media/en/category/articles/450/face-to-face-with-the-museumification-in-china.

"BB6 Final Report." 2014. *Pavilion Magazine.* http://pavilion.pavilionmagazine .org/?p=1048.

Becker, H. S. (1982) 2008. *Art Worlds.* Updated 2nd ed. Berkeley: University of California Press.

Belting, H. 2007. "Contemporary Art and the Museum in the Global Age." In *Contemporary Art and the Museum: A Global Perspective,* ed. P. Weibel and A. Buddensieg, 16–38. Ostfildern, Germany: Hatje Cantz.

———. 2009. "Contemporary Art as Global Art: A Critical Estimate." In *The Global Art World: Audiences, Markets, and Museums,* ed. H. Belting and A. Buddensieg, 38–73. Ostfildern, Germany: Hatje Cantz.

Belting, H., and A. Buddensieg, eds. 2009. *The Global Art World: Audiences, Markets, and Museums.* Ostfildern, Germany: Hatje Cantz.

Bennett, T. 1988. "The Exhibitionary Complex." *New Formations*, no. 4 (Spring): 73–102.

Benjamin, W. (1935) 1999. "Paris, the Capital of the Nineteenth Century." In id., *The Arcades Project,* ed. H. Eiland and K. McLaughlin. Cambridge, MA: Harvard University Press.

Berger, J. 1972. *Ways of Seeing.* London: BBC and Penguin Books.

Bergevelt, E., D. Meijers, L. Tibbe, and E. van Wezel, eds. 2009. *Napoléon's Legacy: The Rise of National Museums in Europe, 1794–1830.* Berlin: G + H Verlag.

Bernstein, J. 2016. "Hiding Money: The Art of Secrecy." *Modesto Bee.* April 7. www .modbee.com/news/nation-world/world/article70505092.html#storylink=cpy.

Biennale di Venezia. 2015. "Great Audience Success: The Biennale Arte 2015 Attracts over 500,000 Visitors." *La Biennale*, November 22. www.labiennale.org/en /news/22–11.html?back=true.

Biennial Foundation. N.d. Directory of Biennials. www.biennialfoundation.org /biennial-map.

Bliss, L. 2015. "The Backlash to Mexico City's High Line–Style Park." *Citylab,* September 29. www.citylab.com/design/2015/09/the-terrible-plan-for-mexico-citys-high-line-style-park/408010.

Blum, J., M. Levi, T. Naylor, and P. Williams. 1998. *Financial Havens, Banking Secrecy and Money Laundering.* United Nations Office for Drug Control and Crime Prevention. www.cardiff.ac.uk/socsi/resources/levi-laundering.pdf.

Bond, P. 2014. *Elite Transition: From Apartheid to Neoliberalism in South Africa.* Rev. expanded ed. London: Pluto Press.

Bourdieu, P. 1986. "The Forms of Capital." In *Handbook of Theory and Research for the Sociology of Education,* ed. J. G. Richardson, 241–58. Westport, CT: Greenwood Press.

Bourriaud, N. 2002a. *Postproduction: Culture as Screenplay: How Art Reprograms the World.* Translated by J. Herman. New York: Lukas & Steinberg.

———. 2002b. *Relational Aesthetics.* Dijon: Les Presses du réel.

———. 2009. *The Radicant.* New York: Lukas & Sternberg.

Bowley, G. 2013. "For Art Dealers, a New Life on the Fair Circuit." *New York Times,* August 22. www.nytimes.com/2013/08/22/arts/for-art-dealers-a-new-life-on-the-fair-circuit.html?pagewanted=all&_r=0.

Bowley, G., and D. Barboza. 2013. "An Art Power Rises in China, Posing Issue for Reform." *New York Times,* December 13. www.nytimes.com/projects/2013 /china-poly-auction.

Bowley, G., and D. Carjaval. 2016. "One of the World's Greatest Art Collections Hides Behind This Fence." *New York Times,* April 28. www.nytimes.com/2016 /05/29/arts/design/one-of-the-worlds-greatest-art-collections-hides-behind-this-fence.html?smid=nytcore-ipad-share&smprod=nytcore-ipad.

Bradburne, J. M. 2004. "The Museum Time Bomb: Overbuilt, Overtraded, Overdrawn." *Informal Learning Review,* 65 (March–April).

Brandellero, A. 2015. "The Emergence of a Market for Art in Brazil." In *Cosmopolitan Canvases: The Globalization of Markets for Contemporary Art,* ed. O. Velhuis and S. Baia Curioni, 215–37. Oxford: Oxford University Press.

"Brazil's Burgeoning Art Scene." 2014. *Technosyncratic,* June 15. http://technosyncratic .com/articles/brazils-burgeoning-art-scene.html.

Bredin, L. 2010. "Behind the Scenes in Private Museums." *Financial Times,* November 26. www.ft.com/intl/cms/s/2/b1309d24-f823–11df-8875–00144feab49a.html.

Breitz, C. 1995. "The First Johannesburg Biennale: Work in Progress." *Third Text 9,* no. 31: 89–94.

Brenner, N., and R. Keil. 2006. *The Global Cities Reader.* New York: Routledge.

Brownlee, D. 1997. *Making a Modern Classic: The Architecture of the Philadelphia Museum of Art.* Philadelphia: PMA.

"Brush with the Law: A Well-Known Middleman Is Accused of Fleecing Wealthy Clients." 2015. *Economist,* March 7. www.economist.com/news/business/21645762-well-known-middleman-accused-fleecing-wealthy-clients-brush-law.

Bryant, R., ed., 2015. *The International Handbook of Political Ecology.* London: King's College.

Bucharest Biennale. 2012. "Brief Final Report: Bucharest Biennale 5." Press release, July 22. http://bucharestbiennale.org/history.html.

Bull, M. 2011. "Two Economies of World Art." In *Globalization and Contemporary Art,* ed. J. Harris. New York: Wiley.

Bürger, P. 1984. *Theory of the Avant-Garde.* Minneapolis: University of Minnesota Press.

Burns, C., and M. Gerlis. 2013. "How Prevalent Is Money Laundering in the Art World?" *Art Newspaper,* no. 246 (May). www.theartnewspaper.com/articles /How-prevalent-is-money-laundering-in-the-art-world/29412.

Butt, Z. 2012. "Xe Ôm Drivers of the Mind: The Journey of Sàn Art." In *Six Lines of Flight: Shifting Geographies in Contemporary Art,* ed. A. DiQuinzio. San Francisco: San Francisco Museum of Modern Art; Berkeley: University of California Press.

Bydler, C. 2004. *The Global ArtWorld inc.: On the Globalization of Contemporary Art.* Uppsala, Sweden: Uppsala University Press.

CAJ. See under South Africa. Department of Labour.

Capgemini and RBC Wealth Management. 2014. "Nearly Two Million Individuals Join High Net Worth Ranks as Wealth Levels Reach Another Record High." *World Wealth Report,* June 18. www.capgemini.com/news/nearly-two-million-individuals-join-high-net-worth-ranks-as-wealth-levels-reach-another-record.

———. 2015. "Global Population of High Net Worth Individuals and Their Wealth Hit New Highs." *World Wealth Report,* June 17. www.capgemini.com/sites /default/files/global_population_of_high_net_worth_individuals_and_their_ wealth_hit_new_highs.pdf.

Carvajal, D. 2011. "'This space for rent': In Europe, Arts Now Must Woo Commerce. *New York Times,* January 23. www.nytimes.com/2011/01/24/arts/24squeeze .html?_r=0&pagewanted=print.

Castells, M. 1996. *The Rise of the Network Society.* Malden, MA: Blackwell.

Chong, D. 2011. "The Emergence of Powerhouse Dealers in Contemporary Art." In *Globalization and Contemporary Art,* ed. J. Harris. London: Wiley-Blackwell.

Christie's. 2013. Interview with Lekha and Anupam Poddar, founders of the Devi Art Foundation, August 23. www.christies.com/features/interview-with-lekha-anupam-poddar-3892-3.aspx.

———. 2014a. Press Release. "Expanding Buyer Base Drives Record Year at Christie's with Art Sales of £4.5 billion." www.christies.com/presscenter/pdf/2014 /RELEASE_CHRISTIES_FIGURES_2013_EN.pdf.

———. 2014b. Video. A History of Christie's in the Middle East. www.youtube .com/watch?v=-DlsHfEd9Fo.

———. 2015a. Christie's figures, 2014.www.christies.com/about-us/press-archive /details?PressReleaseID=7712&lid=1.

———. 2015b. "Christie's 2014 Global Art Sales Total Record £5.1 Billion." www.christies.com/presscenter/pdf/2015/RELEASEINFOGRAPHIC2014 .pdf.

———. 2016. "Christie's Art Sales in 2015 Total £4.8 Billion / $7.4 Billion." www .christies.com/features/Christies-annual-sales-report-2015-7019-1.aspx.

Ciotti, M. 2012. "Post-colonial Renaissance: 'Indianness', Contemporary Art and the Market in the Age of Neoliberal Capital." *Third World Quarterly* 33, no. 4: 637–55.

Codignola, F. 2006. "Global Markets and Contemporary Art." *Symphonya: Emerging Issues in Management,* no. 2. www.unimib.it/upload/gestionefiles/symphonya /f2006issue2/codignolaeng22006.pdf.

Coffey, M. K. 2010. "Banking on Folk Art: Banamex-Citigroup and Transnational Cultural Citizenship." *Bulletin of Latin American Research* 29, no. 3: 296–312.

Cohen, P. 2013. "Valuable as Art but Priceless as a Tool to Launder Money." *New York Times,*May12./www.nytimes.com/2013/05/13/arts/design/art-proves-attractive-refuge-for-money-launderers.html?pagewanted=all.

Cole, W. 2013. "Sunday Dialogue: What Is Art Worth?" *New York Times, Sunday Review,* January 5.www.nytimes.com/2013/01/06/opinion/sunday/sunday-dialogue-what-is-that-art-worth.html.

Colección Isabel y Agustín Coppel. N.d. Statement. www.coppelcollection.com /statement.php.

Comité Invisible Jaltenco. 2012. "El papel cultural y político del arte contemporáneo en México según Cuauhtémoc Medina." October 11. http://comiteinvisiblejaltenco .blogspot.com/2012/10/el-papel-cultural-y-politico-del-arte.html.

Coslor, E., and O. Velthuis. 2012. "The Financialization of Art." In *The Oxford Handbook of the Sociology of Finance,* ed. K. Knorr Cetina and A. Preda, 471–87. Oxford: Oxford University Press.

Cotter, H. 2012. "On an Island, Worker Bees Fill a Long White Hive: Frieze New York Contemporary Art Fair." *New York Times,* May 4. www.nytimes .com/2012/05/05/arts/design/frieze-new-york-contemporary-art-fair.html.

———. 2013. "A Building Boom as China Art Rises in Stature." *New York Times,* March 20. www.nytimes.com/2013/03/21/arts/artsspecial/a-prosperous-china-goes-on-a-museum-building-spree.html?_r=0.

Crow, K. 2011. "The Larry Gagosian Effect." *Wall Street Journal,* April 1. www.wsj.com/articles/SB10001424052748703712504576232791179823226.

Csaszar, T. 1996–97. "The Spectacular Record-Breaking Sold-Out Smash-Hit Blockbuster Supershow! A Phenomenon of Museum Culture." *New Art Examiner,* no. 24 (December 1996–January 1997): 22–27.

Cuno, J. 2004. "Introduction." In *Whose Muse? Art Museums and the Public Trust,* ed. J. Cuno. Princeton, NJ: Princeton University Press.

Currier, J. 2008. "Art and Power in the New China: An Exploration of Beijing's 798 Arts District and Its Implications for Contemporary Urbanism." *Town Planning Review* 70, nos. 2–3: 237–65.

Cwi, D., and K. Lyall. 1977. *Economic Impacts of Arts and Cultural Institutions: A Model for Assessment and a Case Study in Baltimore.* Washington, DC: National Endowment for the Arts.

Dasgupta, R. 2014. *Capital: The Eruption of Delhi.* New York: Penguin Press.

Davidts, W. 2006. "Art Factories: Museums of Contemporary Art and the Promise of Artistic Production, from Centre Pompidou to Tate Modern." *Fabrications* 16, no. 1 (June): 23–42.

Davis, B., and S. Roffino. 2013. "Istanbul Biennial Protests Foreshadowed Battle for Gezi Park." *BlouinArtInfo* Blogs, June 11, 2013. http://blogs.artinfo.com/artintheair/2013/06/11/istanbul-biennial-gets-swept-into-controversy-over-gezi-park-protests.

Deliss, C. 1989. "Conjuring Tricks: 'Magiciens de la Terre.'" *Artscribe International,* no. 77 (September–October): 48–53.

Deliss, C. 1993. "The Dakar Biennale 92: Where Internationalism Falls Apart." *Third Text,* no. 23 (Summer 1993): 136–41. www.tandfonline.com/doi/pdf/10.1080/09528829308576427.

Deloitte and ArtTactic. 2014. "Art & Finance Report 2014." www2.deloitte.com/content/dam/Deloitte/at/Documents/Tax/art-finance-report.pdf.

De Sanctis, F. M. 2013. *Money Laundering through Art: A Criminal Justice Perspective.* Heidelberg: Springer.

De Soto, H. 1989. *The Other Path: The Invisible Revolution in the Third World.* New York: Harper & Row.

Dhaka Art Summit. 2016. *Dhaka Art Summit 2016 Report.* Dhaka: Samdani Art Foundation.

Dickinson, M. 2014. "New Allegations Are Made Public but Blatter Remains Aloof." *Sunday Times* (London), December 1, 4.

DiQuinzio, A., ed. 2012. *Six Lines of Flight: Shifting Geographies in Contemporary Art.* San Francisco: San Francisco Museum of Modern Art; Berkeley: University of California Press.

dOCUMENTA 13. 2012a. "The Dance Was Very Frenetic, Lively, Rattling, Clanging, Rolling, Contorted, and Lasted for a Long Time." http://d13.documenta.de/#welcome.

————. 2012b. *Guidebook: Catalog 3/3*. Ostfildern, Germany: Hatje Cantz.

Donadio, R. 2014. "In Turkey, the Arts Flourish but Warily." *New York Times,* November 18. www.nytimes.com/2014/11/19/arts/in-turkey-the-arts-flourish-but-warily-.html?_r=1.

Duncan, C. 1995. *Civilizing Rituals: Inside Public Art Museums*. New York: Routledge.

Elkins, J., Z. Valiavicharska, and A. Kim. 2011. *Art and Globalization*. College Park, Pa.: Penn State University Press.

Enciclopédia Itaú Cultural. N.d. "Museu de Arte Contemporânea de Niterói." http://enciclopedia.itaucultural.org.br/instituicao0109820/museu-de-arte-contemporanea-niteroi-rj.

Enwezor, O. 2007. "Tibbet's Ghost." In *The Manifesta Decade: Debates on Contemporary Art Exhibitions and Biennials in Post-Wall Europe.*, ed. B. Vanderlinden and E. Filipovic, 75–86. Cambridge, MA: MIT Press.

Esche, C. 2005. *Modest Proposals=Mütevazi öneriler.* Istanbul: Bağlam.

Esman, A.R. 2012. "VIP Art Fair Bombs Again: A Lesson in Art Marketing and Online Sales." *Forbes,* February 14. www.forbes.com/sites/abigailesman/2012/02/14/vip-artfair-bombs-again-a-lesson-in-art-marketing-and-online-sales.

Evans, G.E., and M.Z. Saponaro. 2012. *Collections Management Basics*. 6th ed. New York: ABC–CLIO.

"Exhibition and Museum Attendance Survey and Visitor Figures, 2014." 2015. *Art Newspaper,* no. 267 (April): 2–15.

EY [Ernst & Young]. 2015. "Cultural Times: The First Global Map of Cultural and Creative Industries." December. www.ey.com/Publication/vwLUAssets/ey-cultural-times-2015/$FILE/ey-cultural-times-2015.pdf.

Fahy, A. 1994. *Collections Management*. New York: Routledge.

Feige, E., ed. 1989. *The Underground Economies: Tax Evasion and Information Distortion*. Cambridge: Cambridge University Press.

Feldstein, M.S., ed. (1989) 1991. *The Economics of Art Museums*. Chicago: University of Chicago Press.

Fialho, A.L. 2007. "Are Biennials Redefining the Art World Map?" Paper presented at the American Sociological Association Conference.

Fillitz, T. 2012. "Worldmaking: The Cosmopolitanization of Dak'Art, the Art Biennial of Dakar." In *Global studies mapping contemporary art and culture,* ed. H. Belting, J.M. Birken, A. Buddensieg, and P. Weibel. Ostfildern, Germany: Hatje Cantz.

Filipovic, E., M. van Hal, and S. Øvstebø. 2010. *The Biennial Reader*. Bergen, Norway: Bergen Kunsthall; Ostfildern, Germany: Hatje Cantz.

Fleming, D. 2004. "Blockbuster Exhibitions—Why?" Paper presented at ICOM (International Committee on Management) conference, October 6. Seoul, South Korea.

Florida, R. 2002. *The Rise of the Creative Class: And How It Is Transforming Work, Leisure, Community and Everyday Life*. New York: Basic Books.

Forbes, A. 2016. "West Bund Marks a Shift in World Power." *Artsy*, November 14. www.artsy.net/article/artsy-editorial-shanghai-s-west-bund-fair-marks-a-shift-in-world-power.

Foster, H. 1996. *The Return of the Real: The Avant-garde at the End of the Century.* Cambridge, MA: MIT Press.

Foucault, M. 1977. *Discipline and Punish: The Birth of the Prison.* Translated by A. Sheridan. New York: Pantheon Books.

Fowle, K. 2013. 'Local Refreshment." *Art in America,* no. 101 (June 6–July 2013): 61–63.

Freedberg, S. J., et al. 1987. "Discussion: On Art History and the Blockbuster Exhibition." *Art Bulletin* 69, no. 2: 295–98.

Froio, N. 2012. "Impressionist Art Exhibit at CCBB in Rio." *Rio Times*, November 20. http://riotimesonline.com/brazil-news/rio-entertainment/impressionist-art-exhibit-at-ccbb-in-rio.

Fundación Jumex. N.d. "Acerca de." *Fundación Jumex Arte Contemporáneo.* www.fundacionjumex.org/en.

Furuto, A. 2013. "Koç Contemporary Art Museum Winning Proposal / Grimshaw." *ArchDaily,*July22.www.archdaily.com/405092/koc-contemporary-art-museum-winning-proposal-grimshaw.

Galloway, D. 2008. "Art Cologne's Emerging New Identity." *International Herald Tribune,* April 22.

Garcia, B., R. Melville, and T. Cox. 2010. *Impacts 08.* Liverpool: Cultural Capital Research Programme, University of Liverpool. www.liverpool.ac.uk/impacts08.

Garcia-Navarro, L. 2013. "All Across Brazil, the Art Scene Is Shifting." *NPR,* September20.www.npr.org/2013/09/20/224490054/all-across-brazil-the-art-scene-is-shifting.

Gardner, A., and C. Green. 2015. "South as Method: Biennials Past and Present." In *Making Biennials in Contemporary Times. Essays from the World Biennial Forum no. 2,* 28–36. Biennial Foundation. http://issuu.com/iccoart/docs/wbf_book_r5_issuu.

Garza, N. 2013. "El arte de lavar dinero." *Reporte Indigo,* no. 399 (November 22). www.reporteindigo.com/reporte/mexico/el-arte-de-lavar-dinero.

Gerlis, M. 2011. "Building the Brand: Big Fairs Take the Corporate Cue and Multiply Internationally." *Art Newspaper* (Art Basel Daily Edition), June 14, 1.

———. 2014. "Auction Figures for 2013 Are In—and Christie's Again Takes the Crown." *Art Newspaper,* January 22. www.theartnewspaper.com/articles/Auction-figures-for—are-inand-Christies-again-takes-the-crown-/31587.

Gielen, P. 2009. "The Biennial: A Post-institution for Immaterial Labor." *Open: Cahier on Art and the Public Domain,* no. 16, 1–10.

Gilman, N., J. Goldhammer, and S. Weber, eds. 2011. *Deviant Globalization: Black Market Economy in the 21st Century.* New York: Bloomsbury.

Gittings, P. 2014. "World Cup Bids Corruption: 'Picasso painting offered as kickback.'" *CNN,* December 1. http://edition.cnn.com/2014/11/30/sport/football/football-platini-picasso-world-cup.

Giunta, A. 2011. "Post-Crisis: Scenes of Cultural Change in Buenos Aires." In *Globalization and Contemporary Art,* ed. J. Harris, 105–22. London: Wiley-Blackwell.

Glanz, J., R. Kennedy, and W. Rashbaum. 2013. "Case Casts Harsh Light on Family Art Business." *New York Times,* May 16. www.nytimes.com/2013/05/17/arts /design/helly-nahmad-gallery-owner-indicted-in-gambling-case.html?pagewanted= all&_r=0.

Global Private Museum Network. N.d. "About Us." http://globalprivatemuseum network.com/about-us.

Goldstein, A. 2009. "Non-profit Galleries Pop up in Vacant Sites." *Art Newspaper,* November 25. www.theartnewspaper.com/articles/Non-profit-galleries-pop-up-in-vacant-sites/19804.

Goetzmann, W., L. Renneboog, and C. Spaenjers. 2010. "Art and Money." Discussion Paper No. 2010–08, Tilburg University, 1–40. http://papers.ssrn.com/sol3 /papers.cfm?abstract_id=1501171.

Goldberger, P. 2004. "Outside the Box: Yoshio Taniguchi's Elegant Expansion of the Modern." *New Yorker,* November 15.

Goodwin, J. 2008. *The International Art Markets: The Essential Guide for Collectors and Investors.* Philadelphia: Kogan Page.

Gopnik, B. 2013. "The Rush to the Box Office." *Art Newspaper* 22, no. 245 (April): 16.

Graw, I. 2009. *High Price: Art between Market and Celebrity Culture.* Translated by N. Grindell. New York: Sternberg Press.

Gu, L. 2013. Interview with Ferdie Ju. *Randian Online,* March 30. www.randian-online.com/np_feature/interview-ferdie-ju-gallery-55-yellow-ants-art-lab.

Guetzkow, J. 2002. "How the Arts Impact Communities: An Introduction to the Literature on Arts Impact Studies." Taking the Measure of Culture Conference, Princeton, NJ, June 7–8.

Gule, K. 2004. "Introduction." In *10 Years, 100 Artists: Art in a Democratic South Africa,* ed. S. Perryer. Cape Town: Bell-Roberts and Struik.

Gupta, L., P. Sood, et al. 2008. *Filament: 6 Years of the Peers Residency at KHŌJ.* New Delhi: Vadehra Art Gallery.

Hagg, G., ed. 2010. *An Assessment of the Visual Arts Sector in South Africa and Assistance to the Department of Arts and Culture in Developing a National Policy for the Visual Arts.* www.hsrc.ac.za/en/research-data/view/5456.

Hall, S., and M. Hardt. 2004. "Changing States: In the Shadow of Empire." In *Changing States: Contemporary Art and Ideas in an Era of Globalization,* ed. G. Tawadros. London: Institute of International Visual Arts.

Halperin, J. 2011. "Everything You Always Wanted to Know about the Knoedler Forgery Debacle but Were Afraid to Ask." *Blouin Art Info,* December 6. www .blouinartinfo.com/news/story/753301/everything-you-ever-wanted-to-know-about-the-knoedler-forgery.

Hampton, M., and M. Levi. 1999. "Fast Spinning into Oblivion? Recent Developments in Money-Laundering Policies and Offshore Finance Centres." *Third World Quarterly* 20, no. 3: 645–56.

Hansen, S. 2012. "The Istanbul Art-Boom Bubble." *New York Times*, February 10. www.nytimes.com/2012/02/12/magazine/istanbul-art-boom-bubble.html? pagewanted=all&_r=0.

Harrendorf, S., M. Heiskanen, and S. Malby, eds. 2010. *International Statistics on Crime and Justice*. European Institute of Crime Prevention and Control (HEUNI), United Nations Office on Drugs and Crime (UNODC). HEUNI Publication Series No. 64. Helsinki: HEUNI.

Harris, J., ed. 2011. *Globalization and Contemporary Art*. London: Wiley-Blackwell.

Hart, K. 1973. "Informal Income Opportunities and Urban Employment in Ghana." *Journal of Modern African Studies* 11, no. 1 (March): 61–89.

Harvey, D. 2005. *A Brief History of Neoliberalism*. Oxford: Oxford University Press.

Hearst, C. 2012. "Niterói Contemporary Art Museum, MAC." *Rio Times*, October 23. http://riotimesonline.com/brazil-news/rio-travel/visit-the-niteroi-contemporary-art-museum-mac/#.

Heilbrun, J., and C. Gray. (1993) 2001. "The Market in Works of Art." In Heilbrun and Gray, *The Economics of Art and Culture*. 2nd ed. Cambridge: Cambridge University Press.

Herzog, G. N.d. "A History of the First Modern Art Fair." *Art Cologne*. www.artcologne.com/ART-COLOGNE/Trade-fair/History-of-ART-COLOGNE/index.php.

Higgs, P., S. Cunningham, and H. Bakshi. 2008. "Beyond the Creative Industries: Mapping the Creative Economy in the UK." www.nesta.org.uk/library/documents/beyond-creative-industries-report.pdf.

Ho Hing-Kay, O. 2009. "Government, Business and People: Museum Development in Asia." In *The Global Art World: Audiences, Markets, Museums*, ed. H. Belting and A. Buddensieg, 266–77. Ostfildern, Germany: Hatje Kantz.

Hoffmann, J., and A. Pedrosa, eds. 2011. *Untitled (12th Istanbul Biennial, 2011)*. Istanbul: Istanbul Foundation for Culture and Arts.

Horowitz, N. 2011. *Art of the Deal: Contemporary Art in a Global Financial Market*. Princeton, NJ: Princeton University Press.

———. 2012. "Internet and Commerce." In *Contemporary Art and Its Commercial Markets: A Report on Current Conditions and Future Scenarios*, ed. M. Lind and O. Velthuis, 85–114. Berlin: Sternberg Press.

Hou, H. 2007. Biennials and 'global art.'" In *The Manifesta Decade: Debates on Contemporary Art Exhibitions and Biennials in Post-Wall Europe*, ed. B. Vanderlinden and E. Filipovic, 57–68. Cambridge, MA: MIT Press.

———. 2013. *Utopia for Sale: An Homage to Allan Sekula*. Rome: MAXXI Museo. www.fondazionemaxxi.it/en/events/utopia-for-sale.

Hourani, K. 2011. "Globalization Questions and Contemporary Art's Answers: Art in Palestine." In *Globalization and Contemporary Art*, ed. J. Harris, 297–306. London: Wiley-Blackwell.

Hoving, T. 1993. *Making the Mummies Dance: Inside the Metropolitan Museum of Art*. New York: Simon & Schuster.

Howkins, J. 2002. *The Creative Economy: How People Make Money from Ideas.* London: Penguin Books.

Hughes, H. M. 2000. "A Short History of Manifesta." *Manifesta 3.* http://m3 .manifesta.org/history.htm.

Hyde, L. 1983. *The Gift: Imagination and the Erotic Life of Property.* New York: Vintage Books.

IANS. 2006. "Rise and Rise of Indian Art." *Tribune* (India), October 15. www .tribuneindia.com/2006/20061015/spectrum/main3.htm.

India Art Fair. 2014. Press release. 6th ed. www.indiaartfair.in/document_pdf /PRESS_RELEASE_2014.pdf.

Institute for Applied Aesthetics. 2012. "The Artist-Run Space of the Future." www .applied-aesthetics.org/wp-content/uploads/2012/01/artistrunspaceofthefuture_ lores.pdf.

Institute of Museum and Library Sciences (IMLS). 2014. "Distribution of museums by discipline, FY 2014." Graph from the Museum Universe Data File, FY 2014 Q3. www.imls.gov/assets/1/AssetManager/MUDF_TypeDist_2014q3.pdf.

Istanbul Foundation for Culture & Arts (İKSV). 2011. "The 12th Istanbul Biennial Ended." www.iksv.org/en/archive/p/1/422.

———. 2013. "Istanbul Biennial." http://bienal.iksv.org/en.

———. 2014. "13th Istanbul Biennial Closed Its Doors." http://bienal.iksv.org/en /archive/newsarchive/p/1/881.

———. 2016. "The 14th Istanbul Biennial Ended." http://bienal.iksv.org/en /archive/newsarchive/p/1/1241.

Jinks, B. 2016. "Sotheby's Acquires Yet Another Activist in China's Taikang Life." Bloomberg online, July 27, 2016. www.bloomberg.com/news/articles/2016–07– 27/sotheby-s-attracts-yet-another-activist-in-china-s-taikang-life.

Jones, C. 2010. "The Historical Origins of the Biennial." In *The Biennial Reader,* ed. E. Filipovic, M. van Hal, and S. Øvstebø. Bergen, Norway: Bergen Kunsthall; Ostfildern, Germany: Hatje Cantz.

Kapferer, J. 2010. "Twilight of the Enlightenment: The Art Fair, the Culture Industry and the Creative Class." *Social Analysis,* 54, no. 2.

Kapur, A., N. Macleod, and N. Singh. 2005. "Equity Strategy. Plutonomy: Buying Luxury, Explaining Global Imbalances." Citigroup. https://docs.google.com/file /d/0B-5-JeCa2Z7hNWQyN2I1YjYtZTJjNyooZWU3LWEwNDEtMGVhZD- VjNzEwZDZm/edit?hl=en_US.

Kapur, G. 2010. "A Phenomenology of Encounters at KHŌJ." In *The KHŌJ Book, 1997–2007: Contemporary Art Practice in India,* ed. P. Sood, 4–45. London: Collins.

K Auction. 2014. "About Us." www.k-auction.com/En/About/Company.aspx.

Kar, D., and J. Spanjers. 2014. "Illicit Financial Flows from Developing Countries: 2003–2012." www.gfintegrity.org/wp-content/uploads/2014/12/Illicit-Financial- Flows-from-Developing-Countries-2003–2012.pdf.

Karroum, A. 2000. "Expédition no. 1, jeudi 15 juin 2000. Le bout du monde." http:// lebdm.free.fr/article.php3?id_article=2.

———. 2008. *L'appartement 22*. Paris: Hors'champs.

Kaufman, J. E. 2004. "Boston Museum of Fine Arts Sends Its Monets to Vegas." *Art Newspaper,* no. 14 (March): 15.

———. 2009. "How the Richest Museums in the US are Weathering the Storm." *Art Newspaper,* no. 198 (January 8). www.theartnewspaper.com/articles/How-the-richest-US-museums-are-weathering-the-storm/16705.

KEA. 2006. "The Economy of Culture in Europe." http://ec.europa.eu/culture/library/studies/cultural-economy_en.pdf.

Keeffe, H. 2014. "Valuing Labor in the Arts." *Art Practical* 5, no. 4 (April 3). www.artpractical.com/feature/valuing-labor-in-the-arts-the-manifestos.

Kessler, D., H. den Hartog Jager, O. Velthuis, and H. Mous. 2009. *Art Fairs: Mise-en-scènes from the Art World.* Zwolle, Netherlands: d'jonge Hond.

Kester, G. 2004. *Conversation Pieces: Community and Communication in Modern Art.* Berkeley: University of California Press.

———. 2011. *The One and the Many: Contemporary Collaborative Art in a Global Context.* Durham, NC: Duke University Press.

Khaire, M., and R. D. Wadhwani. 2010. "Changing Landscapes: The Construction of Meaning and Value in a New Market Category—Modern Indian Art." *Academy of Management Journal* 53, no. 6: 1281–1304.

KHŌJ International Artists' Association. N.d. http://khojworkshop.org/khoj-legacy.

Kim, E., ed.. 1999. *The Four Asian Tigers: Economic Development & the Global Political Economy.* Bingley, England: Emerald Group.

Kimmelman, M. 2013. "Defending a Scrap of Soul against MoMA." *New York Times, The Arts,* May 13, C1, 6.

King, A. D., ed. (1990) 1997. *Culture, Globalization, and the World-System: Contemporary Conditions for the Representation of Identity.* Rev. ed. Minneapolis: University of Minnesota Press.

Kino, C. 2010. "Private Collection Becomes Very Public." *New York Times, Art and Design,* June 2. www.nytimes.com/2010/06/06/arts/design/06fisher.html?_r=0.

Kinsella, E. 2010. "A Guide to the Virtual Art Market." *ARTnews* 109, no. 10 (November): 98–105.

———. 2015. "Top Collector Budi Tek has Big Plans for Private Shanghai Museum." *Artnews,* July 24. https://news.artnet.com/market/top-collector-budi-tek-big-plans-private-shanghai-museum-305784.

Kiran Nadar Museum of Art (New Delhi). N.d. "About KNMA." http://knma.in/about#verticalTab1.

Kirpal, N. 2014. "A New World of Art." *India Times,* February 3, 12.

Knight, C. 2015. "An Early Look in the Broad Museum Reveals a Show That Doesn't Quite Gel." *Los Angeles Times, Arts and Culture,* September 13. www.latimes.com/entertainment/arts/la-et-broad-museum-review-20150913-column.html.

Knight Frank. 2014. "The Wealth Report." www.thewealthreport.net.

———. 2015. "The Wealth Report." http://content.knightfrank.com/research/83/documents/en/wealth-report-2015-2716.pdf.

Krauss, R. 1985. *The Originality of the Avant-Garde and Other Modernist Myths.* Cambridge, MA: MIT Press.

Kuper, J. 2012. "Jo'burg Gallery Awash in Sewage." *Mail & Guardian* (Johannesburg), January 27. http://mg.co.za/article/2012–01–27-joburg-gallery-awash-in-sewage.

Kurtarir, E., and H. Cengiz. 2005. "What Are the Dynamics of Creative Economy in Istanbul?" 41st ISOCARP Congress paper. www.academia.edu/891798 /What_are_the_dynamics_of_creative_economy_in_Istanbul.

Lanchester, J. 2014. "Money Talks: Learning the Language of Finance." *New Yorker*, August 4. www.newyorker.com/magazine/2014/08/04/money-talks-6.

Larry's List and Artron 2016. "Private Art Museum Report." www.larryslist.com /report/Private%20Art%20Museum%20Report.pdf.

Lee, P. 2000. *Object to Be Destroyed: The Work of Gordon-Matta Clark.* Cambridge, MA: MIT Press.

———. 2012. *Forgetting the Art World.* Cambridge, MA: MIT Press.

Lewellen, C. 2014. Marian Goodman interview. *SFAQ: International Art and Culture* 16 (May–July): 100–103.

Li, G. R. 2013. Lars Nittve, executive director of Hk's M+ museum, interview (part two). *Jing Daily*, January 24.

Lippard, L. R. (1973) 2006. *Six Years: The Dematerialization of the Art Object from 1966 to 1972.* Berkeley: University of California Press.

Llanes, L. 1992. *Third Text: Third World Perspectives on Art and Culture*, no. 20 (Autumn): 5–12.

Loos, T. 2006. "Curator Lend Me Your Miró." *New York Times,* September 10. www.nytimes.com/2006/09/10/arts/design/10loos.html.

Los Angeles County Economic Development Corporation. 2010. *2010 Otis Report on the Creative Economy of the Los Angeles Region.* Los Angeles: Otis College of Art and Design.

———. 2015. *2014 Otis Report on the Creative Economy of the Los Angeles Region.* Los Angeles: Otis College of Art and Design.

Los Angeles Department of City Planning. 2014. "Arts District Draft: Live/Work Interim Zone." http://planning.lacity.org/Ordinances/DraftArtsDistrictLive-WorkOrd.pdf.

Louise, D. 2012. "Liverpool Biennial: Big, Ambitious and of the City." *a-n*, September 4. www.a-n.co.uk/news/liverpool-biennial.

Lowry, G. 2004. "A Deontological Approach to Art Museums and the Public Trust. In *Whose Muse? Art Museums and the Public Trust,* ed. J. Cuno. Princeton, NJ: Princeton University Press.

Lynch, R. L. 2012. "'Arts & Economic Prosperity IV' Proves That the Arts Industry Is Resilient, Even in a Down Economy." *Huffington Post,* June 12. www .huffingtonpost.com/robert-l-lynch/arts-and-economy_b_1588034.html.

Mabandu, P. 2015. "The Rise of Black Art Collectors." *Sunday Times Lifestyle* (Johannesburg), December 4. www.timeslive.co.za/sundaytimes/lifestyle/2015 /04/12/the-rise-of-black-art-collectors.

MacFarquhar, N. 2015. "Russia's Expanded Garage Museum Aims to Be a Global Art Player." *New York Times*, June 5. www.nytimes.com/2015/06/06/arts/design /russias-expanded-garage-aims-to-be-a-global-art-player.html?_r=0.

"Mad about Museums." 2013. *Economist,* December 21. www.economist.com/news /special-report/21591710-china-building-thousands-new-museums-how-will-it-fill-them-mad-about-museums.

Mainardi, P. 1987. *Art and Politics of the Second Empire: The Universal Exhibitions of 1855 and 1867.* New Haven, CT: Yale University Press.

Maloney, J. 2014. "Qatar Buying Art Dealer Wildenstein's Manhattan Headquarters." *Wall Street Journal*, January 24. http://online.wsj.com/news/articles/SB10 001424052702303973704579350641075915588.

Maneker, M. 2016. "Online Sales Are 3.6% of Sotheby's Auction Total." *Art Market Monitor,* August 8. www.artmarketmonitor.com/2016/08/08/online-sales-are-3-6-of-sothebys-auction-total.

Manifesta. 2014. "Manifesta 10 Facts and Figures." http://manifesta.org/wordpress /wp-content/uploads/2015/01/FactsandFigures-from-M10-.pdf.

Markusen, A. 2010. "Los Angeles: America's Artist Supercity." In *2010 Otis Report on the Creative Economy of the Los Angeles Region.* Los Angeles: Otis College of Art and Design.

Martí, S. 2013. "How Long Can Brazil's Exhibition Boom Last?" *Art Newspaper,* no. 235 (March 28). www.theartnewspaper.com/articles/How-long-can-Brazils-exhibition-boom-last/29145.

Martin, J.-H. 1989. *Magiciens de la terre.* Paris: Centre Pompidou.

Matt, G. 2001. "The Vienna Kunsthalle—Its Future in the Museum Quarter." *Museum International* 53, no. 1: 46–50.

Mbembe, A., and S. Nuttall, eds. 2004. *Johannesburg: The Elusive Metropolis.* Durham, NC: Duke University Press.

McAndrew, C. 2007. *The Art Economy: An Investor's Guide to the Art Market.* Dublin: Liffey Press.

———, ed. 2010. *Fine Art and High Finance: Expert Advice on the Economics of Ownership.* New York: Bloomberg Press.

———. 2012. *The International Art Market in 2011: Observations on the Art Trade over 25 Years.* Helvoirt, Netherlands: European Fine Art Foundation.

———. 2014. *TEFAF Art Market Report 2014: The Global Art Market, with a Focus on the U.S. and China.* Helvoirt, Netherlands: European Fine Art Foundation.

———. 2015. *TEFAF Art Market Report 2015.* Helvoirt, Netherlands: European Fine Art Foundation.

———. 2016. *TEFAF Art Market Report 2016.* Helvoirt, Netherlands: European Fine Art Foundation.

McCann, H. 2006. *Offshore Finance.* New York: Cambridge University Press.

McClellan, A. 1994. *Inventing the Louvre: Art, Politics, and the Origins of the Modern Museum in Eighteenth-century Paris.* New York: Cambridge University Press.

———. 2008. *The Art Museum: From Boullée to Bilbao.* Berkeley: University of California Press.

McLean-Ferris, L. 2012. "Research and Rescue: Istanbul." *Art Review,* no. 64: 76–81.

McQuire, S., and N. Papastergiadis. 2005. *Empires, Ruins + Networks: The Transcultural Agenda in Art.* London: Rivers Oram.

Medina, C. 2012. "Exhibitions 'are material forces' Too." *Manifesta 9: The Deep of the Modern—A Subcyclopedia.* Amsterdam: Manifesta Foundation.

Meinicke, T. 2015. "Os marcos que fizeram da ArtRio o maior evento de arte do país." VEJA Rio, September 7. http://vejario.abril.com.br/materia/exposicoes /os-marcos-que-fizeram-da-artrio-o-maior-evento-de-arte-do-pais.

Meller, H. E. 2001. *European Cities, 1890–1930s: History, Culture and the Built Environment.* Chichester, England: Wiley.

Memela, S. 2013. "There Is Talent but No Gallery in Soweto. Thought Leader." *Mail & Guardian* (Johannesburg), May 5, 2013. http://thoughtleader.co.za /sandilememela/2013/05/05/there-is-talent-but-no-gallery-in-soweto.

Mendoza Escamilla, V. 2013. "Capital creativo, la otra palanca del crecimiento." *Forbes México,* November 9. www.forbes.com.mx/capital-creativo-la-otra-palanca-del-crecimiento.

Merriman, N. 2008. "Museum Collections and Sustainability." *Cultural Trends* 17, no. 1 (March): 3–21.

Metropolitan Museum of Art. 2015. Annual report for the year 2014–15. www .metmuseum.org/~/media/Files/About/Annual%20Reports/2014–2015 /Annual%20Report%202015%20Report%20of%20the%20Chief%20 Financial%20Officer.pdf.

Mettera, P. 1985. *Off the Books: The Rise of the Underground Economy.* New York: St. Martin's Press.

Milliard, C. 2013a. "REVIEW: An Istanbul Biennial Caught Up in History." *BlouinArtInfo,* September 23. http://uk.blouinartinfo.com/news/story/961885 /review-an-istanbul-biennial-caught-up-in-history.

———. 2013b. "What Happened to Haunch of Venison? Christie's Surprise Move Leaves Questions." *BlouinArtInfo,* February 5. www.blouinartinfo.com/news /story/864003/what-happened-to-haunch-of-venison-christies-surprise-move.

Minaar, M. 2013. "Ayana Jackson Undresses the Past." *Mail and Guardian* (South Africa), September 5. www.youtube.com/watch?v=hSpLE0AM9bM.

"The Missing $20 Trillion." 2013. *Economist,* February 16. www.economist.com /news/leaders/21571873-how-stop-companies-and-people-dodging-tax-delaware-well-grand-cayman-missing-20.

Montero, G. G. 2011. "Biennialization? What Biennialization? The Documentation of Biennials and Other Recurrent Exhibitions." *Art Libraries Journal* 37, no. 1: 13–23.

Montgomery, J. 2004. "Cultural Quarters as Mechanisms for Urban Regeneration, Part 2: A Review of Four Cultural Quarters in the UK, Ireland and Australia." *Planning, Practice & Research* 19, no. 1: 3–31.

Moon S. 2012. "SeMA to Shift Away from 'blockbuster' Exhibitions." *Korea JoongAng Daily,* February 6. http://koreajoongangdaily.joinsmsn.com/news/article /article.aspx?aid=2947954

Mörtenböck, P., H. Mooshammer, T. Cruz, T., and F. Forman, eds. 2015. *Informal Market Worlds: The Architecture of Economic Pressure*. 2 vols. Rotterdam: nai010.

Moss, S. 2011. "Is the Blockbuster Exhibition Dead?" *Guardian* (London), May 9. www.guardian.co.uk/artanddesign/2011/may/09/blockbuster-exhibition-national-leonardo.

Mosquera, G. 1998. "Infinite Islands: Regarding Art, Globalization, and Cultures, Part I." *Art Nexus*, no. 29 (August–October 98): 64–67.

———. 2011. "The Third Bienal de La Habana in Its Global and Local Contexts." In *Making Art Global (Part 1): The Third Havana Biennial*, ed. R. Weiss, 70–80. London: Afterall Books.

Moulin, R. 1967. *Le marché de la peinture en France*. Paris: Minuit.

Mous, H. 2009. "The Art Fair and the Religion of the Spectacle." In D. Kessler, H. den Hartog Jager, O. Velthuis, and H. Mous, *Art Fairs: Mise-en-scènes from the Art World*. Zwolle, Netherlands: d'jonge Hond.

Movius, L. 2010. "Cultural Globalisation and Challenges to Traditional Communication Theories." *PLATFORM: Journal of Media and Communication* 2, no. 1 (January): 6–18.

———. 2011. "Vanity, Vanity: The Problems Facing China's Private Museums." *Art Newspaper*, no. 229 (November 2): 28..

Nairne, S. 1999. "Exhibitions of Contemporary Art." In *Contemporary Cultures of Display*, ed. E. Barker, 105–26. New Haven, CT: Yale University Press.

Negro, V. 2016. "Messico, una cooperativa sociale alla Biennale di Architettura di Venezia 2016." *Repubblica*, January 27. www.repubblica.it/solidarieta/cooperazione/2016/01/27/news/una_cooperativa_sociale_rappresentera_il_messico_alla_biennale_di_architettura_di_venezia_2016–132138209.

Nelson, R. 2013. "Steiv Selapak: A Cambodian Artists' Collective." *Art Monthly Australia*, no. 261 (July): 47–49.

Neuwirth, R. 2011. *Stealth of Nations: The Global Rise of the Informal Economy*. New York: Random House.

New Museum (New York City). N.d. Art Spaces Directory. http://archive.newmuseum.org/index.php/Detail/Object/Show/object_id/10198.

Newhouse, V. 1998. *Towards a New Museum*. New York: Monticelli Press.

Ng, D. 2013. "Milestone for the Broad, an Art Museum Coming to Grand Avenue." *Los Angeles Times*, January 8. http://articles.latimes.com/2013/jan/08/entertainment/la-et-cm-broad-museum-topping-out-20130109.

Nikodijevic, D. 2010. "Art, Economy and the Market: The Aesthetic Syndrome and Market Rules." *Megatrend Review* 7, no. 2: 188–200.

Ojama, H. 2013. "Strategy or Survival?" In "The Economic Crisis and Its Effects on Affiliate Contemporary Art Museums." MA thesis, Sibelius Academy, University of the Arts, Helsinki.

Olson, E. 2013. "Enshrining Art with a Permanent, and Personal, Home." *New York Times*, March 20. www.nytimes.com/2013/03/21/arts/artsspecial/a-flurry-of-museum-building-with-a-personal-stamp.html.

Osborne, P. 2015. "Every Other Year Is Always This Year: Contemporaneity and the Biennial Forum." In *Making Biennials in Contemporary Times: Essays from the World Biennial Forum no 2, São Paulo, 2014*, 15–27. Biennial Foundation. http://issuu.com/iccoart/docs/wbf_book_r5_issuu.

Ouroussoff, N. 2004. "Art Fuses with Urbanity in Redesign of the Modern." *New York Times*, November 15. www.nytimes.com/2004/11/15/arts/design/15moma.html?_r=0.

———. 2006. "A Razor-Sharp Profile Cuts into a Mile-High Cityscape." *New York Times*, October 12. www.nytimes.com/2006/10/12/arts/design/12libe.html?pagewanted=all&_r=0.

Palan, R. 1998. "Trying to Have Your Cake and Eating It: How and Why the State System Has Created Offshore." *International Studies Quarterly* 42, no. 4: 625–43.

Papastergiadis, N. 2011. "Collaboration in Art and Society: A Global Pursuit of Democratic Dialogue." In *Globalization and Contemporary Art,* ed. J. Harris, 275–88. London: Wiley-Blackwell.

Patry, S. 2014. *Paul Durand-Ruel: Le pari de l'impressionisme.* Paris: RMN.

Paulré, B. 2010. "Cognitive Capitalism and the Financialization of Economic Systems." In *Crisis in the Global Economy: Financial Markets, Social Struggles and New Political Scenarios,* ed. A. Fumagalli and S. Mezzadra. Los Angeles: Semiotext(e).

Payne, M. 2014. "Vladimir Putin Allegedly Gave UEFA President Michael Platini a Picasso in Exchange for a FIFA World Cup Vote." *Washington Post*, December 1. www.washingtonpost.com/blogs/early-lead/wp/2014/12/01/vladimir-putin-allegedly-gave-uefa-president-michel-platini-a-picasso-in-exchange-for-a-fifa-world-cup-vote.

Pera Museum (Istanbul). N.d. "About Pera Museum." www.peramuseum.org/Content/about-pera-museum/58.

Perl, J. 2008. "The Man Who Remade the Met." *Atlantic Monthly* 302, no. 3 (October): 94–108.

Perlez, J. 2012. "China Extends Reach into International Art." *New York Times,* April 23, C1.

Pes, J. 2012. "Hey Big Spenders . . . There's More to Building a Contemporary Museum from Scratch Than Eye-Watering Acquisition Budgets." *Art Newspaper*, March 11. http://old.theartnewspaper.com/articles/Hey,%20big%20spenders%E2%80%A6/26708.

Pes, J., and E. Sharpe. 2012. "Brazil's Exhibition Boom Puts Rio on Top." *Art Newspaper,* no. 234 (April): 35–37.

———. 2015. "Visitor Figures 2014: The World Goes Dotty over Yayoi Kusama." *Art Newspaper,* April 2. http://theartnewspaper.com/news/museums/17584.

Phillips, D. 2013. "The New Art of the Carioca: Rio's Artistic Renaissance." *Financialist* (Credit Suisse), July 17. www.thefinancialist.com/the-new-art-of-the-carioca-rios-artistic-renaissance/#sthash.W3030rj7.JFkkxVx4.dpuf.

Picton, J. 1999. "The New Way to Wear Black." In *Reading the Contemporary,* ed. O. Enwezor and O. Oguibe. London: Ininva, 1999.

Pieprzak, K. 2010. *Imagined Museums: Art and Modernity in Postcolonial Morocco.* Minneapolis: University of Minnesota Press.

Piketty, T. 2014. *Capital in the Twenty-First Century.* Translated by A. Goldhammer. Cambridge, MA: The Belknap Press of Harvard University Press.

Pine, J., and J. Gilmore. 1998. "Welcome to the Experience Economy." *Harvard Business Review,* July–August 1998. https://hbr.org/1998/07/welcome-to-the-experience-economy.

Plaza, B. 2007. "The Bilbao Effect (Guggenheim Museum Bilbao)." *Museum News* 86, no. 5 (September–October): 13–68. American Association of Museums.

———. 2008. "On Some Challenges and Conditions for the Guggenheim Museum Bilbao to be an Effective Economic Re-Activator." *International Journal of Urban and Regional Research* 32, no. 2 (June): 506–17.

Pogrebin, R. 2013. "Overshadowed, and Now Doomed." *New York Times,* April 11, C1, 2.

Pollock, B. 2011. "China: Boom or Bust?" *Art in America,* no. 99 (October 2011): 132–41.

Port Authority of New York and New Jersey. 1993. *The Arts as an Industry: Their Economic Importance to the New York–New Jersey Metropolitan Region.* New York: Port Authority of NY & NJ Cultural Assistance Center.

Portes, A. 2010. *Economic Sociology: A Systematic Inquiry.* Princeton, NJ: Princeton University Press.

Pound, E. 1951. *Letters of Ezra Pound, 1907–1941,* ed. D. D. Paige. To Harriet Monroe, November 7, 1913.

Power Station of Art. 2013. Summary of the Shanghai Biennial 2012. http://www.powerstationofart.org/en/press/details/dcokx.html. No longer available online.

Prashad, V. 2007. *The Darker Nations: A People's History of the Third World.* New York: New Press.

PTI. 2016. "Delhi Out of Unesco's Heritage City Tag Race; Eyes on Nalanda in 2016." *Indian Express,* January 6. http://indianexpress.com/article/lifestyle/art-and-culture/delhi-out-of-unescos-heritage-city-tag-race-eyes-on-nalanda-in-2016/#sthash.gjdAEXMm.dpuf.

Pyś, P. S. 2012. "Bucharest Biennale 5." *Frieze,* no. 149 (September 2012). https://frieze.com/article/bucharest-biennale-5.

Quemin, A. 2012. "The Internationalization of the Contemporary Art World and Market: The Role of Nationality and Territory Is a Supposedly "Globalized" Sector." In *Contemporary Art and Its Commercial Markets: A Report on Current Conditions and Future Scenarios,* ed. M. Lind and O. Velthuis, 53–84. Berlin: Sternberg Press.

Ramírez, M. C. 1996. "Brokering Identities: Art Curators and the Politics of Cultural Representation." In *Thinking about Exhibitions,* ed. R. Greenberg, B. W. Ferguson, and S. Nairne. New York: Routledge.

Redburn, T. 1993. "Arts World: Many Tiny Economic Stars." *New York Times,* October 6. www.nytimes.com/1993/10/06/nyregion/arts-world-many-tiny-economic-stars.html.

Robertson, I. 2011. *A New Art from Emerging Markets.* Burlington, VT: Lund Humphries.

——. 2016. *Understanding Art Markets: Inside the World of Art and Business.* New York: Routledge.

Rogers, S. 2013. "Culture '45 and the Rise of Beirut's Contemporary Art Scene." In *Six Lines of Flight: Shifting Geographies in Contemporary Art,* ed. A. DiQuinzio. San Francisco: San Francisco Museum of Modern Art; Berkeley: University of California Press.

Rojas-Sotelo, M. 2010. "The Other Network: The Havana Biennale and the Global South." Global Art and the Museum, guest author. May. www.globalartmuseum.de/site/guest_author/262. Web site under construction.

Rojo, J., and S. Harrington. 2013. "Huge Street Art Murals Transform City of Lodz in Poland." *Huffington Post,* June 12. www.huffingtonpost.com/jaime-rojo-steven-harrington/large-murals-transform-lodz_b_3428241.html.

Rosenfield, K. 2013. "Herzog and de Meuron Win Competition to Hong Kong Museum." *Arch Daily,* June 28. www.archdaily.com/395561/herzog-and-de-meuron-win-competition-to-hong-kong-museum.

Russouw, S. 2002. "SA Crafts Industry Keeps Growing." *Brand South Africa* September 12. www.southafrica.info/business/trends/newbusiness/craftsindustry.htm.

Sallier, P.-A., and D. Haeberli. 2015. "Yves Bouvier: 'Il a détruit ma réputation, je détruirai sa fortune.'" *24 Heures,* September 1. www.24heures.ch/economie/Yves-Bouvier-Il-a-detruit-ma-reputation-je-detruirai-sa-fortune/story/19767835.

Saner, E. 2013. "Blockbuster Art: Good or Bad?" *Guardian* (London), January 25. www.guardian.co.uk/commentisfree/2013/jan/25/blockbuster-art-good-or-bad.

Sansom, A. 2012. "Bringing Back Art Cologne" *Art Newspaper,* April 24. www.theartnewspaper.com/articles/Bringing%20back%20Art%20Cologne/26433.

Sassen, R. 2015. "JAG Puts on Show of a Lifetime." *Mail & Guardian* (Johannesburg), November 6. http://mg.co.za/article/2015-11-05-jag-puts-on-show-of-a-lifetime.

Sassen, S. 1991. *The Global City: New York, London, Tokyo.* Princeton, NJ: Princeton University Press.

——. 2000. *Cities in a World Economy.* Thousand Oaks, CA: Pine Forge Press.

Sawant, S. 2012. "Instituting Artists' Collectives: The Bangalore/Bangaluru Experiments with 'solidarity economies.'" *Transcultural Studies,* no. 1. http://heiup.uni-heidelberg.de/journals/index.php/transcultural/article/view/9275/3237.

Schjeldahl, P. 2012. "All Is Fairs: The Shows That Are Changing the Art World." *New Yorker,* May 7, 32–37.

Schmitt, J.-M. 2008. *Le marché de l'art.* Paris: La Documentation française.

Schuker, L. 2008. "The Firestorm over Private Museums." *Wall Street Journal,* April 4.

Schwarzer, M. 2006. *Riches, Rivals, and Radicals: 100 Years of Museums in America.* Washington, DC: American Association of Museums.

Segal, D. 2012. "Swiss Freeports Are Home for a Growing Treasury of Art." *New York Times,* July 21. www.nytimes.com/2012/07/22/business/swiss-freeports-are-home-for-a-growing-treasury-of-art.html?pagewanted=all&_r=0.

———. 2015. "Petrobras Oil Scandal Leaves Brazilians Lamenting a Lost Dream." *New York Times,* August 7. www.nytimes.com/2015/08/09/business/international/effects-of-petrobras-scandal-leave-brazilians-lamenting-a-lost-dream.html?_r=0.

Sepúlveda dos Santos, M. 2001. "The New Dynamic of Blockbuster Exhibitions: The Case of Brazilian Museums." *Bulletin of Latin American Research* 20, no. 1 (January): 29.

Shah, G. R. 2010. "India's Online Auction Pioneers." *New York Times,* September 7. www.nytimes.com/2010/09/08/arts/08iht-rartsaffron.html?pagewanted=print.

Shaxson, N. 2011. *Treasure Islands: Uncovering the Damage of Offshore Banking and Tax Havens.* New York: Palgrave Macmillan.

Silva, B. 1998. "The Johannesburg Biennale." *Artnet,* April 28. www.artnet.com/magazine_pre2000/reviews/silva/silva4-28-98.asp.

Sinclair, C. 2012. "How to Spend It: Arts and Giving, Art for One and Art for All." *Financial Times,* February 18. http://howtospendit.ft.com/arts-giving/6658-art-for-one-and-art-for-all.

Smith, T. 2004. "Biennials in the Conditions of Contemporaneity." In *Criticism + Engagement + Thought: 2004 Biennale of Sydney,* ed. B. French, A. Geczy, and N. Tsoutas. Woolloomooloo, N.S.W.: Artspace Visual Arts Centre.

———. 2009. *What Is Contemporary Art?* Chicago: University of Chicago Press.

"Smoked Venison: Can an Auction House Successfully Manage a Living Artist's Primary Market?" 2010. *Economist,* June 2. www.economist.com/node/16267901.

Sood, P., ed. 2010a. *The KHŌJ Book, 1997–2007: Contemporary Art Practice in India.* Noida, India: Collins.

———. 2010b. "Mapping KHŌJ: Idea/Space/Network." In *The KHŌJ Book, 1997–2007: Contemporary Art Practice in India,* ed. id., 4–45. Noida, India: Collins.

Sotheby's. 2015. "2014 Annual Report." http://files.shareholder.com/downloads/BID/1305447228x0x817588/A824E970-0B75-48F9-B835-EE7F28DC78F2/BID_2014_Annual_Report.pdf.

South Africa. Department of Labour. CAJ for HSRC. 2007. *Creative Industries Sector Report.* December 15. www.labour.gov.za/DOL/downloads/documents/research-documents/Creative%20Industries_DoL_Report.pdf.

———. Statistics South Africa. Census 2011. www.statssa.gov.za/publications/P03014/P030142011.pdf.

Spear, R. E. 1986. "Editorial: Art History and the Blockbuster Exhibition." *Art Bulletin* 68, no. 3 (September): 358–59.

Stallabrass, J. 2004. *Art Incorporated: The Story of Contemporary Art.* Oxford: Oxford University Press.

Steeds, L. 2013. "'Magiciens de la Terre' and the Development of Transnational Project-Based Curating." In id. et al., *Making Art Global: Part 2, Magiciens de la terre, 1989*, 24–92. London: Afterall Books.

Steeds, L., et al. 2013. *Making Art Global: Part 2, Magiciens de la terre, 1989*. London: Afterall Books.

Storr, R. 2005. "To Have and to Hold." In *Collecting the New: Museums and Contemporary Art*, ed. B. Altshuler, 29–40. Princeton, NJ: Princeton University Press.

Stromberg, M. 2015a. "Why Do US and European Galleries Flock to Mexico City's Zona MACO?" *Hyperallergic*, February 7. http://hyperallergic.com/180889/why-do-us-and-european-galleries-flock-to-mexico-citys-zona-maco.

———. 2015b. "The New Broad Museum Brings LA Lots of Blue-Chip Art and a Few Surprises. *Hyperallergic*, September 17. http://hyperallergic.com/237478/the-new-broad-museum-brings-la-lots-of-blue-chip-art-and-a-few-surprises.

Sutton, B., and C. Voon. 2016. "Panama Papers Shed Light on Shadowy Art Market." *Hyperallergic*, April 12. http://hyperallergic.com/289250/panama-papers-shed-light-on-the-shadowy-art-market/?utm_medium=email&utm_campaign=Panama%20Papers%20Shed%20Light%20on%20the%20Shadowy%20Art%20Market&utm_content=Panama%20Papers%20Shed%20Light%20on%20the%20Shadowy%20Art%20Mar.

Swartz, J. 2010. "Space-Run Artists: A Cultural Activism in Contemporary Barcelona." *Leonardo* 43, no. 1: 6–7.

Talwar, D. 2013. "The Great Indian Art Bazaar." *ArtAsiaPacific*, 83 (May–June 2013). http://artasiapacific.com/Magazine/83/TheGreatIndianArtBazaar.

Tan, P. 2006. "Self-Initiated Collectivity: Artist-Run Space + Artist Collectives in Istanbul." *Art Papers*, 40, no. 4: 20–23.

Tanner, S. C. 2010. "The Changing Role of the Art Dealer." *Art Book*, 17, no. 2: 52–53.

TEFAF [European Fine Art Fair]. 2013. *History, from the Beginning*. Maastricht: TEFAF. www.tefaf.com/about/tefaf.

———. 2016. "TEFAF History Overview." www.tefaf.com/about/history/tefaf-history-overview.

Thompson, D. 2008. *The $12 Million Stuffed Shark: The Curious Economics of Contemporary Art*. New York: Palgrave Macmillan.

———. 2014. *The Supermodel and the Brillo Box*. New York: Palgrave Macmillan.

Thornton, L. 2008. *Seven Days in the Art World*. New York: Norton.

Today's Zaman. 2011. "New York's Metropolitan Museum Names Two Galleries after Koc Family." *Today's Zaman*, October 26. In Turkish. www.todayszaman.com/newsDetail_getNewsById.action?load=detay&newsId=261056&link=261056.

UNCTAD (United Nations Conference on Trade and Development). 2010. "Creative Economy Report 2010." http://unctad.org/en/Docs/ditctab20103_en.pdf.

Unilever Institute of Strategic Marketing, University of Cape Town. 2012. "Four Million and Rising: Black Middle Class Expanding." June 18. www.uctunileverinstitute.co.za/research/4-million-rising.

United Kingdom. Department for Culture, Media, and Sport. 2011. Creative Industries Economic Estimates. Full Statistical Release. December 8. www.gov.uk /government/uploads/system/uploads/attachment_data/file/77959/Creative-Industries-Economic-Estimates-Report-2011-update.pdf.

URBACT. 2008. "Creative Clusters in Low Density Urban Areas—Baseline Study." http://urbact.eu/sites/default/files/import/Projects/Creative_Clusters /documents_media/02_-_Baseline_Creative_Clusters.pdf.

Urban Institute. National Center for Charitable Statistics. 2012. "Registered Nonprofit Organizations by Level of Total Revenue." BMF 08. www.urban.org /research/publication/nonprofit-sector-brief-public-charities-giving-and-volunteering-2012/view/full_report.

Van Bruggen, C. 1997. *Frank O. Gehry: Guggenheim Museum Bilbao.* New York: Simon R. Guggenheim Foundation.

Van Niekerk, G. 2016. "Muholi Is Africa's Most Powerful Female Artist." *City Press,* October 23. www.channel24.co.za/News/Local/muholi-is-africas-most-powerful-female-artist-20161022.

Van Onselen, C. 2001. *New Babylon, New Nineveh: Everyday Life on the Witwatersrand, 1886–1914.* Johannesburg: Jonathan Ball.

Vanderlinden, B., and E. Filipovic. 2007. *The Manifesta Decade: Contemporary Art Exhibitions and Biennials in Post-Wall Europe.* Cambridge, MA: MIT Press.

Velthuis, O. 2005. *Talking Prices: Symbolic Meanings of Prices on the Market for Contemporary Art.* Princeton, NJ: Princeton University Press.

———. 2007. "Prelude to a New Artistic Landscape." In D. Kessler, H. den Hartog Jager, O. Velthuis, and H. Mous, *Art Fairs: Mise-en-scènes from the Art World,* 52–57. Zwolle, Netherlands: d'jonge Hond.

———. 2011. "The Venice Effect." *Art Newspaper,* May 2011, 1.

———. 2012. "Introduction: The Contemporary Art Market between Stasis and Flux." In *Contemporary Art and Its Commercial Markets,* ed. M. Lind and O. Velthuis. Berlin: Sternberg Press.

Velthuis, O., and S. Baia Curioni, eds. 2015a. *Cosmopolitan Canvases: The Globalization of Markets for Contemporary Art.* Oxford: Oxford University Press.

———. 2015b. "Making Markets Global." In *Cosmopolitan Canvases: The Globalization of Markets for Contemporary Art,* ed. O. Velthuis and S. Baia Curioni, 1–31. Oxford: Oxford University Press.

Viegener, M. 2015. "Speculative Futures: Social Practice, Cognitive Capitalism and/ or the Triumph of Capital. In *Informal Market Worlds: The Architecture of Economic Pressure,* ed. P. Mörtenböck, H. Mooshammer, T. Cruz, and F. Forman, 1: 185–204. Rotterdam: naio10.

Vogel, C. 2012. "The Art World, Blurred." *New York Times,* October 26. www .nytimes.com/2012/10/28/arts/artsspecial/boundaries-blur-at-art-showcases.html? pagewanted=all&_r=0.

Vogel, S. 1994. *Africa Explores: 20th Century African Art*. New York: Museum for African Art.

Waelder, P. 2013. "Different but Always the Same: The Online Art Market." *ETC*, no. 98 (February–June): 51–55. http://id.erudit.org/iderudit/68785ac.

The Wall Art TV. *India Art Fair 2015*. 2015. www.thewallartmag.com /eachVideo/221.html.

Waterfield, G. 2011. "Blockbusters: Too Big to Fail?" *Art Newspaper*, no. 224 (May): 43–44.

Watts, O. 2013. "Emerging Arts and the New Collectivisation." *Arts Monthly Australia*, no. 257 (March): 20–24.

Weibel, P., and A. Buddensieg, eds. 2007. *Contemporary Art and the Museum: A Global Perspective*. Ostfildern, Germany: Hatje Cantz.

Weibel, P., H. Belting, and A. Buddensieg, eds. 2011. *Global Studies: Mapping Contemporary Art and Culture*. Ostfildern, Germany: Hatje Cantz.

——, eds. 2013. *The Global Contemporary and the Rise of New Art Worlds*. Karlsruhe, Germany: ZKM/Center for Art and Media; Cambridge, MA: MIT Press.

Weiss, R., ed. 2011. *Making Art Global (Part 1): The Third Havana Biennial*. London: Afterall Books.

Werner, P. 2005. *Museum Inc: The Global Art World*. Chicago: Prickly Paradigm Press.

West Kowloon Cultural District Authority (WKCD). 2006. Report to the Consultative Committee on the Core Arts and Cultural Facilities of the West Kowloon Cultural District Museums Advisory Group. http://d3fveiluheoxc2 .cloudfront.net/media/_file/mag-report.pdf.

White, H. C., and White, C. A. 1965. *Careers and Canvases: Institutional Change in the French Painting World*. New York: Wiley.

Whitelegg, I. 2013. "The Bienal Internacional de São Paulo: A Concise History, 1951–2014." *Perspective: Actualité en histoire de l'art*, no. 2 (2013): 380–86. https:// perspective.revues.org/3902.

Whiting, S. 2015, October 21. "SFMOMA to Reopen in May as Largest Museum of Its Kind in U.S." *San Francisco Chronicle*, October 21. www.sfchronicle.com/art /article/SFMOMA-to-reopen-in-May-as-largest-museum-of-its-6582330.php.

Wilson, M. 2007. "Autonomy, Agonism and Activist Art: An Interview with Grant Kester." *Art Journal*, Fall 2007, 106–18.

Wilson-Goldie, K. 2013. "Public Relations." *ArtForum* online, May 22. www .artforum.com/diary/id=41191.

Wong, M. 2014. *Sighting Islands: Notes on Artist-Run Spaces*. Hong Kong: 100ft park.

Wu, C. 1998. "Embracing the Enterprise Culture: Art Institutions since the 1980s. *New Left Review* 1, no. 230 (July–August): 28–57.

Wu, H. 2000. "The 2000 Shanghai Biennial: The Making of a Historical Event." *ArtAsiaPacific*, no. 31: 42–49. https://lucian.uchicago.edu/blogs/wuhung /files/2012/12/2000_2000-Shanghai-Biennale-pp42–49.pdf

Xu, J., and X. Li, eds. 2012. *Reactivation: 9th Shanghai Biennial*. Shanghai: Power Station of Art.

Yablonsky, L. 2011. "Mexican Recipe: Art Basel Miami Beach Influencers 2011." http://id.erudit.org/iderudit/68785ac.

Yazici, D. 2011. "The Curatorial Turn in the International Istanbul Biennial." www .academia.edu/2319466/The_Curatorial_Turn_in_The_International_Istanbul_ Biennial.

Yogev, T., and G. Ertug. 2015. "Global and Local Flows in the Contemporary Art Market: The Growing Prevalence of Asia." In *Cosmopolitan Canvases: The Globalization of Markets for Contemporary art,* ed. O. Velthuis and S. Baia Curioni, 193–212. Oxford: Oxford University Press.

Zagaris, B. 1997. "The Underground Economy in the US: Some Criminal Justice and Legal Perspectives." In *The Underground Economy: Global Evidence of Its Size and Impact,* ed. O. Lippert and M. Walker. Vancouver: Fraser Institute.

Zarobell, J. 2014. "Paul Durand-Ruel et le marché de l'art moderne (1870–1873)." In *Paul Durand-Ruel: Le pari de l'impressionisme,* 60–75. Paris: Réunion des musées nationaux.

———. 2015. "Three Perspectives on the Globalization of the Art Market." *SFAQ: International Art and Culture* 19 (March): 48–49. http://sfaq.us/2015/03 /three-perspectives-on-the-globalization-of-the-art-market.

Zhong, S. 2011. "By Nature or by Nurture: The Formation of New Economy Spaces in Shanghai." *Asian Geographer* 28, no. 1: 33–49.

INDEX

India, 21–27, 118, 192, 215, 269, 274, 277
 art market, 23
Indonesia, 269
informal economy, 240–253
indigenization, 153, 155, 159, 190
industry, 7
 fine art, 221
informal economy, 17, 179, 234, 244–253
Instagram, 164
Institute for Applied Aesthetics, 264
Institute of Museum and Library Sciences,
 37
intelligentsia, 91, 95
international bourgeoisie, 15, 130
international business corporation (IBC),
 239–240, 244
International Confederation of Societies
 of Authors and Composers (CISAC), 9
"international gatekeepers," 156
international law, 239, 277
International Monetary Fund, 3
International Symposium on Contempo-
 rary Art Theory (SITAC), 199
international trade, 23
internationalism, 119, 120, 217
internationalization, 106, 124, 199
internet, 183
investment, 12, 22
investors, 233
Iraq, 271
Israel, 271, 277
 Occupied Territories, 271
Istanbul, Turkey, 9, 12, 49, 50, 54, 73, 116,
 121, 128, 129, 131–136
 Beyoğlu, 12
 Galata, 135
 Gezi park protests, 131
 Hagia Sophia, 121
 "Independence Avenue," 131
 SAHA, 135
 Taksim Square, 122, 131
 Tophane, 13
 Topkapi Palace, 121
Italy, 51

Jackson, Ayana V, 226
Jakarta, Indonesia, 51, 52, 219
Japan, 69, 73

Johannesburg, South Africa, 152, 221–231
 Assemblage, 231
 August House, 231
 Braamfontein, 225
 "Centre for Historical Reenactments,"
 230
 Maboneng, 225
 National School for the Arts (Braam-
 fontein), 225
 Nugget Street Studios, 231
 Soweto, 223
 Troyeville, 223, 225
 University of the Witwatersrand
 (Wits), 225
 Wits University School of Arts,
 230
Joo, Eungie, 263
Joreige, Lamia, 88
Journal of Arts and Ideas, 274
Ju, Ferdie, 192
Julien, Isaac, 69

Kabokov, Ilya and Emilia, 94
Kahlo, Frida, 132, 154
Kahnweiler, Daniel-Henry, 184
Kallat, Jitish, 24
Kapkov, Sergey, 95
Kapur, Geeta, 119, 274, 275
Karachi, Pakistan, 275, 277
Karroum, Abdellah, 272–4
Kashmir, 277
Kassel, Germany, 108, 110
KEA, 10
Kearny, A. T. *See* A. T. Kearny
Kentridge, William, 225, 276
Kessler, Dolph, 139, 149
Kester, Grant, 265
Khaire, Mukti, 206, 211, 216, 217
Kher, Bharti, 22
Khmer Rouge, 270
Kiev, Ukraine, 83
King Tut, 64, 68
Kinkade, Thomas, 172
Kiraç family, 82, 132
Kirpal, Neha, 23
Klabin, Vanda, 259
Koç Holding A. S., 132, 134
Kolkata, India, 149

United Nations, 3, 9, 19, 124, 226, 240
 United Nations Conference on Trade
 and Development (UNCTAD), 11,
 12, 113
 Creative Economy Programme, 11
 convention in Accra, 11
 Sao Pãolo consensus, 11
University/Universities, 25
 Delhi University, 25
 Jamia Millia University, 25
 Mass Communication Research
 Centre, 25
 Jawaharlal Nehru University (JNU), 25
 School of Art and Aesthetics, 25
 Lalit Kala Academy, 25
 National Academy of Art, 25
URBACT II, 114
urban development, 112
urban planning, 41, 53
urban policies, 12
urban renewal, 225
urban spaces, 27
urban sprawl, 21

Valadares, Elisangela, 256
Valansi, Brenda, 256
van Gogh, Theo, 185
Vazirani, Minal, 218
Velthuis, Olav, 142, 157, 172–179, 184, 186,
 190, 237, 247
Venice, Italy, 52
Vermeir & Heiremans, 131
vertical integration, 209
Vidarte, Juan Ingnacio, 53
video art, 86
Vietnam, 267, 269
Villar Rojas, Adrián, 194
Virginia Commonwealth University,
 Doha, 164
VIP's, 138, 155, 187. See also VVIP's
Visual culture, 55
Vollard, Ambrose, 184
Voges, Uli, 145
VVIP's, 138

Wadhwani, R. Daniel, 206, 211, 216, 217
Walton, Alice, 51
Wang Wei, 51
Wang Yannan, 216
Warhol, Andy, 132, 133, 250
Washington Consensus, 9
Watts, Oliver, 263
Wen Chiang, 249
West Kowloon Cultural District, 31, 49
Weiner, Lawrence, 154
Weiss, Rachel, 119
Weissmann, Franz, 258
Whistler, James Abbott McNeill, 45
white cube, 84, 149, 265
Williams, Tod, 42
World Heritage City, 22
World Trade Organization, 3
World Cup, 162
World's Fair, 6, 66, 99, 138
 Centennial Exhibition (Philadelphia),
 66
 Crystal Palace Exhibition, (London),
 66, 99
 Exposition universelle (Paris), 66
 Panama-Pacific Exhibition (San Fran-
 cisco), 67
World Expo (Shanghai), 67
Wright, Frank Lloyd, 52
Wu Hung, 124, 125

yenhui, 249
Yogev, Tamar, 159

Zabludowica, Anita, 50
Zainy, Jassim, 166
Zaire (Democratic Republic of Congo),
 215
Zavale, Isaac, 230
Zhang Daquian, 250
Žižek, Slavoj, 227
Zkukova, Dasha, 84
Zuma, Jacob, 224
Zürich, 144, 235
Zwirner, Rudolf, 142